The Sculptural Idea

Third Edition

James J. Kelly

Macmillan Publishing Company
New York
Collier Macmillan Publishers
London

Editorial: Kay Kushino, Elisabeth Sövik, Nelda Wright, J. D. Wicklatz

Art: Joan Gordon, Priscilla Golz, Addy Trettel

Production: Morris Lundin, Pat Barnes

Cover: James O. Clark.
Untitled. 1976, Wood, fluorescent fixture, algae.
(Courtesy of the artist.)

Macmillan Publishing Company
866 Third Avenue
New York, N.Y. 10022
Collier Macmillan Canada, Inc.

Printing 7 8 9 10 Year 7 8 9 0

To the light . . .

Contents

Illustrations vii

Preface x

1 The Ambivalence of Sculpture
 The Artist, the Critic, the Consumer, and the Consumed 1

2 Sculpture as History
 The Evolution of Forms 11

3 Universal Form
 The Search for Form of Consequence 33

4 Matter
 The Material of Sculpture 47

5 Form
The Method of Sculpture 65

6 Content
The Meaning of Sculpture 101

7 The New Technology and Beyond
Resources, Problems, and Potentials in Relation to the Sculptural Idea 107

8 The Changing Role of the Sculptor
Stance, Direction, Force 149

9 Materials and Their Characteristics 157

10 Techniques and Processes 169

Appendix A
Resource Information 191

Appendix B
Abrasives, Glues, Metric Conversions 203

Bibliography
Suggested Further Readings 211

Index 217

Illustrations

1. Auguste Rodin, **The Burghers of Calais**, 1884-1888
2. Medardo Rosso, **The Bookmaker**, 1894
3. Aristide Maillol, **Torso of the Monument to Blanqui (Chained Action)**, 1905-1906
4. Constantin Brancusi, **Torso of a Young Man**, 1924
5. Jacques Lipschitz, **Figure**, 1926-1930
6. Antoine Pevsner, **Torso**, 1924-1926
7. Jean Ipousteguy, **David and Goliath**, 1959
8. Alberto Giacometti, **Man Pointing**, 1947
9. Eduardo Paolozzi, **Japanese War God**, 1958
10. Cesar (Cesar Baldaccini), **The Yellow Buick**, 1961
11. Red Grooms and the Ruckus Construction Co., **Ruckus Manhattan**, 1975-1976
12. Vito Acconci, **Claim**, 1971
13. William King, **Big Red**, 1968
14. Ernest Trova, **Study Falling Man: Landscape on Wheels**, 1966-1967
15. Harold Tovish, **Accelerator**, 1968
16. John de Andrea, **Seated Japanese Woman with Legs Crossed**, 1976
17. Chris Burden, **Transfixed**, 1974
18. Gilbert and George, **The Singing Sculpture**, 1971
19. Gilbert and George, **Dead Boards, No. 11 Sculpture**, 1976
20. Vito Acconci, **Seedbed**, 1972
21. Douglas Davis, **Questions—Moscow—New York**, 1976-1977
22. Bruce Nauman, **Diamond Mind II**, 1977
23. Takis, **Anti-gravity**, 1968
24. Richard Serra, **Sightpoint**, 1971-1975
25. Constantin Brancusi, **Bird in Space**, 1927(?)
26. Anonymous, **Machete Blade**
27. Stephen De Staebler, **Standing Man and Woman**, 1975
28. Anonymous, **Venus of Willendorf**, ca 30,000-10,000 B.C.
29. Hannah Wilke, **S.O.S. Starification Object Series**, 1974
30. Klaus Ihlenfeld, **Sun**, 1960
31. **Coral, Gourd, Billiard Balls**
32. Cecile Abish, **Near/Next/Now**, 1977
33. Marcel Duchamp, **Ready Made Balls of Twine (With Hidden Noise)**, 1916
34. Clement Meadmore, **Upstart II**
35. Charles Ginnever, **Pueblo Bonito**, 1977
36. Reuben Nakian, **The Burning Walls of Troy**, 1957
37. Christo, **Valley Curtain**, 1971-1972

38. Jan Groover, **Untitled**, 1976
39. Barry Le Va, **Accumulated Visions: Series II**, 1977
40. Michelle Stuart, **Quarry Notebook, Sayreville, New Jersey**, 1976
41. Avital Oz, **Installation View**, 1976
42. Patsy Norvell, **Untitled**, 1972-1973
43. Paul Suttman, **Sculptor's Meal #3**, 1968
44. Dennis Oppenheim, **Identity Stretch**, 1975
45. Carl Andre, **36 Pieces of Steel**, 1969
46. Donna Byars, **Rabbit Pen (A Reclamation)**, 1976
47. Jim Roche, **Tree Altar**, 1975
48. Keith Sonnier, **Double Loop**, 1969
49. Vito Acconci, **Where Are We Now/(Who Are We Anyway)**, 1976
50. Kurt Schwitters, **Merzbau**, begun 1920, destroyed 1943
51. Bernard Rosenthal, **5 in 1**, 1971-1974
52. Nancy Graves, **Inside-Outside**, 1970
53. Brenda Miller, **Cassandra**, 1976
54. Bruce Nauman, **From Hand to Mouth**, 1967
55. Sylvia Stone, **Shifting Greys**, 1976-1977
56. Hanna Wilke, **Centerfold**, 1973
57. Jackie Winsor, **55" × 55"**, 1975
58. Robert Cremean, **Vatican Corridor**, 1974-1976
59. Andrea Cascella, **Thinker of Stars**, 1976
60. Nancy Graves, **Variability of Similar Forms, 36 Parts**, 1970
61. Kenneth Capps, **Attic**, 1974
62. James Rosati, **Shorepoints I**, 1966-1968
63. Peter Agostini, **Baby Doll and Big Daddy**, 1967
64. Sol Le Witt, **Semi-Cube Series, Seven Parts, #20**, 1974
65. Ruth Vollmer, **The Shell #1**
66. Arnaldo Pomodoro, **Sfera**, 1976
67. Sol Le Witt, **Corner Piece #4**, 1976-1977
68. Louise Nevelson, **Canada Series III**, 1968
69. David Smith, **Cubi XVI**, 1963
70. Jack Youngerman, **Orion**, 1975
71. Clement Meadmore, **Dervish**
72. Herbert Ferber, **Marl II**, 1971
73. Charles Ginnever, **Daedalus**, 1975
74. Donald Judd, **Untitled**, 1974-1976
75. Richard Lippold, **Variation Number 7: Full Moon**, 1949-1950
76. Jose de Rivera, **Construction #35**
77. Ibram Lassaw, **Kwannon**, 1952
78. Lucas Samaras, **Chicken Wire Box No. 13**, 1972
79. John Duff, **Passage** (three views), 1976
80. Jean Arp, **Human Concretion**, 1935
81. Jackie Ferrara, **Curved Pyramid**, 1974
82. Michael Gitlin, **Demarcation II**, 1976
83. Jim Dine, **Portrait of Kitaj**, 1976
84. Otto Piene, **Olympic Rainbow**, 1972
85. Charles Ross, **Double Wedge**, 1969
86. Robert Stackhouse, **Running Animals—Reindeer Way** (outer view), 1976
87. Robert Stackhouse, **Running Animals—Reindeer Way** (inner view), 1976
88. Nancy Graves, **Variability and Repetition of Various Forms**, 1971
89. Bernard Rosenthal, **Alamo**
90. Bernard Kirschenbaum, **298 Circles**, 1977
91. Lucas Samaras, **Mirrored Room**, 1966
92. Charles Ross, **Sunlight Convergence/Solar Burn**, 1972
93. Michelle Stuart, **Jemez History Book**, 1975
94. Duane Hanson, **Old Man Dozing**, 1976
95. Claes Oldenburg, **Soft Toilet**, 1966
96. Ronald Bladen, **Raiko I**, 1973
97. George Rickey, **Three Lines**, 1964
98. Kenneth Snelson, **Cantilever**, 1966
99. Kenneth Snelson, **Untitled**, 1968
100. Hans Haacke, **Grass Cube**, 1967
101. Harry Bertoia, **Stainless Steel, Gold Plated** 1967
102. Marvin Torffield, **Untitled**, 1976
103. Joe Moss, **Sensory Environments**, 1977
104. Joe Moss, **Sensory Environments**, 1977
105. Bruce Nauman, **Acoustic Pressure Piece**, 1970
106. Richard Serra, **Casting**, 1969
107. Mel Bochner, **Axiom of Indifference**, 1972-1973
108. Nam June Paik, **TV Set Pattern**
109. James Seawright, **Sunsieve**, 1972-1976
110. Pol Bury, **24 Boules Sur 3 Plans**, 1967
111. Dan Flavin, **Untitled**, 1977
112. Mark Di Suvero, **Mother Peace**, 1970
113. Bill Beckley, **Drop in Bucket**, 1976
114. Hans Haacke, **The Road to Profits Is Paved with Culture**, 1976
115. Otto Piene, **Light Line Experiment**, 1968
116. Otto Piene, **Olympic Rainbow**, 1972
117. Hans Haacke, **Ice Stick**, 1966
118. Otto Piene, **Anenomes**, 1976
119. John Chamberlain, **Oraibi**, 1970
120. Lynda Benglis, **Pinto**, 1971

121. Ric Puls, **Untitled**, 1973
122. Otto Piene, **Manned Helium Sculpture**, 1969
123. James Wines and Emilio Sousa (SITE), **Ghost Parking Lot**, 1977
124. James Wines (SITE), **Indeterminate Facade Project**, 1975
125. James Wines (SITE), **Notch Project**, 1977
126. Richard Fleischner, **Wood Interior**, 1976
127. Richard Fleischner, **Wood Interior**, 1976
128. Christo, **Running Fence**, 1972-1976
129. Michael Helzer, **Complex One/City**, 1972-1976

130. Bob Wade, **Bicentennial Map of the United States**, 1976
131. Carl Andre, **Lament for the Children**, 1976
132. Michael Singer, **First Gate Ritual Series**, 1976
133. Charles Simonds, **Cairns**, 1974
134. Patsy Norvell, **Installation**, 1975
135. Alice Aycock, **Wooden Posts Surrounded by Fire Pits**, 1976
136. Herbert George, **Clearing, Spacehold Forest**, 1977
137. Mary Miss, **Untitled**, 1976

Preface

It is interesting and useful to juxtapose two statements from the Introductions to the two previous editions of this book.

In this second half of the twentieth century sculpture has developed to a point that only a few years ago was unpredictable. No longer are restrictions of any type or consequence imposed on the sculptor. His is to do as he wills. Complete freedom of sculptural form and expressions is his. This is not to imply that he has reached the end of any given direction, but rather, that any conceivable possibility is open to him. Restrictions of subject matter, form, or content are nonexistent. He may exploit any theme, idea, emotion, object, use any materials, utilize any techniques, say anything he wishes in his sculpture to create aesthetic value. This is as it should be. (First Edition, 1970)

Since that time, sculpture as form and object has been severely challenged as the most significant dimensional expression. Total freedom of materials, ideas, and directions has brought with it a strange dichotomy of attitudes among artists, the market system, and the general public. On the one hand, there is a return to figurative concerns, not from a point of mere recognizable representation but to a super-realistic portrayal of accuracy of the minutest detail. Completely contrary to these attitudes, there are involvements with more conceptual, cerebral, informational, situational, process, body art, and other more transient forms. (Second Edition, 1974)

This juxtaposition is revealing because it points out that both statements are still applicable today. The old adage, "the more things change the more they remain the same," seemingly applies to the current status of sculpture. If one could characterize the present involvements in

dimensional form, the term *holding pattern* would be most descriptive. What appears to be taking place among artists over the last five years is a gathering in of ideas, concepts, and directions and a general reevaluation of the past experimentation and the establishment of a viable vocabulary to carry over into the twenty-first century. In this regard, there appears to be a refinement of form, materials, and technology and, to some extent, a concentration on works that emphasize the physical existence of the individual in relation to the environment. Upon closer examination many of these forms and attitudes merely build on previous modes of experimentation. The more recent explorations of these foregoing approaches seem to dwell on simple repetition of form, sound, image, material, and even concept, *ad infinitum*, with occasional subtle, shifting variations. This is most obvious in the realm of performance pieces and work that integrates sound or dance into dimensional context. Often, it consists of a rudimentary, or simple isolation of one or two elements, notes, fragments, or material in a reductivist mode. This is also evident in the conventional form approaches.

It should be stated here that simple is not meant to imply simplistic. These simplified structural members are repeated over and over, setting up a monotony that causes the viewer or participant to turn within and meditatively accomplish *content.* Content is the idea, message, or whatever one chooses to call that which is transmitted from the artist through the work to the audience.

Content or even the concept of communication through the work would be challenged or looked upon with disfavor in some quarters. The absence of such content, while turning a participant inward for contemplation, also runs the risk of dulling the senses beyond necessity and, in a broader range, creates a boring sensibility within even the aesthetically astute. While these approaches might have significance in relation to Eastern thought, Western civilization is accustomed to the two-all-beef-patties syndrome and is not about to reflect on contemporary work that is not served up in a "fast" art manner.

Another recent concern is with art that tends to disorder the universe through the use of widely divergent materials or forms. One reasoning suggests that by its very nature the universe is ordered and that the role of the artist is to strike the nerve endings of dissonance, of routine, of the unexpected, of chaos. While this has been the artist's role over the ages, the inherent risk with this attitude is that difference for the sake of difference becomes its own dogma and denies the obvious interrelatedness and cycles within an ordered universe.

Over the last ten years, sculptural involvement has manifested itself in many directions, and a long procession of new movements has followed in rapid succession. Madison Avenue hype has been at its best. One movement after the other became all important, then faded in the next light. During this period the trend among artists was away from galleries and museums in general, and the uptown variety of gallery with its emphasis on merchandising, in favor of the downtown, grass-roots galleries, events, alternate spaces, and a community of artists. In reality many of the same dealers were busy being fitted for lamb's clothing at downtown locations. Artists were also moving out into the environment, experimenting with large-scale works, technology, and interdisciplinary performances which negated the importance of the conventional, precious-object gallery scene. While on an ideal level this is compatible with the artist's purpose, it does not provide the financial and promotional means that the market system allowed. Thus, over the last few years there has been a return to a more defined symbiotic relationship between the artist and the economic-support institutions, whether they are galleries, museums, foundations, governmental agencies, or patrons.

In view of these shifting factors, it is hoped that these essays, which express a personal viewpoint and philosophy, will provide starting points for students of sculpture so that they will be cognizant of what has preceded them and will be able to sense the rhythms and pulse of the times in relation to their own persons. The extension of their ideas and themselves will enable

them to create art that will become paramount to their culture and civilization. It is imperative to assimilate the aesthetic vocabulary of the age in which one finds oneself without feeding off of this season's success.

Sculpture as a vehicle of and for ideas is not a new concept. Men and women, and artists in particular, have always been bound by the necessity for conveyance of free thought and expression. The sculptor of today creates new sculptural realities, separate yet interrelated entities, that project and expand into the future of thought, sensation, and meaning. They are realities that were nonexistent before the artist created them. They may be permanent or transient ideas of objects that consist of some matter, are affected by time, occupy and penetrate space, and convey some content. Sculpture today, then, is its own reality. It is the existence, in relation to time, space, form, context, and content, of that which responds to manipulation by the artist. This is the sculptural idea.

1

The Ambivalence of Sculpture

The Artist, the Critic, the Consumer, and the Consumed

Encountering the complexity and ambivalence in contemporary sculpture, one stands in awe. Reviewing the past twenty years we find primary structures and minimal art, kinetic, junk, assemblage, object, reductive, deductive, destructive, planal, spatial, hard edge, soft, structured, serial repetition, happenings, environments, multiples, monochrome, polychrome, funk, punk, pop, op, combined, technological, and systems-oriented sculpture, plus all the traditional forms. The diversity of expressions overwhelms the aspiring sculptor, critic, consumer, and innocent bystander. Add to all of these expressions the involvements in the past few years of conceptual, informational, situational, body art, performance, and theatrical forms; stir in process; add a dash of self-concern with reality and the environment; the result is overpowering.

The current scene in sculpture is one of overkill that appears to be in a holding pattern of questioning transition that will lead to more significant forms. Variety has not been detrimental to the advancement of sculpture in this century; in fact, the reverse is true. Never in the history of art has there been such a burgeoning of forms, materials, attitudes, and involvement. This new era, however, is characterized by an entirely different set of ground rules that, in effect, prescribe the elimination of all ground rules. Innovative artists have always rejected contemporary standards in order to project their own concepts and forms but rarely to the degree and extent that is evident today. The entire structure of the art process, from the schooling of the artist through the market system of exhibition and collection, to the galleries and museums, to the artist's role in environment and society, is undergoing serious questioning and refutation by the more experimental artists.

Art may reflect society and may even contribute to shaping its cultural posture, but art cannot offer solutions that, in our civilization, develop from a position of power in the nuclear age. Art in this century provides options and alternative attitudes like an exclamation point in

1

which the ascending line is warping into a question mark. Questioning is a healthy process, but, for the beginning student of sculpture, it can be an awesome process with an array of directions. Let us examine some of these aspects more closely.

When do one's actions, taken by themselves, become sculpture, dimensional awareness, or even art? Is it enough to jump, run, sing, repeat sounds *ad nauseum*, dance with sticks or other props, walk in the rain, plant a garden, calculate or compute a physical or literary function, plan and execute one's own demise, record or document this in some fashion as information or narrative, and call it dimensional involvement of sculpture? What separates such actions from normal activity? Is it the removal of ideas, forms, or whatever from context that makes them sculptural? Or does simply attaching a label of art make them so? Is intent enough justification? Canned feces may be art, but they are also canned feces. A rose by any other name. . . . Is the label *sculpture* any different from any other label attached to recent experimental work? Is not the entire establishment art system just as guilty of a mass public-relations brainwashing and rip-off? Maybe, but the means have been more subtle and convincing. If it is false to label normal activities as *art*, what about the gallery or museum that exhibits them with price tags? Is this not just as misguided?

All of this is after the fact and actually lessens the recent work. If we are now in a period of the human as an art form, it may at times become uncomfortable, but at least it will return the significance of creation to its rightful position—to the person of the artist. This is not a suggestion that experimentation should or should not continue, nor is it a suggestion that the system must be purged to cleanse itself. The main concern is that each new approach, no matter how outrageous, be examined extensively by each viewer for its basic significance and then be accepted or rejected accordingly. One criterion for evaluation might be the degree to which the work extends knowledge, form, and ideas, and whether it can be built upon and expanded. As in all experimental endeavors, many forms will fall by the wayside, but many more new forms will trigger new directions and sensibilities and thus push form further into the realm of sculptural reality. However, it should be remembered that, while doing one's own thing lies at the core of aesthetic freedom, aesthetic freedom should also imply a responsibility to individual and collective standards and quality and avoidance of polluting thy fellows.

It is not the purpose of this essay to go into the qualitative standards and any of the specific directions mentioned above. These will be discussed later. They are noted only to show the varied approaches of contemporary sculpture and to bring this diversity into focus in order to help the individual sculptor, observer-critic, and consumer determine their own inclinations and preferences. An attempt has been made throughout the text to incorporate these directions wherever they become pertinent.

THE ARTIST

Although sculptors create much of the ambivalence of sculpture, they do so out of the conviction that each sculptor is his or her own person and, as such, totally unique. This quality is pursued not by identifying with a certain style or manner but by developing an imagery of the world as only the artist senses it. Never before and never again will there be an individual with the exact genetic and personality structure that that person possesses, nor will any individual experience exactly the same stimuli and responses. It is this factor that the artist must continually recognize within and work toward translating into sculptural form and idea. The sculptor, therefore, must not only know his or her form and identity, but must constantly work to clarify and extend it further for one's own individuality and in relation to the artist's immediate world. While approaching this problem one is faced with the paradox of the innovator-practitioner.

The artist, while possessing both traits to some degree, leans towards one or the other. To be a practitioner one works hard to refine those ideas and forms that have relevance to oneself and the world. This is basically a reflective or analytic approach. To become an innovator, an individual must choose one's grandparents wisely. This is not a flippant remark but an indication that a great deal of the artist's basic nature is preestablished and comes into play in determining direction. This is primarily synthesis. The subject of originality and newness immediately comes to mind. Too often, newness is confused with originality and vice versa. One might argue that no idea, form, or concept is original and that the context merely has been put into a new arrangement. The extension of knowledge, idea, and form is supported firmly "on the shoulders of giants." While this is true in almost ninety-nine percent of cases, there exists the remaining one percent who create on a truly original level.

It is one thing to work in a new material, method, or form and to create sculpture that is somewhat unique to the individual; but it is quite another thing to introduce a new concept of dimensional involvement that alters the course of art. The impression should not be promoted that this only occurs with one individual on a given date and time. Although this is sometimes the case, it more often happens simultaneously throughout the world, with artists continents apart arriving at similar solutions at the same time. This is partly due to the collective consciousness of the world population brought about by mass communication.

What, then, is the aspiring sculptor to do if ninety-nine percent of all artists are actually practitioners most of the time and are innovators only on rare occasions? First, one should accept that the basic premise for entering the pursuit of sculpture is because one feels the need to create a dimensional expression and that each person's uniqueness will contribute to the cumulative knowledge and extension of ideas and form. Second, the artist must determine and utilize that which is valid and significant for that person because it reveals a relationship and cogency to the civilization in which one lives and searches for expression. Our senses are under constant bombardment by all of the mass media of the twentieth century, and one must ferret out what holds meaning. This is not an easy task, and, despite all the newness in recent years, much of the sculpture being produced today seems to be similar in approach and to fall into a few general categories.

The history of sculpture does not begin with any one individual — it is a continuum. About the only way individual sculptors can keep their wits about themselves is to pursue that personal imagery through which they can project to the future. Immersed in the past and cognizant of the present, the artist looks forward. In all of these pursuits the artist must always be his or her own person. The artist must think in unusual combinations, not rejecting any materials, techniques, forms, ideas, or concepts that at the time seem unlikely and impractical. The ability to think laterally, i.e., in diverse relationships, is crucial. A willingness to enlarge one's form vocabulary as the need arises and a lack of hesitation to step into the unknown realm of perception can only further the development of new concepts and forms.

THE CRITIC

It would be extremely difficult to determine exactly how many practicing sculptors there are, but a very conservative estimate for America alone must be close to 10,000. When this figure is coupled with interdisciplinary artists who are working from a conceptual-dimensional reference, the figure would almost double. Add to this number the artists with masters' degrees in sculpture coming from universities every year, and the total aggregate is closer to 25,000. Taking this arbitrary figure and multiplying it by a minimum of five works, we begin to see the magnitude of the production of sculpture (125,000) each year. When this is multiplied over a period of five years, the production (625,000) becomes staggering and readily focuses on the

problem of quantity-quality, to say nothing of energy expenditure and the debris problem. The variations and diversity of expression found within this number of works is equally enormous, as each is a separate entity unto itself. Granted, many of the sculptures and concepts produced will be insignificant and inferior works, but many will be valid and exciting forms. The immediate problem is discerning the good from the bad. This, theoretically, is the realm of the critic.

A relevant paraphase points out the nature of much art criticism as it exists today. Never in the history of art has so much been written and spoken by so many to so few about so little. The lengths and absurdities to which writers and commentators on art go can be observed by picking up any current art periodical or by listening in on dilettante conversation and trying to decipher what is really being said about an artist's work. In most instances, the language is so verbose that it is beyond the comprehension of a reader with normal intelligence. It is written for a coterie, and it is incomprehensible to the uninitiated but is readily understood by the indoctrinated, sophisticated, in-group members. The language is excessive and usually pretentious, and this is just the language, not the thought, meaning, or content. But not all art criticism is bad. When used with restraint, criticism serves as a vital link between the work of the artist being discussed and the viewer, reader, or listener. At its very best it can be as significant as the work in question. On the negative side it can influence, program, and promote trends. The most important fact to understand, however, is that the critic is making value judgments and is one step removed from the actual creation of the work. When artists become critics in print, they can be more guilty than the self-appointed high priests of gobbledygook, especially when discussing their own work.

No amount of words or soothsaying will determine the validity or stupidity of a work of sculpture. For some unknown reason the critic's role of separating the chaff from the wheat has been broadened, in some instances, to include not only actual altering or participation in the work but also public relations for the most recent vogue and the assignment of all sorts of symbolic meaning and significance to the artist's intentions. How could the critic possibly know? Sometimes the artist is not fully aware of what has been wrought and the full implications of the work. The ethics of art criticism must stem from a base of honesty and integrity and be devoid of power and ego brokering.

If sculpture is the creation of a new reality, the work must stand or fall on its own merits. Society generally will accept and preserve that which is of value. No amount of art criticism, especially the hybrid, pop form, can alter this reality. It would be interesting to see the results of a one-year moratorium on written commentary on contemporary sculpture, with only photographic reproductions of the works being allowed. We might soon discover that, in many instances, the emperor was indeed naked or not present at all. In the face of much of the propaganda of the public-relations critic, aspiring sculptors must look and think hard, accept and reject on the basis of their own value judgments, then stand on their own individual convictions and, at the same time, keep an open mind.

THE CONSUMER AND THE CONSUMED

Now we come to the marketplace. It is here that the ambivalence of sculpture truly manifests itself. It is one thing to discuss sculpture as a new reality which, for the artist, it will always be. However, the marketplace in art, the actual exchange of money for goods, is quite another kind of reality in itself.

The enormous wealth in America today enables corporations, foundations, and individuals to purchase, commission, and acquire art on a grand scale. The colleges and universities have also become modern patrons both through commissions and the employment of many artists.

The National Endowment for the Arts has, through many of its programs, extended the role of government in the support of the arts. For many, it is just patronage of the artist and the works; for others, it is the true love of fine objects or intriguing ideas. Some use it primarily for tax purposes, some for investment. Whatever the reasons, art is bought and sold at an unprecedented rate at astronomical prices, and the market for art deserves to be examined more closely.

Generally speaking, there are three major parties involved in the art transactions: the artist (if living), the buyer, and the seller. The artist, you noticed, was placed first only because that person created the work. Actually, the artist is one of the least important aspects of any transaction once the work is completed and out of the creator's hands, although many artists are utilizing sales contracts. This is especially true in subsequent sales of the work.

Recently, a California law has sought to redress the inequity of the artist being ignored on subsequent sales of the work. The law states that the artist or the estate must receive a royalty commission on any future sale of any work. This complicates the issue because previously the work was handled like so much merchandise with the artist relinquishing all claims to the work after it was sold. The new California royalty law and the revised copyright laws of this country begin to protect some of the artist's financial interests. They are not entirely popular from the market interest standpoint, obviously, because they take an additional cut out of the pie. This becomes an important consideration when a great deal of the relative market value of works is dependent on auction prices. While this royalty law is not applicable to the large auction houses in New York, where most of the work is auctioned, one can readily see how prices can become inflated through various maneuvers. This is not to suggest that the auction places are in any way dishonest, but they are prone to inflate or overestimate value since their existence is based on a percent commission of sales. From the established artists' point of view, higher prices at auctions are like money in the bank on future sales. It is somewhat akin to handicapping a horse race based on past performance.

It is unfortunate but more and more evident that in contemporary art the artist is beginning to play a more vital role in the various ritualistic dances of the marketplace. The establishment of the artistic star system in this country has greatly embellished the role of the artist. In the past, artists were paraded out for exhibition openings and kept on the payroll and mailing lists so that the small percentage of the take could be forwarded; in some circles the artists have now been elevated to the status of personalities or celebrities, with many of their slightest movements reported in great detail.

There is absolutely nothing wrong with the artist making a decent living and monetary return on artistic pursuits. Perhaps, "living well is the best revenge" as a noted poet once said, but it makes this author nervous when one reads an article in the *New York Times* (January 8, 1978) entitled "The Artist as Millionaire." Nervous because the dollars are reverting to the established artists, who at that point in their careers least need support, rather than to the young experimenters who could truly use some of this assistance. Yet, it is disconcerting that even among this younger group of artists there is evidence of an obsession with the competition of making it, with building a reputation, or name, with moving onward and upward, and the promotion of this by the press. See the articles by Carter Ratcliff in the November 27, 1978 issue of *New York Magazine* titled "The Art Establishment: Rising Stars vs. the Machine" (pages 53-58) and "Making It in the Art World: A Climber's Guide" (pages 61-67). All of this money concern does little to alleviate the ambivalence and significance of the artist's individuality and the work. If one happens to be riding a short-lived bandwagon or, as Andy Warhol suggests, "has been a celebrity for fifteen minutes," one might even find oneself not only deleted from the mailing list previously mentioned, but confused and embittered about one's own role and purpose as an artist. Fame and money are to the artist as alcoholic drinking is to automobile driving.

Fame is a transient thing. How much fame is enough? How much money does one need? Many of the giants in the visual arts today will be only footnotes or slight paragraphs in the history of art. At the time when an artist starts to sell work is perhaps the very time to reexamine or to begin to reexamine direction and purpose rather than merely to produce many variations on the salable form. Acceptability and sales often serve to take the edge off and reduce the risk-taking within the work. (The question often arises about whether an artist's work continues to look consistently like that individual's work because of something loosely called style.) Purchase of the artist's work does not necessarily mean acceptance of it, but purchase does give some indication of acceptance. This acceptance becomes a critical problem for the sculptor. On the one hand, one needs to feel that one is developing and contributing and is receiving recognition for the sculpture; on the other hand, one also needs more money to carry on the work. The image of the unappreciated artist starving in some bohemian hovel went out of style long ago.

As was stated above, there is nothing dishonorable with living well and even having one's ego massaged occasionally, but the aesthetic independence that a spartan existence suggests is still very desirable for the artist. This independence is not only desirable but necessary if the artist is to remain honest to his or her own person. It would be pleasant to think that the young, capable, promising artists will get a fair share of financial return and recognition if the work is of high enough quality, but too often it is not forthcoming when it is needed most. Generally, if the young artist's work is significant and exciting enough, the individual will receive just rewards. Promoters in the arts have a strange gift for sniffing out, not snuffing out, a promising money-maker. In case of financial failure, the snuffing out comes very quickly. One must realize that when the artist enters the marketplace, the rules of the marketplace prevail, not the rules of the art world. For some people art is first a business, period.

Whatever the case, at some point in the artist's development, the sculptor encounters a financial or philosophical turning point. The artist finds a patron, gets a commission or grant, is invited into the marketplace, and partially or totally rejects the financial implications and practices of the art-market system.

We have just gone through a period where many artists opted for the last of the above courses of action, but currently there seems to be more of a concern to seek various means of financial renumeration, either through grants, fund raising for large-scale projects, and just plain marketplace hustling. The thrust of most sculptural directions is away from the marketable static object and into involvements that defy marketability. Many of the earlier conceptual, informational, and process directions that are still in evidence have as one of their major goals the elimination of the market—at least in theory.

In practice, it is quite another thing. The documentation of these cerebral and large-scale works includes photographs, charts, diagrams, videotapes, drawings, and other graphic or illustrative means that then become the objects to be peddled. However, while documentation is necessary, hucksterism is not. What started out as an antigallery, antimuseum, antiart movement is gradually acquiring all of the trappings and public relations of the establishment. Anonymity is a byword only up to the point of proper capital gains. This statement is not meant to indict all of the sculptors working in experimental directions; many have not succumbed to the green and are pursuing their work with intensity and little or no return.

This movement away from the market system was an inevitable outcome of the change in direction of sculpture after World War II. The sculpture of this period became increasingly larger in scale and dimension. The involvement with the technological means of the age and the translation of these processes into sculptural form, in addition to the concern with environmental relationships, led the artist away from the galleries and museums and into scientific arenas and the actual environment. It was a short move from this position to the

conceptual areas that not only negated the market but also the dependency on it for subsistence. The artist was free to pursue thoughts and expressions with a minimum of expenditure of energy and money and, in the process, create a quasi-antiart movement. The current prevailing trend in this regard appears to be an amalgamation of technological, conceptual, large-scale works that are more inherent in the environment than merely objects placed in a natural or artificial setting. While this is greatly simplified, it presents the basic evolution of current involvements. Also contributing to these factors was the nature of the society and the artist's reaction to the chaos, inhumanity, and deceit that was prevalent throughout the 1960s and into the early 1970s.

It was a time of great political and social upheaval in America, and the younger artists reacted to this situation by examining, questioning, and rejecting large segments of established practice in the arts. The old values were not applicable to these new times and conditions. Rejection and rebellion against the *status quo* have always been the role of the artist, and these attitudes are not unique to the present period. However, the presence of the mass media and other forms of communication, the instantaneous and spontaneous nature of new technology, and the general affluence of society created a means of spreading the new gospel and withstanding the pressures of the establishment while also making many converts along the way to a counterculture. As was mentioned earlier, the start of this movement away from the museums and galleries came about because the sculpture was of ever-increasing scale and dimension that were not suited to a museum, gallery, or private residence. The ideas, concepts, and materials central to the sculpture, such as environments, happenings, earthworks, etc., were equally unsuited for display or collection in the conventional sense.

It might be well, at this point, to discuss the relative difference between scale and dimension. If dimension is actual measure, scale becomes the total graduated proportion of one form to another form or to a specific environment. Many of the sculptural works evolving during this period and continuing to the present day depend on large dimensions for their visual force. If the dimensions were to be reduced to gallery or museum size, much of the quality of each piece would be reduced correspondingly. Scale is relative, and many small pieces can appear monumental in size because of the forms employed and the relationship of these forms to others within the piece and the immediate environment. Within a museum or gallery, because of the natural confinement of the structure, scale can be manipulated more easily than it can outdoors. It is remarkable that, while large monumental sculpture was being and is currently being practiced, the world was shrinking and becoming obsessed with miniaturization. It is also interesting to note that in a period of great development in the chemical and synthetic manufacture of new materials a great deal of contemporary sculpture has returned to natural materials. Perhaps these sculptural trends are a response to the minutia or the slick materials; more likely, it is the increasing concern with combining ideas, concepts, materials, and the environment as sculptural in themselves that has influenced these trends.

Sculpture historically has been concerned with the adorning of architecture in one form or another and with relating it to human size. However, today's sculpture, concerned as it is with process, situation, concepts, systems, and environment, operates on an entirely different premise — that of encompassing human scale and immediately and actually involving a person within the work itself, or that of involving only the artists and participants and photographing or otherwise documenting and recording the experience. Architecture in this sculptural context may or may not be a consideration. It is interesting to note that after a long period dominated by a severe, international style, many recent post-modern architectural structures are historically derived and a great deal more sculptural and actively involve the inhabitants.

There are some differing points of view of this utilization of architecture as sculpture. One faction argues that architecture should be architecture, period. It should not be at the disposal of amorphic shapes and monstrosities, but rather should elevate the functionality and essence to precise geometry. Still others in the architectural community believe that we live in a pop culture of jumbled billboards, shopping centers, and industrial shapes and building components, and therefore our architectural idiom should reflect these attitudes. Closely related to this approach are the functionalists who believe in leaving all aspects of the workings, such as ducts, pipes, etc., exposed as a major visual part of the structure. Perhaps the most obvious recent example of this oil-refinery-appearance approach may be found in the new Museum of Modern Art, Beaubourg, Paris. Still another school of thought promotes what might be called the visual pun of sight-gag architecture-sculpture. The best illustration of this may be found in the work of the group called SITE, Inc., of which this and other examples may be found in Chapter 7 (Figures 123, 124, and 125).

These various involvements in architecture reflect some similar attitudes in sculptural directions whereby a passive role on the part of the general public is no longer possible, and, good or bad, tangible or not, they cannot be ignored and must initiate response.

All of these factors and other less crucial ones, such as financial and technological support from various industrial corporations, art-science groups, the patronage of the college and business groups and the grant aid from the National Endowment for the Arts and other foundations, contributed to the independence of the artist and the gradual drifting away from museums and galleries. Obviously, this is not the case among all sculptors, for the museums and galleries are still functioning. The market system is thriving mainly because they still have a very real service to perform in finding an audience and an outlet, where applicable, for the artist's past, present, and future production. At this writing, the art hierarchy or establishment is divided into various camps, and the redefinition of roles that seems to be forthcoming favors a modified marketplace or at least some semblance of a structured lifeline to organization legitimacy. This may be evidenced in various alternate spaces and such places as The Kitchen Center for Video and Music and The Institute for Art and Urban Resources in New York City. There are similar groups in many other cities throughout the United States. Whatever the outcome, the structure of the old system will never be the same. If anything, it has tried to accommodate much of the recent experimental work. This serves neither the museum, the gallery, nor the artist very well and may even represent a sellout on the part of the artist in an antiart posture.

In view of all this it is understandable that the consumer can be dismayed and overwhelmed with the ambivalence of sculpture. The large-dimensioned works limit collection of them. These forms simply do not fit into average surroundings, and the motorized pieces and the electric and electronic systems-oriented pieces do not adapt easily to collection. Similarly, the stymied collector wonders how to collect some of the more radical experimental sculptures or ones that are of a completely transient nature. Although all of this may create a problem for the individual collector-consumer, museum, and gallery, in one sense it has liberated the sculptor even more from preconceived dimensions, materials, concepts, ideas, and other restrictions of expression, and the artist is free to expand individual concepts of reality.

The many modern tools, equipment, and materials available have enabled the sculptor to extend the force exerted beyond normal human capacity. This has brought about an expanded technique and form vocabulary, but in the process it has increased the cost of materials and execution of the work. As a result, many pieces are being priced out of the consumer market and are becoming less dependent on the market system and more reliant on subsidy. (There are numerous examples that could be cited here to emphasize this point, but perhaps the most significant example is Christo's **Running Fence** (Figure 128), which cost in excess of two million dollars.)

The consumer and collector, like the museums and galleries, may have to change. The consumer may commission a sculptural work to be placed in a public place or a specific environment, or assume the costs of a daring experiment with no final product or financial return and be pacified by receiving the model, preliminary studies, photographs, or whatever form the documentation may take. Many museums, collectors, institutions, city governments, etc., already have the available outdoor space and the means to make this feasible; however, much more needs to be done to allow the sculptor to create for the public and even the isolated environment. Some examples of notable support are the governmental percentage spent on the arts in public buildings (unfortunately, this is often reduced each year rather than increased), the National Endowments supporting programs for public art, and such regional endeavors as Artpark in Lewiston, New York, and the Nassau Museum of Fine Arts in Roslyn, New York.

Art, and particularly sculpture, has always been a public consideration, and bringing art to the people can only serve to increase involvement and awareness in the arts. Unfortunately, smart money is attracted to the known quantity, and such a proposal or project usually helps to serve a few established artists. There should be a more satisfying and comprehensive system for identifying capable and promising young artists through more national exhibitions and commissions over and beyond the New York City museum and gallery route. Some of the government-sponsored programs mentioned above are a step in this direction, but much more has to be done on the governmental and corporate level and on the part of the individual collectors and promoters.

Work exhibited in New York City, the great mecca of art in America, varies greatly in quality. In galleries one can find the very best of things and the very worst of things. Outside the galleries, the same condition prevails. In between is a huge gray area of mediocrity and triviality that caters to every taste and, through promotion and public relations, gains notoriety. The consumer, the critic, and the mere observer are immediately faced with aesthetic decisions. This is as it should be. But the difficulty is in the enormous proportion of bad works to good. The critic, too often afraid of being proven wrong, writes a favorable review; the consumer too often follows the critic's advice; and the casual observer is turned off to all experiment by exposure and hype of the inferior and absurd. This is some of the unpleasant fallout of individual freedom, but it is the only possible way for advancement of the arts.

Integrity on the part of the artist, the museum, the dealer, the critic, and the buyer is the key. One does not have to be naive to wish this. It would be nice to go to the marketplace or anyplace else in the realm of art and be assured of a certain amount of quality, and this is often possible through name artists and galleries. But this path, though tried and true, is limited; the sensation of tasting a strange and exotic, honest new fruit is unlikely to occur very often. What then is the consumer to do? Like the artist, the critic and the observer, one must wade through all the subterfuge, keeping an open mind, and decide individually which directions in sculpture have relevance and meaning. Only then is the ambivalence of the work removed, for the consumer of the work becomes just that—a consumer who happens to have purchased, financed, participated, or merely observed a specific work. That the work relates to the evolution of the history of art, or society, or only raised the level of appreciation of a sculptural reality is truly a wonderful thing. The secondary results—investment, status, tax deduction, artist support, etc.—hold little meaning in comparison to true empathy for a new sculptural reality.

The clear fact about contemporary sculpture is simply this: there are a considerable number of artists, young and old, rich and poor, practicing their craft with extreme dedication, some traditionally and some experimentally, with extremely exciting and progressive results. They are commenting on and reshaping the world's objects, thinking, and way of life; they are creating new realities that, through their ideas, concepts, and technology, project well into the

future. Above all, they are bringing their minds and thoughts to bear on the rights of the individual's forms and ideas to be seen and heard and to evoke response. They are doing and will continue to do this in cooperation with, or in spite of, the masses, critics, the art market, consumers, foundations, grants, industrial support, or other financial dependence. The ambivalence of direction and production in sculpture is the lifeblood of the sculptor. For through it, he or she may sing the one song of life and existence.

2

Sculpture as History

The Evolution of Forms

As we have seen in the last chapter and will explore in later chapters, the wide diversity of approach to sculpture in the twentieth century has occurred mainly in the use of many new materials and techniques. However, it is in the area of form, the total configuration of a work, that the greatest change has developed. In this last quarter of the century we have the advantage of employing hindsight to study those sculptures that seemingly extend the concept of form. Later, in Chapter 5, Form, and Chapter 7, The New Technology and Beyond, it will be possible to cite many evolutionary approaches to sculpture as a new reality. But here it would be wiser to examine and trace the evolution of one specific area of sculptural concern, such as representational figurative sculpture. While the figure is not the main or only consideration of twentieth-century sculpture, it is continually evident and perhaps more tangible for the reader.

The basis of much sculptural concern is the human figure. Humanity has always been concerned with the concept and nature of the human species. Even today, with extreme experimentation in material, process, form, and content, the human condition serves as a wellspring for the sculptor's exploration. For these reasons, the examples used to illustrate this chapter have as their common denominator the human form.

In examinations of a body of contemporary art work in any given period during the twentieth century, it is always difficult to select a truly significant work because much of the work is so recent that the test of time has not been applied. Only those works which tend to extend the concept of the figurative form language have been selected. In this regard, figurative sculpture in the twentieth century appears to be divided into ten general directions: (1) transition, (2) classicism, (3) constructivism, (4) surrealism, (5) expressionism, (6) environmental commentary, (7) dehumanization/mechanization, (8) super realism, (9) humanization/process, and (10) situational reality.

These *isms* and polysyllabic words can tend to become complex labels, but they also tend to point out the increasing complexities of more recent sculpture. This is evident in the latter five categories where context and content seem to be of greater concern than in the former five where more emphasis is placed on material and technique. The works in the first five categories exemplify forceful communication and serve as a technical basis for the other five categories, but they are primarily concerned with the human form as a representative object. The last five categories, although sometimes dealing with persons as objects, push deeper into the realm of human existence as process and system and the relationship to given situations in the environment. The representation of the human figure as sculpture is pushed and pulled out of context and into confrontation context and all the while is extending the form, content, and boundaries of that which is called *sculpture*.

The variety of approaches shown in the following examples is due in part to individual stylistic differences, the specific period and environment in which they were created, and, above all, the ultimate concept and statement of the artist. In more recent conceptual figurative sculpture, we are seeing an almost total rejection of stylistic considerations and more concern for assimilation of all that went before into a realm of anonymity, and anyone and everyone is a sculptor. Obviously, this is not the case in those sculptural approaches that still deal with material, form, and object in a conventional sense, but even these approaches tend to relate to the content of those concerned with process, systems, and situational forms of sculpture.

This will be discussed in a future chapter, but it would be well to point out that, although the evolution and interpretations of the figurative sculptural form are continually shifting with progressive concerns, each sculptor pursues the forms of the world as only he or she understands. Genre and milieu are for the individual to decide, and, as the world changes, the artist modifies the language of form for the individual as needs and capabilities expand.

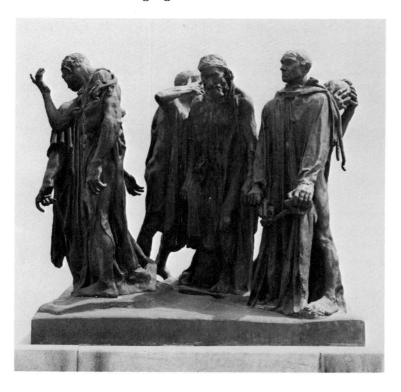

Figure 1. Auguste Rodin, **The Burghers of Calais**, 1884–1888. Bronze. (Rodin Museum, Philadelphia. Courtesy, Philadelphia Museum of Art.)

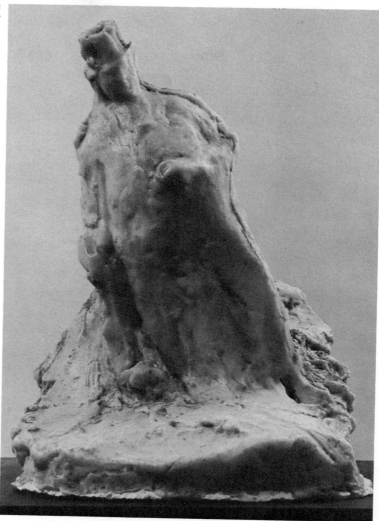

Figure 2. Medardo Rosso, **The Bookmaker**, 1894. Wax over plaster, 17½″ H. (Collection, The Museum of Modern Art, New York. Acquired through the Lillie P. Bliss Bequest.)

TRANSITION

In the works of Auguste Rodin, **The Burghers of Calais** (Figure 1), and Medardo Rosso, **The Bookmaker** (Figure 2), we find a bridge from the more romantic attitudes of the nineteenth century. In the Rosso, a greater concern with impressionistic surface quality and figurative gesture is evident. Impressionism was a nineteenth-century approach entailing the breakdown of traditional attitudes toward viewing the world. The translation of these attitudes from painting to the dimension of sculpture was of monumental significance for the abstraction that was to follow.

In the work by Rodin, the placement and relationships of the individual figures to one another create a grouping we see as one; yet, there is a spatial environment that is comprised of separate and distinct parts. This environmental grouping, as it centers our attention on the figurative whole, also manages to create a feeling of monumentality within each figure. This is

in part due to the strong modeling and surface manipulation. The spaces around the figures also emphasize the figure in an environment, in actual dimensional space. Our eye tends to move back and forth, in and around the space surrounding the figures. This experience of sculptural space defines each form of the figures while creating an ever-changing compositional tableau.

The loose manipulation of the forms and surface quality by Rosso suggests less concern for the specific statement of subject matter and more involvement with the thrust of the figure through abstract form. The form language of Rodin, though in **The Burghers of Calais** more concerned with the appearance of reality, captures and almost appears to freeze the figures in gesture. The work by Rosso, on the other hand, captures the fleeting glance with more abandon. In both of these examples, implied or anticipated movement permeates the figures. Rosso's surface technique tends to emphasize this by its almost volcanic appearance.

This quality of movement can be found somewhat later in the works of the futurist Umberto Boccioni and also in the works of Ernst Barlach. Both men tend to simplify their forms, but Boccioni utilizes many more dynamic forms to create a swirling turbulence of

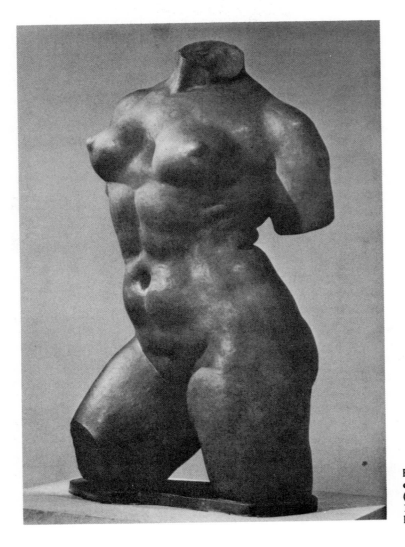

Figure 3. Aristide Maillol, **Torso of the Monument to Blanqui (Chained Action)**, 1905–1906. (Courtesy, The Tate Gallery, London.)

action, whereas Barlach simplifies into a minimum of forms that all contribute to a single gesture or thrust of movement.

CLASSICISM

In two comparison photographs of the torso, we see diverse approaches to a similar subject. In the **Torso of the Monument to Blanqui (Chained Action)** by Aristide Maillol (Figure 3), a rejection of impressionistic handling and a simpler, more precise *real* form is employed. More concern with the *ideal* or classic figure is readily apparent. Very little is left unsaid for the viewer. The masses and contours of the work are clearly spelled out, and, while it is real with its straining and tense forms, it seems almost too perfect a representation and is desperately in search of a soul.

Figure 4. Constantin Brancusi, **Torso of a Young Man**, 1924. Brass. (Collection, Joseph H. Hirschhorn, New York. Photo, Solomon R. Guggenheim Museum, New York.)

The work by Constantin Brancusi, **Torso of a Young Man** (Figure 4), with its cold, calculated, machined form, still manages to transmit the essence of the torso. The simplification or abstraction of form does not tend to reduce the symbolic idea of the torso. In fact, the reverse is true. The attraction to the abstracted form is in complete harmony with the *idea* of the torso. It is the work of Brancusi that exemplifies the concept of the simplification of form in the early stages of twentieth-century sculpture.

CONSTRUCTIVISM

Although the **Figure** by Jacques Lipchitz (Figure 5) was modeled and cast, its basic concept is one of construction, a construction of mass and space that becomes almost a symmetrical exercise in pure design. It also utilizes a simplification of form, but in this instance a primitive

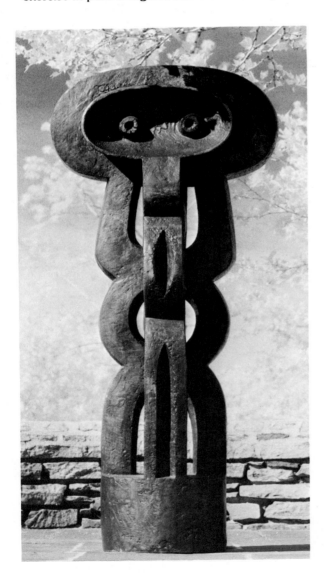

Figure 5. Jacques Lipchitz, **Figure**, 1926–1930. Bronze, 85¼″ H. (Collection, Joseph H. Hirschhorn, New York. Photo, Solomon R. Guggenheim Museum, New York.)

suggestion of the human form dominates. The overall content of the work is that of a towering and imposing figure, with the eyes acting as an intense point of no return, coiled and prepared to lash out with any one of its powerful appendages.

Antoine Pevsner's **Torso** (Figure 6), although contemporary with the Lipchitz and the Brancusi, appears to be more of a transition between the realism of Maillol and the simplification of Brancusi to the greater abstraction of the **Figure** by Lipchitz. In this piece, a greater sense of analysis and synthesis seems to be taking place. When one views the work by Maillol and turns immediately to the Pevsner, a sensation of anatomical dissection and building occurs. Obviously, the **Torso** by Pevsner is more concerned with the abstraction of form, as evidenced by the use of planes, transparent, repeated, overlapped, interlocked, and combined with the distribution and organization of spaces.

This constructive approach of manipulating planar surfaces activates the viewer to exercise a visual closure of the unstated forms and complete the energetic image. The additive process of *building* a sculpture by the use of *parts*, fabricated or found, is a constructive attitude which has its roots in the collages of cubism. Other examples of this constructive technique may be found in the work of the Bauhaus and in sculpture of this time period in the work of Max Ernst, Kurt Schwitters, Julio Gonzales, and Pablo Picasso.

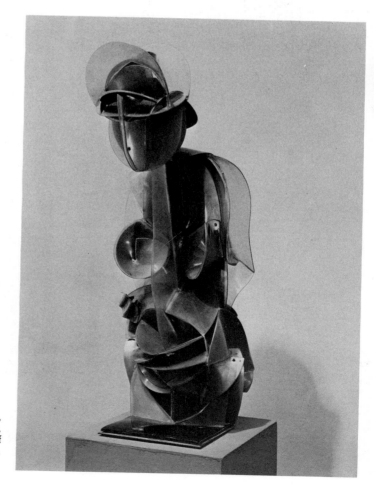

Figure 6. Antoine Pevsner, **Torso**, 1924–1926. Plastic and copper, 29½″ H. (Collection, The Museum of Modern Art, New York. Katherine S. Dreier Bequest.)

SURREALISM

In one sense the two works represented here, Jean Ipousteguy's **David and Goliath** (Figure 7) and Alberto Giacometti's **Man Pointing** (Figure 8), carry on the tradition seen in the work of Rodin and Rosso, mainly in the technique of modeling (their respective imagery and form are quite individually their own). This is especially true in their use of matter and its displacement in space toward an isolated surreal quality of form. The work by Giacometti is a great deal less massive, though no less imposing, than the work by Ipousteguy. The *spatial* isolation of **Man Pointing** is almost akin to a cry in the night. The space around the figure presses in and strains the forms of the figure to remain firm. The elongation of the figure serves to isolate and draw attention to the insignificance of every man. One does not readily see a Giacometti; instead, one feels or is a Giacometti.

In the example by Ipousteguy, the horizontal figurative masses act visually to hold the eye earthward as much as the Giacometti causes it to soar. Similarly, it uses the space around the figure to emphasize its concavities and its distributions of massive forms. Though the degree of abstraction in the work by Ipousteguy is greater than in the Giacometti and the manipulation of the surface is agitated almost as much, the overall feeling is toward a smoother simplification of figurative form. In both of these works, the surreal, dreamlike qualities permeate their content.

Figure 7. Jean Ipousteguy, **David and Goliath**, 1959. Bronze, two figures in four parts. **David**—47⅞" × 24¼" × 25". **Goliath**—(3 sections) 30⅜" × 53¾" × 29½". (Collection, The Museum of Modern Art, New York. Matthew T. Mellon Foundation Fund.)

Figure 8. Alberto Giacometti, **Man Pointing**, 1947. Bronze. (Courtesy, The Tate Gallery, London.)

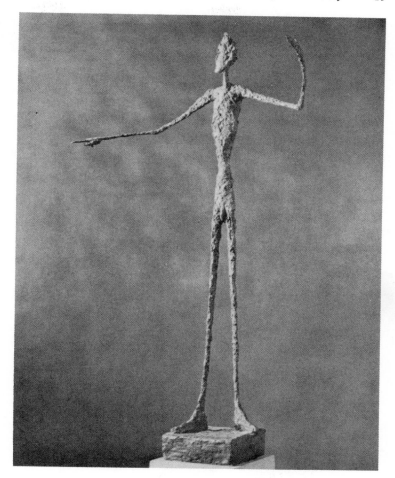

EXPRESSIONISM

Expressionism, although it had its roots in early twentieth-century painting, did not manifest itself in sculpture until after the Second World War, through the 1950s and into the early 1960s. In the work by Eduardo Paolozzi, **Japanese War God** (Figure 9), we see represented the assembled concept of the devastated figure. We see no glorification of humanity in this work; instead, we are confronted with a destructive nature, epitomized by the shadow of nuclear holocaust and the resultant waste and utter lack of concern for humanity.

The piece is as much a commentary on mid-twentieth-century civilization as it is a sculptural figurative idea. The sculptural form that is employed seems to be an assemblage or amalgamation of the endless discarded objects, debris, and mechanistic forms that characterize society in the twentieth century. Contemporary life is seen in the highly activated surface treatment, in the disintegration and devastation of matter and form to complete an expressive content or message.

Although the work by Cesar Baldaccini, **The Yellow Buick** (Figure 10), is not figurative, it speaks so thoroughly of contemporary man and the automobile as an extension of adulthood that it is included here to emphasize this exercise in expressive futility. The piece is

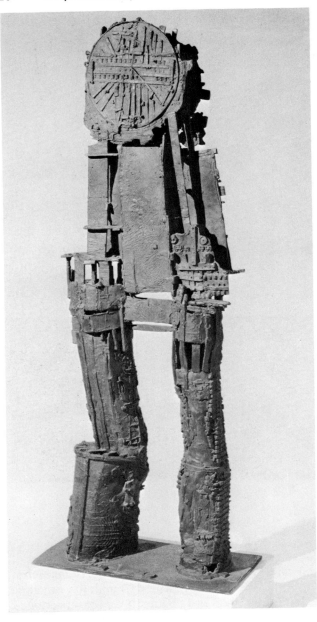

Figure 9. Eduardo Paolozzi, **Japanese War God**, 1958. Bronze, 64½″ H. (Collection, Albright-Knox Art Gallery, Buffalo, New York. Gift of Seymour H. Knox. Photo, Sherwin Greenberg Studio, Buffalo, New York.)

actually a compressed automobile and not only shows the range of the sculptor's use of power and technology but the expressive ability to convert an everyday object into sculptural form.

The works of Richard Stankiewicz and John Chamberlain from this same period create similar sensations of the broadening of the sculptor's form language to include assemblage, found and discarded objects, industrial processes, and the incorporation of these techniques into forceful expression of ideas. The difference in this work by Cesar is that freedom of expression ,enjoys a greater latitude with less concern for organized art *principles* and conventional materials and techniques while still allowing for the creation of a new, powerful three-dimensional expressionistic experience that becomes its own reality.

Figure 10. Cesar (Cesar Baldaccini), **The Yellow Buick**, 1961. Compressed automobile, 59½″ H × 30¾″ W × 24⅞″ D. (Collection, The Museum of Modern Art, New York. Gift of Mr. and Mrs. John Rewald. Photo, Rudolph Burckhardt, New York.)

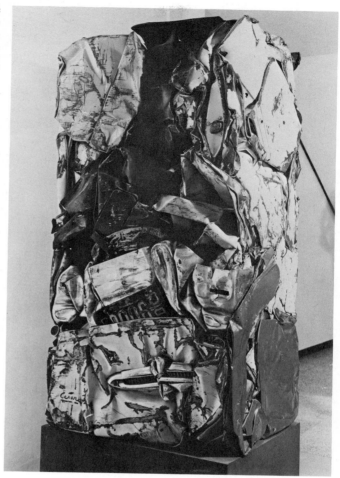

ENVIRONMENTAL COMMENTARY

During the 1960s, events that were called happenings or environments took place. These were primarily theatrical or performance pieces that involved a single person or a group of people. They ranged from a tightly structured script to a free-wheeling expressionistic approach to awareness of self within or outside of the context of society and the environment. Group psychological and encounter therapy had its counterpart in sculpture and specifically in happenings and environments.

During this period and even more recently, more static forms of sculptural environments or tableaux were explored. Many poignant and biting satires of this concern may be found in the works of Edward Kienholz. This is evident in such environmental works as **State Hospital**, **The Beanery**, **Backseat — '38 Dodge**, and others. A more recent example of this environmental concern is the work **Ruckus Manhattan** (Figure 11), by Red Grooms and the Ruckus Construction Co. This detail of the interior of a subway car is only a small fraction of the overall construction. While the technique is not as refined or humanly accurate as some recent figurative sculpture, the overall impression is one of its own reality within a controlled environment and speaks entirely for itself. In one sense, this work is a conglomerate image of the sculpture of this century in that it uses representation, abstraction, manipulation

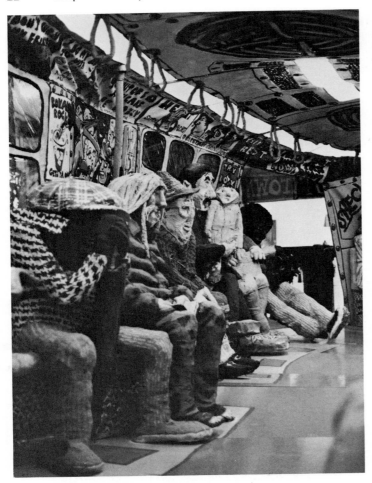

Figure 11. Red Grooms and the Ruckus Construction Co., **Ruckus Manhattan**, detail: **Lexington Local**, 1975–1976. Mixed media, papier maché, 10′ × 9′ × 36′. (Courtesy, Marlborough Gallery, New York. Photo, Richard L. Plant, New York.)

of materials and techniques, found and discarded objects, and a content that is human, literary, and environmental. Although the image may be harsh and crude to some viewers, it speaks of contemporary urban life with powerful clarity.

These involvements with happenings and environments have continued into the 1970s and 1980s, but the form has shifted to a more personal concern with the sculptor and that person's relationship to the environment. In the work by Vito Acconci, **Claim** (Figure 12), this is graphically explained by the accompanying description. At work here is more than just a frivolous ego trip. What is taking place with Acconci, and with many other contemporary sculptors, is an abandonment of object making and the conceptualization of ideas into a form of living their art within their environment and existence.

These attitudes and directions of self-involvement are closely related to the categories humanization/process and situational reality. It should be mentioned that all developments in art within any given period of time are interrelated and defy categorization. Generalizations are possible, but they should be regarded as only that and not as rigid schools, movements, or categories. For within any time frame, counter directions, attitudes, forms, subject matter, and content are also present. It is possible to find sculptors today practicing the craft of sculpture as

it was practiced ten, twenty, fifty, one hundred, or four hundred years ago. The choice is individual, and the degrees and levels of innovation and practice must be approached individually. Ideally, the individual is left to pursue one's own vision, imagery, form, and ideas.

DEHUMANIZATION/MECHANIZATION

The artist in the twentieth century often reacts to and reflects in his or her sculpture our dehumanized and mechanized society. The work of Marisol mirrors the individual's attitudes toward modern society. The combination of found objects and superimposed images goes beyond assemblage and into literary comment and a biting wit. The uniqueness of her forms and environmental placement seems somewhat related to a surreal and *pop* form that suggests an updated folk art. Closely related to this pop and dehumanized attitude is the work of William King, **Big Red** (Figure 13). Aside from the caricatural quality of the figure, the red vinyl speaks of a *plastic man*. The material by itself creates a familiar sensation, but the oversize scale and the representation of a man create a pop idiom that is quite satirical.

Although the work by Ernest Trova, **Study Falling Man: Landscape on Wheels** (Figure 14), at first glance may appear to elevate humanity, it communicates more readily of mechanization and dehumanization. The metal-plated surface quality suggests a technology at the expense of the individual, and the combination of mechanical devices or objects creates a suggestion of robotlike, space-age form. It speaks of humanity in this time and place.

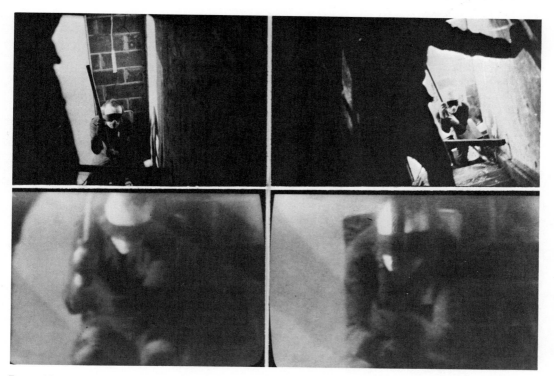

Figure 12. Vito Acconci, **Claim**, September 1971, 3 hours. "In the basement: blindfolded—talking myself into possession obsession, swinging a weapon at anyone who comes down the stairs (a video monitor, upstairs, serves as a forewarning)." (Courtesy, Sonnabend Gallery, New York.)

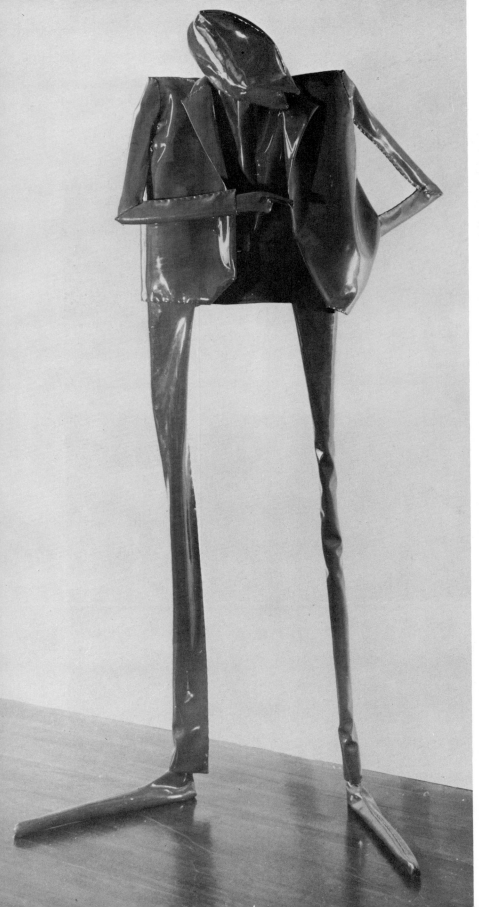

Figure 13. William King, **Big Red**, 1968. Red vinyl, approximately 10′ H. (Collection, Terry Dintenfass. Courtesy, Terry Dintenfass, Inc., New York. Photo, John D. Schiff, New York.)

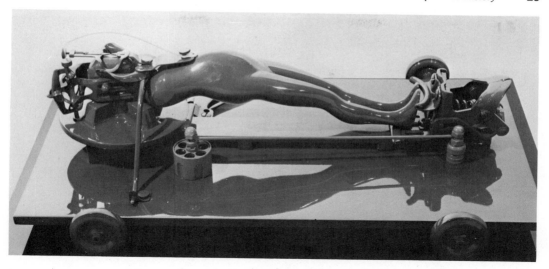

Figure 14. Ernest Trova, **Study Falling Man: Landscape on Wheels**, 1966–1967. Baked enamel on bronze. (Courtesy, Pace Gallery, New York. Photo, Ferdinand Boesch, New York.)

Closely related to the feelings and attitudes transmitted by the work of Trova is **Accelerator** (Figure 15) by Harold Tovish. The use of varied materials and precision craft suggests a mechanistic, space-age portrayal of civilization. There is something disquieting about the content interpretation of the piece. Removed from the natural environment and placed into a hermetically sealed tube the person becomes somewhat depersonalized. One should realize that any mechanistic representation of a human is just that—representation. Recently, however, the technology of the age has allowed a duplication of various human functions. Systems-oriented devices can approximate but never truly duplicate human actions, and they should not necessarily try. There are realms of expression through technology that the artist has just begun to explore, and, currently, they seem to physically involve humans rather than merely represent them. At this point in history, this seems the probable direction. But whatever trends develop, the creation of new sculptural realities through technology should not be undertaken without awareness of the responsibilities entailed.

SUPER REALISM

While it may seem incongruous to have a direction that runs counter to extreme experimentation away from the figure as the object, this is exactly what happened in the early 1970s. This trend indicates the individuality of the artist and the pursuit of form in relation to the way one views the world. **Seated Japanese Woman with Legs Crossed** by John de Andrea (Figure 16) is an example of the sculptor's concern with minute detail and close representation of the human form. Although the work is cast, it points out the facility of the artist in adapting technique to content. The sculpture is so natural and lifelike that the viewer reacts uncertainly. The resulting effect is to jar the viewer's sensibilities between different levels of reality.

A similar direction can be found in the work by Duane Hanson, **Old Man Dozing** (Figure 94), except that in that instance, the clothing, chair, and placement in the environment tend to add and heighten the illusion of a real situation. The fact that both of these works are life-sized intensifies the drama of being sculptural realities.

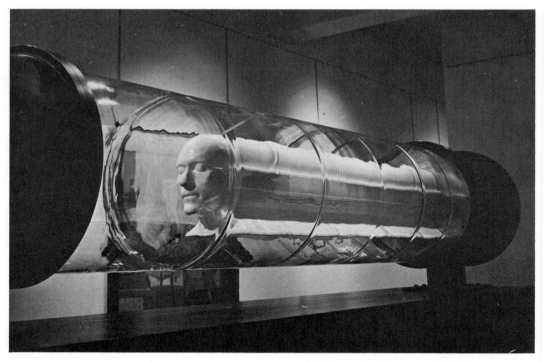

Figure 15. Harold Tovish, **Accelerator**, 1968. Aluminum, wood, and glass, 62″ × 108½″ × 24″. (Courtesy, Terry Dintenfass, Inc., New York.)

The question arises as to the difference between these works and those that may be found in wax museums. The answer would have to be not a great deal, except that the attention to detail and the lack of notoriety of the subject might be considered factors. Actually, the intent is much the same—the jarring awareness of the appearance of reality on different levels. Another difference may be the process of paying admission and anticipating what you may see in a wax museum.

HUMANIZATION/PROCESS

As mentioned earlier, this category is very closely related to environmental commentary and the following section, situational reality. The overriding concern on the part of some contemporary sculptors is the extension of the conventional ways of creating dimensional involvements by examining and exploring the systems, processes, concepts, attitudes, and information-communication by which the artist extends the knowledge, form, and idea of one's own body to the world. The range of possibilities is endless, and in some instances the results seem quite feeble, but new knowledge and awareness of human existence is increasing, and if these new pursuits tell us nothing more than what is not desirable they have served some purpose. The ends do not justify the means, and experimentation may be a slow and arduous task. However, the means should not be discounted before they are begun. Conversely, the experimenters should not engage in merely repeating the latest trick or pursuing trivia for its own sake. They should make a sincere effort to enlarge their own sensibilities of dimensional involvement.

It is difficult to pass comment on a work such as **Openings** by Vito Acconci, which is described in the following manner: "(Stomach, Hair, Clearance) fifteen minutes. Pulling out the hairs around my navel (clearing a space, clearing the film frame, extending the opening of my navel, opening myself up)." Is this sculpture, theater, or just pain?

Body art that involves manipulating the body even to the point of martyrdom, such as in the case of Rudolf Schwarzkogler, who practiced self-amputation to the point of no return and eventually expired, or the self-inflicted pain/danger involvement of Chris Burden, **Transfixed** (Figure 17), whereby he was nailed to an auto, may be stretching the limits of dimensional expression to psychopathic performance. While it is conceivable to involve the body as the object as well as the subject of expression, the range of commitment seems futile and self-indulgent. The disturbing aspect of body art is the preoccupation with inflicting nonsense, pain, or threat with no concern for the other end of the spectrum and all that lies in between. The idea of humanizing art and drawing attention to the processes by which the human species functions is a valid and necessary pursuit. Too many of these factors have disappeared from contemporary society, but merely inflicting pleasure or pain and calling the body art does not make it so.

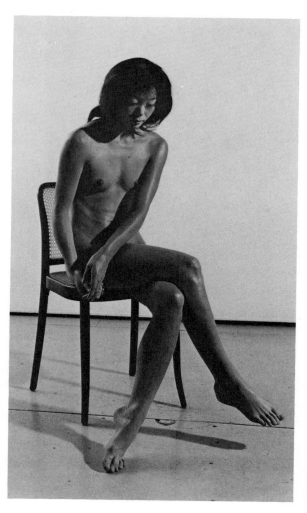

Figure 16. John de Andrea, **Seated Japanese Woman with Legs Crossed**, 1976. Life-size cast vinyl, polychromed in oil. (Courtesy, O. K. Harris, Works of Art, New York. Photo, D. James Dee.)

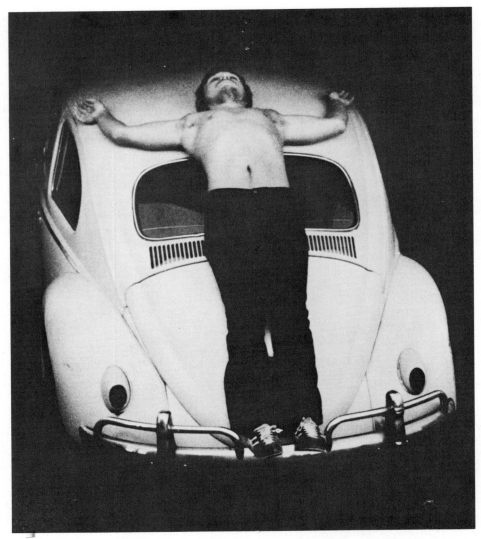

Figure 17. Chris Burden, **Transfixed**, 1974. (Courtesy, Ronald Feldman Fine Arts, Inc., New York.)

SITUATIONAL REALITY

This particular involvement is very closely aligned with the previous category. It is a direction that programs a controlled situation that evokes viewer response and participation. Although dimensional in form, it is theater in format. **The Singing Sculpture** (Figure 18) by Gilbert and George is a repetitive three-minute song piece done over a period of five hours with metallized hands, a rubber glove and a squeaking cane, precise movements, and a tape recorder for accompaniment. **Dead Boards** (Figure 19), one of their recent works, depends more on photographs but deals with a similar situational reality. In another work by Vito Acconci, **Seedbed** (Figure 20), the artist has constructed a false floor within the gallery space under which he crawls about, masturbating and maintaining narrative comments

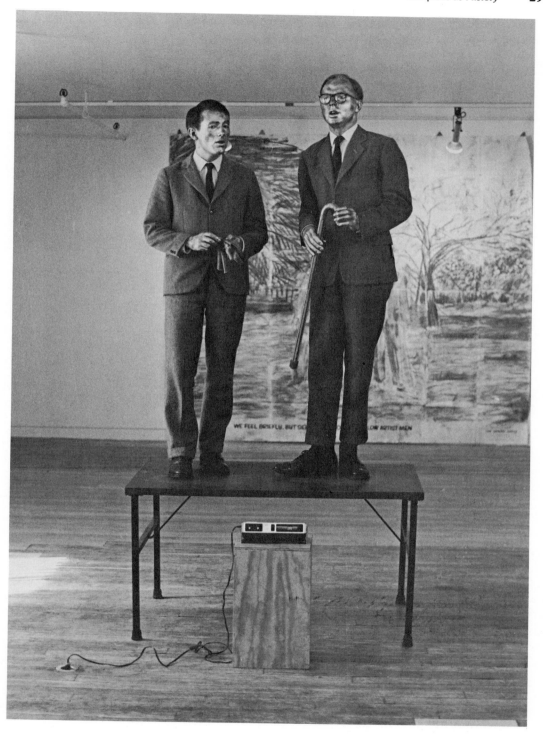

Figure 18. Gilbert and George, **The Singing Sculpture**, Autumn 1971. Metalized faces and hands, props, recorder. (Courtesy, Sonnabend Gallery, New York.)

In all three of these works a certain absurdity and novelty are present. In the Gilbert and George works, these are achieved by dress, props, and the creation of situations that are removed from the context and highlighted by the unusual and unexpected reference. In the Acconci work, the artist creates a situation that is almost too real but is disguised so that although it is in the public arena it is still shielded from view. What one thinks, hears, or surmises from the situation is just as critical to the work as what may or may not be taking place.

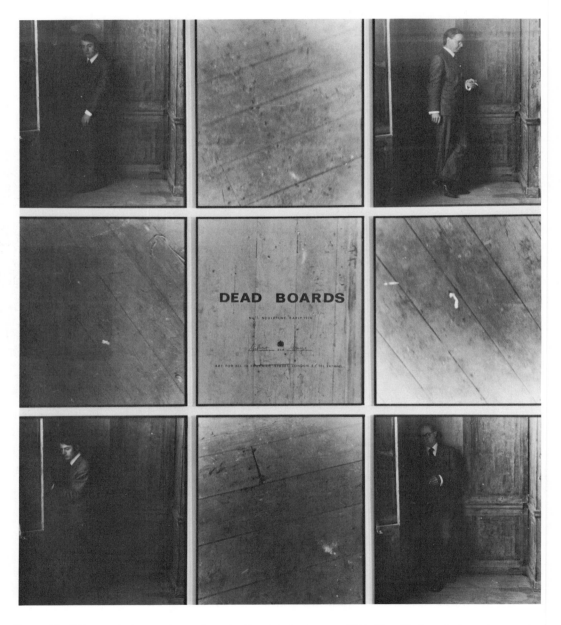

Figure 19. Gilbert and George, **Dead Boards, No. 11 Sculpture**, 1976. Nine black and white photographs. (Courtesy, Sonnabend Gallery, New York.)

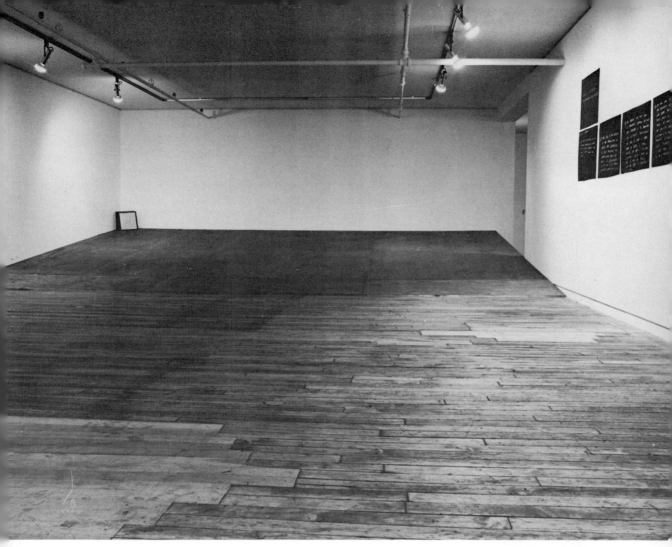

Figure 20. Vito Acconci, **Seedbed**, 1972. Wood construction, body/voice/visitors. (Courtesy, Sonnabend Gallery, New York.)

What results with many situational-reality pieces, whether they involve the body, process, information, or conceptual thinking, is that often they come off as sight gags, visual puns, cheap shots, or trivial exercises that pale in the comparison when placed alongside reality. A paradox exists because experimentation into new dimensional form and experience must continue. The difficulty arises when the new academy merely replaces the old with its own constricting principles, jargon, and attitudes. The idea of sculpture as object must be examined and expanded into new realms but not discarded just on the say-so of the new order. Art, like water and nature, seeks its own level and balance, and grows, mutates, and passes through cycles.

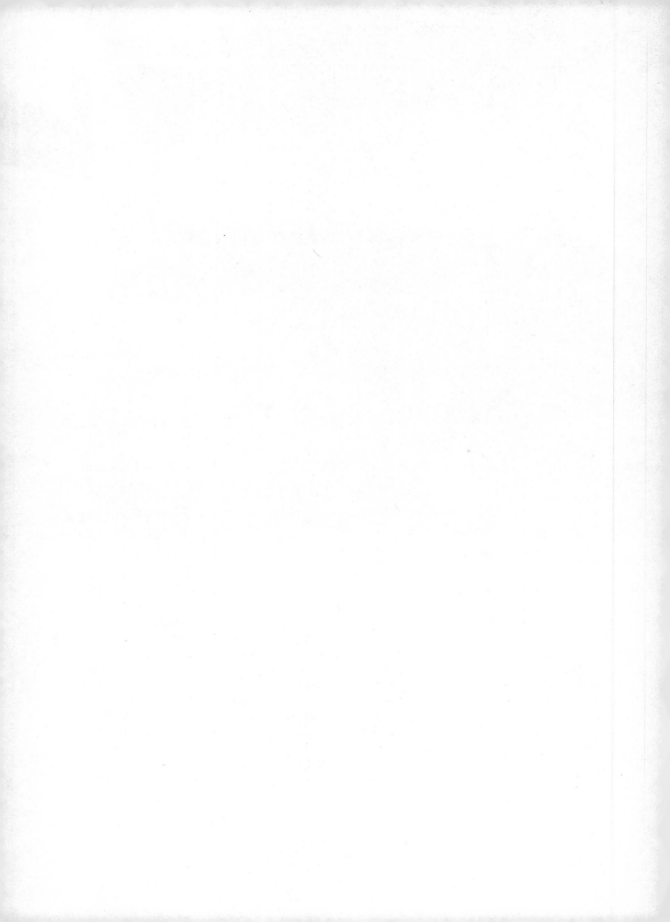

3

Universal Form

The Search for Form of Consequence

The idea that certain sculptural forms or approaches have more universal appeal is obviously an intriguing thought for the artist. It is also a common pitfall to think that a formula of this sort can be applied by the sculptor in some magical fashion and a universal form will evolve. Over the past ten years or so there have been various consumer research, collaborative, and *group-think* attitudes applied to the arts. While many of these endeavors have some interesting results, the majority rule is usually alien to the core of creativity. The individual choice of the artist most often supercedes the collective preferences of society. Sheer numbers and amounts of data collected will not make one approach or form more valid than any other. Statistics can be manipulated to prove anything, depending on their selection, interpretation, and application. A plumber or a ditchdigger will give a different response from an artist whose eye has been trained for different types of decision making.

By the same token, methods of accumulating popular information often are a large part of any work and do not totally invalidate the creative process. In fact, in some approaches it might have a great deal of applicability. Consumer research may gauge a potential market and sell a specific commercial product, and it may even allow for artistic collaboration and anonymity, but being based on current attitudes it is susceptible to fads and a built-in self-destructive, obsolescent nature. To attach special significance to this method of gathering information and response would be erroneous. It is possible for the artist to deal in forms other than the conventional means of creating sculpture, and the technique of polling, questioning, or otherwise surveying the public is only one method in the artist's expanded vocabulary. All creative forms of expression have inherent within them a certain amount of data or facts that are manipulative and studied. It is perfectly feasible to utilize commonalities that have more universal appeal than to ignore these factors.

During 1970, The Museum of Modern Art in New York put together an exhibition called "Information," the main purpose of which was to present an international report on the work and involvements of the younger artists around the world. The exhibition depended on photographs, documents, films, and other means of information transference with an obvious absence of the object as sculpture. The exhibition was not dimensional in the sculptural sense but dealt instead with ideas and concepts that exist in the environment or in the field of communication. Though the language could serve as a barrier, the ideas, images, and involvements go beyond this level and communicate worldwide concepts and universal human response. The rapid transmission of information on and around the shrunken planet earth has created an instant communication that has updated the idea that humans respond to similar forms and stimuli. Yet, the very basis of this communication is the recognition and assimilation of a form, a shape, or an idea on a more simplified or primitive level.

A more recent example of collaboration on an international scale can be found in the work by Douglas Davis, **Questions — Moscow — New York** (Figure 21), in which, through

Figure 21. Douglas Davis, **Questions—Moscow—New York**, 1976–1977. One of four photos. In collaboration with Komar and Melamid. (Courtesy, Ronald Feldman Fine Arts, Inc., New York.)

prearranged collaboration, a work is created and documented. By the juxtaposition of both languages, the obvious communciation barrier is overcome.

At this point, it would be appropriate to examine more closely those aspects in the existence of the human species that seem to have close associations for all persons. First, human beings respond with their senses to matter and material, color, surface, sound, taste, smell, and other factors of the environment. Above all, they bring their mentality and emotions to bear on grasping and comprehending form. Second, subject matter often clarifies and determines the universality of sculpture. Certain themes experienced by all persons communicate more readily that others of more local or national concern. The obvious trap here is the cliché or precious nonentity, especially when the result is the opposite of the intention. Third is the ultimate transmission of idea or message; what the work says or fails to say, intentionally or otherwise.

Sculptors today may or may not be concerned with the message, and, while in some instances this consideration is not applicable to content, the form may still convey a great deal of universality. No work stands totally alien to humanity. Some universality must exist, for the artist has created it and, as the creator, has had common experiences and sensations that bear relationships to the larger world. This is becoming more evident with much of the recent interest in biorhythms, including brain waves, circadian, perceptual, symbolic, and other physiological responses and patterns.

Even though the roles of the artist and observer differ in that the observer is usually not a part of the selective vision, conception, absorption, and determination of the sculptural form, the observer responds to the artist as a fellow person. Certain new sculptural realities may seem divorced from human nature, but close examination reveals some relationship to other objects or concepts. It is not always possible to know or understand the bases of these things, but eventually someone can or will explain them. As the understanding of the technology and complexity of our civilization is increased, so too will familiarity bring comprehension. Even a computer-oriented sculptural phenomenon must rely on a person to program or activate it. It may be impossible to explain what electricity is, but we understand the basis of electricity on one level of knowledge and can, therefore, employ, exploit, and relate it to other objects or concepts. Similarly, the era of group-think permeates our society.

However, it is in the area of form—the basic shape, dimension, configuration, and displacement of matter and space in time—that the concept of universality is experienced more clearly. The forms of the sculptor in today's society reflect a greater concern for mathematics and the laws of other sciences than for the human figuration. Mathematical solids, such as the cube, cylinder, cone, pyramid, prism, sphere, etc., have associations other than their geometrical character. Even primitive people saw geometric shapes—the sun, moon, rocks, and certain crystals—that geometry later explained. Logarithmic spirals are the bases for many forms in nature. Other examples of geometric manipulation have long been evident in architecture, notably the *golden ratio* or *golden section* of ancient Greece, the Fibonacci numbers, and, more recently and perhaps more obviously, the geodesic domes of Buckminster Fuller, in which the equilateral triangle is the basis for the sphere and hemisphere. The spiral usage in architecture is most clearly shown in the Solomon Guggenheim Museum, New York City, by Frank Lloyd Wright, and its counterpart in sculptural form is shown in **The Spiral Jetty** at Great Salt Lake, by Robert Smithson.

Perhaps some of the recent experimentation in sculpture best exemplifies the use of mathematics and science for visual expression. The present minimal use of form, found in the works of Anthony Smith, Donald Judd, Sol LeWitt, Carl Andre, and explicitly in the work **Diamond Mind II** (Figure 22) by Bruce Nauman, suggests an obvious mathematical involvement. The concern with physical laws is evident in the kinetic work of Alexander Calder, and Tsai,

Figure 22. Bruce Nauman, **Diamond Mind II**, 1975. Plaster for stone, twelve rhombohedrons in two shapes, seven shape *A*, five shape *B*, 15″ each face. (Courtesy, Sperone Westwater Fischer, New York. Photo, Bevan Davies, New York.)

George Rickey, and Lye, as well as in the laser-beam work of Rockne Krebs, the electromagnetic experimentation of Takis (Figure 23), and the exploitation of natural phenomena by Hans Haacke and Otto Piene. On a more subtle level, the work of Richard Serra (**Sightpoint**, Figure 24) deals with, among other aspects, the use of enormous weights and precarious balance of the physical law of center of gravity to produce a daring thrust into space. Although these areas necessitate consideration by contemporary sculptors, they must not stop there; instead, artists must continually work to expand their own understanding and experimentation toward what each believes are the universal absolutes.

Let us now take a brief look at some sculptural applications of universal form.

Constantin Brancusi's **Bird in Space** (Figure 25) deals not with the reality of a bird in flight but with the essence of the idea. The **Machete Blade** (Figure 26), on the other hand, is concerned with the aerodynamics of the blade through space, the action as the metal comes in contact with the objects to be cut, and the shape of the cutting blade. The principles of aerodynamics are involved in both but at different levels: in the blade, functionally; in the sculpture, symbolically. It is easy to pass off this strong similarity as coincidence, but forms from nature that also bear resemblance come to mind: an actual bird's wing, a seed pod from a maple or ash tree, or forms of technology such as an airplane wing. In all of these instances, function is a major consideration, and certainly Brancusi was aware of the forms of actual flight; however, the form of his sculpture transcends the mere representation of any of these objects. What is experienced as **Bird in Space** may be called not only a simplification of

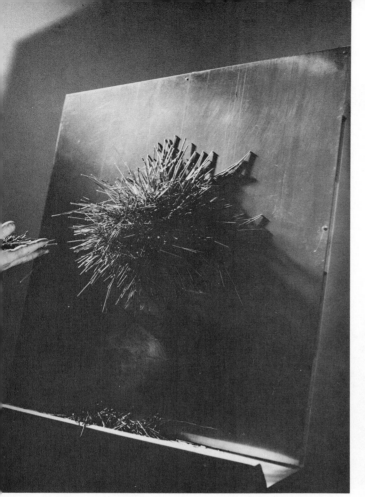

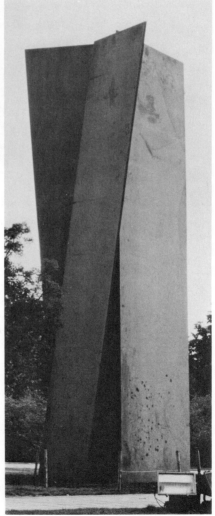

Figure 23. Takis, **Anti-gravity**, 1968. Magnetic field, nails. (Courtesy of the artist. Photo, Nishan Bichajian, Massachusetts.)

Figure 24. Richard Serra, **Sightpoint**, 1971–1975. Cor-ten steel, 40′ × 14′. (Collection, Stedelijk Museum, Amsterdam. Courtesy, Leo Castelli Gallery, New York.)

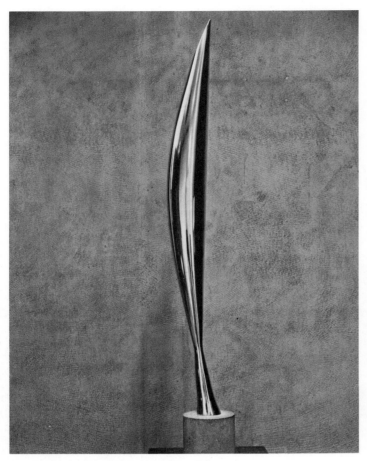

Figure 25. Constantin Brancusi, **Bird in Space**, 1927(?). Bronze, unique cast, 54″ H. (Collection, The Museum of Modern Art, New York.)

Figure 26. Anonymous, **Machete Blade**. Steel, ebony, 24″ L. (Collection, J. J. Kelly, Mertztown, Pennsylvania. Photo, Paul Laincz, Kutztown, Pennsylvania.)

forms but the extraction of an idea — namely, flight. The intriguing aspect of this comparison of objects is that two individuals, at different times and in different parts of the world, evolved similar forms. One can only speculate on why.

The intent and purpose of the following two examples are quite diverse. In the photograph of the two figures by Stephen De Staebler, **Standing Man and Woman** (Figure 27), we sense echoes of form similar to the **Venus of Willendorf** (Figure 28). In both instances the handling of the figurative forms is quite explicit, and even though one is quite recent they both seem to convey a timelessness. It is not the exaggeration of the forms that relates these works but rather the relationship to the human condition.

In more recent contemporary figurative work it is possible to observe this same human quality even though the work may be abstract or derivative. The early work (**Les Nanas**) of Nikki de Saint-Phalle, and Hannah Wilke's **Venus Cushion** or **S.O.S.** (Figure 29) speak of woman in all of her abundance and, whether through simplified mass or pliant, draped planes or shapes, these contemporary works are quite related to the **Venus of Willendorf**, even though 12,000 to 32,000 years separate the works. How can this be? The materials are often different and do not result in the similarity. Obviously, subject matter has to be a part of it. It is in the form language that the universality is grasped. The distribution of masses and hollows

Figure 27. Stephen De Staebler, **Standing Man and Woman**, 1975. High-fired clay, 96″ H × 33″ W × 33″ D. (Courtesy, James Willis Gallery, San Francisco. Photo, Susan Felter, San Francisco.)

and the knowledge we have accumulated about the human female completes the universality for us. If it were possible to somehow reverse the order and show the contemporary work to primitive people or even persons from another era or a remote area of the world, the grasp of the universality of the form would be no less great.

In the history of civilization, one of the most universal symbols is the circle. There is no need here to examine the psychological basis for this except to indicate that people in all civilizations have employed the circle. The dimensionally expanded circle becomes the sphere; the sphere elongated becomes the ovoid. The distortions and variations of the circle are infinite. One has only to think of the wheel, the ball, the globe, the skull, the gear, the Colosseum, or the atomic cloud. Although the circle is geometric, it also possesses a visual appeal. It utilizes the idea of continuation. Generally, the artist in his use of the circle or sphere does so only as a point of departure. In the work by Klaus Ihlenfeld, **Sun** (Figure 30), we see a direct relationship to the circle and the wheel and yet total individuality of form dominates. The universality in this work lies not only in the geometry of the circle but in the manipulation of forms used by the sculptor and the response aroused in the viewer.

Similar forms (Figure 31) evoke a close association with the Ihlenfeld sculpture, and, though they are natural and manufactured objects, a universality of form is communicated. Two more recent involvements in sculpture, Richard Fleischner's **Sod Maze, Chateau sur Mer** (a sod-over-earth, built-up circular maze 142 feet in diameter located in Newport, Rhode Island), and the work of Cecile Abish, **Near, Next, Now** (Figure 32), employ the universality of the circle in diverse approaches.

In the work by Richard Fleischner, the concern of the raised circular-maze form is primarily one of environment and earth work. The form of circles and mounds, however, can

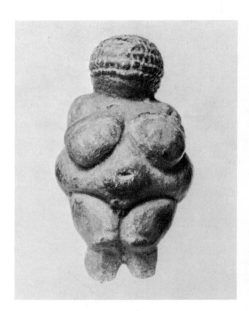

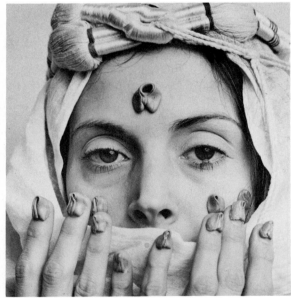

Figure 28. Anonymous, **Venus of Willendorf**, ca 30,000–10,000 B.C. Limestone, 4⅜" H. (Casting of original—Courtesy, American Museum of Natural History, New York.)

Figure 29. Hannah Wilke, **S.O.S. Starification Object Series**, 1974. From a series of twenty-eight photographs in a multiple. (Courtesy, Ronald Feldman Fine Arts, Inc., New York. Photo, Les Wollam.)

Figure 30. Klaus Ihlenfeld, **Sun**, 1960. Brass. (Courtesy of the artist. Photo, John D. Schiff, New York.)

Figure 31. **Coral, Gourd, Billiard Balls**. (Photos, Paul Laincz, Kutztown, Pennsylvania. Billiard Balls—Bernard Perch.)

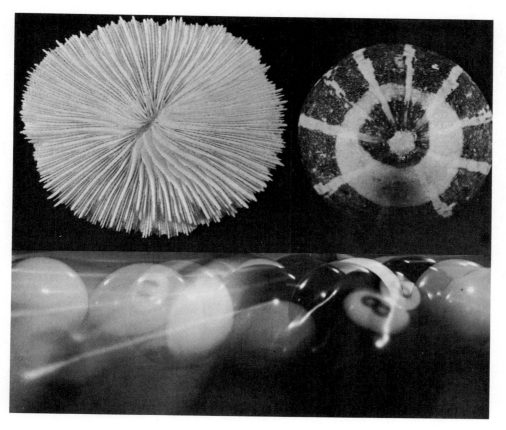

be traced through many civilizations back to Stonehenge and is ageless in its form and idea. In the work by Abish, the circle and its parts and the sphere of the marbles, while not the main consideration of the work, are nonetheless an inherent part, and present an entirely different environmental context.

Marcel Duchamp's **Ready Made Ball of Twine** (Figure 33) presents a strikingly similar configuration to some of the wrappings and bindings of the earlier work of Jackie Winsor. While the intent and involvement of these works are drastically different, the spherical form and qualities of the materials are quite related.

All geometric forms find their counterparts in sculptural form. The sculpture by Clement Meadmore, **Upstart II** (Figure 34), while related to the spirals mentioned earlier, goes beyond this with its undulating planar surfaces. It, like the works by Charles Ginnever (**Pueblo Bonito**, Figure 35), Max Bill, and others, although not exactly like a Mobius strip or endless surface, evokes a similar response. Both works begin with geometric concepts, but the ultimate context and universality is dependent on the artist and the arrangement of forms. In one the curved surface is dominant, and in the other the rigid plane governs the form. Yet

Figure 32. Cecile Abish, **Near/Next/Now**, 1977. Particle board, marbles, 1¼" H × 16′ W × 23′ L. (Courtesy of the artist and Alessandra Gallery, New York.)

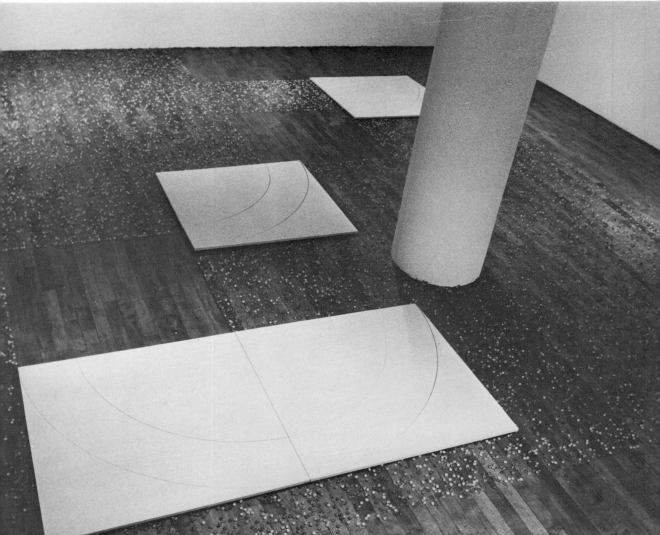

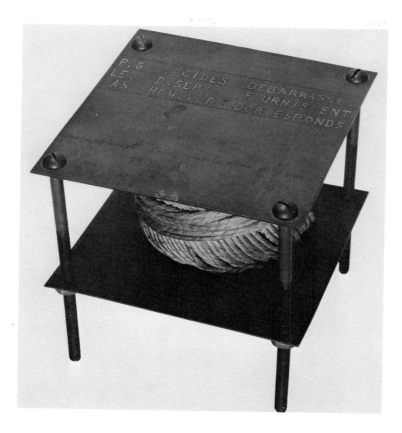

Figure 33. Marcel Duchamp, **Ready Made Ball of Twine (With Hidden Noise)**, 1916. (Courtesy, Philadelphia Museum of Art. Collection, Louise and Walter Arensberg.)

both cause the eye to travel and also to be contained. In **Upstart II**, the use of structurally strong materials, in this case steel, makes it possible to appear to defy balance and gravity and, in so doing, to heighten and contribute to the universality of the form. The individual is conscious of actual balance and gravity, but, when they are placed in a strange context, one's sense must respond. Numerous other examples of geometry as a starting point for sculpture and dimensional involvements may be seen throughout the text.

In **The Burning Walls of Troy** by Reuben Nakian (Figure 36), still another aspect of universal form becomes evident—the workings of nature. Forms like those by Nakian can be found in glacial rocks, volcanic formations, and eroded land. The one revealing expression of the sculpture that differentiates it from rock is the form manipulation that states very clearly that the artist was here and cut and gouged variance of forms into the rocklike material.

A recent environmental piece that transmits similar qualities to the work by Nakian and natural rocks is **Valley Curtain** (Figure 37) by Christo. Spanning 1250 feet across Rifle Canyon, Colorado, the undertaking was enormous. Aside from the physical task, the monumentality of the work is complemented by synthetic material and its relationship to nature. It also shows that the artist exercised his will on the natural environmental context. The universal image and form is immediately recognized as a barrier and relates in subject matter to the previous example. However, the force of the wind, as an element of nature, causes variations in form that are beyond the control of the sculptor.

People continually leave traces of their existence by bringing force to bear upon matter. Imperfections are usually evident. This is not always the case with nature, for in nature we find

Figure 34. Clement Mead-more, **Upstart II**. Cor-ten steel, 25′6″ × 18′ × 25″. (Collection, Princeton University, New Jersey. Courtesy, Hamilton Gallery of Contemporary Art, New York.)

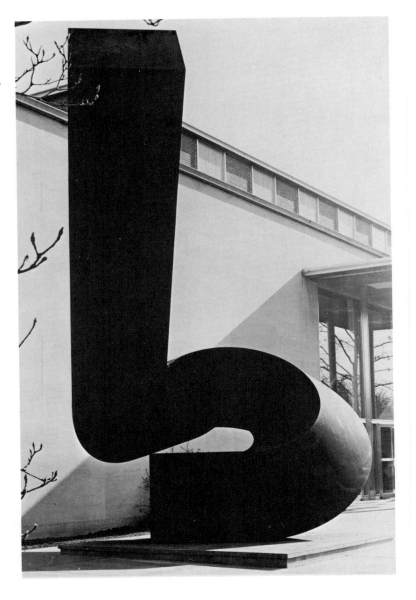

a built-in mechanism for maintaining the balance of things. The sculptor, like nature, experiences mutations that sometimes develop into totally new species. This in a sense is the role of the sculptor, the sculptural idea, and universal form—the evolution and creation of new realities. In the two sculptures just shown, the artists have taken an idea and a material concept of nature (in one case fired clay and in the other plastic sheeting), have given it the familiar form of humans (the wall or barrier), and have extended it into a new interpretive, universal, and sculptural reality. The workings of nature present one other universality in the vocabulary of the sculptor.

These are but a few of the aspects of universality with which the sculptor should be concerned. Certainly, more crucial considerations are not only the response of the viewer or participant but the actuality of the *individual's* approach to sculptural form and dimensional

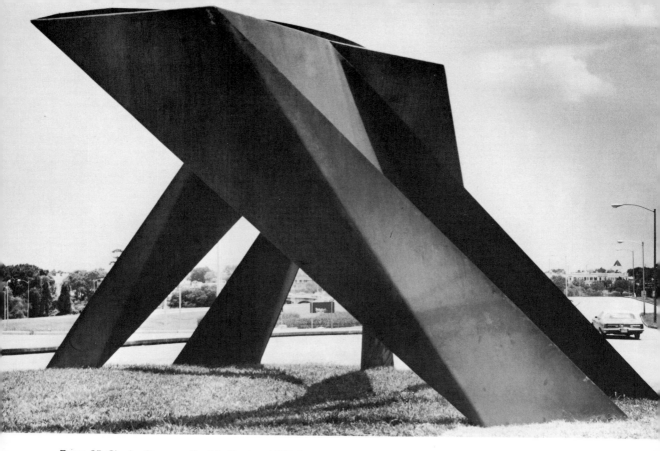

Figure 35. Charles Ginnever, **Pueblo Bonito**, 1977. Cor-ten steel, 12′ × 23′ × 30′. (Collection, City of Houston, Knox Park. Courtesy, Sculpture Now, Inc.)

Figure 36. Reuben Nakian, **The Burning Walls of Troy**, 1957. Terra-cotta, 8⅛″ H × 11⅝″ W × 5⅜″ D. (Collection, The Museum of Modern Art, New York. Gift of Wilder Green in memory of Frank O'Hara.)

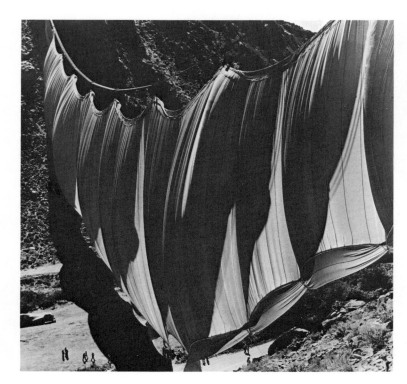

Figure 37. Christo, **Valley Curtain**, 1971–1972. Rifle, Colorado, span 1250', height 185'–365', 20,000 square feet of nylon polyamide, 110,000 pounds of steel cables. Project director, Jan van der Marck. (Courtesy, Allan Frumkin Gallery, New York. Photo, Skunk-Kender.)

involvement. This aspect of individuality becomes vital in any creation of a new sculptural reality. Collaboration by artists can and has worked; however, it is the exception rather than the rule. Individual endeavors seek forms and ideas that take on significance for present and future viewers and participants; the work is an infinite moment. The sculptor evolves a form and idea that speak not only of the dawn of history but of infinity. The work speaks for the artist and says, "I was here. At a time in history I was here; I thought and felt this way, and I created this object and awareness and communication." Its mere presence acknowledges an evolutionary process that is ongoing and cannot be denied. The relationship of the artist to experiences and form language determines the ultimate form of the sculpture and expression. If the creator of a new sculptural reality is concerned with universality, the work will manifest this concern, subliminally or otherwise.

In examining these few examples of universal form, the reader should be aware that an equally convincing argument could be made for or against the universality of all forms—a fact that magnifies the problem of selectivity for the sculptor. It may well be totally impossible to create a form, sculptural or otherwise, whose presence and communication does not create a response on the part of the viewer or participant. Although the sculptor may not consciously employ universal forms in a work, one's background, experiences, and concerns—in fact one's very being—must come to bear on form language. Because sculpture is tangible, it cannot be denied. Because ideas, concepts, systems, process, and communication are a perceptual fact of the species, they cannot be ignored. Presence activates response. The artist, a maker of form and communication, cannot disregard this response in other beings.

At this point, it would be well to examine what lies at the core of the sculptural idea—namely, matter, form, and content—always keeping in mind the concept of universality.

4

Matter

The Material of Sculpture

In the sculptural sense, matter is physical in nature, is composed of materials that respond to manipulation, and is the *stuff of experience* given form.

PHYSICAL NATURE

When we speak of that which is physical in nature, we refer to the very core of the sculptural idea. Sculpture is matter; matter is sculptural. One cannot exist without the other. All sculptural matter takes on physical characteristics. It is material. It is here. It affects our senses. At the present time, any and all materials are fair game for the sculptor.

Traditionally, the sculptor worked stone, wood, clay, and metal. Today this has been extended to include materials such as synthetic stones, i.e., cements, plaster, and various aggregates. The artist has benefited by the technology of the age by utilizing plastic and other synthetic chemical compounds, as well as other materials and technological processes, such as chemicals and electronic components, that lend themselves to manipulation. Perhaps as a reflection of society, the artist sometimes employs materials that are manufactured for other purposes. These old, new, and scrap materials expand the artist's range of materials, and currently any material in its raw, processed, or refined state is suitable for sculptural exploration.

Further, through much of the recent explorations, matter has expanded in definition and documentation to include everything from a photograph to a pencil (graphite) on paper, to extraneous materials (butter, string, tape, etc.), to the human body, and, in fact, to anything that can be manipulated physically or mentally by the sculptor (see Figures 38 and 39).

47

Figure 38. Jan Groover, **Untitled**, 1976. Three color photographs, 26″ × 41″. (Courtesy, Sonnabend Gallery, New York.)

Figure 39. Barry Le Va, **Accumulated Visions: Series II**, Whitney Biennale Installation, 1977. Wood on floor and walls. (Courtesy, Sonnabend Gallery, New York. Photo, Bevan Davies, New York.)

Figure 40. Michelle Stuart, **Quarry Notebook, Sayreville, New Jersey**, 1976. 12″ × 8½″ × 2¼″. Handmade paper, earth, handwoven string. (Courtesy, Max Hutchinson Gallery, New York.)

SELECTION, MANIPULATION, EXPLOITATION

Selection

With the wide range of materials available, the primary problem becomes one of selection. How does the sculptor select materials? What influences choice? Basically, there are only two major means of selection. One may select the material and fit the particular idea to it or have the specific idea and adapt the material. This then is the initial response. In a general sense, one is physical, the other mental. After a period of time and the execution of several pieces, a preference usually manifests itself. Experimentation leads to the discovery of what is most compatible with one's form of expression and temperament. In one's attitudes toward materials and their selection, the sculptor should be careful to maintain an open-minded, unrestricted approach to matter.

The range of matter is too great to lock oneself into narrow limits of materials. With a broadened range of materials, the potential for ideas, forms, and concepts multiplies, and the sculptural process becomes an ongoing, expanding exploration. Many contemporary sculptors feel the need for a relatively quick image. The world changes so rapidly and new materials and forms so dazzle our sensibilities that materials worked with traditional techniques requiring patience and perseverance are seen less and less. Often, the more conventional materials are used in combination with a more contemporary one (Figure 40), or, if the traditional media

are employed, the size is expanded and given new and different form relationships (Figure 41). In some cases, material is used in its natural state but removed from its usual context (Figure 42), or the context is normal but the material is not anticipated (Figure 43).

Still other devices include the manipulation of the properties of the natural material, the use of materials as environment, or as the idea and concept (Figure 44), and the use of material as material (Figure 45). These are but a few of the possibilities in the selection of materials, and, whatever the choice, the selection should be determined by the individual in relation to the ideas, concepts, and forms that best convey these concerns.

Scrap materials, found objects, or matter in its raw state are being utilized in sculpture with increasing frequency (Figures 46 and 47). Basic questions arise in the employment of such materials. Should a dematerialization and the elimination of function take place, or should the material remain in context or in its natural state and location? In the case of a found object, should the material be its own reality, or should it be reshaped or distorted into the sculptor's concept of reality?

Figure 41. Avital Oz, **Installation View**, 1976. Plywood. (Courtesy, O. K. Harris, Works of Art, New York. Photo, Eric Pollitzer, Hempstead, New York.)

Figure 42. Patsy Norvell, **Untitled**, 1972–1973. Hair and tape, 62″ × 73″. (Courtesy, AIR Gallery, New York.)

Figure 43. Paul Suttman, **Sculptor's Meal #3**, 1968. Bronze, approximately 4½′ H × 3′ W. (Collection, Mr. and Mrs. Robert Lang. Courtesy, Terry Dintenfass, Inc., New York. Photo, John D. Schiff, New York.)

Figure 44. Dennis Oppenheim, **Identity Stretch**, 1975. Aerial detail, 300′ × 1000′. Hot sprayed tar. Left print, right thumb, Erik Oppenheim. Right print, right thumb, Dennis Oppenheim. (Courtesy, Artpark, Lewiston, New York.)

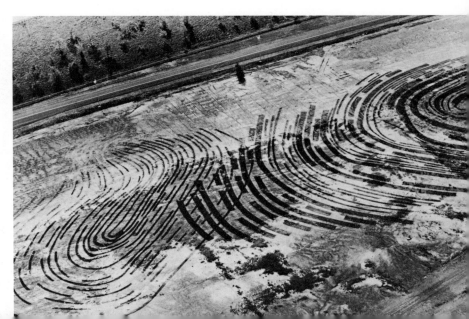

Figure 45. Carl Andre, **36 Pieces of Steel**, 1969. Steel, 6′ × 6′ × ⅜″. (Courtesy, John Weber Gallery, New York. Photo, Walter Russell, New York.)

Figure 46. Donna Byars, **Rabbit Pen (A Reclamation)**, 1976. Wood, clay, bandaged rabbit, 7″ × 7⅜″. (Courtesy, AIR Gallery, New York. Photo, Maude Boltz.)

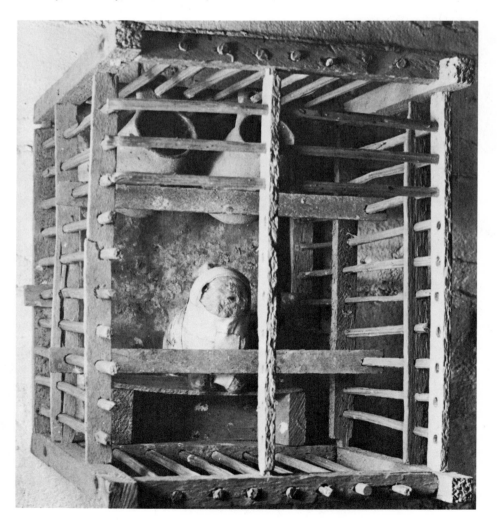

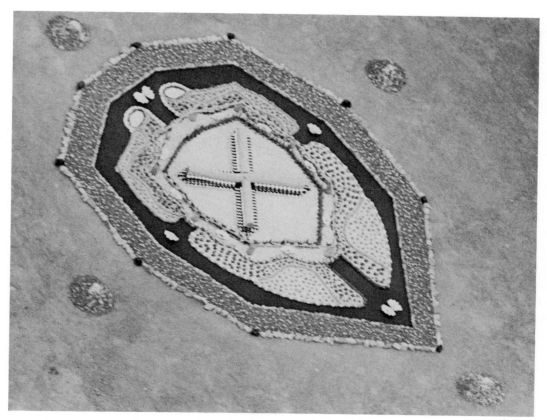

Figure 47. Jim Roche, **Tree Altar**, 1975. Mixed materials. (Courtesy, Artpark, Lewiston, New York. Photo, Bob Sacha.)

Although the answer is relative to the specific individual and that person's expression, some generalities may be made about these three material approaches. Scrap materials that include standard and stock sizes, shapes, and forms (such as sheet, rod, tube, etc.), fall into one category. Found objects that have been made of a specific material and have been fabricated or shaped in some manner constitute a second area. Materials in their natural state (for example, earth, wool, hair, skin, etc.), or those that have been refined into a slightly different but natural state (such as firebrick, cloth, rubber, paper, etc.), are included in a third classification. Loosely defined, dematerialization is the taking or distorting of the material from its original function or appearance while retaining the use of the basic substance. Often, a machine or manufactured object will have aesthetic qualities of shape, line, and texture that may be retained even after removing the object from context (Figure 48).

The sculptor can use many such ready-made scrap and found materials that he or she could not possibly fabricate and that originally had a greater emphasis on function than on form or design. But the following questions should be considered: Is it possible to eliminate the function while retaining the inherent quality of form and idea? On the other hand, if this object is of such beauty or ugliness, why remove it from its context? Is not the function, in all of its banality, just as strong a statement? Should raw or naturally refined materials be employed on site, removed from context, remain true to their own essence, or be mixed or contrasted with other matter? Is the use of raw and natural materials a substitute for the exercise of the

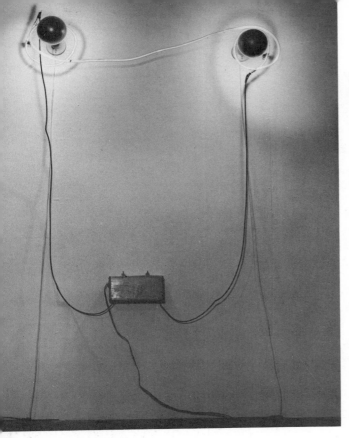

Figure 48. Keith Sonnier, **Double Loop**, 1969. Neon and incandescent bulbs, 5' off ground × 5' W. (Courtesy, Leo Castelli Gallery, New York.)

sculptor's will over the material? Left in their natural state and location, what distinguishes these materials from similar materials if the artist does not at least rearrange the context? Is the refining process that produces such materials as body solder, roofing cements, various glues, and industrial coatings for specific intentions a contradiction of natural materials? When they are employed by the sculptor, are they not a concession to a process that is once removed from their natural state, or does the transformation present new qualities and sensibilities of matter? These are but a few of the many considerations facing the sculptor in the selection of matter. It would be wise to examine other factors of matter.

This brings us to perhaps the essence of matter: the intrinsic character of the material. Different materials possess properties that transmit two primary sensations to the viewer: physical and psychic. Physically, our senses react to the grain of wood, the texture of stone, or the ubiquitous roofing cement. Psychically, we feel the warmth of wood, the coldness of stone, and the clamminess of tar. In some of the more recent experimental forms in which matter is used minimally or suggestively, the description or projection of these materials still evokes a physical and psychic response in the viewer or participant. The form utilizes psychic response which, in turn, causes recall of previous experience with the physical material. Individuals seem to gravitate toward those materials that soothe or stimulate their sensibilities. Universal discernment of materials is also a factor for consideration. Whatever the heritage of the artist, there will be response to primal instincts of inherent qualities of material or substances.

One cannot say that one material is right for any specific person or form of expression. It may be right at a given moment, but it does not and should not remain constant for the sculptor. One must continually investigate new feelings, new materials, and new surfaces. But in so doing, the artist should not neglect or ignore the possibilities of old materials placed in new arrangement and context. It is not the purpose of this essay to examine specific materials

and discuss the intrinsic and extrinsic nature of each. The needs and sensitivities of each individual vary too greatly. Each must find his or her own way. When asked some years ago, "What is jazz?" a famous musician replied, "If you have to ask, you will never know." If one is not attuned to the inherent qualities of matter, perhaps one should abandon or reconsider ambitions in sculpture.

Another problem in the selection of materials is focus. It can be said that the sculptor lives in one huge environmental sculpture and that all physical matter in the immediate area possesses varying degrees of sculptural merit. The sculptor must focus on a grouping of physical materials or narrow his or her sights even further to a single material. The number of choices or options is not the problem when selecting materials. Rather, the sculptor must have the ability to limit the selection to those materials that best reinforce the sculptural idea and the form that is being projected. Whatever is chosen, one must cope with the qualities of these materials. They have a reality of their own, and they exist in an environment related to other physical matter. They must either be taken out of that relationship and context or placed in a different ambient. The sculptor must establish for these materials their own reality at the same time that the person relates to or contradicts the original environment (Figures 49, 50, and 51).

Figure 49. Vito Acconci, **Where Are We Now/(Who Are We Anyway)**, 1976. Wood construction/audio tape. (Courtesy, Sonnabend Gallery, New York.)

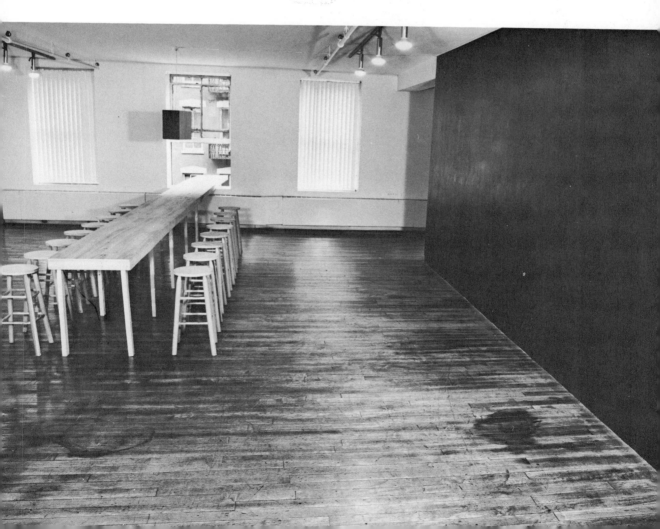

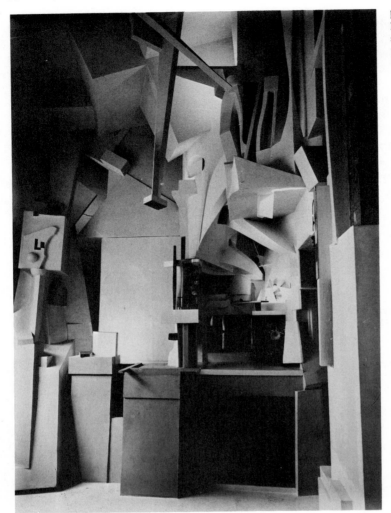

Figure 50. Kurt Schwitters, **Merzbau**, begun 1920, destroyed 1943. Assorted materials. (Courtesy, Landesgalerie, Hannover, West Germany.)

Two final considerations in the selection of materials are permanence and transience. Two schools of thought exist on this subject: either sculpture remains ageless, to be seen, felt, and appreciated centuries from now, or sculpture reflects the fleeting quality of life. Both of these attitudes are cogent and dependent on each other. In fact, it is possible to combine both positions. Certain innovations, ideas, and concepts in less durable materials often serve to break ground for exploitation in more immutable matter and vice versa. To say the sculptor should not react to or explore ideas because they will not survive the test of time is intolerable. One might argue that what is worth doing should be done to last, but many ideas do not adapt to permanent, tangible form, and, in certain cases, spontaneity and a new reality might be sacrificed. In a way, the fleeting song of a bird is just as timeless as the rocks of the Palisades. The feeling that things of quality live on, regardless of their fragility, seems to be the rule of permanence. Those things of a more transient nature will either be translated into more permanent form through documentation or be carried and passed on through the stream of conscious communication.

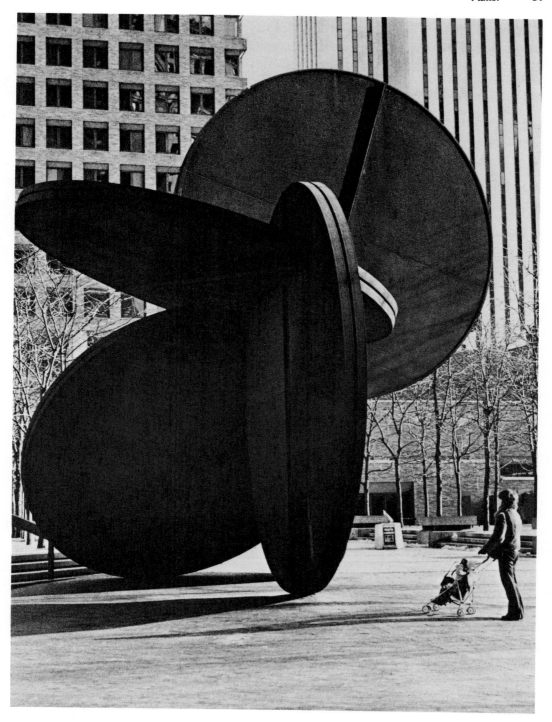

Figure 51. Bernard Rosenthal, **5 in 1**, 1971–1974. Weathering steel, 42′ L × 30′ H × 28′ W. Fabrication—Milgo. (Courtesy of the artist and Knoedler Gallery, New York. Photo, Hans Namuth.)

Manipulation

Manipulation, the second major aspect of matter, follows selection. The basic question the sculptor must ask at this point is *how?* The artist must devise ways to manipulate, shape, and control the materials to establish a reality for the ideas. The materials must respond to the touch. In a sense, the sculptor must be master of the selected materials, fighting along the way to be sure, but victor in the end by forcing the artist's will over the specific materials. With modern technological means at one's disposal, it is possible for the sculptor to make the strongest materials yield to touch. Various types of welding equipment, power tools, hand tools, as well as electrical and electronic devices and industrial processes, serve the sculptor in the quest of how. Through the exercise of mental reasoning and capacity, the sculptor may also hypothesize concepts, ideas, and forms that lie outside normal body rhythms and capabilities but within the realm of scientific application. Chemical, physical, and natural phenomena may also be brought to bear on the materials of the sculptor. They may even become the materials themselves.

The sculptor must work toward automatic manipulation of materials, making the artist and materials one. Obviously, this is an ideal situation, for people, being what they are, have certain body rhythms and limitations. Uppermost of these are the physical restrictions that establish a normal frame of reference in which one may work comfortably. One may achieve great heights or depths, but a person is capable of certain body movements and incapable of others. People cannot fly like a bird, nor swim like a fish. With some manufactured aids, such as airplanes, gliders, scuba-diving apparatus, and submarines, one can approximate these movements and others outside the human sphere (such as the chemical, physical, and natural phenomena mentioned above), but they can never be duplicated exactly. Moreover, these aids are still restricted to natural body movement and capacities. In this sense, these movements establish a rhythm of which the sculptor must be aware. To work outside or to stretch this rhythm, although challenging, is extremely difficult, if not impossible. Many of the current explorations into dimensional concepts deal with this very premise. Process, conceptual, body, and situational art forms all deal with the extension of the relation of humans to these rhythms. The fact that reach directly influences the form that evolves may account for the infirmity of many of the results of these involvements. On an intellectual level, they are sustained; on a physical level, they are irresolute and mainly serve to emphasize the species' limitations.

Related to manipulation are two basic approaches or techniques: direct (Figures 52 and 53) and indirect (Figure 54). The direct approach places more emphasis on a spontaneous, expressionistic treatment that is its own reality when the sculpture is complete. The indirect approach is more controlled, systematic, and objective, and preliminary work usually comes before the final form or record of documentation is made. In the latter, the sculptural reality is once removed in that the original form, idea, or concept has been transcribed, usually into a different material. These factors are applicable whether dealing with traditional materials and techniques or more contemporary approaches. One may disagree with calling these approaches objective or subjective. However, such generalizations, while arbitrary, nonetheless have some degree of accuracy. When working in the direct method, one cannot readily hide the flaws; the indirect method usually allows a second chance. Whether the sculptor's weaknesses as well as strengths should be shown becomes a highly personal question.

It is quite possible to combine the two approaches (direct-indirect) toward a new sculptural reality (Figures 55 and 56). This is also becoming more evident in contemporary work with the use of photographs and intermedia as a record of documentation and material. Closely associated with the direct and indirect approaches are the factors of addition and subtraction, of plus and minus.

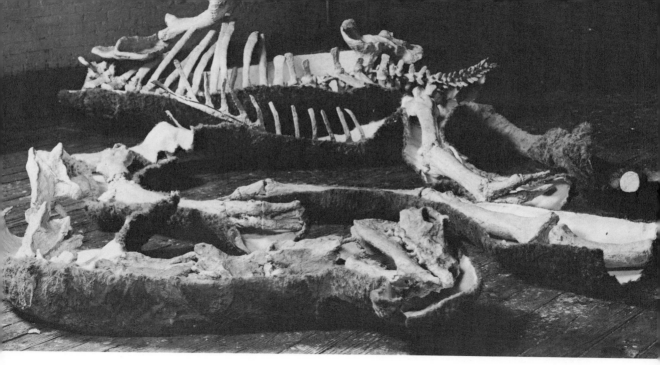

Figure 52. Nancy Graves, **Inside-Outside**, 1970. Steel, wax, marble dust, acrylic, fiberglass, animal skin, oil paint, 4′ × 10′ × 10′. (Courtesy of the artist.)

Figure 53. Brenda Miller, **Cassandra**, 1976. Sisal (1″–40″), 80″ square. (Courtesy, Sperone Westwater Fischer, New York.)

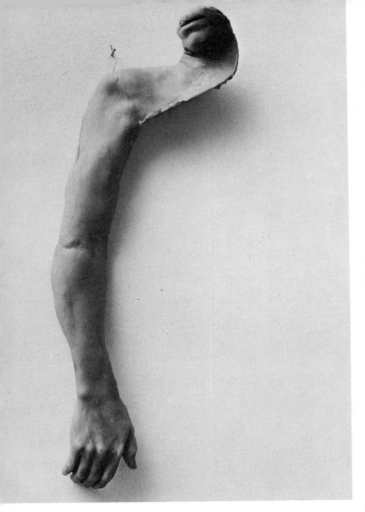

Figure 54. Bruce Nauman, **From Hand to Mouth**, 1967. Wax over cloth, 30″ × 10″ × 4″. (Collection, Mr. and Mrs. Joseph Helmen. Courtesy, Leo Castelli Gallery, New York. Photo, Rudolph Burckhardt, New York.)

Figure 55. Sylvia Stone, **Shifting Greys**, 1976–1977. Grey Plexiglas and aluminum, 4′ H × 15′6″ W × 16′ L. (Courtesy, Andre Emmerich Gallery, New York. Photo, Geoffrey Clements.)

The concept of addition, or plus, is the building, modeling, constructing, welding, etc., toward a cumulative end (Figure 57). The subtractive, or minus, implies the taking away by eliminating, carving, melting, etc., toward a diminutive result (Figure 58). In more contemporary approaches, the same attitudes of addition and subtraction apply. In both techniques, a new sculptural reality evolves by the creation or destruction of matter into a new form. The additive can be stated as plus equals plus; the subtractive, minus equals plus. The isolation of these two techniques should not suggest they are not easily combined. Often, they are inseparable, especially in the current involvements and experimentation with dimensional concepts, process, systems, and environmental situations. It is this continual freedom of manipulation that leads to exploitation of matter.

Figure 56. Hannah Wilke, **Centerfold**, 1973. Latex and snaps, 9′ × 4′. (Courtesy, Ronald Feldman Fine Arts, Inc., New York. Photo, Eeva-Inkeri, New York.)

Figure 57. Jackie Winsor, **55″ × 55″**, 1975. Wood and nails, 40″ × 40″ × 40″. (Courtesy, Paula Cooper Gallery, New York.)

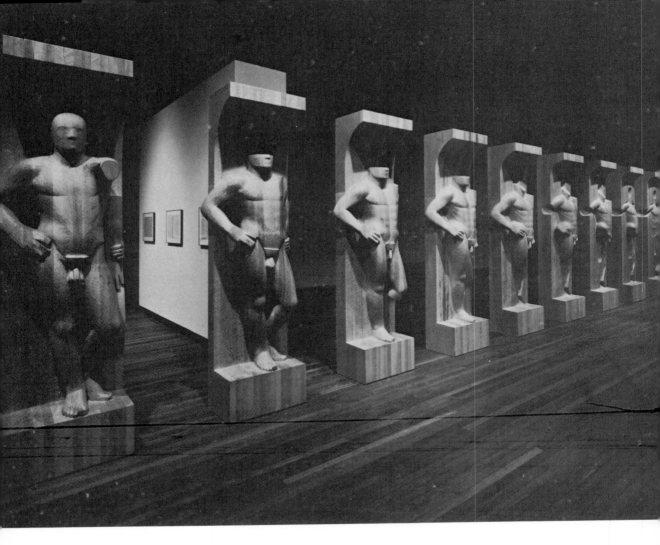

Exploitation

For the sculptor, matter must lend itself to exploitation. It must be able to be arranged in an endless number of relationships. The artist demands choice. Freedom to select, reject, assess, and assign values to matter is the essence of experimentation. In each changing relationship, the sculptor must exercise mind and will over the material. The artist exploits the material for itself, for oneself, and ultimately for the new sculptural reality that evolves.

FORM OF MATTER

Matter, as the term has been used throughout this chapter, refers primarily to material and the various alterations and changes of state to which matter can be subjected. It naturally can also be interpreted in the philosophical sense as the *stuff of experience* given form. The sculptor takes a material, itself evolved through many experiences, applies his or her *stuff*, experiences, and entire being to it and gives it new form and meaning. It is a virgin form or idea of a specific material, tangible or otherwise, that has assumed a new life and a new reality. Its form can never be repeated in precisely the same way; the matter is also unique. Attempts at similarity or even reproduction are possible but futile since minute variations always occur, the material is

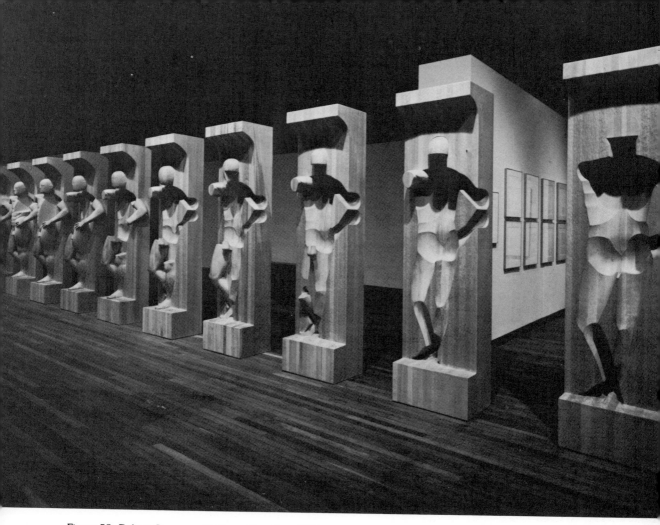

Figure 58. Robert Cremean, **Vatican Corridor**, 1974–1976. Wood. (Courtesy of the artist and Braunstein/Quay Gallery, New York, San Francisco.)

different, and the environmental situation and time-frame have changed. It is one of a kind, period. This is the great gift of matter on which the sculptor depends.

In the history of art, sculpture has assumed many things, served many purposes, and taken on many differing forms and ideas through the utilization of various kinds of matter and the artist's ability to place it in context with communication and meaning.

THE RELATION OF MATTER TO FORM

The sculptor's knowledge, experiences, and interpretations of and attitudes toward matter increase in direct proportion to the greater awareness of science. The scientist's constant search for and discovery of the nature of materials, most recently and notably in the realm of antimatter, must ultimately cause the sculptor to explore this nature, give it form, and create new sculptural realities. In this endeavor, the artist strives toward new avenues of thought and sensation by clarifying intent, assimilating experiences, and giving universal meaning to one's sculptural objects and ideas.

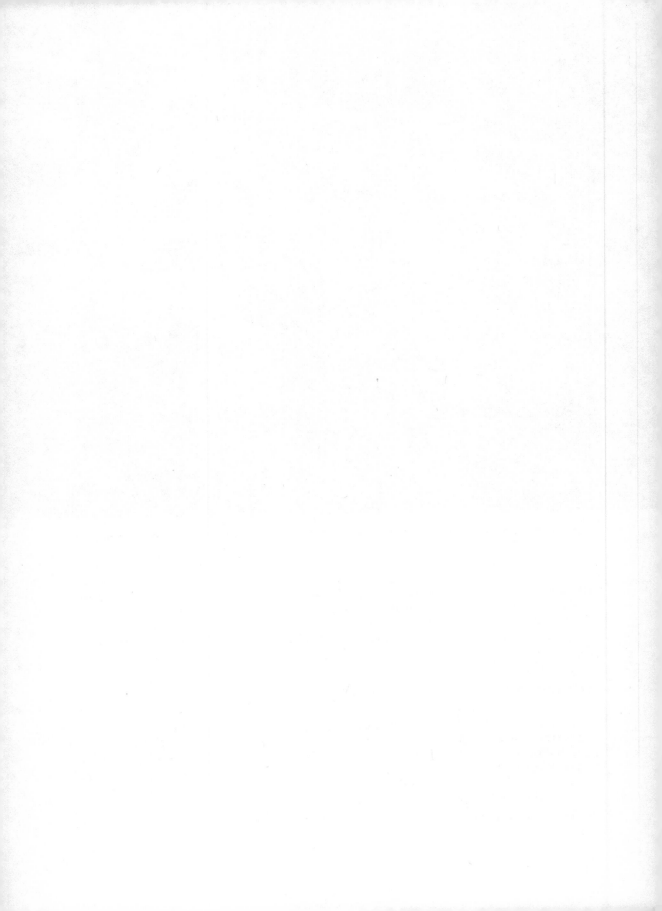

5

Form

The Method of Sculpture

For they make many things out of the matter, and the form generates only once. . . .

<div align="right">Aristotle</div>

When used in reference to sculpture, form is an elusive term. It has been defined as the universal meaning of sculptural objects. While this may be true, it is often much more. It is shape, dimension, structure, technique, the intrinsic and extrinsic character, the arrangement of content, and all of these things in combination. Further, and most important, it is the sculptor exercising his or her will on the piece and giving it life. Form is the utilization of various techniques to impose on matter a unity of idea and image that creates a new sculptural reality. But the meaning derived from form depends on many factors. The viewer, as a third party, interprets a work according to individual perception and background. A work is placed in a new environment with changed relationships to its immediate surroundings, and the work itself changes form and appearance.

Examining the nature of form in outline immediately illustrates its complexity.

I. Structure
 A. Elements
 1. Mass
 2. Volume
 3. Plane
 4. Line
 5. Texture
 6. Color
 B. Three-dimensional design and systems of order

C. Space
 1. Environment and context
 2. Inner space
 3. Positive-negative space
 4. Aggregate of points
 5. Extensions and directions
D. Time
 1. Interval of measure
 2. Occurrence
 3. Relation of the work and the viewer to time
 4. Movement and existence in time
II. Technique
 A. Methods employed (possibilities for exploration)
 B. Method and matter
 C. Evolution and exploitation of technique
 D. Drawing as reference
III. Individual sculptor
 A. Relation to matter
 B. Intrinsic and extrinsic character
 C. Style-manner
 D. Arrangement and relation of form to content

STRUCTURE

Structure may be defined as the interrelationship of parts to the whole. It is also the arrangement of elements into a substantial body radiating out from, into, or in defiance of a central core or base. For the sculptor, the elements are: mass, volume, plane, line, texture, color. It would be wise to examine each one of these elements in depth and, in so doing, establish a common meaning toward a universally accepted vocabulary of form.

Elements

Mass. Mass is solidity; it is bulk. It is the concentration of matter in a confined area. It is also a quantity and shape of a given material. But one cannot isolate mass from plane, line, volume, texture, or even from color. In the sculptural, nongeometric sense, plane has thickness and, therefore, a certain amount of mass. Line is the edge of mass. Volume can be considered a hollow or negative mass. Texture and color are surface qualities of mass. The isolation of mass from the other elements is, therefore, quite impossible.

When speaking of a grouping of forms or elements, it is common to refer to them as a mass or a massive form. Here the sculptor utilizes all of the elements to achieve mass. Through repetition or accumulation, any single element may become mass. To emphasize mass the artist concentrates matter in a confined area while subordinating the other elements (Figure 59). On the other hand, if the need is for a less massive form, greater dispersion and displacement is necessary (Figure 60). Some sculptors define sculptural form as shape, as dimension, or as the displacement and relationship of masses. But mass can be better regarded as one facet of a multiple consideration. Equally important are the basic penetration of space that occurs and the form and meaning imparted by the sculptor to the viewer. Penetration of space is the displacement of air or space by a given matter. On the other hand, if this mass is not only related to other masses but is dependent on the displacement of air and

is formed by the sculptor into a meaningful shape both for the artist and the viewer, it can be said to approach a significant or universal form. Mass is, like all of the other elements, just one means to an end.

While working on a piece of sculpture, the sculptor revolves the form to see the distributions of masses as well as the penetration into space of various parts (Figure 61). If the piece is too

Figure 59. Andrea Cascella, **Thinker of Stars**, 1968. Granite, 28″ × 18″ × 10″. (Courtesy, Betty Parsons Gallery, New York.)

Figure 60. Nancy Graves, **Variability of Similar Forms, 36 Parts**, 1970. Wax, acrylic, marble dust, and steel, 7½′ × 15′ × 18′. (Courtesy of the artist. Photo, Janie C. Lee Gallery, Dallas, Texas.)

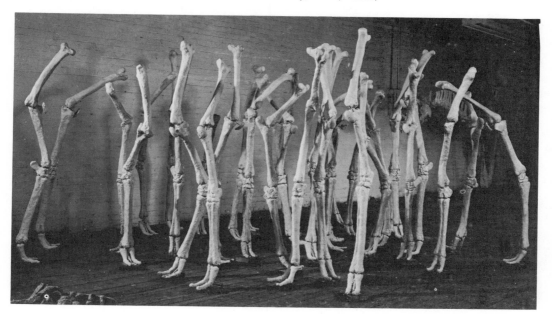

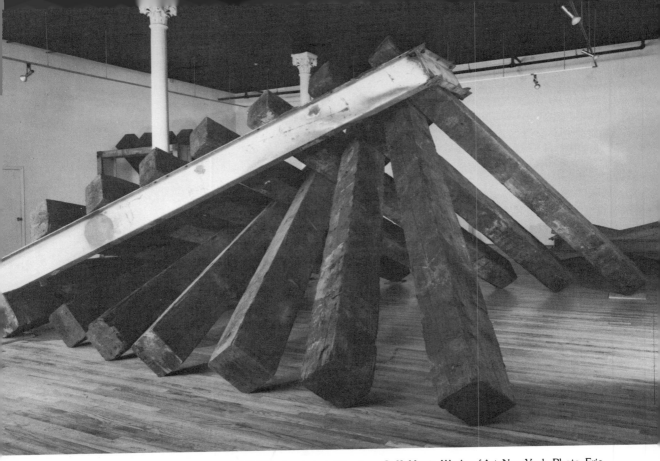

Figure 61. Kenneth Capps, **Attic**, 1974. Wood and steel. (Courtesy, O. K. Harris, Works of Art, New York. Photo, Eric Pollitzer, Hempstead, New York.)

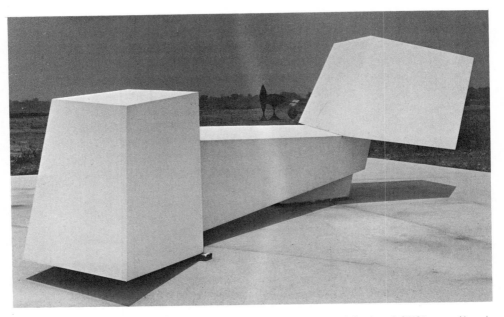

Figure 62. James Rosati, **Shorepoints I**, 1966–1968. Painted Cor-ten steel, first length 21′3″, second length 16′, span 22′6½″ H. (Courtesy, Marlborough Gallery, New York.)

large, the same effect is accomplished by stepping back, walking around, and studying it from as many angles as possible or necessary (Figure 62). Many questions are asked. How do the masses relate to each other? Are all the shapes and contours clearly defined? What displacement of air space occurs? Are the forms significant enough and stated clearly to communicate meaning? For the sculptor? For the viewer? Does transition occur between the masses? Are our eyes taken around the piece before we get there? Must we encompass the entirety in one glance (Figure 63)? Does not simplification of form define mass most obviously? Will complexity of many masses obliterate the whole by emphasis on the parts? Another consideration is the nature of the material and its adaptability to mass. In their natural state, some materials, such as stone and wood, lend themselves to mass. Should the sculptor defy this innate character? Can this quality be used to better advantage? How important is the initial selection of material in regard to mass and the other elements? Should not the form evolve and be dictated by the material? Is not the sculptor the necessary master over materials and the elements? These questions and many others must necessarily be answered by the sculptor as a piece evolves.

Volume. Volume is enclosed or defined space, a negative mass. It is the absence of matter, defined by matter. In this respect, what the sculptor does *not* say is all-important. Volume has the characteristic of shape without being occupied by matter. Its form is created by the forms around it. Being of such low density, it is at once unique and elusive. It is unique because of its dependence on the other elements for its formation and elusive due to its illusionary nature (Figure 64). It cannot be isolated. All elements have volume. Mass, it can be said, is a positive volume. Line and plane (Figure 65) define volume. Texture and color

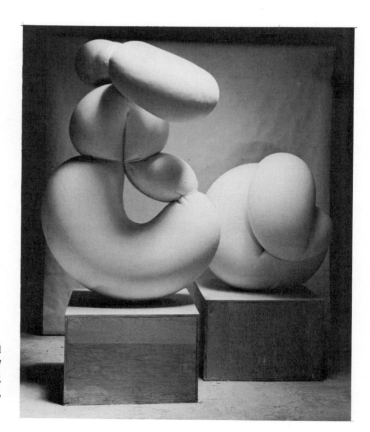

Figure 63. Peter Agostini, **Baby Doll and Big Daddy**, 1967. Plaster. **Baby Doll**—80″ H × 51½″ L × 50½″ W; **Big Daddy**—46¼″ H × 42½″ L × 43″ W. (Courtesy, Zabriskie Gallery, New York. Photo, Don Cook, New York.)

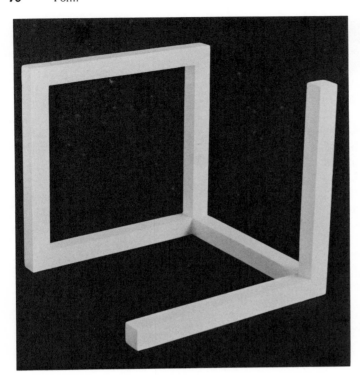

Figure 64. Sol Le Witt, **Semi-Cube Series, Seven Parts, #20**, 1974. White painted wood. Each part 8″ × ¾″ × ¾″. (Courtesy, John Weber Gallery, New York.)

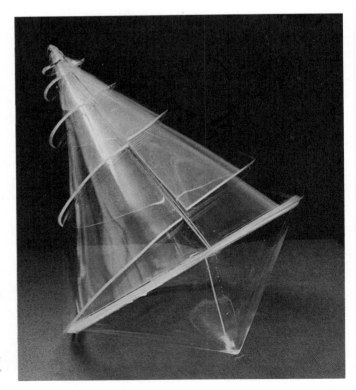

Figure 65. Ruth Vollmer, **The Shell #1**. Acrylic, 21″ H × 15″ diameter. (Courtesy, Betty Parsons Gallery, New York.)

Figure 66. Arnaldo Pomodoro, **Sfera**, 1976. Bronze, 30 cm. diameter. (Courtesy, Marlborough Gallery, New York. Photo, Boschetti, Milan.)

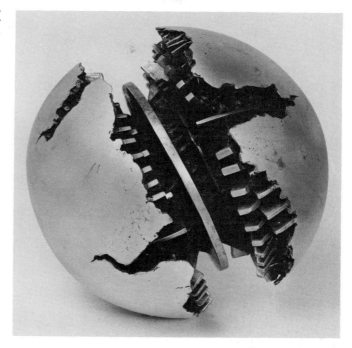

contrast volume. Obviously, volume is indispensable to the molder of form. Yet, we generally do not speak of the relationship of volumes to each other except as they relate to the masses and, in this sense, as the darks or those areas that retain darkness or shadows. This relationship of mass to volume (Figure 66), or lights to darks, is often called chiaroscuro and will be discussed later in the section on color. Likewise, it is closely associated with space, which will also be examined in a later section.

Although related to these other elements, volume is clearly more individual. The shape and area of volume, though dependent on surrounding forms, is always present and merely needs bounds (Figure 67). It is the most automatic of the elements. One cannot exploit any form without creating a volume. This self-perpetuation, however, requires a certain amount of control. While dependent on its immediate surroundings, each volume also dominates and, to a degree, determines both its form and its environment. This duality at once defines mass and obliterates volume temporarily. After a work is closely examined, the volumes are realized, and it is seen that they are caused by surrounding forms that directly influence the totality of the piece.

In considering the elements of volume, certain questions arise. To what degree must space be enclosed before the volume is defined? Is there a minimum point at which volume occurs and yet does not diminish or distort the encompassing element? If such a point does exist, to what extent should the volume be defined or enveloped? Does a point of tension occur at some degrees of closure, and, if so, is this desirable? Is volume an end in itself or a means of refining adjacent forms? Are volumes static or only given movement by their relationship to their parts (Figure 68)? In the case of transparent (e.g., acrylic-sheet) enclosures, is not the volume both an interior and exterior concern? Does the nature of volume suggest specific meanings of universal form? Is this application too literal?

These questions, while collectively unanswerable, have considerable individual importance and application. They are important even if only one applies to any given piece.

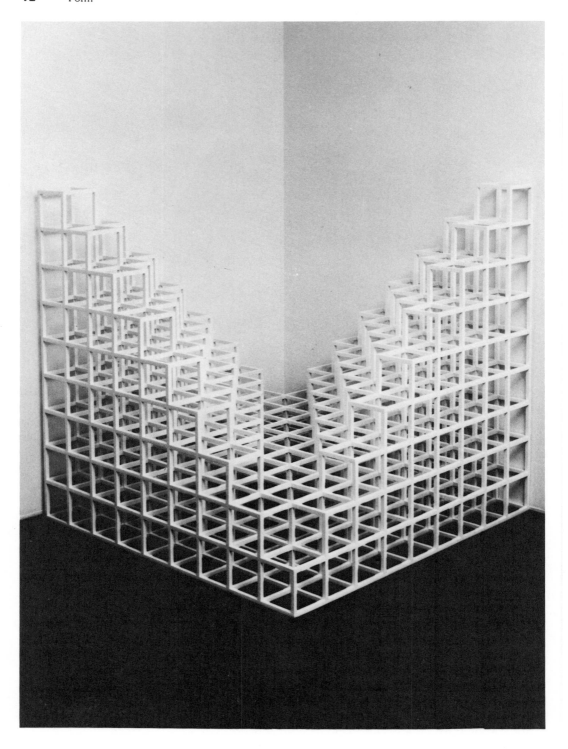

Figure 67. Sol Le Witt, **Corner Piece #4**, 1976–1977. White painted wood, 43¼″ × 43¼″ × 43¼″. (Courtesy, John Weber Gallery, New York.)

Figure 68. Louise Nevelson, **Canada Series III**, 1968. Plexiglas, 42½″ × 27″ × 7½″. (Courtesy, Pace Gallery, New York.)

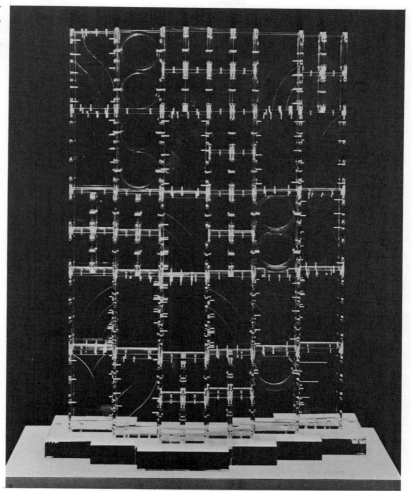

Plane. Plane is the surface area of a given or defined shape. All structural form has plane. The underlying principle is the change of direction on any given surface. Like mass and volume, plane cannot be isolated. Mass has surface; therefore, it has plane. Volume, though a negative form, is defined by elements which must have surface and, thus, plane. Line, while thin, not only defines plane but in reality is a plane itself. Texture and color, occurring mainly on surfaces, create planes. Planes may be flat or curved, concave or convex, occurring individually on one level or grouped with changes of direction (Figures 69 and 70). In this last instance, the outside edge, elevated or depressed, forms a plane or a cross contour as well. To illustrate this point, imagine a book, each page representing a plane. When the book is closed, we find many planes: the edges of the pages, the side or edge of the book. If one were to take these pages out of the binding and rearrange them, the possibilities for exploitation of plane become enormous and the relationships endless. The individual sheet may be scored, folded, rolled, crumpled, placed in relation to other sheets, cut, textured, or colored in infinite combinations. These possiblilities exist, however, only if we think of thin sheetlike material as the only type of plane. There are numerous other planes, some more subtle than others.

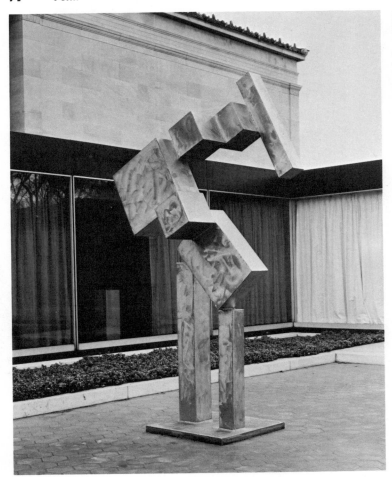

Figure 69. David Smith, **Cubi XVI**, 1963. Stainless steel, 11' × 5'. (Collection, Albright-Knox Art Gallery, Buffalo, New York. Gift of Seymour H. Knox. Photo, Sherwin Greenberg, McGranahan & May, Inc., Buffalo, New York.)

Possibly the greatest attribute of plane is its ability to establish and modify direction (Figures 71 and 72). The choice of material directly affects the strength of this direction but only through exploitation by the sculptor. As the sculptor controls the planes, so the direction is controlled (Figure 73). Direction is the implied force and movement of one or more surface areas. Another factor is introduced in the work of Donald Judd (Figure 74), where planal form appears to float and not only implies movement of form and plane but adds constantly shifting relationships. It is also possible to create the illusion of plane utilizing space. For example, if we were to take that same book in its binding and separate the pages for a specific distance, an imaginary plane is created in space between the pages and their edges. Many other explorations of plane are possible, and it may be well to suggest application through some of the following queries. Is a plane basically a two-dimensional form? Must many planes be utilized to create planes in three dimensions? Will the undulating plane not create this sensation, or does this enter into the realm of volume? Again, how does a transparent material affect plane? Does this confusion result in a distortion of plane? How can this distortion be exploited? What about the juxtaposition and disintegration of planes? Finally, how may a plane be placed in a context that employs its basic attributes?

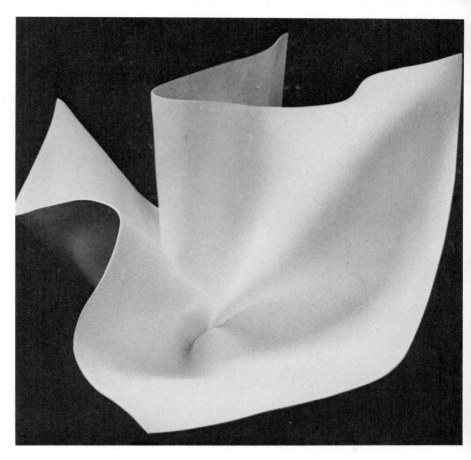

Figure 70. Jack Youngerman, **Orion**, 1975. Fiberglass and polyester resin, 53″ × 80″ × 58″. (Courtesy, The Pace Gallery, New York. Photo, Hans Namuth.)

Figure 71. Clement Meadmore, **Dervish**. Cor-ten steel, 15′ × 18′ × 15½′. (Courtesy, Hamilton Gallery of Contemporary Art, New York.)

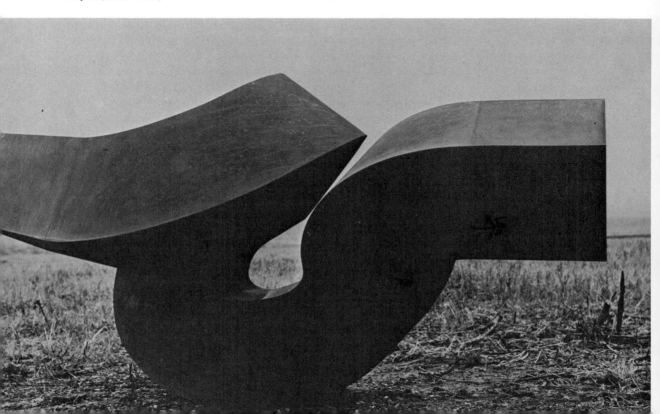

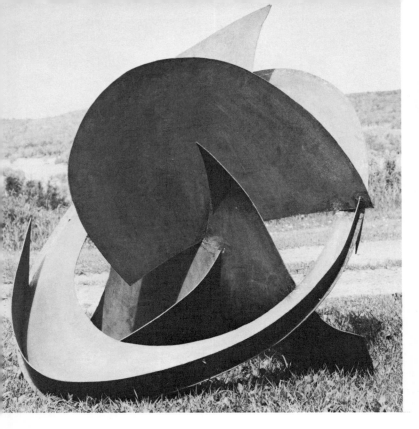

Figure 72. Herbert Ferber, **Marl II**, 1971. Cor-ten steel, 43″ × 45″ × 41″. (Courtesy, Andre Emmerich Gallery, New York.)

Figure 73. Charles Ginnever, **Daedalus**, 1975. Cor-ten steel, 10′ × 30′ × 21′. (Courtesy, Sculpture Now, Inc., New York.)

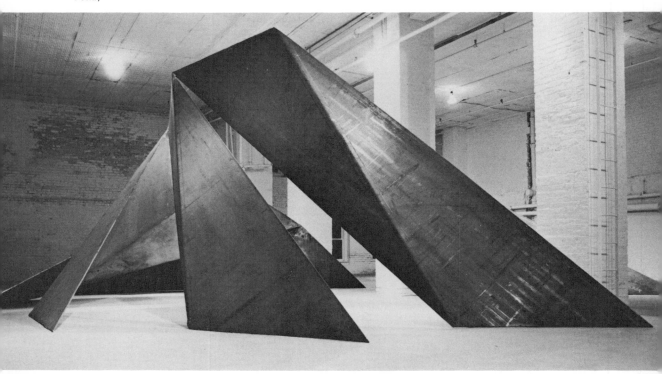

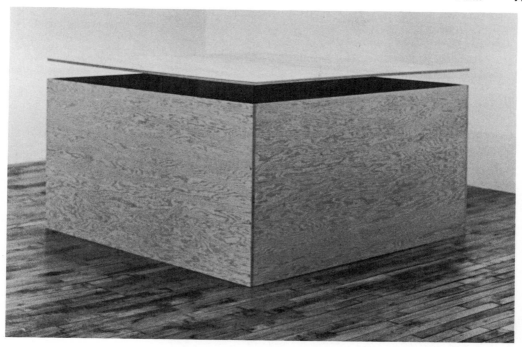

Figure 74. Donald Judd, **Untitled**, 1974–1976. No. 6 plywood, 60″ × 60″ × 36″. (Courtesy, Heiner Friedrich, Inc., New York.)

Line. Line is the edge of mass, the edge of contour, the edge of space that suggests the boundaries or limits of a shape or object but which in reality is nonexistent. Line, as the edge of mass, is directly akin to the other elements but has a greater illusion of isolation. We tend to see line for itself and not as a thin mass or a cylindrical plane with texture and color or enclosing a volume. Line is so strongly embedded in our two-dimensional sense of perception that it becomes quite difficult not to think of it in isolation. Treating line as a thin mass or round plane may oppose its very nature. Yet, it is equally important that line be utilized in the two-dimensional sense.

A good example of exploration of this concept is the early work of Richard Tuttle. Wires attached to a wall in a number of places are allowed to project out and cast shadows that create a two-dimensional linear pattern. Other linear patterns are drawn on the wall, creating an immediate contradiction and relationship between the actual line of the wire, the shadow, and the drawn line. The work goes beyond mere line and into the realms of dimension, concept, process, and perception.

Both two- and three-dimensional applications are valid, although the final importance lies in the more sculptural association. Certain materials actually take on a linear form, while others require the addition or subtraction of matter to create line. The use and intent of line is directly related to the selection of material and vice versa. Line concentrates the quality of movement and direction, while plane, mass, and volume tend to disperse these aspects. Line can be straight, curvilinear, or any combination of both (Figures 75, 76, and 77), giving the sculptor an infinite number of linear possibilities. Line can create a rhythm, a transition from one area to another, a concentration of interest, a tension between points, and, above all, it can establish distinct and abrupt limits.

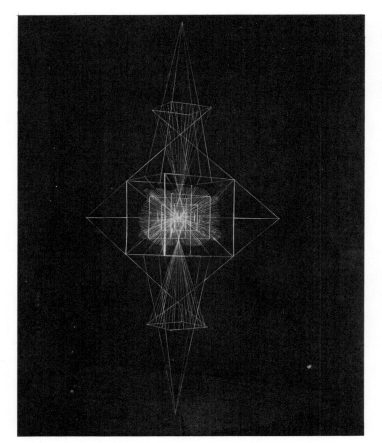

Figure 75. Richard Lippold, **Variation Number 7: Full Moon**, 1949–1950. Brass rods, nickelchromium, and stainless steel wire, 10′ H. (Collection, The Museum of Modern Art, New York. Mrs. Simon Guggenheim Fund.)

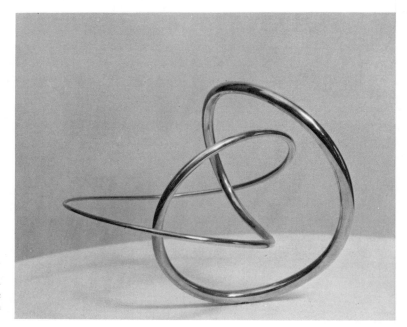

Figure 76. Jose de Rivera, **Construction #35**. Steel. (Collection, Joseph H. Hirschhorn, New York. Photo, The Solomon R. Guggenheim Museum, New York.)

Figure 77. Ibram Lassaw, **Kwan-non**, 1952. Welded bronze with silver, 6' H. (Collection, The Museum of Modern Art, New York. Katherine Cornell Fund.)

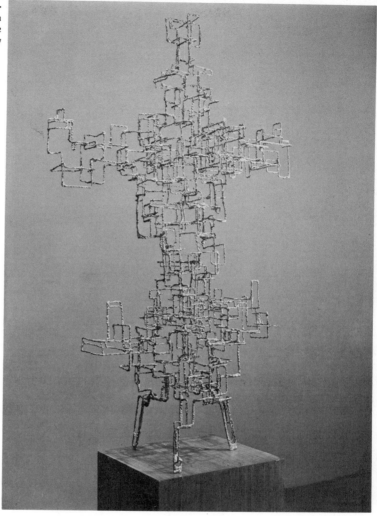

Is this all line is capable of? Cannot line create pattern (Figure 78)? A perceptual illusion (Figure 79)? Is it not possible, through repetition of a straight line to evolve a curved plane? But when does a line become mass? At what point does a line, because of its structure, cease to support its own weight? What three-dimensional sensations take place when actual movement occurs by striking or revolving a thin line of matter. Is this actual movement related to the visual sensation of movement, direction? How? Is line horizontal, vertical, diagonal? At what point does it become one or the other? These are but a few of the many aspects of line relevant to the sculptor.

Texture. Texture is the surface quality of matter. It is the manner in which the particles of specific substances are joined. There are two types of sensations that are caused by texture: actual and visual. Actual texture is realized by touch; the visual is implied by sight.

Of all the elements, texture is far more important than we would normally suppose. First, the surface quality, in affecting our senses, establishes the reality and existence of the form and, in so doing, creates a desire to handle and experience the surface (Figure 80). We have a

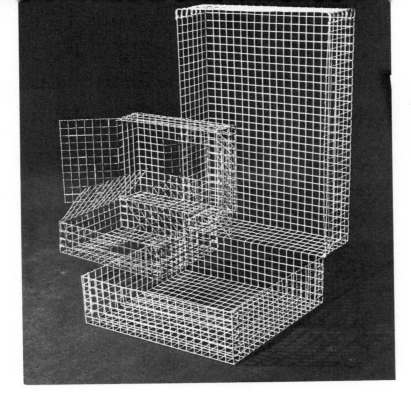

Figure 78. Lucas Samaras, **Chicken Wire Box No. 13**, 1972. Acrylic paint on chicken wire, 17¾″ × 16½″ × 12½″. (Courtesy, Pace Gallery, New York. Photo, Al Mozell, New York.)

Figure 79. John Duff, **Passage** (three views), 1976. Steel rod, 24″ × 36″ × 72″. (Courtesy, Willard Gallery, New York. Photo, Gwenn Thomas, New York.)

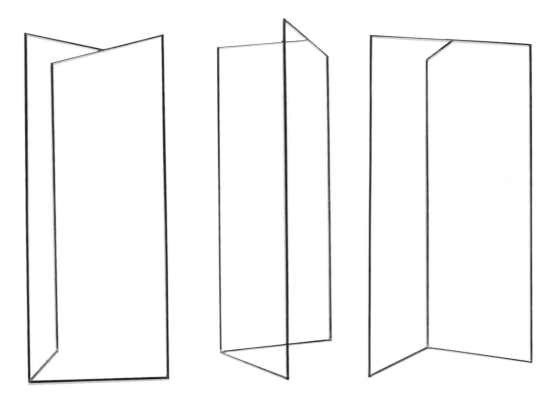

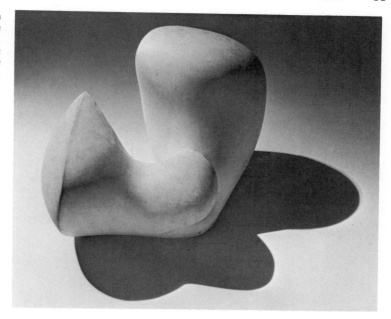

sensory reaction to actual texture. For example: is it rough, smooth, bumpy? This aspect is one of the strongest qualities that can and must be employed by the sculptor. For through the manipulation of this surface, the artist not only breathes life into a form but transmits these feelings and interpretations of surface to the viewer. Obviously, a visual sensation of surface is equally significant. Visual texture occurs in a more indirect manner. Our eyes perceive what our hands want to tell us. The major difference between the two is one of illusion; whereas our eyes are easily deceived, actual touch gives a greater measure of reality. It is most disheartening to visit many fine works in museums and not be allowed to touch them. Our visual perceptions must sustain us at such times.

Several questions arise about textures and their employment. Should the artist have full control over the surface? If this is true, will the form be more tight or objective? Is this undesirable? How much does a material dictate the ultimate quality of texture? Is it possible to defy this inherent characteristic? At what price? What influence does the surface quality have on the distribution of lights and darks? Can this distribution serve to convey greater meaning? Is texture only a means of defining other elements? Why does texture often become superfluous? Is it because it is more readily associated with a two-dimensional surface? Each must find his or her own answers for every new reality created.

Color. Color, in the sculptural application, falls into three categories: the natural coloring of the material, the addition of color in the form of patina or actual pigment-coloration material to the matter, and the distribution of lights and darks or chiaroscuro (Figures 81, 82, and 83).

In the history of sculpture, color has always played a major role. At various times, the above applications fell in and out of general acceptance, but today all of these approaches are valid and widespread. So it should be. Any element, device, or tool that helps the artist intensify his expression is acceptable.

The natural color of the material, while important, should not dictate or govern form. The sculptor may assume that what is in a natural state is best left in this state. But certain materials, such as plaster, have a lifeless quality to begin with. Unless this is the specific quality the artist is trying for, isn't it wiser to alter this naturally dead appearance and enhance it with color if it serves to strengthen the work?

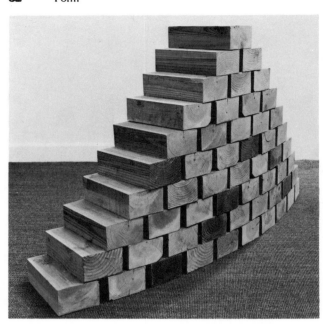

Figure 81. Jackie Ferrara, **Curved Pyramid**, 1974. Wood (4″ × 6″), 35″ × 60″ × 18″. (Courtesy, Max Protech Gallery, New York. Photo, Eeva-Inkeri, New York.)

Figure 82. Michael Gitlin, **Demarcation II**, 1976. Painted wood, 7′7″ × 14′. (Courtesy, O. K. Harris, Works of Art, **New York**. Photo, Eric Pollitzer, Hempstead, New York.)

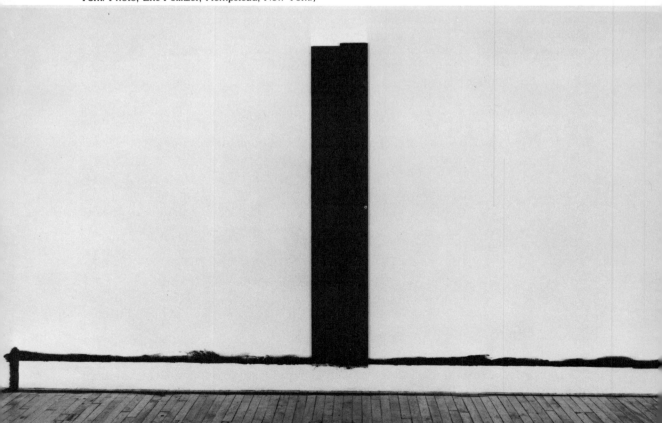

Figure 83. Jim Dine, **Portrait of Kitaj**, 1976. Bronze, 14½" H. (Courtesy, Pyramid Arts, Ltd., Tampa, Florida. Photo, A. Mirzaoff.)

This brings us to the second aspect of color: the addition of color by patina or pigment. Any addition of color, by any means, if it enhances the form and intensifies the expression, is justified. Polychromatic form has always been a tool in the artist's vocabulary and is experiencing a greater revival today. One difficulty in its use is that it becomes primarily a two-dimensional surface on a three-dimensional form. Exceptions to this can be seen in various technologically oriented sculptures such as Otto Piene's **Olympic Rainbow** (Figure 84) and Charles Ross's **Double Wedge** (Figure 85), where the color is inherent in the inflatable tube and prism forms. Another is the utilization of raw pigment as material in itself.

The distribution of lights and darks, or chiaroscuro, created by the manipulation of elements, is extremely important as coloration. As light sources change and fall on the work, the shifting patterns of light and dark continually alter the color within the work, and it creates its own hues and values. The position of the viewer in relation to this light source also serves to alter the coloration. Chiaroscuro serves not only as a coloring device but also as a means of defining and relating other elements within the object.

Should color be employed only as a means of defining a shape, area, or form? Or is it possible to defy and contradict underlying form through color? Will the limitation of the color range intensify the form? Should color assume only the actual colors of reality? Is not color its own reality? Finally, does color contribute to the essence of the reality that is created?

Three-dimensional Design and Systems of Order

From the preceding discussion of elements, it becomes quite clear that a certain order of organization exists within three dimensions. With a given set of factors, certain assumptions may be made. Of course, these assumptions are not dogma. On the contrary, it is quite

Figure 84. Otto Piene, **Olympic Rainbow**, 1972. Munich Olympics, inflatables. (Courtesy of the artist. Photo, Walt Seng, North Versailles, Pennsylvania.)

Figure 85. Charles Ross, **Double Wedge**, 1969. Prism, 50″ W × 100″ H × 24″ D. (Courtesy, John Weber Gallery, New York.)

impossible to determine any right order for any specific individual or sculpture. In contemporary sculpture, it is increasingly difficult to distinguish between three-dimensional order in the round, in relief, in combine painting, and shaped canvas in floor, wall, or environmental pieces, to say nothing of technological and recent dimensional experimentation. Those sculptures that have come down through the ages have often defied convention. The intuitive approach to sculptural form, design, and even content usually results in a more accurate expression of the sculptor's real intent than any contrived system of order. The end result may very well be ordered, but the creative spirit that led the artist usually is not.

Most artists sense and evolve rather than totally preconceive and execute. The sculptor allows the mind to conjure up images and explore ideas. As the sculptor works, the ideas are allowed to freely manifest themselves, and new forms and concepts are created that give substance to these thoughts. Of course, the sculptor does not always operate in the realm of the subconscious, although much of the conception of form occurs there; rather, it is critical that the artist be aware of the elements, their potentials and limitations, and also be attuned to other visual and natural phenomena. Balance, movement, proportion, transition, unity, opposition, distribution, variation, sound, light systems, process, and environment fall into this category. These precepts are used and misused as the need and occasion arise. The artist knows and feels that certain forms with certain weight and shape will balance others; that movement is more or less static, dynamic, or moveable with one element rather than another; that forms can be distributed and yet unified, be varied and in opposition, while still maintaining transition up, down, around, and into the piece. How does one know and feel these things? If the artist is attuned to the concept of dimension, the creating and shifting of form or its parts becomes instinctive. Experience of many forms, lively imagery, physical and conceptual relationships to establish new realities, perception of the whole in mental terms, and emotional saturation in the essence of forms, materials, and ideas direct the sculptor toward this instinct. But the artist cannot rely solely on instinct to evolve new realities, nor can he or she be governed by dogmatic systems of order. At the point when instinct reaches a conscious or intellectual level and can be controlled and exploited, then the form created or the concept exploited is real and unique and takes on added significance. At a given point the artist must integrate all of these factors and intellectualize specifically what ideas, concepts, and forms are being advanced.

Space

Sculpture is dependent on space. Without space, sculptural form would not exist. Without matter given form in space, the reality of the sculptural idea is not possible. The displacement of space by a new and intentional form by the artist creates a new reality: sculpture.

Environment and Context. Different principles of sculptural space organization have been promoted through the years by numerous individuals and groups. But no one principle or practice is right or wrong all the time. The artist stays flexible. While the rule of thumb is a natural order of space, the space organization is particular to the individual sculptor at a given moment. One does not approach space in a preconceived manner. Often, space defies convention. By exploiting space, new sculptural realities are evolved in direct accord with the larger environment.

The world is one great big environmental sculpture. We are influenced by matter, space, form, and content through sensory perception — particularly by touch, sight, and sound — toward an understanding of three-dimensional form. This is reality. The sculptor takes this environment and through selection and rejection, plus and minus, evolves an individual sculptural reality. The work, however, can never escape the relationship to this larger environment. Each sculptural piece, though it occupies and creates its own reality, is influenced

by its immediate surroundings. Those surroundings are in turn influenced by their surroundings, *ad infinitum*. The root of the tree is related to the tree, to the ground, to the atmosphere, and to the sun. So, too, form is dependent on matter and the elements of mass, volume, etc., as they relate to each other and to their individual spatial environment. At this point, it would be well to examine some of the specific workings of space.

Inner Space. One consideration of space lies at the very core of every work. If we call this inner space, it almost defines itself. Inner space may be defined as that area within the inner environment of the sculpture that exists in relation to the forms that separate it from exterior space (Figure 86). This might be loosely labeled as positive-negative space, which will be examined shortly, except that the meaning goes beyond this concept. Mass possesses a molecular structure whereby many particles make up a solid bulk. Space occurs in and around these particles. Is it possible for space to occur around other space? Is a fishing net made up of string or a series of holes? If we accept that such an inner space exists, is it possible to penetrate this space? Visually and in two dimensions it appears feasible, but in the round it becomes somewhat more complex. This aspect deserves closer examination.

One example of the sensation of inner space might be the effect of attending a planetarium. Here we are contained within a sculptural environment. Through illusion, we react to exterior and infinite space, and yet we are aware of the space in which we sit. It is as if we were in a space within space. A similar feeling must happen when man experiences weightlessness in the outer reaches of terrestrial space. Perhaps this feeling can be explained away as an effect on our gravitational equilibrium. However, certain inner sculptural space appears to bounce, to vibrate, and to live. This phenomenon sometimes occurs more obviously with the penetration of inner space. A work that is comprised of many small elements or parts will occasionally allow the eye not only into and around the spatial core of the work but through the piece itself

Figure 86. Robert Stackhouse, **Running Animals—Reindeer Way** (outer view), 1976. Wood, 144″ H × 66′ × 72″. (Courtesy, Sculpture Now, Inc., New York.)

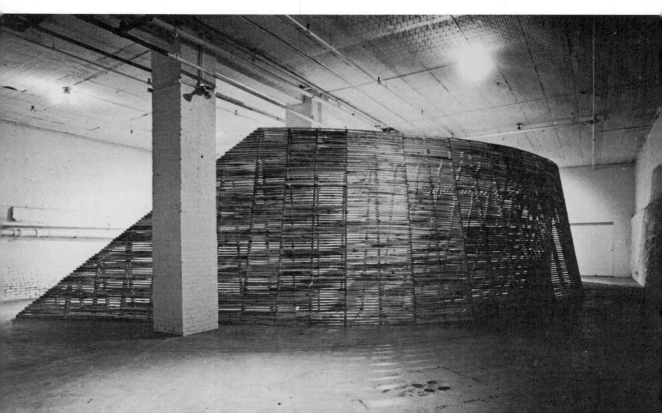

(Figure 87). As we look into a bush or shrub, our eyes sight the core, dwell on the inner space, and proceed on to the space of the exterior. To what degree are matter and form responsible for the action of inner space? Is this not probably caused by the interaction of positive and negative space? To what degree is negative space dependent on positive matter?

Positive-Negative Space. Positive space is that area of air mass that is occupied and displaced by matter that has been given form by the sculptor. Negative space is primarily the area of air mass that is not occupied by matter but has a direct proximity and influence on the appearance of form (Figure 88). Inner space is space itself made up of finite particles that exist independent of any visible reference. When matter pierces or penetrates space, negative space directly influences the form, while inner space is constantly changing. It is possible for both negative and inner space to contribute to form, and, at times, the two appear inseparable. Let us expand the example of the fishing net previously cited, only this time use ordinary wire screening. Does the screening define and enclose space or is the screen just a series of holes strung together? The space that is occupied by the wire could be called positive space. The space that is defined by the wire might be called negative, while the space or air that passes through the mesh and metal might be referred to as inner space. Negative space usually remains quite stable; inner space constantly changes; but both aspects are activated as the sculptural form in the round. An exception to the stability of negative space occurs when mass is pierced and a positive shape appears though it is still only space or a hole.

This brings us to the subject of control. It has been said that a certain amount of artistic control is required in all sculptural form, and this is essentially true in the exploration of sculptural space whether dealing with form or idea. With awareness, spatial relationships can be exploited. One tries to understand the causes but concentrates on experimenting with and appreciating the existence of spatial relationships.

Aggregate of Points. When a unity of points occurs, it may be called space. The creation of any reality of any form is dependent on the establishment of three dimensions in relation to space and time. This is to say that some definition of air mass with boundaries must be decided on and defined by the sculptor, who examines specific interests and sets arbitrary limits. In some instances, it may be inner space in conjunction with or in contrast to positive-negative space. It might be infinite or outer space, a more specific space, or any number of combinations of these. These limits may fluctuate continuously. One must be constantly aware of the changing relationships of spatial arrangements as form is explored. In sensibility, choice, and chance, this change should be intuitive and automatic. It evolves and is examined, retained, or discarded. Thus, an aggregate of spatial points is organized.

Extensions and Directions. Though the sculptor is concerned with the theoretical implications of space, the extension and direction of forms in space are of more implicit concern. How do different types of matter displace air? What spatial relationships occur with the alteration of matter? In what capacity is form dependent on space? On gravity? Can gravity be defied or at least extended? Does the direction of matter control certain types of space? Can the elements become the means for the organization of space? All of the above questions are important factors in the manipulation of space.

Matter, by its very nature, continually displaces air differently according to its quantity, shape, and general character. A log of wood creates a spatial penetration that is quite different from a plank of the same material. Both of these forms are spatially unlike dense stone, thin metal, plastic clay, or sheet acrylic. Having unique molecular structure, each material automatically evolves distinctive space. Although carved wood and stone remain massive, they have the tendency to utilize a subtle, flowing space. By nature of its plasticity, clay has a limit to which it can be stretched. Greater compositional latitude, surface treatments, and use of varying spatial relationships are possible with clay and other modeling materials. This is also

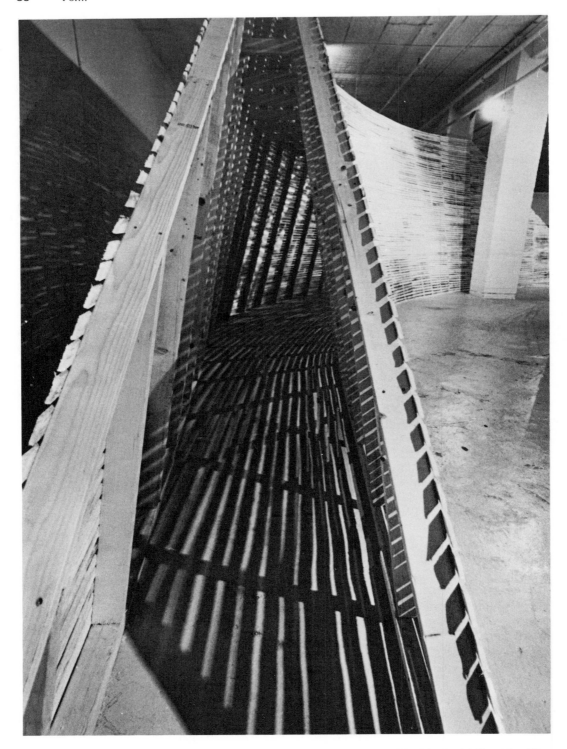

Figure 87. Robert Stackhouse, **Running Animals—Reindeer Way** (inner view), 1976. Wood, 144″ H × 66′ × 72″. (Courtesy, Sculpture Now, Inc., New York.)

Figure 88. Nancy Graves, **Variability and Repetition of Various Forms**, 1971. Steel, oil, latex, gauze, marble dust, and acrylic. (Collection, National Gallery at Ottawa, Canada. Courtesy of the artist. Photo, Janie C. Lee Gallery, Dallas, Texas.)

true of forms cast or constructed in metal and other castable material. Transparent acrylic sheet can visually defy space and thereby create new and unique spatial considerations. It appears that in the constructive approach to sculpture, either with scrap, found, new technological materials, or combined media, greater potentiality of space exploration takes place. The very manner in which these forms and space are altered and placed in new contexts may explain the popularity of this technique in this century. The alteration of matter increases the extent of spatial relationships.

Addition or subtraction of matter makes possible a rearrangement of form and space. The first gouge or cut into a material immediately establishes a space, and with each additional removal of matter this space relationship changes. In the additive technique, one form exists in relation to the next and so on toward an entity. With the addition of every form, new penetration into space happens. How are these forms dependent on space? Form is dependent on matter in space; without space, matter would not exist. Without defined matter present in space, the reality of the sculptural idea cannot exist. More specifically, form and even idea are dependent on space for limitation of their boundaries.

Gravity limits form, to be sure, but mainly in a physical way. Visually, it is possible to create the illusion of defiance of gravitational pull (Figures 89, 90, and 91). An elevated mass, a suspended mobile form, reflective material, and kinetic extensions in space all give the sensation of floating and, to a certain degree, gravitational pull. As we will see later on in the book, some of the new technology and the use of electromagnetic fields are making actual defiance of gravity applicable for the sculptor. However, a similar feeling of weightlessness takes place when specific forms go in certain directions. Horizontal, vertical, and diagonal forms all bear differently on space. Any matter in any form will cause a distinct positioning to one of these directions. We are accustomed to certain forms being in a usual direction, and, when a contradiction occurs, the sensation is one of incredibility. For example, a utility pole is

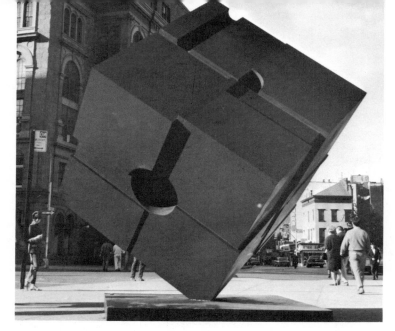

Figure 89. Bernard Rosenthal, **Alamo**. (Courtesy, M. Knoedler and Co., New York.)

Figure 90. Bernard Kirschenbaum, **298 Circles**, 1977. Painted Upson board, steel weights, stainless cable, 30 ½″ × ⅜″ each. (Courtesy, Sculpture Now, Inc., New York.)

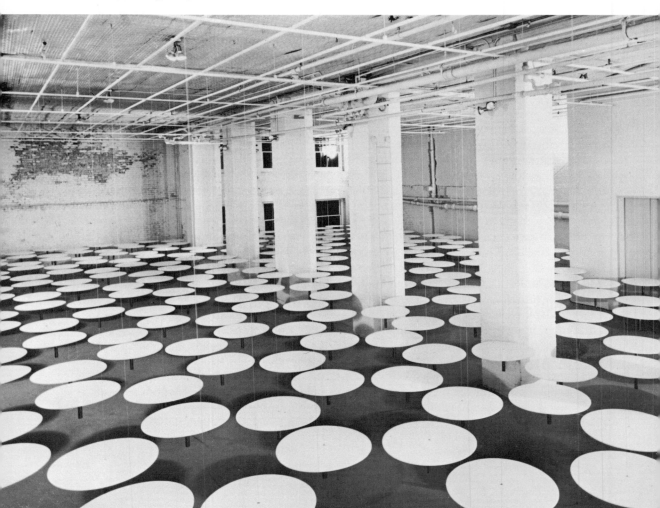

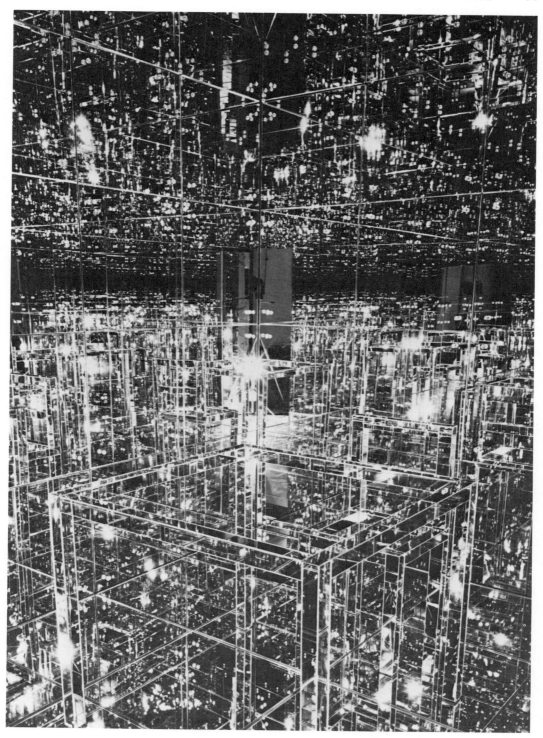

Figure 91. Lucas Samaras, **Mirrored Room**, 1966. Mirrors, 8′ × 8′. (Courtesy, Albright-Knox Art Gallery, Buffalo, New York. Gift of Seymour H. Knox. Photo, Greenberg-May, Buffalo, New York.)

oriented to the vertical; when this shaft is cut in half, it hangs in space held up by the previously horizontal lines which now become diagonal under the weight of the severed pole, which in turn assumes new space and gravitational exertion. A helicopter or V TOL craft that by general appearances looks like an airplane has unique movements that differ from those of the conventional aircraft. It hovers, ascends, and descends vertically. It is possible for the sculptor to approximate these and other illusions of space and gravity by concept, placement, balance, and weight. The manipulation of the elements becomes the means for the individual's organization of space as matter penetrates and is affected by space. Without this order, conscious or intuitive, the nature of gravity at once defeats us. In the realm of space lies the greatest understanding and challenge of sculptural form. It is with the extensions and directions of space and environment that most twentieth-century sculpture has been concerned, and the future seems to indicate an intensification of this pursuit.

Time

Time, as it applies to the sculptural idea, has many implications. If we assume that time is a form of measure or an interval in history, then it becomes fairly simple by means of a chronological time line to place a sculptural work and its creator in their proper period; but this by itself does not satisfy the artist's concern about time. The relationship of a new sculptural reality to this time line reveals the following: (1) the period of thought and time of execution, (2) the point when the form is finalized, (3) the time of comprehension by the viewer, and (4) space-time. In this regard, item 1 becomes the interval of measure, item 2 the occurrence, item 3 the unity of the work to the viewer and its relation to time, and item 4 the movement and existence in time.

Interval of Measure. The length of time for thought to manifest itself varies with the individual and the idea. In some instances, it happens within a brief moment; in others, it takes a considerable time developing. Time is the essence of thought. Ideas need time to gestate, to be born, and to mature. Though our thought mechanisms are centered in our brains, emotional ideas are also perceived from our senses. The human body is a storehouse of information. As we experience organic and inorganic form, the recording of these sensations is being made in our mind's eye. At any given time, as the need arises, these recorded ideas and thoughts reach consciousness and activate the artist to create form. When this level of awareness occurs, the actual period of execution begins. This is also an interval of time and of measure back to the artist's first conception of the idea and forward to the finalized form.

Occurrence. A totality of form and of sculptural reality occurs at some point in every sculpture. This varies greatly from artist to artist and from piece to piece, but at some point a work becomes an entity unto itself. For some individuals, conveying seventy-five percent of the essence of the idea is sufficient; for others the percentage is higher or lower. It is never totally consistent but usually falls within a close range. This is the artist's limit and prerogative. The viewer accepts the work totally. This is not meant to suggest that the sculptor is not giving entirely but, rather, that at some point in the manipulation and execution of the work the idea is given form. When this level is reached, the artist stops. The total form evolves from mind and body, and the artist alone determines when it is finished.

Relation of the Work and the Viewer to Time. As we have seen, a thought develops, evolves, is given form, and at some point is finished. The next general concern is the relation of the work and its comprehension by the viewer to time. This raises some immediate questions. Is it important that a work have a viewer? Is not a work its own reality? Must it be viewed and comprehended? While a work is truly its own reality and is conceived and viewed by the sculptor, it also possesses a force of communication. The nature of this comunication will be discussed in the next chapter, Content. Assuming that this commmunication is a valid

and necessary part of sculpture, how does it relate to the viewer and time? The amount of time between encounter of the work and realization of the communicative purpose is different with each viewer. When the viewer understands even the smallest part of the communciative purpose, the person has united with the past, present, and future time of the work and the message. The viewer has then reached an understanding of movement and existence in time between the individual, the work, and, to some degree, the artist.

Movement and Existence in Time. Sculpture is created in space and exists in relation to the passage of time (Figure 92). (In Figure 92, the path of the sun burned its pattern through a high-powered lens onto these panels. This occurred over a period of one year.) Time is dependent on movement. The reality of sculpture is dependent on time and the movement thereof. This is not actual movement, although, as in the case of mobile or kinetic sculpture, this is sometimes so; rather, it is implied or indirect movement between thought and reality, conception and execution. As time moves, the sculptor continually alters the reality of forms just as the artist is altered. The artist sees and interprets forms differently with the passage of each moment, hour, or day. As time elapses, significant forms and ideas are profitably selected, rejected, and evolved.

TECHNIQUE

Technique is usually interpreted as the means employed by the sculptor to achieve an end — the creation of a sculptural reality. Generally, when technique becomes an end in itself, it is reduced to showmanship. Of course, showmanship may be valid in certain instances when an idea seems best conveyed only through extensive concentration on technique. The reverse

Figure 92. Charles Ross, **Sunlight Convergence/Solar Burn** (installation view), 1972. Wood, 366 boards, 12″ × 60″ each. (Courtesy, John Weber Gallery, New York.)

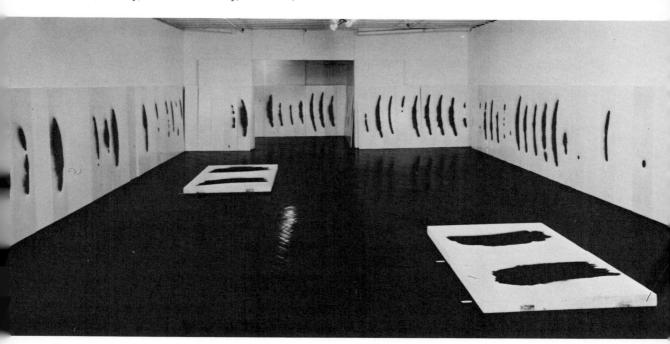

is also true; the technique may be promoted through idea. Craftsmanship, on the one hand, and total disregard for technique, on the other, are extreme ends of a wide spectrum that contains many combinations and degrees of technique. An artist must be able to conceive an idea and understand, utilize, and control the means to evolve that idea into form.

Methods Employed

As was previously stated under manipulation of matter, the *how* of sculpture is primarily concerned with the manipulation and control of materials, body rhythms, the direct and indirect manner of working, the plus and minus factor, and the exploitation of matter through technique. The concern here is directed toward a partial listing of possibilities for technique exploration. No attempt has been made here to present the intricate workings of each medium. General technique information may be found in the books listed in the bibliography. It is the intent of this section to suggest experiments that may serve as a point of departure, rather than show the reader how.

Possibilities for Exploration. Combine materials of similar substance but different qualities, e.g., steel and brass.

Combine materials of dissimilar substances and qualities, e.g., wood and cement, aluminum and plastic, oil and water, twine and stone, liquid and solid, actual and illusionary perception.

Add extraneous matter to the original matter.

Defy the nature and substance of the material by imposing techniques, concepts, systems, and situations to which it does not readily respond, e.g., opening up media that normally resist spatial treatment; for example, dense stone and wood.

Stretch or defy the gravitational limits of the material by elevation, suspension, composition, or technology.

Join forms through an interlocking of self-supporting devices by tension or compression. Use similar or dissimilar matter.

Leave parts detached for the viewer to arrange and manipulate.

Expose the armature of mechanizations as a supporting, compositional, or aesthetic device.

Construct by joining with glues, nails, screws, rivets, string, wire, etc., in unorthodox combinations.

Apply joining material, filler, and coating materials, etc., as ends in themselves.

In the case of found or scrap objects, incorporate the surface qualities, i.e., paint, images, etc., as they are into the sculptural arrangement.

Consider the introduction of actual movement, sound, and other sensory sensations, e.g., mobile, kinetic, optical sensations, within the piece.

Color through the addition of stains, chemicals, paints, patinas, etc., in contradiction to the form it coats.

Juxtapose a two-dimensional image directly on the three-dimensional form.

Utilize new technological materials and methods, concepts, and ideas as sculptural devices in themselves and in relation to all of the preceding possibilities for exploration and one's own imagery.

Method and Matter

Method leads to a definition of form and eventually to a definition of content. In many instances, the method employed is directly determined by the matter itself, mainly through its plasticity (its willingness to yield to formation). Certain materials resist the sculptor. But with the many powerful tools available today, all material can be altered. Yet some matter requires

the sculptor to devise unorthodox techniques. The artist eventually overcomes the material to arrive at a workable technique. For example, stone has traditionally been carved. It is in the nature of stone, marble, and granite, for example, that large massive forms can be evolved only by taking away. The contemporary sculptor, however, desiring to break from tradition, sees the possibilities of using stone in an additive manner. Methods are devised that make this feasible. These are evaluated, and the one that best answers the problem by overcoming the nature of matter is selected. The extremely strong epoxy resin glues available today make it possible to join smaller pieces of stone together. But even without modern technology, stone can be made to bend to the additive process by attaching rope, wires, or dowels. One could combine stone with other matter by shaping wood, metal, or plastic in such a manner that the stone can be added to it and encased or interlocked enough to remain secure.

In all of these cases, the sculptor has had to find a means of combining method with matter to evolve form. Traditionally, the various techniques of shaping form were almost automatically adapted to matter. Method for centuries was static. Stone and wood were carved, clay was modeled, fired, or cast, and metal was cast. But this is certainly not true today. The sculptors of this century have at their disposal more knowledge, technique, and equipment than in any previous civilization. It is not only constantly changing and improving but freeing the sculptor from mundane labors and allowing more time for the conception of new works, concepts, and ideas. This will be discussed more fully in Chapter 7, The New Technology and Beyond.

However, when primitive people desired to shape a three-dimensional object with nothing but the material and the idea at hand, they had to devise tools and methods of working with the materials before any form could start to emerge. The contemporary sculptor, even with the knowledge of the past and the methods of today, has a similar exploratory approach to technique and matter. Indeed, it is necessary to research the ways of uniquely shaping and projecting ideas of form and, in many instances, to devise new techniques to solve the problem. In all ages, sculptors have successfully combined method and technique with matter in their desire to evolve new forms. Method and technique must readily adapt to change as matter demands and the form and idea dictate. This, then, leads us to the study of technique.

Evolution and Exploitation of Technique

As we have seen in the previous section, technique is adapted as the need arises. Whether by conventional or newly devised means, technique evolves and is exploited by immediate response to the qualities of the material. Through constant examination and testing, the sculptor soon learns what a specific substance or concept can and cannot do. By evolving different combinations of technique the artist begins to understand the nature of the material and its relation to the idea. This understanding is a prerequisite to the creation and exploration of form and idea.

To examine the evolution and exploitation of technique, let us use the example of a metal sculptor, who is aware that metal can be melted and cast, welded, brazed, riveted, screwed, bolted, blasted, cut, colored, forged, and combined. The substance and peculiarities of the specific metal are known—the strength, surface qualities, and the life or essence that it emits. What is not known and must be devised are the combinations and relationships of these techniques and others to the idea that is trying to be expressed and given form.

Should this shape be welded to this one, or would it be better to braze and introduce different color and metal? Does the bead of the joint distract from the plane of the metal or should it be ground down and blended in to obscure it? Is it not a worthy textural addition? How does the surface of the metal relate to this textural addition and vice versa? What effect

does cutting by a torch, as opposed to a more precise technique such as cutting with a saw, have on the outline of the shape, and is one more in keeping with the form and the idea? When the metal is warped by excessive heat, does it alter the definition of the form? If this shape is added, will it be too heavy to support? How could it be added and be in better balance? Does color become a consideration? Is it possible to use the material as material, as placement, or as concept within an environment, or as an extension of information? These and many other questions enter and run through the sculptor's mind as a combination of techniques are developed, related, and employed to create a new sculptural reality. The application of technique varies from material to material and sculptor to idea and it must be fluid and changing rather than dogmatic. It is this selection, rejection, and exploitation of technique that allows the sculptor to evolve matter into form.

Drawing as Reference

Drawing serves the sculptor by creating a two-dimensional illusion of a three-dimensional reality. It serves to clarify the work both in isolation and in an environment and as process and concept. Of course, preliminary drawings are not absolutely necessary before beginning work; on the contrary, many drawings are made while the work is in progress, after the work is completed for further exploration, or in some cases not at all. When no drawings are produced, a visual two- to three-dimensional association takes place in the mind of the sculptor and is a form of mental drawing. Drawing is a means of distilling ideas and concepts and saves considerable energy and time in the execution of the actual work.

In a very broad sense, our world is comprised of a visual two-dimensional surface overlaid on an actual three-dimensional object. Most of our manufactured world fits this description and, in a much more subtle way, so does the natural world. Think of any synthetic object and one from the natural world and compare and contrast the surface quality with the actual form of the objects. While the two are distinct forms, they are nonetheless related. Surface is not necessarily form. A similar relationship exists between a two-dimensional drawing and the three-dimensional sculpture. To stretch a point, is not the paper a dimensional plane in itself? Is not drawing with pencil on paper in reality graphite (matter) applied to this thin planal mass (also matter)? To stretch the point even further, is this not a form of extremely low relief sculpture?

The purpose here is to establish that drawing enters into the realm of technique as a means of visual note-taking, of isolation of a particular view, area, or surface, as a device to explore numerous variations of form quickly and easily, and as a device of concept and process by and for itself. In some instances, the sculptor utilizes a three-dimensional form of drawing, a maquette, or model, in clay, metal, wood, plastic, etc. Approached in this manner, drawing does not hinder spontaneity but, instead, serves to focus and channel this quality toward the work.

THE INDIVIDUAL SCULPTOR

Relation to Matter

In this section, we are concerned with the configuration of form as it relates to matter, the intrinsic and extrinsic character of the work, the style-manner of the artist, and the arrangment of content. It should be clear at this point that form is dependent on matter and matter on form. The two are inseparable. The sculptor must dominate matter by imposing strength of will on it, yet, to some extent, must be governed by the matter. The artist shapes, molds, joins, carves, pushes, and pulls matter according to personal imagery and ideas and the nature of

the matter. This external force is exercised on the inner feeling of the medium and leads toward a unique arrangement of meaning. Thus, again, we have matter, form, and content: *The Sculptural Idea.*

Intrinsic and Extrinsic Character

All matter has internal and external qualities that make it individually different from all other matter. Surface qualities are not the only peculiarities that exist, for each material transmits an inner feeling as well. This inherent essence, this nature, is the intrinsic character of the material. The warmth and subtlety of the grain of wood communicates specific traits distinct from stone, clay, metal, or plastic. Any material has its own internal, external, and intrinsic composition. The sculptor cannot deny the existence of this intrinsic composition. When the sculptor works matter, this essence is heightened or limited. One cannot deny its existence, only control and direct it. This control and direction of matter is extrinsic. This is not a surface quality but is distinctly outside matter and is produced by the artist's will. It is the reality that has been given to the work by the combination of matter, technique, and the imagery of the artist. The style-manner of sculpture is the extrinsic character peculiar to an individual's mode of expression.

Style-Manner

Each person sees in an individual way. Each sees two- and three-dimensionally, subjectively, and objectively, in small and in large areas, horizontally, vertically, and diagonally. Preferences among these traits as well as for materials, technique, imagery, and documentation account for individual style-manner.

Our eyes are oriented to two-dimensional appearances and to see objects by their boundaries. Realities, on the contrary, exist in three dimensions. People are not born with the ability to perceive depth. It is only after our eyesight develops and matures that we are capable of seeing three-dimensionally, and even then the tendency is to see shape rather than depth of form. To see three-dimensionally is not a universal gift, though with greater concentration of sight and the other senses, the depth of an object emerges. To sense this added dimension is one thing, to translate it into form is another. Once one's mind conceives an idea, that idea must be defined and oriented in space in three dimensions and documented. This ability is vital to the sculptor, for how one sees will determine how one will form.

By temperament and experience, individuals tend to be more subjective or objective. The subjective person tends to be more introspective, emotional, and personally biased, and this is usually reflected in the imagery and form (Figure 83). The objective person, on the other hand, seems to be impersonal, views things as external and detached, is concerned more with factual data, and usually interprets form by external means (Figure 85). Both types of individuals have made many contributions to the development of sculpture. Some sculptors utilize both subjective and objective forms in their creativity (Figure 66). While we may not be able to control this aspect of our personality, we can recognize this tendency and better understand the forms we evolve.

Another factor is perceiving in small or large areas. Some people see the world in small broken areas while others see it in large unified shapes. Conceiving a form in a single entity evokes a considerably different feeling from conceiving the many parts that make up a whole. Generally, these two qualities are mixed to form contrasting areas of excitement and calm. Like a symphony, the tone of the work may be calm and marked by an occasional agitation (Figure 93), or it may be continually agitated and interspersed with periods of calm (Figure 91). Again, combinations of the two are infinite, but sculptors usually gravitate toward one or

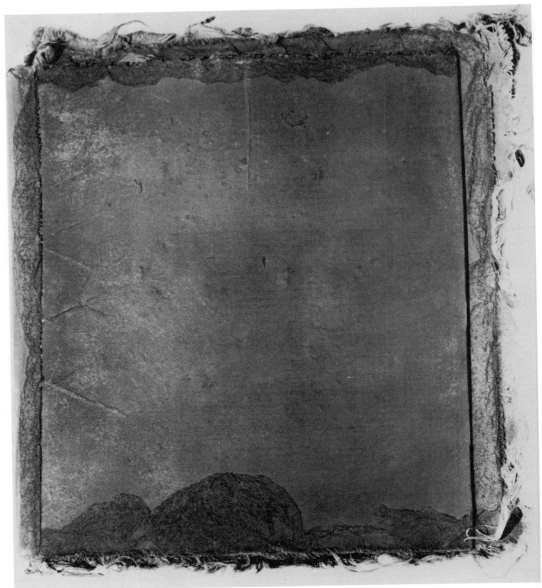

Figure 93. Michelle Stuart, **Jemez History Book**, 1975. Earth from Jemez, New Mexico, linen, rag paper, 13″ × 11″ × 1″. (Courtesy, Max Hutchinson Gallery, New York.)

the other. This also holds true in the more experimental forms, whereby the form, concept, system, etc., may be simple, complex, or combinations of both.

The last of these generalizations deals with the artist in the selection of horizontal, vertical, and diagonal preferences in the work. While we continually see these three directions in form and even idea, one direction tends to eventually dominate the artist's work. Again, this is not a rigid and never-changing device, but one that is communicated through the artist to the work. The Gothic cathedrals convey quite a different attitude from the prairie houses of Frank Lloyd

Wright. The verticality of a Giacometti is different from the reclining figures of Henry Moore. The horizontal qualities of the wrappings and curtains of Christo (Figures 37 and 128) are opposed to the ascension of the inflatables of Piene (Figures 84, 118, and 122).

Are these the only components that go into the makeup of style? Is it this manner of working that creates individual form? Does style-manner distinguish one work from another, one artist from another, one artist from all others? How does subject matter or lack of it determine style-manner? Obviously, broad classifications only begin to cause this thing called style-manner. Style-manner is a composite of the above factors, the manner of working material and form, the perception of organic and inorganic forms as they relate to three dimensions, the imagery and interpretation of the artist, and the intent of the work itself. Subject matter, or lack of it, is only an appendage to style-manner. Some sculptors work with a recurrent subject matter that becomes a theme throughout their work. Although this establishes a certain association between the artist and the work, the significance of style-manner lies in the interpretation of the subject through form and not entirely on the subject matter. What about recent antiart forms that deny the object and promote anonymity? Even in these more experimental forms, an individual style-manner of concern, concepts, involvements, and documentation appears to manifest a consistency.

Each must find a specific way; having reached an understanding of oneself in relation to this world, the individual must explore and exploit it. This is not to say that one must then be restricted to one's own truths and never venture to the opposites and combinations within and outside of this sphere. By no means would this be wise. To remain with a safe or proven type of form with habitual reaction patterns and never dare to venture outward can lead only to a sterile style-manner. The sculptor pursues form as ideas are pursued, with an understanding of these innate factors and with an anticipation of evolving new sculptural realities that uniquely reflect the artist's world.

Arrangement and Relation of Form to Content

When the sculptor arrives at this point in understanding form, it is the beginning of relating and arranging form to meaning, to sculptural ideas, and to content. Arrangement of form directly causes and presents the essential nature of the three-dimensional idea or ideas in an unprecedented manner. The sculptor assumes the role of the intermediary between that which is matter and that which is meaning and, in so doing, creates a spark in a previously lifeless form. This spark can be found in all sculptural work of quality, ancient or *avant-garde*. This ingredient can be referred to as a transitional or bridge factor. This factor serves as the relationship between specific forms and parts within the piece; it unifies the work to the viewer and back to the work. Content is now part of the sculptural reality.

6

Content

The Meaning of Sculpture

Content, in the broad sense, is a complex term with many facets. In the traditional sense, matter plus form equals sculptural content. Recent dimensional experimentation somewhat altered this definition when the object was eliminated as central to the basis of sculpture. However, a great many sculptors still maintain the use of material, technique, form, and even content in the method of concept, statement, message, information, process, or situation. The sculptor still exercises will over material, form, and idea and communicates some meaning and reaction through sculptural realities.

MATTER, FORM, AND CONTENT

Sculpture begins with substance and idea. When given form by the sculptor, the idea evolves and transmits an essence. This primary quality cannot be readily defined. In one case, it appears as specific subject matter, in another as nonobjective form. In both of these and other instances, the form of the matter or essence of the dimensional involvement translates a central idea to the viewer or participant. It would be well to examine this more closely. A stuffed bird creates an extremely close similarity to reality, and, in fact, once was the real live animal. By its appearance, it might suggest a movement of flight, but in its present state is actually a lifeless reproduction of reality. The airplane is a closely associated object, but here the manufactured functionality outweighs to a degree any sculptural form it might possess, and, yet, it duplicates the flight of the bird. Lastly, the example of a sculptural realization of flight can be found in Brancusi's **Bird in Space** (Figure 25). Here the very essence of soaring flight is conveyed, not through feathers or motors, but by sheer material and form. A sculptural reality and content are present. Even the more conceptual pieces utilize matter, form, and content.

Relating to the bird analogy above is the **Rooster, Bed, Lying Piece** by Bill Beckley, which consists of a platform cage suspended between two columns with a bed on the floor underneath. Anyone in the gallery could see the rooster, but from a reclining positon on the bed, the rooster was out of sight. His presence was reaffirmed through the various sounds he made overhead. The piece "is concerned with the relationship between sounds or activities and what is seen, and both are dependent on the decision of the bird to go to a certain place or to produce a sound, and the decision of the visitor to use the apparatus presented." Certainly, matter in the nature of the chicken, the cage, and the bed is present. The artist, through manipulation of these materials, has evolved form. The degree of content, although varying with each individual, is present and conveys some meaning, however slight. The quality or significance of the work is not the issue here; the conveyance of idea, thought, action, and meaning is. All of these qualities are directly dependent on the will of the sculptor, for content can be more individually oriented than matter or form.

THE WILL OF THE SCULPTOR

The will of the sculptor comes to bear on matter and form to control and communicate content. Artists form matter to reflect the sum of their influences, experiences, perceptions, and interpretations of the environment. One must use the entire being to forge matter into a separate entity that is sculpture. To do this, awareness of and response to external and internal drives and stimuli that affect forms and convey individual meaning must be sharpened. This creates an attitude or style-manner that is unique and can never be duplicated in exactly the same way, time, and place. This is the ultimate truth of creation and the point where many conceptualists and other experimental artists part company with the traditionalists. Anonymity is often a byword of the new forms. Mass participation and the attitude that "everyone is an artist" is not justified with mere activity, to say nothing of the results. But then, if objects are not important, why are photographs, videotapes, exhibitions, and other forms of documentation so crucial and evident? Would not the accidental discovery of an earthwork, performance, conceptual, or other process form be heightened by complete anonymity? For most individuals, the complex character of creation is one of anguish. To penetrate into one's own emotions and sensations and into the inner depths of one's being and project this to the public sector is not an easy task, but gratification and ego building are derived from the understanding of self and the forms, meanings, and communications that evolve. Content can be joyous, satirical, conceptual, or humorous, etc., but the actual means of bringing these qualities out are meditative and intense. Whatever the mode of expression, it is possible to achieve significant content only after the exercise of the sculptor's will on the material, form, and idea.

COMMUNICATION OF MEANING

Meaning does not necessarily imply surface attributes or shallow thought or idea. Stated simply, meaning connotes the ability of the sculptural form to be its own reality that speaks for itself to announce its presence to the viewer in a vital and lasting manner. To whom does the sculptor speak? To oneself, a selected few, to the masses, or to the sculptural reality itself? Or does the artist create because of opposition to all of these things? Quite obviously, each work will vary in audience, purpose, and response and, therefore, must remain open to individual interpretations. In many instances, the sculptor may incorporate any and all of these considerations. Whatever the individual choice or choices, pursuit of these beliefs with total

commitment is required until such time as experiences and sense of forms dictate otherwise; only after concentrated examination and application does the will of the sculptor manifest itself. Does a choice really exist? If one is committed to the demise of the object as sculpture and the collection and exhibition and market system of the art world, should the artist patronize it by even showing photographs, proposals, and other documentation of involvements? Half a loaf may be subterfuge.

What effect do intuition and the subconscious have on the content a sculptor gives to a work? Although this question is unanswerable, it is possible that the subliminal factor greatly influences the artist in any meaning that is instilled in the objects or pursuits. Certainly, the more recent forms are dependent on the cerebral thought processes. Further, because humans are prone to introspective thought, certain forms take on universal meaning; for example, the collective unconscious of "race," e.g., Henry Moore's "totem forms." The disappearance of process in contemporary society and the installment of "instant everything" in its place has also become an introspective annoyance to the artist. The sculptor cannot escape the ramifications of intuition and the subconscious, for, when coupled with intentional, intellectual, conscious thought and the three-dimensional reality of sculpture, it can only serve to clarify and communicate more forcefully meaning and essence.

THE RELATION OF SCULPTURAL REALITY TO CONTENT

The sculptor is primarily concerned with taking an idea, selecting matter, giving it form, and, through content, creating a sculptural reality. Matter, form, and content are inseparable in the establishment of this sculptural reality. They may have varying emphasis, but they are never absent. Without these factors, one might engage in communication, language, or thought transfer, but these activities by themselves are questionable as sculpture. The mere fact that a sculptor thinks and exists is matter with distinctive form, and unless the projection and involvement with dimensional form and ideas assume some tangibility of form or documentation of the extension of the idea, content is absent. But what exactly is content? Is it only ideas, thoughts, subject matter—or a combination of all of these? Though content is or can be all of these, it is also much more. It is the visionary sense of the artist, the quantity and quality of form and matter, the freedom to pursue and express change, and, above all, the spirit of the artist transcribed through the work.

In most instances, content is related to the subject matter that is being dealt with. This subject matter may be a realistic form (Figure 94), a banal statement (Figure 95), an abstract thought, a nonobjective expression of form (Figure 96), a conceptual approach, a process concern, body art, environmental alteration and exploration, or any of a host of other hybrid combinations. In the more representational forms, content may be more clear but not necessarily more profound. The selection of the subject matter and the application of content to this concern is dependent on the artist's vision, and that person alone makes the initial choice. It is this visionary sense of the artist that determines interpretations of materials, subject matter, and form, and consequently the meanings thereof. It is a continual focus on generalizations many steps beyond the specific and ordinary.

The sculptor's imagery depends on this ability to sense, discover, and change. With the development of an individual imagery, it is possible to exploit matter, forms, and ideas, and to achieve subtle balances that promote the sculptor's particular expression regardless of direction. With the attainment of this level, the spirit and ideas of the sculptor are transcribed through the work to the viewer and back to the essence of the sculptural idea.

Matter, form, and content, the bases of the preceding three chapters, are the core of the sculptural idea. Regardless of the materials, direction, and intent of the sculptor, these **three**

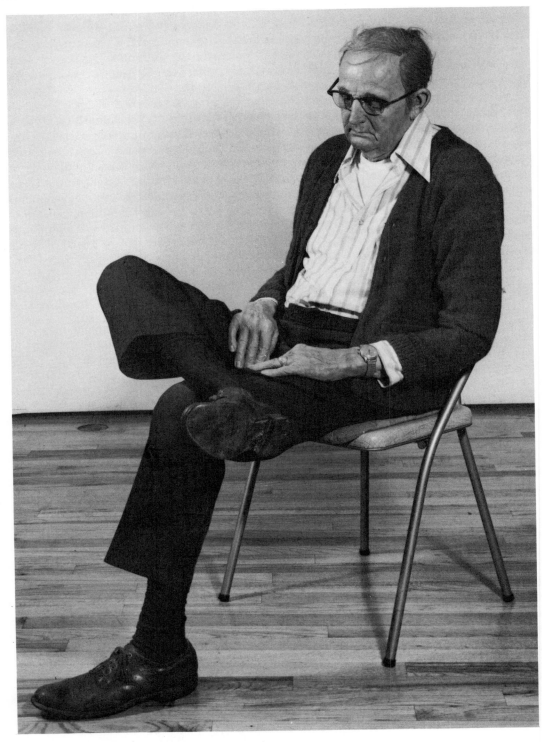

Figure 94. Duane Hanson, **Old Man Dozing**, 1976. Cast vinyl, polychromed in oils, life-size. (Collection, Frederick Wiseman. Courtesy, O. K. Harris, Works of Art, New York. Photo, Eric Pollitzer, Hempstead, New York.)

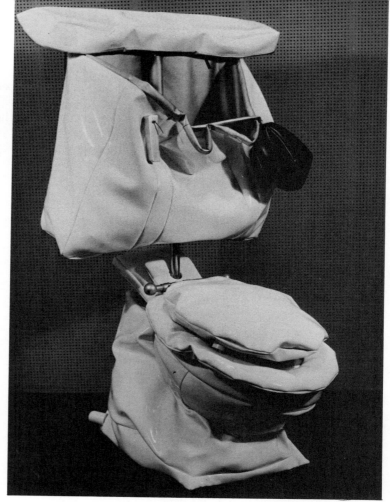

Figure 95. Claes Oldenburg, **Soft Toilet**, 1966. Vinyl, Plexiglas, kapok, 55″ × 28″ × 33″. (Collection, Mr. and Mrs. Victor Ganz, New York. Courtesy, Sidney Janis Gallery, New York. Photo, Geoffrey Clements, New York.)

Figure 96. Ronald Bladen, **Raiko I**, 1973. Wood for steel, 20′ × 8′ × 53′. (Courtesy, Sculpture Now, Inc., New York.)

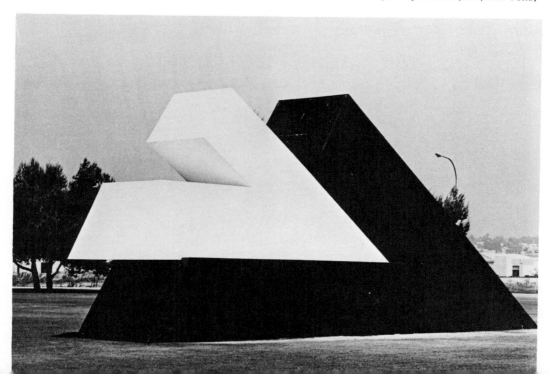

considerations seem to form the nucleus of all sculptural endeavors. When approached philosophically, they appear to be applicable to all sculpture, whether ancient or the most advanced ideas and forms of recent involvements in this century. It would be well at this point to discuss some of the ramifications of the new technology and some of the more extreme explorations of dimensional experience and to examine whether they give credence and reinforce matter, form, and content as the sculptural idea.

7

The New Technology and Beyond

Resources, Problems, and Potentials in Relation to the Sculptural Idea

Now as never before, sculptors are exploiting the new materials and techniques of industrial technology. Artists are not only intrigued by the characteristics of these new materials and processes but have broadened their vocabularies to include them in the approach to creating form and evolving new sculptural realities. In direct contrast to this new technological approach, many contemporary sculptors are denying scientific exploration as a means of sculptural involvement and are returning to the basal systems of the processes and to the activities of the human species and the environment. Still others are incorporating technology into conceptual, informational, and situational forms of communication.

The assimilation, reaction, rejection, acceptance, and interpretation of this new technology have created a chaotic situation in contemporary sculpture that has forced a reevaluation of the means of evolving sculptural form and dimensional expression. Diversity and controversy have always been central to the development and progress of the arts and society, and, though these upheavals are sometimes painful, they are necessary to challenge the thinking of the artist about the specific method of expression and its relation to contemporary civilization.

Crucial questions arise for the aspiring sculptor. Should the artist explore the new technology? Can the artist still pursue imagery within the conventional means of materials and techniques? Does technology replace the object with system? If so, how does this affect sculpture as a new reality and the role of the sculptor? If the process is important and not the end product, does not the sculptor in one sense become just a technician? Are technicians artists? Is the role of the sculptor in the twentieth century leaning more and more toward the anonymity of machined surfaces and forms, and, if so, does not technology promote this?

These and many other questions must be answered by the individual sculptor. The sculptor should examine individual directions and preferences to determine if they suggest or

need change. No one else can answer these questions; the artist alone must decide, but also must be cognizant of the forces that change and shape the environment in which they exist. The artist is rarely ahead of the times; the artist is more apt to be of the times, and the general populace lags behind. An obligation exists for the artist to examine society and the environment, and if, after this scrutiny, the artist chooses to reject it to pursue an individual vision, then this approach becomes individually valid.

The converse is also true. If a sculptor pursues technological gadgetry with little regard for individual vision, the artist is not being true to personal ideals. This can be a pitfall for many young sculptors. The technological advances and processes are intriguing, but without the human will and mind applied to them, they remain just that—technology. Perhaps this technological entity is the eventual role for artists of the next century—a bridge between the humanist and scientific cultures. But computers, electronic gear, chemicals, and other processes and materials simply do not bleed or feel. These are basic qualities of humanness that through the ages artists have ascribed to their sculptural expressions. It is unlikely that they will be abandoned now, although they most certainly will be redefined and utilized in ever-widening new realities.

This is especially evidenced in many of the new experimental forms. It is this author's belief that we have gone through a period of exploration with the surface wizardry of the contemporary technology. Presently what appears to be taking place is a refinement and a utilization of technology in all its forms as another means or a device towards a more comprehensive end and significant form. There seems to be less infatuation and intimidation of technology by the artist and a greater assimilation of these aspects into the work. This is certainly evidenced by the ability of individual artists to carry out large-scale and grandiose ideas and works without the limitations of the physical labor and restrictions.

Partly responsible for this involvement and the present reaction to technology may be the current emphasis for uniqueness on the part of many young sculptors and the art market, but, generally, the artistic production that responds to and explores these industrial materials, techniques, and new directions is sincere and valid. Sculptors in the twenty-to-forty age bracket have grown up in a post-World War II technological era, and it is only natural that they would incorporate, explore, and react to these processes in their three-dimensional expressions. However, these concerns are by no means limited to the young, for many of the older sculptors are finding the means to give form to ideas which, without modern technology, were not possible.

It is in this spirit that this chapter is written: not to imply that this is the direction that one should pursue or to list all kinds of technical information and firms to contact, but rather to discuss and project into the future on a philosophical and theoretical level the concept of technology as a force in sculpture. Again, the decision to engage and explore technology as a vehicle for sculptural form and ideas is an individual one and should be based on the artist's personality, sense of form, and awareness of the resources, problems, and potentials of any given approach. It is impossible to know exactly what the future holds in store for the direction of sculpture in the twenty-first century, but by examining the present complexities we can determine what is likely to evolve.

The three major areas of concern for the contemporary sculptor are resources, problems, and potentials.

RESOURCES AND PROBLEMS

Perhaps the most significant development in the exploration of the new technology by the artist was the formation of Experiments in Art and Technology (EAT), Incorporated, based in

New York City, with more than thirty-five chapters in the United States, Canada, and abroad. The main purpose of EAT is to assist the artist in the exploration of technological application and to establish a contact with a scientist or engineer who will collaborate with the artist in these pursuits. It also works to acquire industrial assistance to aid in this collaboration. The organization has received a broad base of support from many industrial corporations, government, and various trade-union groups and, although less visible today, seems well on its way to further exploration of new horizons in the environment of humanity. Many of these exciting possibilities are listed in the EAT literature, and only a sample listing is included here.

Use of sonar to pick up ordinary body motion
Use of airwall
Use of gases
Subsonic sounds
Time compression and extension, recording
Feedback
Infrared TV
Word transformation
Remote control of objects
Activation of distant objects—vortex gun, heat, and light beam
Use of laser beams
Vacuum forming of plastic sheets
Phase change of materials (solid to liquid, liquid to gas)
Temperature- and pressure-sensitive colors
Light-sensitive colors
Decomposition
Sound and image mixing, TV, recorders, etc.
Use of magnetic fields, electromagnets

These ideas were formulated more than twelve years ago and indicate the rapid growth of the artists' technical interest in this age of technology. One other aspect worth noting here, which is related to one of the questions posed at the opening of this chapter, is the philosophical approach of the organization.

"EAT is concerned with the *process* of making art and not with the work of art as a final product."[1] Its major concern, through collaboration with scientists, is the dissemination of information about the new technology to the individual artist..While the organization is not concerned with the final product, the individual artist may or may not be.

Other noteworthy involvements of art and technology are the Center for Advanced Visual Studies at the Massachusetts Institute of Technology, and The Kitchen Center for Video and Music and the LIP Franklin Street Arts Center, both in New York City. The Center for Advanced Visual Studies states that its main areas of interest are: "environmental art and design; developmental artistic media work; interaction of art, science, and technology; celebrations; education toward the new arts—video, holography, computer-aided design and programming, public art."[2] "The Kitchen Center for Video and Music is a contemporary arts center specializing in, as the name states, the arts which incorporate video and music. . . . The Exhibitions, Performances, and Contemporary Music Concerts."[3] The LIP Franklin Street Arts Center "represents an entirely new use of electronic media art . . . a fully professional television studio which will generate a live broadcast signal to TelePromPter/Manhattan Cable's estimated 500,000 subscription viewers."

[1] *EAT News,* 2 (March 18, 1968), p. 1.
[2] *Art Transition,* Center for Advanced Visual Studies, MIT, Cambridge, Mass., 1975, p. vii.
[3] *The Kitchen Center for Video and Music Catalog,* 1976, p. 3.

logy of the present age provides the sculptor with an increasing range of
:hniques. This is partly a result of a highly mechanized society in which many
'aptability for sculpture. Space-age science and engineering have developed
mpletely new technological devices. These are a by-products of this great
⟶u undertaking and burgeoning knowledge; many materials have found commercial
usage, and the sculptor also has adapted them to sculptural form.

Before the advent of such an organization as EAT, there was a wealth of information that
the artist could not hope to acquire without extensive research and detective work. Although
this difficulty has never stopped an artist in the pursuit of creating new forms, materials, and
techniques, it did waste a great deal of time. There is still an enormous amount of information
that the artist does not have access to that is transmitted to many manufacturers and
businessmen through various house organs and trade journals. Though the bulk of this
information is of little value to the average sculptor, a considerable amount of useful
knowledge does not reach the individual artist until a period of at least two to five years has
elapsed. Also, practicing craftspeople, technicians, machinists, welders, and foundry workers
have specific knowledge and training that is not an extensive part of the educational training of
the artist. The artist must seek out these individuals to acquire practical information, technique,
and skills as the need arises.

The basic problem of establishing resources and acquiring specific information and skill in
a new material or process is that no central clearing house for such information exists. Even
though having everything possible spelled out may cut down on the artist's dreaming and
serendipity, it would also save tremendous amount of time and energy and allow pursuit
without impediments, the course of most importance. For some, this will not be the case, for
the chase is sometimes as sweet as the capture. Other sculptors may prefer to work with
discarded materials. Still others may find commenting on the wastes of technology more
fulfilling than using the new technology to evolve new sculptural expressions.

Regardless of one's position, what is needed in this age of exploration is a central bank or
repository of all new materials, equipment, and basic information on recent developments in
the sciences and industry that might have application for the sculptor. Further, research and
experimentation should be published in a small monthly or quarterly newsletter available to
any individual on request. A noteworthy attempt in this regard is the National Sculpture
Conference, sponsored by the University of Kansas, Lawrence, Kansas, which invites people
from the arts and industry to gather for the mutual exchange of information and publishes its
proceedings in a yearbook. In the past, the main concentration has been metal casting, but the
conference has broadened to international scope in its approach to include other materials
and directions. Another organization that promotes the exchange of information among its
national membership is The Southern Association of Sculptors. Similar services are provided
by the Sculptor's News Exchange, 743 Alexander Road, Princeton, New Jersey 08540; the
Center for Welded Sculpture, P.O. Box 512, Allentown, Pennsylvania 18105; and the
Museum of the Media, 1 Union Square, New York 10011.

Although these organizations are linked with commercial enterprise, they nonetheless
dispense valuable information. The exchange has increased substantially in recent years, but
much is still to be done. Industry and technical researchers should see a need and responsibility
to fill the present vacuum that exists in this area. Since the profit motive cannot work here, a
mutual partnership is needed to explore the adaptability of scientific knowledge to three-
dimensional form. Although the benefit to sculpture would seem to be greater than to the
sciences, the experimentation could lead to some commercial adaptability. Multiple art forms
that have come about as a result of manufacturing processes have proven commercial and
marketable. This utility, or profitability — perhaps slightly displeasing — is a factor that must be
considered.

Why should the sciences and industry feel an obligation to expend time, money, and energy with very little return? The best reply is that without the artist as watchdog, the sciences may just science themselves right out of existence. What sustains the human condition is the artist's ability to respond to humanness. Technology makes life more comfortable and science helps to explain physical phenomena, but statistics and computers and all the technology in the world do not possess human qualities. The artist—the intuitive subjective person—gives credence to the machine; the artist's feelings and emotions and thinking interpret, react, and adapt to the technology and change of the age.

There are problems. If it were to welcome the artist to its facilities and equipment and knowledge, industry would be faced with two major difficulties: the trade unions and cost. This essay is not a discussion of trade unions, but they do exist and, in many instances, are a barrier to the successful involvement of the artist within a union shop. Their arguments are generally logical but invalid when applied to the artist who is not a competitor in the labor market. The labor unions, like industry, must meet their responsibility to the artist. They must be willing to make concessions, whenever feasible, if for no other reason than that the pursuit of knowledge and form could eventually benefit them a great deal. In the process of experimentation, it is not inconceivable that the artist could find new applications for specific materials and techniques that would create new jobs.

An even more basic problem than the unions is cost. If, for example, an industrial manufacturer has a specific product with sculptural adaptability, it simply is not possible or profitable, in most instances, to make such a material or process available on an individual basis. Industry is geared for a larger volume and mass production. Even if the manufacturer were sure that every sculptor, college and university art department, and professional art school in the country would use such a material or process, the demand could still be insufficient to make it profitable. Perhaps the profit motive could somehow be suspended or subsidized by industry and government. Industry deals in such large quantities that the amounts used by artists and students would be minimal and not worth the cost. Unless the product or process has more universal application and, thus, would be more profitable (for example, polyester resin), it is unlikely that the material would filter down to the individual sculptor, except in discarded form. The manufacturer is not geared for retail sales, and what sometimes happens is the appearance of a wholesaler who repackages the material for retail sales and raises the cost of the product almost beyond its value.

While all of this is especially true of material, it is even more true of a specific process, which may be patented or franchised. The individual artist cannot possibly afford the highly complex and expensive equipment necessary for the execution of a specific process and must find a substitute or do without. This, of course, alters the original concept, and a dictation of form is imposed on the sculptor simply through the lack of necessary equipment or materials. As a result of these restrictions, it is often difficult for the sculptor to sustain interest or pursue a vision when materials, skills, equipment, and knowledge are too costly or difficult to attain. Often, if there is a glimmer of hope, the artist will persist, but many more times will be denied the opportunity of exploration except within and through such organizations as mentioned above.

The central questions that remain are whether and to what degree the individual sculptor responds to technology as a sculptural expression. The sculptor is constantly trying to heighten an expression. In some instances, the artist relies on tradition, on eroticism, sometimes on shock value, on antiart forms, on commentary, occasionally on the banal, on pure form, and sometimes on technology. Whatever the direction and the means, the sculptor must constantly be aware of the realms in which the artist operates. The artist does this by creating new realities within the framework of reality and environment. To clarify this, one must realize that it is not difficult to shock, to be erotic, trivial, banal, or all four. Even these approaches are

becoming more difficult as a result of desensitizing. What could be more shocking than the happenings at Auschwitz and Buchenwald, or Vietnam?

Each artist has very clearly defined lines of approach within which to operate. Sometimes, extension occurs over and through these lines, but the artist alone weighs the merits and the degree to which violation over these lines relates to reality. For even though the artist is creating realities, one cannot be totally detached from the existing reality. After examining our world with its wars, famines, diseases, inhumanities, assassinations, cloverleafs, dumps, and slums, how much shock is enough? The artist has always commented on injustices, whatever their forms. Is this done to heighten reality or for shock itself? This also applies to technology. And again the question echoes: does the sculptor use technology as an end in itself, or is it utilized to expand awareness of a new reality? Both approaches are valid, but, because one is dealing with machines, computers, chemicals, forces, etc., and they are just that, the new reality that is created through the use of technology is the more desired form.

Technology, for the artist, is a means to an end. The end might be transient or permanent, but the artist creates the end through technological means. The means do not always justify the end. Because humans created technology in the first place, we must never be dominated by technology. People have a responsibility to put it to work for them to search and establish their own resources just as clay, stone, wood, metal, chisels, and other implements have been put to work. The spirit of the sculptor will never be dominated by technology because the person can, at any time, pull the plug and walk away to find still other means for expression. It would be well at this point to examine more closely some of the recent experimentation with technology and the potentials that will expand sculpture even further as a new reality.

POTENTIALS

Humans, as the highest order of animal, have the ability to conceive ideas and through them to evolve a new reality of form, environment, and existence. In his book, *The Medium Is the Massage,* Marshall McLuhan says, "Art is anything you can get away with." Regardless of whether or not you agree, the pivotal and most crucial word in the entire sentence is *you.* For without the individual as the very basis of existence for this and any other philosophy of art, the sentence has no meaning. We could say, "Art is anything," and stop there, but then why not everything? Where does the artist enter into art if it is anything and everything? Where has the artist brought any cunning to bear on form, if it is anything? Art can be anything and everything, but it begins with *you,* the thinking, feeling, creating artist, and then "anything" and "getting away with" follow.

Having examined some of the implications of using the new technology for sculptural form, let us discuss the five areas of the new technology that are evident and have exciting potentials for new forms and expressions in the last quarter of the twentieth century:

1. Natural force, systems, and phenomena
2. Electronic manipulation
3. Mechanization, systems, and process
4. Chemical and synthetic material usage
5. Humanity and technology; environment and action-reaction

It should be noted that very few of the works illustrated in this section exist in only one category. More often these works are interrelated and applicable to some of the other categories so these areas are merely loose designations.

NATURAL FORCE, SYSTEMS, AND PHENOMENA

The human species has always been attuned to the forces that shape the world—wind, water, fire, earth, and sky. Throughout the history of civilization these factors have played a major role in life and art. With the technological expansion of the twentieth century and in reaction to it, the artist has again placed great emphasis on these aspects of existence. In the beginning of this century, the sculptural response moved away from the static representation of form and into the more kinetic areas of motion and dynamics. Perhaps the best-known examples of the interest in natural force are Calder's mobiles of precise balance. Some of the experimentation of these principles took place in the Bauhaus and with kineticism and constructivism in the 1920s and 1930s. The works of the Italian Group N and Group T and the German Group Zero reflected and expanded some of these early considerations.

In the work of George Rickey, **Three Lines** (Figure 97), we see a continuation of the concern with natural and actual balance and movement. Notable also are the tension structures of Kenneth Snelson (Figures 98 and 99), in which natural forces aided by tension, compression, balance, and weight distribution enable forms to be suspended. This concern with natural forces is further exemplified in the work of Alberto Collie and Takis (Figure 23) with magnetic fields. Seemingly more elemental is the use of natural forces of growth by Hans Haacke, **Grass Cube** (Figure 100), which in terms of creating a new sculptural reality is more sophisticated than it might appear. For here sculptural form becomes a natural *system* dependent on soil, seed, moisture, light, and growth, and, similarly, the *system* becomes sculptural form.

Along with the optical and kinetic forces that have been exploited for many years, the many works of Harry Bertoia, among them **Stainless Steel, Gold-Plated** (Figure 101), illustrate experimentation with the natural sound of materials. When any portion of the linear elements is touched or activated by air, it immediately creates sound sensations much in the fashion of wind chimes. Though it is impossible to conventionally photograph sound, a negative photograph of this work creates somewhat the sensation of vibrating sound. Bertoia has used many of these, of all sizes, shapes, and materials, in exploring the unique tonal qualities of sculptural sound.

Sound as an integral part of a sculptural idea is also most evident in the works of Marvin Torffield (Figure 102) and Joe Moss, **Sensory Environments** (Figures 103 and 104). In Figure 103, the wall reflects itself. The man standing on concrete slabs, in the center of the photo, is talking to a person at the other end of the gallery, seventy-five feet away. Each is in acoustic and visual focus with the other. They see and hear each other reflected by twenty-seven panels. A column in the museum prevents them from seeing each other directly. Figure 104 shows a man listening and talking to the man on the other platform. In the works of these two artists the presence of a viewer-participant activates the environment. In both pieces the effect becomes one of rather static objects that respond acoustically to the sounds of the environment. Moss has also utilized the principle of sound waves to shield out, muffle, or manipulate sound within a given environment. The implications of these forms and experimental pieces extend far beyond their obvious intrigue as sculptural phenomena.

The element of sound is also evident in increasing use in dimensional works that have as their basis music or performance. The senses of smell and touch are also being examined and used more frequently by contemporary sculptors in their pursuit of extending the sculptural idea into new realities.

Some of the more recent involvements in dimension also utilize some elements of natural force, and, while this aspect should not be interpreted as the major consideration of the pieces, they are nonetheless present or implied. The piece by Bruce Nauman, **Acoustic**

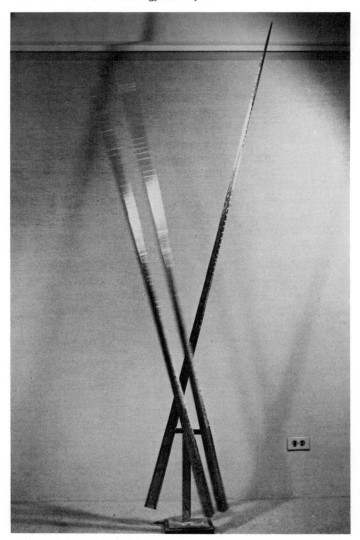

Figure 97. George Rickey, **Three Lines**, 1964. Stainless steel, 100½" H. (Courtesy, Staempfli Gallery, New York. Photo, John D. Schiff, New York.)

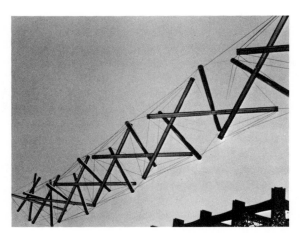

Figure 98. Kenneth Snelson, **Cantilever**, 1966. 30′ L × 3′ W. (Courtesy, Hamilton Gallery of Contemporary Art, New York.)

Figure 99. Kenneth Snelson, **Untitled**, 1968. Anodized aluminum and stainless steel, 20′ H × 60′ L × 20′ W. (Courtesy, Hamilton Gallery of Contemporary Art, New York.)

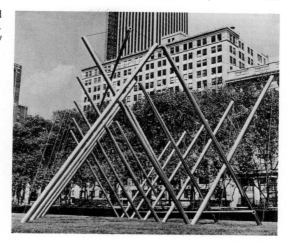

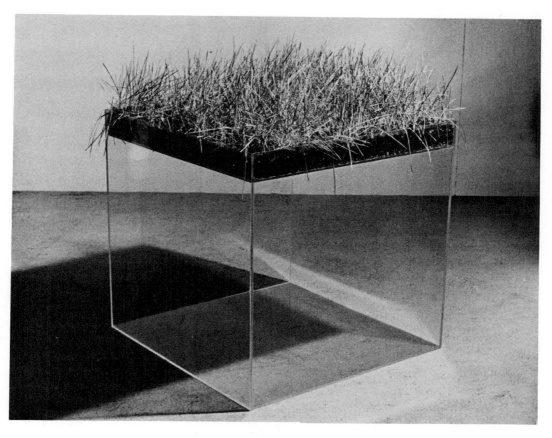

Figure 100. Hans Haacke, **Grass Cube**, 1967. Plexiglas, soil, grass, environmental conditions (light, humidity, temperature, drafts), 30″ × 30″ × 30″. (Courtesy of the artist. Photo, Hans Haacke.)

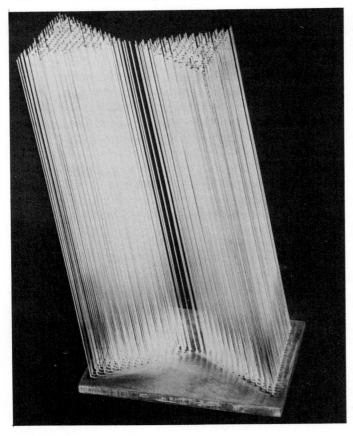

Figure 101. Harry Bertoia, **Stainless Steel, Gold Plated**, 1967. 8½″ H. (Collection, Mr. and Mrs. William A. Potter, New York. Courtesy, Staempfli Gallery, New York.)

Figure 102. Marvin Torffield, **Untitled**, 1976. Birch plywood, 7½′ × 40′. (Courtesy, Paula Cooper Gallery, New York. Photo, Geoffrey Clements, New York.)

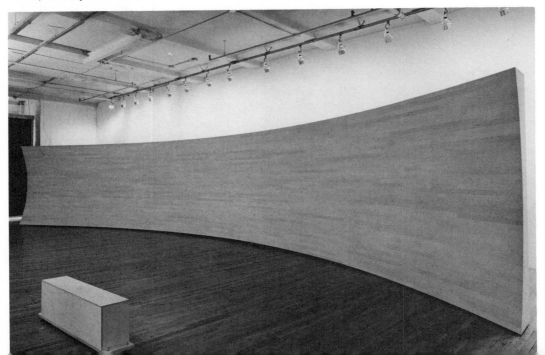

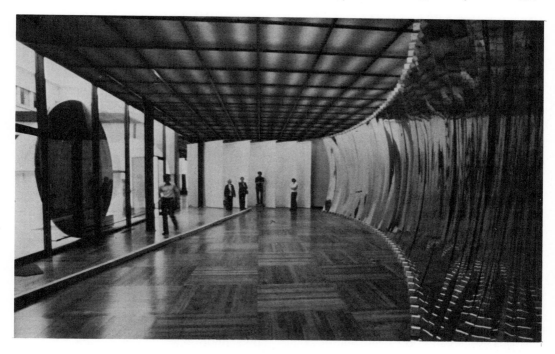

Figures 103 and 104. Joe Moss, **Sensory Environments**, 1977. (Courtesy of the artist and J. B. Speed Museum, Lexington, Kentucky.)

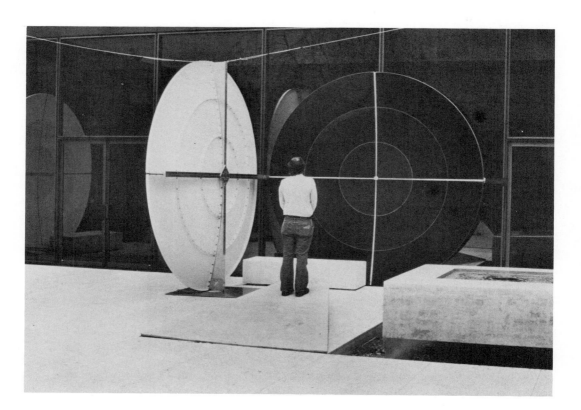

Pressure Piece (Figure 105), is just as involved with the elements of sound and acoustics as are the Moss and Torffield works. No viewer or participant is present in the photograph, but the sound environment created by the presence of people and the resultant echoes and amplification create an exploration of natural phenomena. Another earlier work that illustrates a "natural and systems approach" is the piece by Richard Serra, **Casting** (Figure 106), which was created by physically throwing molten lead at the point where a wall meets the floor. The resultant form is a group of spontaneously shaped wedges of metal that is ordered yet natural. While the link with action or abstract expressionist painting is obvious there is also a bridge to systematic minimalist thinking and attitudes.

The work by Mel Bochner, **Axiom of Indifference** (Figure 107), though not relying on the forces of nature, does incorporate the idea of a system that has been activated by humans. The act of pitching pennies against a wall and categorizing them suggests not only systematic but process and environmental concerns. It is extremely difficult and unwise to attempt labeling a specific work of this kind; however, it does indicate that people were here, that language and communication were factors, and that human actions and reactions were interrelated to concepts of the environment. The simplified appearance of these works indicates not only concern with natural forces but a reaction away from the polished, machined qualities of some of the previous examples.

But much of sculpture using natural force and phenomena is yet to come. Certainly, the vapor trails of jetliners as they streak across the sky are becoming commonplace in our existence. Aside from the cost and logistics involved, the idea of creating vapor-trail sculptural forms is not beyond possibility. Matter would be present; form would assume the role of the sculptor scheduling and determining course; and content could be the reality of the vapor trails themselves. Further, it is not unthinkable to see space sculpture in the true sense existing and orbiting in outer space nor to imagine the many new physical properties that may be discovered on other planets and galaxies that will not only expand the scientist's vocabulary but the artist's as well. Visualizing sculpture in outer space makes the mind whirl, and the difficulties seem irrelevant. Think, for example, of the reentry into the earth's atmosphere.

Figure 105. Bruce Nauman, **Acoustic Pressure Piece**, 1970. Wallboard and acoustical materials, 8' × 4' × 50'. (Collection, Dr. Giuseppe Panza. Courtesy, Leo Castelli Gallery, New York. Photo, Eric Pollitzer, Hempstead, New York.)

Figure 106. Richard Serra, **Casting**, 1969. Lead, 4″ × 300″ × 18″, destroyed. (Courtesy, Leo Castelli Gallery, New York. Photo, Peter Moore, New York.)

Those concerned with destructive art have a built-in means of eliminating and consuming works. The work of sculpture becomes more important when we consider that, even with remote control, the sculpture determines its own rate of destruction, dependent on its materials, orbit, rate of descent, and other natural forces. It is truly its own reality. Fantastic, you say, but where does the sculptor enter into this? The artist obviously determines the material, form, and orbit, and thereby exercises certain controls; but once the work enters the atmosphere, it is dependent on natural forces.

The reality of such a thing is quite remote. The cost and complexities are a luxury no one could readily afford at this point. However, it is inevitable that art will someday exist in outer space, for where people go so goes art. In one sense, despite its tight programming and control, the launching of an Apollo rocket and the subsequent travel of men to the moon are happenings of grand proportions. The sculptor was not consulted in the evolution of the rocket form. The engineers, designers, and scientists determined the shape and form, and aesthetic considerations were not involved. But some day they will be. At the time of this country's first exploration in outer space, a comedy record album intoned that one of the astronauts had forgotten his crayons. The implication was that he was childish; but humans have always sought to give visual expression to their lives, and it can be assumed that ventures into outer space will not change this.

The artist and particularly the sculptor cannot discount any possibility of extending form into the unknown. If one is not attracted to this particular form, it does not have to be explored, but there is a responsibility to keep an open mind as to its potential and validity. In this same regard, the advent of the atomic bomb opened a new era in the history of humankind. The subsequent development of even more deadly weapons made the awesome power of war frightening. Never before has total annihilation been possible. At first, the reaction to these weapons was terror, but with time there is generally less concern with their destructive powers and more with their useful applications. It is possible to harness nuclear power for peaceful and practical usage. It is not absurd to think of the day when the sculptor will be able to use nuclear power directly to shape forms. Presently it is used indirectly in the form of electricity that is generated by nuclear power. This might seem farfetched, but, if the potential usage is there, eventually the sculptor will bring it to bear on the work. It may not occur in our lifetime, but it is inevitable that it will happen. Whether this pursuit is a wise course in view of recent events and attitudes is debatable. The form it takes may be completely beyond our present imaginations, but it will probably be in conjunction with the forces of space science.

Retrospectively, we see that, as a result of the atomic age, sculpture of the 1950s tended toward eviscerated figurative works. During the early 1960s, with the threat reduced and technology expanding, sculpture reflected a more coldly calculating approach to form. The impersonal quality of acquiescence and the social, political, economic, and environmental

Figure 107. Mel Bochner, **Axiom of Indifference**, 1972–1973. Tape, ink, and coins on floor. (Courtesy, Sonnabend Gallery, New York.)

upheavals from the mid-1960s to the present have caused a reaction to technology that is sending tremors through our existence and most readily into sculptural pursuits.

Today, artists are concerned with very basic process, system, information, communication, performance, installation, narrative, charting, situational, body art, and environmental involvements. Technology has either been submerged and rejected, or it has been assimilated and flourishes, depending on one's point of view. Throughout history, these two approaches — the subjective and the objective — have run parallel, and this era still evidences both tendencies and various combinations.

ELECTRONIC MANIPULATION

Related to natural forces and phenomena is the new technology of electronics. It is in this area that the greatest strides have been made. The artist is aware of the exciting possibilities that electronics presents and has recently explored this area with increasing interest. Television, which many of today's younger artists were weaned on, opened the door to even greater exploration. One form of electronic manipulation can be seen in the work of Nam June Paik, **TV Set Pattern** (Figure 108).

Experimental and electronic music, drama, and dance have been incorporated in the three-dimensional forms of the medium and in the environment to extend sculpture as a new reality. Some of the most exciting work that extends the dimensional reference has occurred in the area of audio and video electronic manipulation. The experimental and performance

Figure 108. Nam June Paik, **TV Set Pattern**. (Courtesy, Galeria Bonino, Ltd., New York. Photo, Peter Moore, New York.)

work that has occurred at The Kitchen Center for Video and Music in New York City has been notable. Among the performing artists showing their works have been Vito Acconci, Douglas Davis, Terry Fox, Philip Glass, Robert Wilson, Joan LaBarbara, William Wegman, Trisha Brown, Hannah Wilke, Connie Beckley, Beryl Korot, Steve Paxton, and Steve Reich.

Although much of the electronic technology is a result of military and space exploration and the needs of business and industry, it is being put to work for the artist. If Tony Smith can pick up the telephone and order a large sulptural work, it is not inconceivable that a computer can be programmed to create new forms. Just as humans have been able to translate mathematical theorems into solids and give them three-dimensional form, so also can computers be programmed to activate machines to produce specific forms or can by themselves create new environmental realities.

Recently, there was an ad in the New York Times for portrait sculpture. What was unusual about this particular offer was that it combined optics in the form of photography and computers to accurately and precisely duplicate human features and translate them into solid materials. While the specific processes involved were not defined, the ramifications and potentials of this method of replication are not only far reaching but point up the applicability of electronic technology. This also suggests that new forms can be pure electronic manipulation. The involvement of the viewer or participant in activating the machines and computers opens up areas of potential variations of form and also involves the observers in a new context. In a very broad sense, the human being becomes a new reality in conjunction with the object or program and an extension of matter, form, and content.

We have seen in the listing of possible experiments of EAT the wide range of electronic manipulation. Such electronic equipment as amplifiers, recorders, projectors, encoders, transmitters, receivers, relays, rectifiers, sonar transducers, transistors, printed circuits, and numerous other devices enable the sculptor to create a multitude of effects and forms. In the age of miniaturization, cumbersome equipment that prevented the execution of ideas has

largely been eliminated. Much of this equipment is made available to the artist through such organizations as EAT, and production methods have lowered the cost to within the range of the sculptor. Rockne Kreb's work with laser beams is some indication of the degree of electronic sophistication that is now at the disposal of the sculptor. "Cybernetic Serendipity," an exhibition mounted by London's Institute of Contemporary Art and circulated in this country in 1969 under the auspices of the Smithsonian Institution and displayed at the EAT pavilion at Expo '70 in Osaka, Japan, gives further testimony to the degree that electronics has become another tool in the artist's vocabulary.

It should be explained that the five areas of the new technology are not isolated. Though they can all be used in combination, which will be explored in depth later on, let us now examine just one: the potentials of electronic manipulation. One thing electronic manipulation can do for the sculptor is to extend power beyond his or her body; it can eliminate much of the busywork that now takes so much time. This alone makes it valuable, for it increases the time available for thought and experimentation. The new use of electronics gives the artist power to do things that were previously not possible. The artist now creates new sight, sound, taste, smell, and touch sensations and systems that make possible a new and totally controlled environment, both by the artist and the spectator-participant. Through the use of electronic equipment, the artist can change the spectator from a passive observer to an active partner. The mere presence of an audience can cause photocells and other devices to activate a planned or haphazard environment. Through similar manipulation, the artist can convert such functions as the heartbeat, respiration, and nervous-system pulsations of the viewer into visual patterns.

Perhaps one of the most sophisticated devices evolved is **Searcher** by James Seawright, which not only responds to stimuli within its environment but triggers and establishes new reactions and constantly changing movements and patterns within the work and, in a sense, becomes self-programming. Another exciting work by this artist is the more recent **Sunsieve** (Figure 109), which the artist describes in the following manner: "The piece is a solar-powered

Figure 109. James Seawright, **Sunsieve**, 1972–1976. Mixed media, 11' × 7'. (Courtesy of the artist and the New Jersey State Museum Collection, Trenton. Purchased with funds from the National Endowment for the Arts and the Friends of the New Jersey State Museum. Photo, Joseph Crilley.)

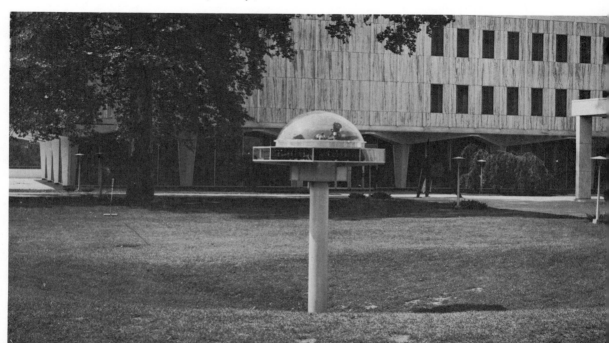

sun-tracking system which splits sunlight into its component colors and disperses it around the area. One can see brilliant images of the sun through the windows around the sides from every direction, the colors changing as one moves about."

Perhaps the single most utilized electronic device with the more recent experimental sculptors has been the half-inch videotape recorder. This has given the artist freedom from the limits of the studio with conventional materials and equipment and has enabled the artist to extend outward toward instantaneous recording of dimensional, environmental, process, and systems concerns and to increase communication with the public. Unfortunately, much of the experimentation that has taken place thus far comes off as amateurish and trivial in its pursuit and as bad technical use of the equipment. This does not lessen its value but indicates the necessity of a new professionalism in its application. When we project the videotape recorder, home computers, and other applicable electronic tools into future use, the prospects are immense. In all of this, we see electronic manipulation giving new meaning, appearance, and documentation to the sculptural idea of matter, form, and content.

To many sculptors, the new technology suggests the cloak of gadgetry, but one must realize that its application to art is in its infancy and, if some of the attempts appear feeble at this time, they can grow and mature into significant and lasting values.

MECHANIZATION, SYSTEMS, AND PROCESS

In many aspects, mechanization is closely allied with electronic manipulation; one is often dependent on the other. Mechanization, however, has been used longer than electronics in sculpture. Though it is not necessary to trace the use of mechanization in and as sculpture, it would be wise to indicate that the use of motors and other sources of power that cause change in the work are accepted today as common practice.

Mechanization in sculpture has increased in recent years in proportion to the use of machines in society and the sculptor's increased interest in expanding form language. Some of the earliest works that utilized mechanization can be traced back to the earlier part of this century, but this approach seemed to reach its main interest in the 1960s. This was true and most notable in the work of Jean Tinguely, some later-day constructivists like George Rickey and Nicholas Schoffer, and in the work of Robert Brees, who utilizes battery-powered mechanisms within lightweight styrofoam shapes that, when activated, move about and change direction when they run into an obstruction.

In the work of Jean Tinguely, we see quite a different type of mechanization, a "Rube Goldberg" configuration with an almost antagonistic attitude towards the machine. In fact Tinguely has developed works that move, whirl, and destroy themselves through their own mechanization. This is a more lighthearted though deadly serious approach to mechanistic sculptural form.

The work by Pol Bury, **24 Boules Sur 3 Plans** (Figure 110), confronts us with quite a different type of mechanization. Each of the small balls is attached and driven mechanically, but ever so subtly. This slight movement plus the polished surface of the metal create an appearance of changing form. If we include the neon-light work of the artists Chryssa and Billy Apple within the area of mechanization, the realm is further expanded, for here the electrical power activates the neon lights, which in turn create a new sculptural reality of the neon tube. In the example of Dan Flavin's work with fluorescent light, **Untitled** (Figure 111), we see the extension of mechanization to light and to the environment.

The mechanization that we have examined falls into two categories: exposed and deceptive. Sometimes this attitude of mechanical concern is explicit, at other times merely implied. Tinguely makes no effort to hide his mechanisms or make comment on the machine.

Figure 110. Pol Bury, **24 Boules Sur 3 Plans**, 1967. Brass, 20¼″ × 12¼″ × 12″. (Courtesy, Lefebre Gallery, New York. Photo, Robert E. Mates, New York.)

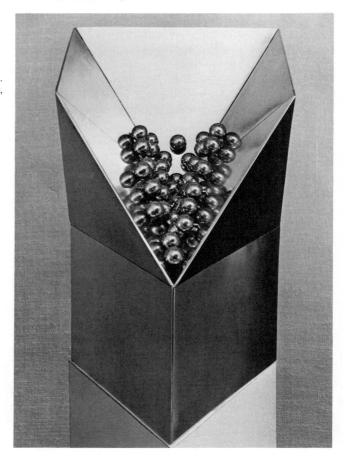

Figure 111. Dan Flavin, **Untitled (For You, Leo, in Long Respect and Affection) 1 & 2**, 1977. Pink, green, blue, and yellow flourescent light, 8′ square across the corner. (Courtesy, Heiner Friedrich, Inc., New York.)

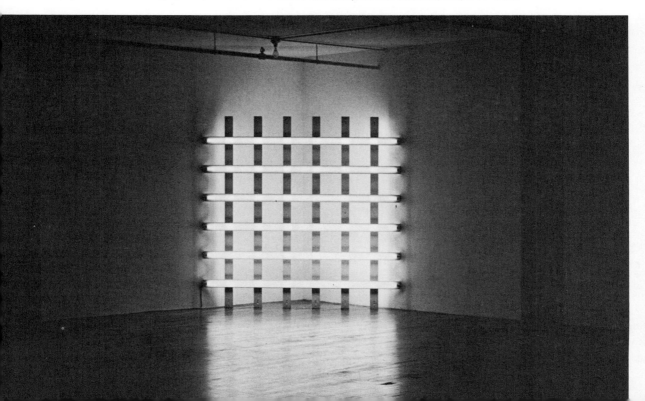

Another example of a mechanistic approach is the work of Mark Di Suvero, **Mother Peace** (Figure 112). In this instance, the mechanical aspects of the work are inherent in various methods of construction and the ability of other parts to actually move. In the work by Pol Bury and the neon and fluorescent-light pieces, the mechanisms are hidden and act to heighten the mystery. In the Flavin, the form of light and environment supercedes electricity or mechanization.

In all of the examples shown, the mechanism activates another process or reaction; this, again, is the nature of the machine, for even though examples of mechanistic sculpture without a power source are shown, they are dependent on change. Exposed mechanisms generally tend to express commentary, and the disguised ones suggest more concern with object, form, and environment. Although Chryssa's work tends to make use of a societal medium, it is considerably removed from context and acts more as a bridge between form and

Figure 112. Mark Di Suvero, **Mother Peace**, 1970. Steel, 40′ H: suspended element, 6½ tons. (Courtesy, Richard Bellamy, New York. Photo, Steven Sloman.)

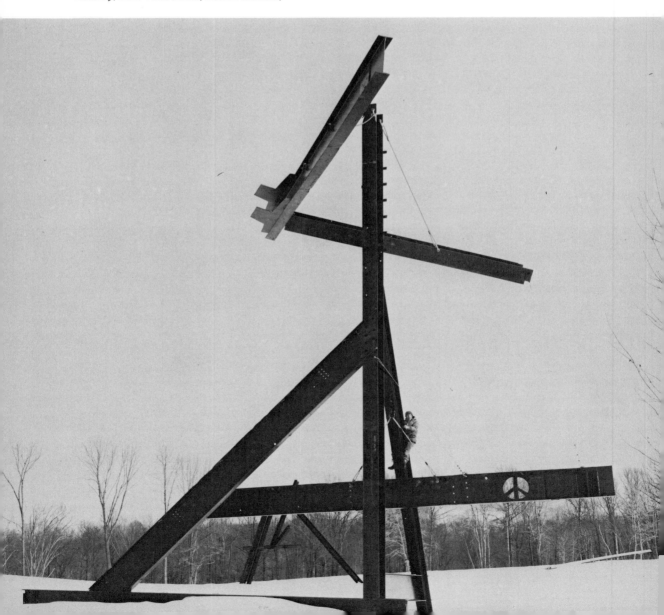

Figure 113. Bill Beckley, **Drop in Bucket**, 1976. Photograph. (Courtesy of the artist.)

commentary. In the utilization of the machine in sculpture, the artist must pay heed to all of these considerations and make the decision to use them according to personal dictates.

Three recent works that are not only related to mechanization, systems, and process but also point up some contemporary trends and attitudes towards concepts are Walter De Maria's **The Vertical Earth Kilometer**, Bill Beckley's **Drop in Bucket** (Figure 113), and Hans Haacke's **The Road to Profits Is Paved with Culture** (Figure 114). It would be well to examine these works more closely. In the earthwork by Walter De Maria a great deal of mechanization went into the execution of the work as evidenced by the following description:

The Vertical Earth Kilometer

Kassel, West Germany, 1977
Small drilling tower—May 5-20
Large drilling tower—May 21-August 9
One-thousand-meter depth reached—July 22
One-kilometer-long brass rod inserted—July 26-27
Clean up and restoration of site—August 9-15
Two-meter-square stone plate placed on top of the
* brass rod—August 16*
Work completed August 17, 1977
Dia Art Foundation

The mechanization that was an integral part of this piece became secondary to the concept and systematic process of inserting a one-kilometer brass rod into the earth. The other two works are not only totally devoid of any mechanical parts but also are quite removed from traditional sculpture. In reality, both of these works exist as photographs; however, they deal with such fundamental processes and systems that they are included here to illustrate a trend of contemporary sculptural ideas that moves away from actual dimension and material.

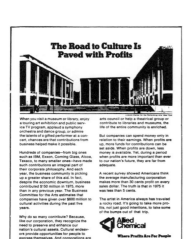
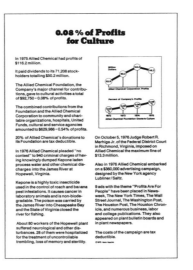

Figure 114. Hans Haacke, **The Road to Profits Is Paved with Culture**, 1976. Three-color silk screen on acrylic. (Courtesy, John Weber Gallery, New York.)

Even though they are based on a previous set of dimensional realities, the finished works move toward a more limited two-dimensional graphic photograph, documentation, or narrative.

It is not necessary to discuss the works of Beckley and Haacke. In fact, they speak for themselves. Rather, the readers should address themselves to the questions of dimensionality and materials vs. systems and concept, and the implications for the future of the sculptural idea.

In projecting the use of mechanization, one does not have to consider outer space for future use. There are more than enough complex forms to explore here on earth. The fact that power can drive, shape, and alter both material and form presents endless directions. The addition of such things as sound, light, water, heat, and smell multiplies potentials even further. To some, the concepts presented here do not qualify as sculpture because they remove the final intent, manipulation, control, and content from the sculptor's hand. But the reverse might hold true; by directly involving mechanisms and the viewer as participants in an environment or by projecting process systems and concepts, the sculptural intent and idea may be more readily understood and form and matter given a new reality.

If the objection to mechanization in sculpture is based on the more traditional idea of truth to materials, stylized form, or principles of order, then the rejection is based on maintaining the *status quo*. Though the purposes of the dirigible and the supersonic jet are basically the same—to move from one place to another—the forms are entirely different. Both are valid airships but have to be judged on individual criteria and merit. Mechanization and the rest of the new technology have to be judged on a new set of values. As in all of the recent developments within sculpture, not enough time has lapsed or experimentation been done to establish what is significant, and so criteria for judgment are difficult to define. General considerations have to be the individual merit of each piece in the realm in which it was created, whether or not the form is enhanced through mechanization, and, finally, whether or not the environment and reality have been expanded.

CHEMICAL AND SYNTHETIC MATERIAL USAGE

Having considered the implications of mechanization, let us examine chemical usage and synthetic materials. These last two aspects of the new technology have been grouped together because of the similar nature of both directions.

The use of chemicals in their pure state constitutes one direction and the evolution of new materials through chemistry the other. Chemicals have been used for many years in the patination of metals; however, we are speaking of a broader use. For example, the inflation experiments by Otto Piene are of particular note and serve to illustrate the association of chemical use and synthetic materials. Let us examine this in depth by studying a statement from the artist:

Light Line (Figure 115) *experiment took place on MIT's Brigg's Athletic Field between 7:30 P.M. and 11 P.M., May 22, 1968, sponsored by the Center for Advanced Visual Studies and the Committee on the Arts, MIT.*

The Light Line consisted of four 250 feet long clear polyethylene sections of hose, two feet in diameter, each inflated separately with helium. The four sections were then knotted together to form one line 1000 feet long. Five strings were attached to the 1000 foot long hose: two strings at the bottom, three at the first "joint" between the two bottom-most hoses. The movement of the Light Line in the sky was controlled by these strings and was also directed by a medium wind off the Charles River about one-and-a-half blocks away.

The Light Line was launched at 8 P.M. to a height of—i.e., the bottom tip was—about 500 feet above ground. The Line was illuminated by one 5 foot in diameter GE searchlight on

*a generator truck; the **Light** followed the **Line**'s path in the sky, sometimes being able to shine on the whole, usually just parts, particularly the top tip.*

*At about 10:30 P.M. the **Line** was brought down and carried by about 150 people across Massachusetts Avenue in one piece still 1000 feet long, up the steps of MIT's main (Rogers) building, where it was loosed in that building's dome. During the procession traffic on Massachusetts Avenue stopped until an instant arch was formed on either sidewalk, with cars passing underneath.*

An even more spectacular event utilizing similar processes can be seen in Piene's **Olympic Rainbow** (Figure 116) from the 1972 Munich Olympics.

It is of interest to note that Otto Piene's first large outdoor experiment with inflated forms (a clear plastic hot-air balloon, oval shape, approximately one hundred feet long, fifteen feet wide) took place in 1961 in Dusseldorf on the banks of the Rhine on the occasion of the publication of the magazine *Zero 3*.

In **Light Line** and **Olympic Rainbow** we see a serious involvement with chemical and synthetic material and in their combination the creation of a new sculptural reality. In the use of the searchlight, we also see a concern with intermedia. Later in this section, we will explore another work of Otto Piene's that deals with other aspects of the new technology in conjunction with an inflation.

Many other chemical phenomena have potential for exploration to create new sculptural realities. Every schoolchild knows that certain chemicals, when combined, will create severe reaction. Some will explode on exposure to the air, and still others will go from one state to another.

Figure 115. Otto Piene, **Light Line Experiment**, 1968. Polyethylene and helium. (Courtesy of the artist. Photo, Nan Piene, Cambridge, Massachusetts.)

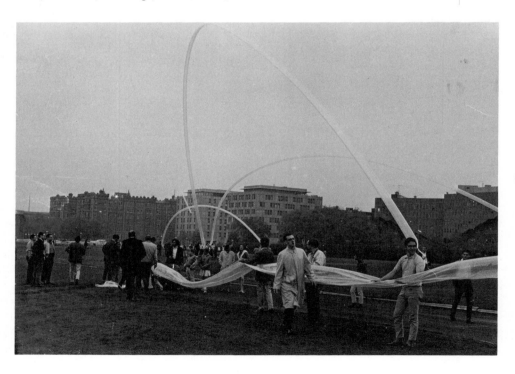

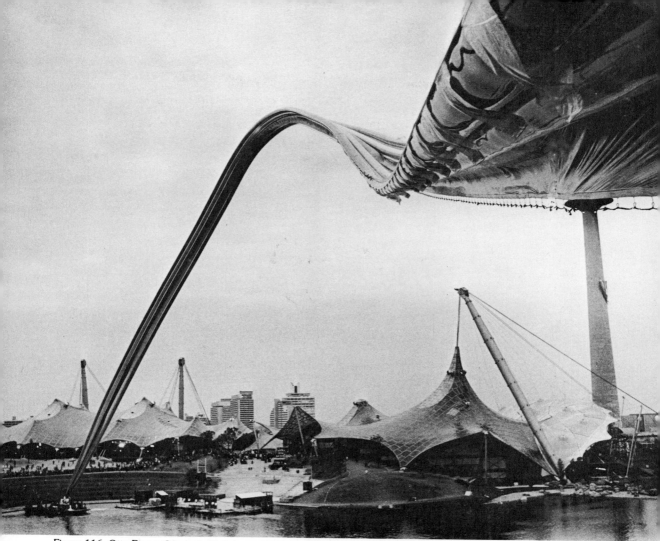

Figure 116. Otto Piene, **Olympic Rainbow**, 1972. Munich Olympics, inflatables. (Courtesy of the artist. Photo, Walt Seng, North Versailles, Pennsylvania.)

The "water boxes" of Hans Haacke are another example of simplified usage of chemicals. These are simply transparent, compartmented boxes filled with water and other fluids that swirl about within the limits of the form. While there is concern with gravity and movement in these, a chemical involvement is also evident. In Hans Haacke's **Ice Stick** (Figure 117), we see a more obvious use of chemicals in the form of a refrigerant. A refrigeration tube is activated and freezes various forms to its surface, which react to the atmosphere, continually melting and refreezing. The pure use of chemicals and chemical agents opens endless possibilities for sculptors and their ideas.

The other direction of chemical use, the changing of matter through chemistry, is the basis for the evolution of many new synthetic materials and surfaces that have applications for the sculptor. Through electroplating and chemical use, it is possible to achieve highly polished and machined surfaces. Perhaps the most notable example of chemical use in this century is the development of plastics—materials never before experienced by people. Otto Piene's polyethylene **Anemones** (Figure 118) uses just one form of plastic. Acrylic sheets have become a common sculptural material. Because of its thermoplasticity, it lends itself to heating

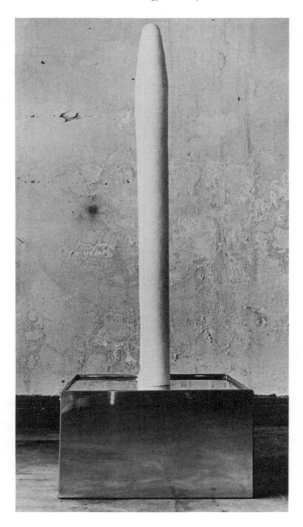

Figure 117. Hans Haacke, **Ice Stick**, 1966. Wood, stainless steel, copper refrigeration unit, electricity, environmental moisture and temperature, 24″ × 24″ × 70″. (Courtesy of the artist. Photo, Hans Haacke.)

and shaping and at the same time retains its rigidity (Figure 119). An earlier work of Lynda Benglis, **Pinto** (Figure 120), utilizes polyurethane foam, which, by its expandable property, allows for a great deal of unique and experimental potential. The employment of impregnating fabric with butyrate dope (Figure 121) permits the construction of rigid forms from limp material.

Much research in new materials has come from the space-age demand for materials with unusual characteristics. In some instances, it has been necessary to first develop or adapt a commercial process in order to create a new material that could be used by sculptors. Many of the new synthetic resins, plastics, and metal alloys have come about as a result of industrial or military needs. The student should consider all materials fair game for sculptural expression and, in so doing, broaden the vocabulary of matter in a continuing search for sculptural ideas. As one studies the illustrations throughout this book and the media listed in them, the wide gamut is even more in evidence.

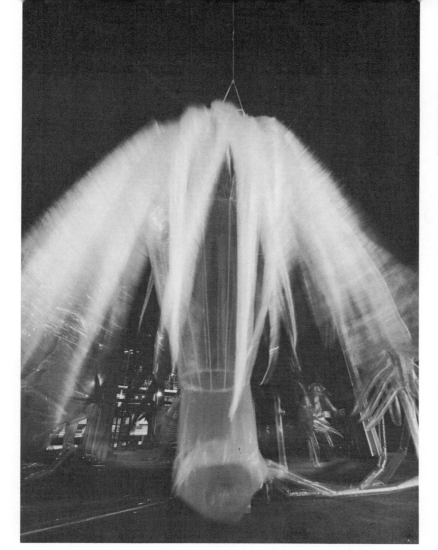

Figure 118. Otto Piene, **Anemones**, 1976. For Creative Time, Inc., 88 Pine Street, New York, inflatables. (Courtesy of the artist. Photo, Peter Moore, New York.)

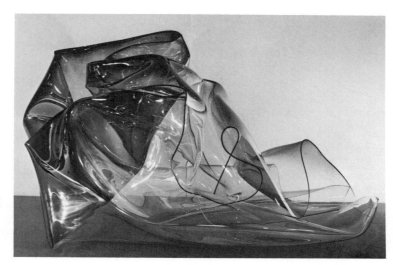

Figure 119. John Chamberlain, **Oraibi**, 1970. Metal-coated Plexiglas, ca 27″ × 48″ × 45″. (Courtesy, Leo Castelli Gallery, New York. Photo, Eric Pollitzer, Hempstead, New York.)

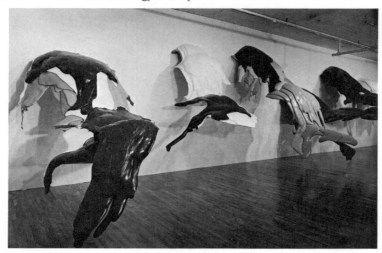

Figure 120. Lynda Benglis, **Pinto**, 1971. Polyurethane foam (five units). (Courtesy, Paula Cooper Gallery, New York. Photo, Geoffrey Clements, New York.)

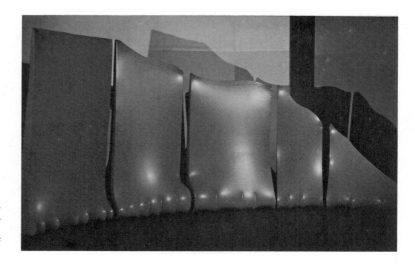

Figure 121. Ric Puls, **Untitled**, 1973. Butyrate dope–impregnated fabric over wood, 8½′ H × 20′ L. (Courtesy of the artist.)

As further evidence of chemical involvement and the interrelationships to other aspects of the new technology, Otto Piene's **Manned Helium Sculpture** (Figure 122) will serve as an exciting example of a new sculptural reality. The sculpture is comprised of eight hundred feet of twenty-six-inch-diameter transparent polyethylene tubing in seven loops that is inflated with approximately four thousand cubic feet of helium; a ninety-five-pound girl is attached with a rope and parachute harness for her thirty-minute ascent forty feet up and is controlled from the ground by ropes attached to her harness and the helium-filled loops. It was performed with two twenty-kilowatt arc lights on January 5, 1969, in the parking lot of WGBH-TV, Boston, as part of Otto Piene's ten-minute videotape for a Public Broadcast program, "The Medium Is the Medium," broadcast on NET-TV in early 1969. Piene's segment of this broadcast was "Electronic Light Ballet" and involved mixing what is seen in the photograph with electronically mixed color images derived from shining light through stencils and then videotaping the combined results.

Figure 122. Otto Piene, **Manned Helium Sculpture**, 1969. Polyethylene and helium. (Courtesy of the artist.)

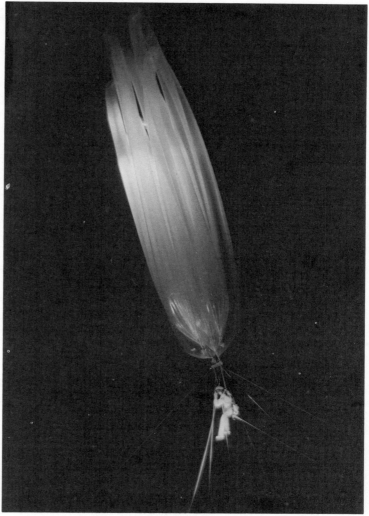

Many questions, ramifications, and insights arise when examining this work. First, is not the work in the photograph sculptural and communicative enough without introducing additional media? Does the adding of multiple media change the reality of the work? In this transformation that crosses all boundaries of the new technology, are two separate works combined to evolve one? Is the title, "The Medium Is the Medium," another way of saying that the sculptural idea creates its own new realities? Are matter, form, and content still applicable? Or are they just generalizations and classifications like the word *performed* used above to describe the sculptural event? How does this work differ from some of those large commercial blimps with trademarks emblazoned on their sides that occasionally hover over large cities or sports events?

In trying to answer these questions, the reader will have to decide whether the following opinions are valid, for they are offered as just that—opinions. To begin with, the work in the photograph is indeed sculptural and communicative enough, but for the artist it becomes one means of expanding his vision through the addition of other techniques. Through this

addition of other media, the reality of the work is changed, but it is also expanded to its final state. In this final statement, then, we see the production or performance culminating in the utilization of all five of the aspects presented previously in this chapter: chemical use in the helium; natural force and phenomena in the properties of helium; synthetic materials in the polyethylene, stencils, and videotape; electronic manipulation in the electronically mixed color images; mechanization in the guide wires and parachute harness; and, in fact, the entire programming of the event. "The Medium Is the Medium" is one way of saying that the sculptural idea creates its own new reality. Matter is obvious in the use of polyethylene, helium, a participant, stencils, and videotape. Form is present in the **Manned Helium Sculpture** and all of its concerns.

In the expanded presentation of the TV program, content is communicated through Otto Piene's manipulation of matter and form. Though these concerns may be generalizations and classifications, the fact that a sculptural idea was given form in **Manned Helium Sculpture** and became a new reality—"Electronic Light Ballet"—by the will of Otto Piene cannot be denied. The association with a commercial blimp merely reinforces the content of Piene's work. Whereas the intent or content is objective and commercial in the blimp, it becomes subjective and individual in the sculpture; the form and matter of the blimp are obvious and functional—in the sculpture they are varied and inventive.

From this brief discussion we begin to see that the final statement of the sculptor, in many instances, takes on a completely different character from traditional sculptural form. The finalization of this work is in the videotape or photographs, but these in themselves are not three dimensional. Yet, they bear witness to aspects of the sculptural idea that they are their own reality whether transient or permanent.

HUMANITY AND TECHNOLOGY; ENVIRONMENT AND ACTION-REACTION

The use of technology to explore and extend sculpture within an environmental reference is becoming more evident and is the area in which much of the significant work of the 1970s has occurred. The technology has been integrated into the work in most instances and is no longer "dazzling." In fact, the reverse is true; the work's natural attributes are emphasized and the technical aspects subdued. The forms and ideas are derived from human works, rather than from nature, and most often they are in sychronization with the environment rather than assuming an intruding stance. This is also true of the tendency to reflect the rhythms and scale of the work first to the environment and then to the viewer. This is not an attempt by the sculptor to order the universe, but rather to extend and impose on it the human reference.

Along with the previously mentioned Experiments in Art and Technology and The Kitchen Center for Video and Music, two other organizations are concerned with dimensional form and experience as they relate to the environment. Notable are the Museum of the Media and SITE (Sculpture in the Environment). The Museum of the Media "utilizes multimedia environments for the purpose of creating a more effective method for group communication. The Museum is experienced and articulate in the imaginative use of all media tools to bring about such an end, be it educational, aesthetic, or economic. The Museum's objective is to create structured experiences for the purpose of achieving information transfer. Our organization has a complete in-house capability for engineering, design, production, installation, and maintenance of media information systems." These include multiprojection and multiscreen exhibits, video, movies, all types of graphics, and a full range of photographic techniques (studio, high speed, 360° panoramic, microscopic, stereo, infrared, polarization, animation, slit scan, high resolution, audio processes, field recording, mixing, rate changing, editing, synchronizing, engineering expertise, optical alignment, screen and stretch systems, and a full

line of chemical and film processes). This list is not the full range of services provided, but it gives some indication of the extent to which this group is involved in technology and its relationship to humanity, communication, and the environment.

SITE (Sculpture in the Environment), 60 Greene Street, New York City, evidences "concern for *total-site*; wherein the character and physical properties of a location determine the sculptural solution. Toward this objective a group of artists has formed an organization to develop imaginative ideas for the environment within a collective and analytical program. SITE is united by the philosophical conviction that sculpture, conceptually realized to involve a total site, is preferable to the decorative placement of object art in architectural settings. Traditionally, public sculpture has been installed as an isolated focal unit without regard for the peripheral influences of environment. Before proposing a solution, SITE considers such factors as land volume, traffic circulation, the flow of human activity, landscaping details, light sources, prevalent weather conditions, and general ecology. A particular style or group sensibility is not the objective of SITE. The corporation functions as a site-oriented think-tank for prospective environments including plazas, parks, lobby interiors, piers, marinas, beaches, malls, roadways, etc." While the employment of technology, *per se*, is not the main concern of this organization, the very nature of its involvement necessitates that technology be fully integrated into its thinking, execution, and finalization of its intended purpose and solutions.

One of these solutions is included here in the proposal for **Ghost Parking Lot** (Figure 123). This project uses existing physical and psychological circumstances in the development of an urban art solution. In the case of Hamden Plaza, the most dominant visual impression is created by the vast expanse of parking lot. It is the type of space that the architectural and planning professions approach with forebearance as undesirable, but inevitable.

Ghost Parking Lot is an endeavor to incorporate the two essential ingredients of the suburban mall—cars and asphalt—and to transform them into another frame of reference. Approximately twenty-seven late-model discarded automobiles are to be enveloped by paving surface on various graduated levels, from full exposure of the car contours to complete burial. Rather than decorate as a denial of the situation's functional reality, the project hyperbolizes this reality as the raw material of art.

Figure 123. James Wines and Emilio Sousa, **Ghost Parking Lot**, 1977. Hamden Plaza Shopping Center, Hamden, Connecticut. Used autos, cement, asphalt coating. (Courtesy of the artist—James Wines, SITE, Inc.)

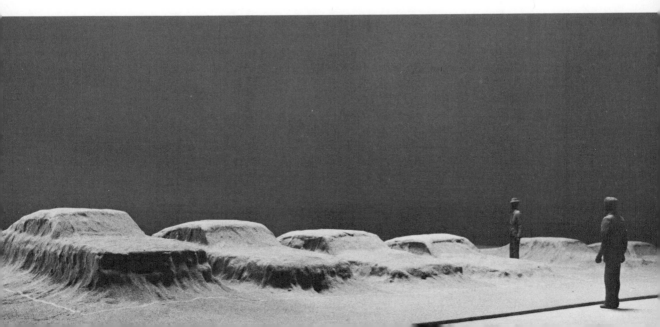

The recent thrust of this group deals primarily with an architectural context, most notably in **Indeterminate Facade Project** (Figure 124) and **Notch Project** (Figure 125). For accurate insight on these two works it would be wise to quote directly from the group's press releases:

Indeterminate Facade Project

This concept involves the "de-architecturization" of the facade and south wall of the structure. This has been achieved by extending the brick facing upward to a variable distance along the top edge of the roof line. The appearance of indeterminacy and dematerialization is heightened by a cascade of loose bricks flowing down the facade and over the pedestrian canopy.

This proposal is an endeavor to project an iconography of indeterminacy, rather than implicit symbol. With the decline of a universal public iconography (church, state) it has become necessary to develop our imagery from a climate of diversity, pluralism, and equivocation — from contradictions to past ritual symbols. The concept is neither "designed" architecture, nor applied sculpture. It is an inversion of situation, an informational facade of "missing parts," an example of art conceived as the process of becoming or reducing architecture, art as a dialogue between constructive and reductive processes.

The Notch Project

The **Notch Project** *represents a further exploration of SITE's interest in an architectural iconography of negation, subtraction, and fragmentation. In this case the showroom corner is penetrated by a fourteen-foot-high, raw-edged notch that serves as a main entranceway. The forty-five-ton wedge extracted from this gap is mechanized to move a distance of forty feet to open and close the building.*

Figure 124. James Wines, **Indeterminate Facade Project**, 1975. Best Products, Kingspoint and Kleckley Streets, Houston, Texas. White brick and Sarabond mortar. (Courtesy of the artist—James Wines, SITE, Inc.)

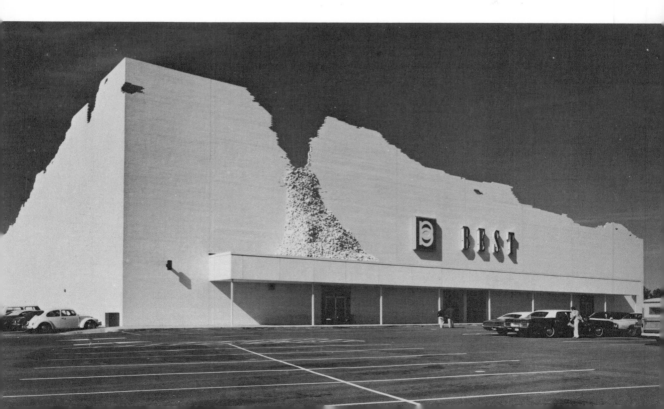

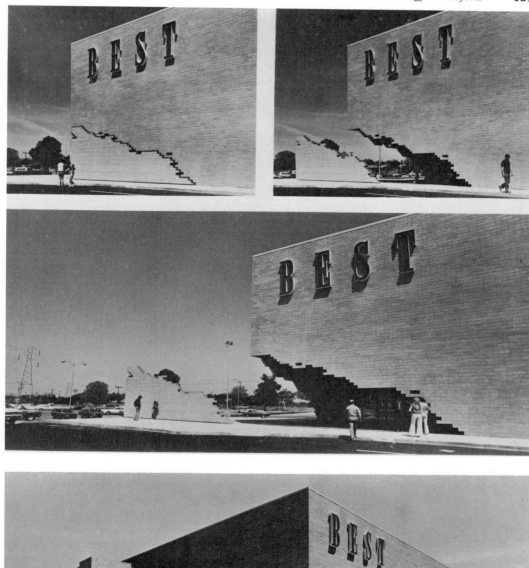

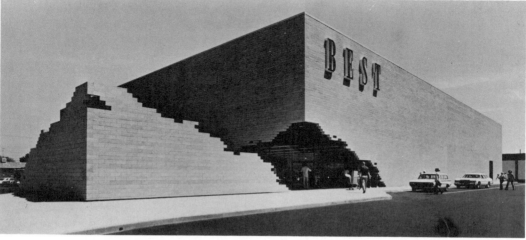

Figure 125. James Wines, **Notch Project**, 1977. 1901 Arden Way, Arden Fair Shopping Center, Sacramento, California. Masonry block. (Courtesy of the artist—James Wines, SITE, Inc.)

While these two recent works by SITE are powerful, attention-getting forms, they also border on being visual puns or sight gags and may prove to be one of the curiosities of late twentieth-century architecture, much like the historical structures constructed in the shapes of elephants, shoes, etc. This is not to dismiss the significance of these works for they do serve their purpose very well. They increase the viewer's interest in the structure and, eventually, in the goods inside and provide the artist with a sculptural opportunity to explore environmental concepts. This mutual relationship between merchant and artist, while questionable for some artists, has the advantage of extending ideas into realities.

The movement away from the isolated art object became extensive in recent times when sculptors became involved with large-scale works that required outdoor space, materials, concepts, and environment. Some of these directions required a more technological approach than others. The work of Otto Piene is an example. This move to the outdoors did not occur at any given time, and, in fact, many sculptors regard it as only one consideration in a much larger existence of thought and sensation. The breaking down of the idea of sculpture as object remains a gradual process in which artists use and extend form in the gallery of architectural environment.

The following portfolio (Figures 126 through 137) indicates the wide variety of works occurring outside the static gallery and museum context. Richard Fleischner's **Wood Interior** (Figures 126 and 127) requires total audience participation in the environment. The **Running Fence** (Figure 128) by Christo, **Complex One/City** (Figure 129) by Michael Heizer, and **Bicentennial Map of the United States** (Figure 130) by Bob Wade all depended on a technology of the age as sculpture moved to the outdoor environment.

Also notable in this aspect is the work on the cover by James O. Clark. The intensive mystery of this form and illusion belies its simplicity as a form illuminated from below floating on a rural pond. The aura that is created within the environment in the dusk, dark, and dawn hours presents the artist's purpose and force through idea and technology.

The systematic breakdown of form in the work of Carl Andre, **Lament for the Children** (Figure 131), Michael Singer's **First Gate Ritual Series** (Figure 132), and others shows concern with process and the environment. The utilization of less formal materials contributed to the departure from the static object and rigid technology. This attitude can be seen in many of the previous photographs and specifically in the work of Charles Simonds, **Cairns** (Figure 133), and Patsy Norvell's **Installation** (Figure 134).

This *material aesthetic* has since expanded into the environment, process, conceptual, body, situational, and other experimental art forms that integrate material and experience into total perceptual and conceptual immersion. In some instances, this includes technology, but, more often, it is a distinct reaction to technology and a return to more primal instincts and responses. Notable for this attitude within the environment are the works of Alice Aycock, **Wooden Post Surrounded by Fire Pits** (Figure 135), Herbert George, **Clearing, Spacehold Forest** (Figure 136), and Mary Miss, **Untitled** (Figure 137).

People evolve from compartments, live in and eventually return to compartments, but they exist in relation to the larger environment. The sculptor creates for, within, and outside this ambience. Artists are no longer restricted to the conventional forms of pedestal, base, materials, techniques, object, forms, concepts, galleries, or museums; they are restricted only by mind and will. New technology has been incorporated into the artist's vocabulary. One can use it, reject it, and react to it, but not totally ignore its force in contemporary sculpture. When the art history of this era is written, the overriding factor probably will be the reemergence of artists, coming to grips with their persons, processes, and environment in the age of expanding technology. Never have changes in knowledge, hardware, and software been so rapid and immense. Sculpture, in its myriad approaches, will be at the core of societal developments. This suggests a changing role for the sculptor.

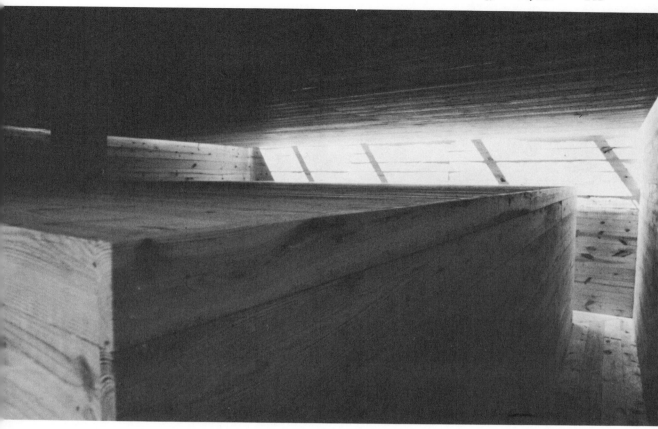

Figures 126 and 127. Richard Fleischner, **Wood Interior** (two views), 1976. Construction. (Courtesy, Artpark, Lewiston, New York. Photo, Gene Dwiggins, Providence, Rhode Island.)

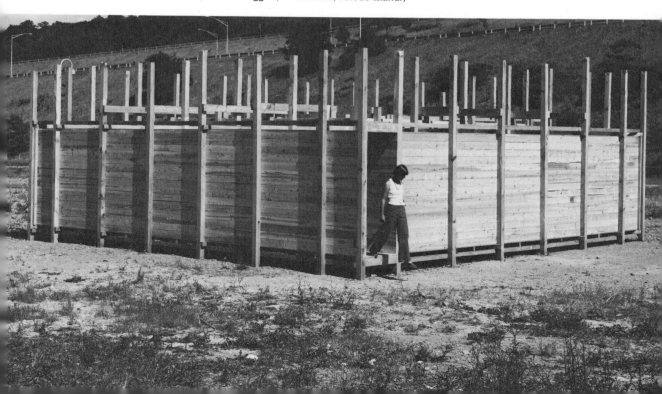

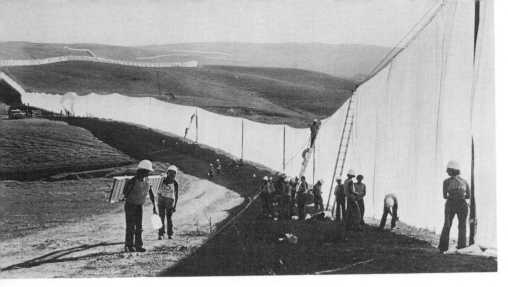

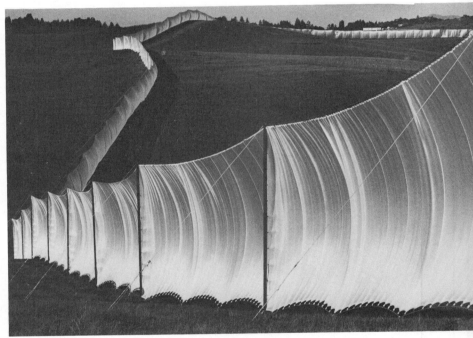

Figure 128. Christo, **Running Fence** (three views), 1972–1976. Sonoma and Marin counties, California. 18′ H × 24 mi. L. (Courtesy of the artist. Photo, Wolfgang Volz.)

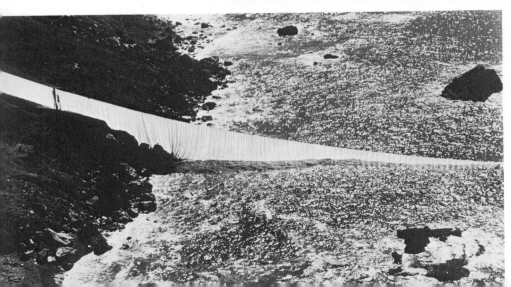

Figure 129. Michael Heizer, **Complex One/City**, 1972–1976. 23½′ × 110′ × 140′. (Collection, Virginia Dwan, Michael Heizer. Courtesy, Xavier Fourcade, Inc., New York. Photo, Gianfranco Gorgoni.)

Figure 130. Bob Wade, **Bicentennial Map of the United States**, 1976. Mixed media, 400′ × 200′. (Courtesy of the artist. Photo, Shelly Katz, Black Star.)

Figure 131. Carl Andre, **Lament for the Children**, 1976. Concrete block, 100 units square, 36′ × 36′ overall. (Courtesy, Sperone Westwater Fischer, New York. Photo, John Dent.)

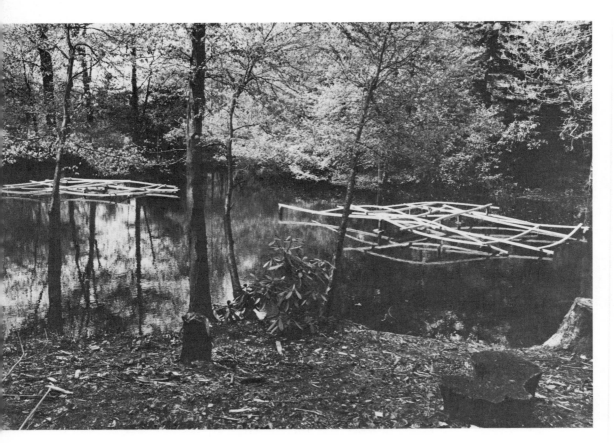

Figure 132. Michael Singer, **First Gate Ritual Series**, 1976. Oak and rock. (Courtesy, Sperone Westwater Fischer, New York, Nassau County Museum of Fine Arts, Roslyn, New York.)

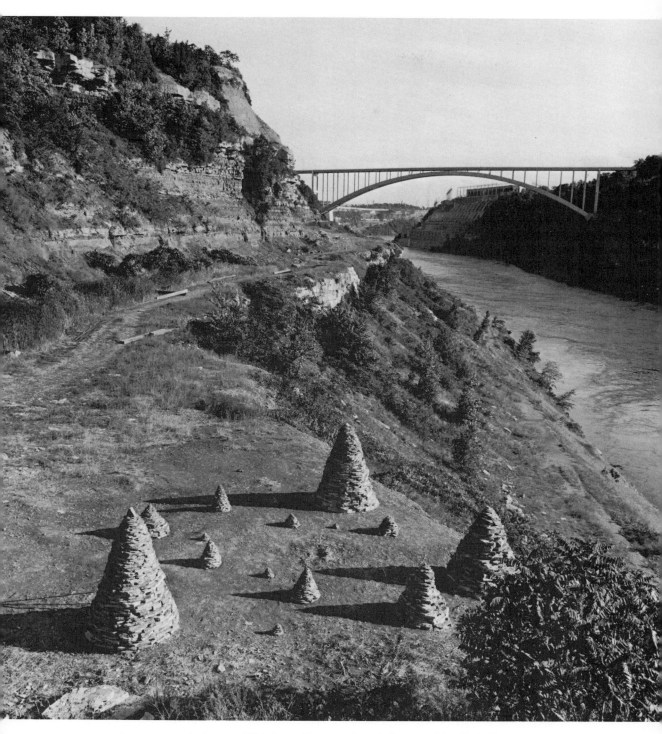

Figure 133. Charles Simonds, **Cairns**, 1974. Stone. (Courtesy, Artpark, Lewiston, New York. Photo, Drisch, Buffalo, New York.)

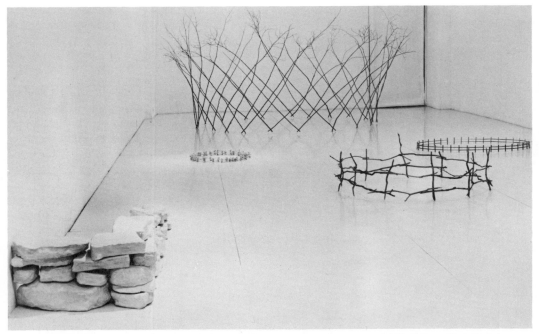

Figure 134. Patsy Norvell, **Installation**, 1975. (Courtesy of the artist and AIR Gallery, New York.)

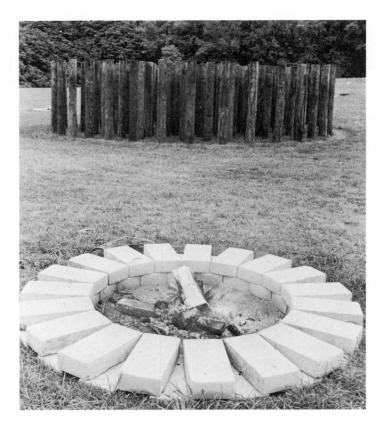

Figure 135. Alice Aycock, **Wooden Posts Surrounded by Fire Pits**, 1976. Wooden posts, concrete, 162 posts 10′ high. (Produced at the Nassau County Museum of Fine Arts, Roslyn, New York.)

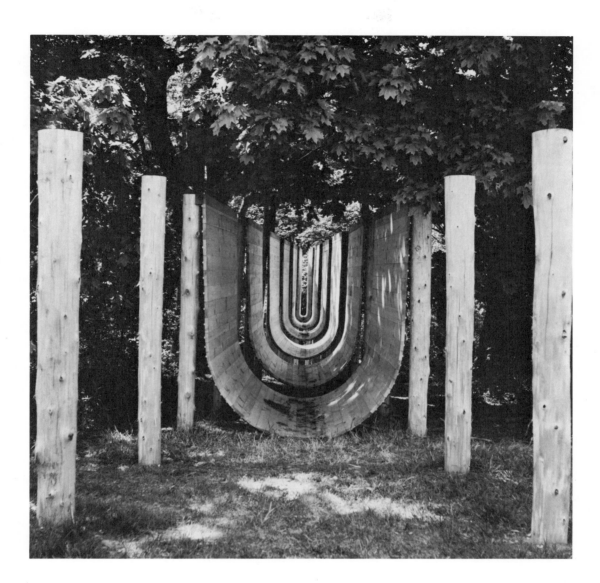

Figure 136. Herbert George, **Clearing, Spacehold Forest**, 1977. Wood, 14' H × 150' L × 14' D. (Produced at the Nassau County Museum of Fine Arts, Roslyn, New York. Photo, Richard di Liberto, Fresh Meadows, New York.)

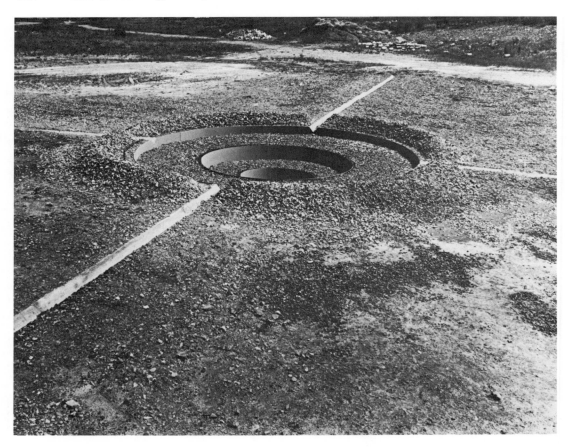

Figure 137. Mary Miss, **Untitled**, 1976. Steel, concrete, crushed rock, 8′ D × 140′ W. (Courtesy, Artpark, Lewiston, New York. Photo, Hoeltzell/Artpark.)

8

The Changing Role of the Sculptor

Stance, Direction, Force

It should be evident at this point that the role of the contemporary sculptor in this society is changing, and that the artist must think and take extreme positions. The sculptor, more than ever before, is reacting to a frenzied world. Artists either can create objects and awareness through experimentation that evoke response and eventually permeate and alter everyday existence, or they can stumble into the pitfalls of triviality or the futility of the mundane. Whichever the choice, the artist must understand one's own identity, determine and confirm individual beliefs, and pursue these to the fullest potential.

Although it may sound theatrical to say that the sculptor must understand his or her own identity, in this day of mass media and the rapid shift of sculptural razzmatazz and press agentry, it becomes imperative for the sculptor to remain free of outside influences. It is quite easy for one to assimilate subconsciously images and ideas related to one's own work through periodicals, exhibitions, etc., though they are not really characteristics of a sculptor's personality and approach. Many are the influences of other sculptural forms and directions; in fact, the sculptor has an obligation to examine not only the historical evolution of contemporary sculpture but other relevant dimensional involvements and to build and extend them in relation to personal creativity. One must also constantly guard against being submerged into someone else's imagery. Originality is a rare, if not unattainable, asset. The sculptor must be able to draw the line between what is truly personal thinking and that which is influenced from outside forces. This is not to suggest that one must become a knowledgeable eclectic, but only that one should know how and why one is pursuing a certain direction. It is conceded that we owe a debt to "the shoulders of giants," but to expect or rely on someone else's ideas and projections is not only intellectually insulting but is an affront to aesthetic sensibilities. To know where one is going is extremely difficult to establish; to know where one has been and where one is at present is not. Searching for one's own thinking, feeling, and being is a constant necessity for the artist.

149

The possibilities of exploration for the sculptor today are myriad. The directions are unlimited and broadening constantly. The basic problem for the artist is not the availability of choice but how to limit the choice so that the most meaningful extensions and directions are clearly defined. This very factor may be the reason why — even in this age of great discovery and promise — many individual sculptors are working in traditional methods and genre, but as themselves, and are not overly concerned with the developments of the present and the potentials of the future. This is a perfectly valid approach for them. If we still find sculptors working in a traditional manner in this day of abstraction, nonobjectivity, and transient involvements, we should not dismiss them, but we should examine the relationships of these traditional forms to the full context in which they exist. If humans are the center of the universe, the representation of the human condition in sculptural form and idea still has great significance. Hopefully, such a work will possess some content that makes it more than just a sterile representation of the species, although even the sterility of everyday existence could be considered rich in content. The reverse should also be true; representational and derivative work should not impede work of a more experimental nature.

Basically, there are two types of sculptors: one who reacts to existence and environment, and one who projects into the future existence and environment. Representation can occur in both classifications, but it is found usually in the former type of artist rather than in the latter. Many sculptors possess both traits but favor one or the other. Both approaches are valid and, indeed, necessary. If the aspiring sculptor can determine a stance in relation to these traits and those stated in previous chapters, then one will recognize individual tendencies and directions. This is no easy task and our concern here, however, is not entirely with the present role of the sculptor, but more with the changing one.

All over America there is an expansion of "art" activities. The word *art* is placed in quotes because, in reality, its use in our present culture is a true bastardization of the meaning of the word. The term *art* is bandied around so loosely that the implicit meaning of the word has almost been lost. The availability of *art* forms makes it possible for almost anyone, in the great American tradition of do-it-yourself, to throw some stuff on the floor or in the corner, bind extraneous materials together, tickle the senses with technology, and create geometric variations *ad nauseum*, with not much more purpose than dilettantism, and call it *sculpture*, read *art*.

One of the greatest pitfalls a person embarking on a career in creating art can encounter is the confusion between *skill, craftsmanship*, and *art*. Skills can be acquired, craftsmanship is inherent or can be developed, but *art* exists on a level that is unique and singular of material, form, and idea, and builds upon and extends the artist's world beyond the existing realm of culture and civilization. It is not the lifting of another's ideas, forms, etc., nor the polluting of the world with *art* debris. This is by no means an easy task. Perhaps the greatest satisfaction lies in the pursuit.

While any definition is open to debate, at least some things should be readily acceptable. Art is the elevation of craft, skill, idea, and, above all, the human spirit to a level that is outstanding and is not achieved by the average person. It is the pursuit of the golden fleece, the ultimate state of perfection. Obviously, this is romantic and rhapsodic in its description but not in its ultimate purpose and goal. Yet, as a civilization, we go on producing an inordinate amount of debris, schlock, or whatever one chooses to call this production, and this on a so-called professional level. The particular notion that everyone in our society has the potential of creating art is a result of: (1) marketing, (2) the willingness of the art critic and the community in general to accept any and everything as potential art, and (3) plain bull.

This attitude has permeated the far reaches of late twentieth-century civilization, all levels of society, advertising, soap operas, comic strips, and has even entered the language, e.g., the *art* of everything from tennis, running, cooking, to Zen. This has been further compounded by

the various educational exposures that one encounters whereby the cloak of authenticity is given to *art* pursuits. Throughout our schools, colleges and universities, continuing education courses, art centers and institutes, the push is on in astonishing numbers to engage people in *art* making. (This is not meant as a comment on the hobby or therapy activities that individuals pursue but on the serious study and pursuit of art.) Yet there is not one single course given in Eye Surgery I or Beginning Probate except on an extremely advanced professional level, and certainly these courses are not available to the layman.

The point to be made here is that somewhere along the line the professional artists and art educators missed the opportunity of maintaining the professional role of the artist. It no doubt began in earnest and became irreversible when the teaching of art moved into the colleges and universities. It is inevitable that if you offer a body of knowlege as a package you will find takers who will assume it can be learned and they will become accomplished professionals in the subject. Many outstanding practicing artists have come through the college and university systems, but the numbers have been negligible when one considers the total enrollments over the past twenty-five years.

Often one hears a medical doctor refer to the state of the *art* in a discussion pertaining to the degree of professional and technological practice of medicine. This is made in all honesty and humility. Contrast this reference with another remark that was overheard, commenting that the attitudes of academic people are nasty and inconsiderate because "the risks are so low." Both are very telling statements and have a great deal of importance for the serious professional artist and the future direction of the sculptor. The current risks in art academia are indeed low, at least in the way the state of the art is practiced.

In theory it is ultimately a greater risk to make art that projects and extends the current thinking and attitudes of a culture than it is for a doctor to patch up someone's physical irregularities or for a lawyer to solve legal complications. This is not meant to single out the professions of medicine and law but only to commend them for the maintenance of a tight code of professional standards and practices.

Our society in America elevates these two professions to the highest status and wealth and relegates the arts to second-class status and to every dime store, shopping mall, and popular market it can find. Is that the key? The marketplace? Somewhat, but that is not the entire answer. The artist in America has prostituted the profession to the marketplace and, in the process, has lowered the level of *art* as well. This appears to be changing, however, and somewhat for the better, but it is not a universal condition. On an individual basis, water will not only seek its proper level but cream will also rise to the top. This is not the Cinderella syndrome—just a twentieth-century fact of mass media. The only problem is that for the serious beginning student it complicates the proper direction, delays the ascent, and creates a lot of unnecessary hassle along the way.

While many doctors recognize that as sophisticated systems engineers they are fast becoming computer analysts and programmers, and many lawyers realize they are becoming mired in paper and various regulations and need to acquire the skills of informational codification and retrieval systems, artists have ignored, rejected, or sublimated the premise that they serve as the guardians, critics, and safety valves of society. The mission of the artist is not only to interpret but to add a creative spirit to scientific and other ideas and technological developments of the societal age, and also to comment and impart meaning, understanding, and implications to these actions. This role of the artist then, implies a much greater significance in society than is usually accorded. The difficulty with these conclusions is that they are personal ones and very difficult to substantiate with data.

On the education and training of artists we might ask if the academic ambiance of colleges and universities is by nature the best environment for the aspiring artist. In theory colleges and universities appear to be vital in pushing back the frontiers, but in actual practice they assume

rather safe and conservative postures in the training of artists. This can be evidenced by the homogeneity of the students, faculty, production, and experimentation, which usually runs thirty to sixty days behind the latest art periodicals. The very nature of academe with its course numbers, clock and credit hours, compartmentalization of knowledge, and other academic trappings is not conducive to the creative temperament of the artist. The resources of the colleges and universities, both physical and intellectual, are indeed assets but the underlying philosophy is often stymied by various regulations, economics, and other survival consider-ations. If the artist-teacher has the least little bit of individuality, one soon compromises some principles or moves on. Yet the very nature of the artist sometimes requires challenge and defiance of order, structure, and conventionality. Assuming that it is possible to work out a mutual tolerance between the artist and the college or university community, the situation that evolves would be at best a weaker facsimile of a working artist's community.

This does not have to be the case, however, if some really serious consideration were given to the role of the artist in the college and university communities and to the concept of teaching art as part of a course of study. While time and space do not permit a thorough discussion of the problem, it might be well to offer some general observations and proposed changes not only for improvement but for an upgrading of the profession. These proposals will seem drastic to some and elitist to others, yet they nonetheless address themselves to the basic issues that eventually will have to be confronted.

The college or university, in spite of everything else it may be, is a business and as such must operate on the profit motive. This is not a negative aspect but one that allows it to continue its good deeds. The problem arises, however, when the profit motive comes in direct conflict with the philosophical objectives or goals of a specific program. The first major concession made here, and one that must be acknowledged by the administrative quarter, is that not all departments and curricula can be held accountable to the profit motive, regardless of whether this is because of esoterica or lack of vocational application.

The philosophy that says to the average artist/teacher in a large university or college art department, "take these three or more classes with twenty to thirty students in each for a semester and teach them something about sculptural and dimensional awareness and creation" is entirely different from the philosophy that says "take these five, seven, or ten students for four years and equip them to be sculptors." The first attitude becomes the vehicle for producing aesthetically hip future salesclerks or people that will drift off into other vocations; it is not only a waste of time and energy but borders on absurdity and fraud. While it may keep people off the streets and out of the job market, it does very little for the quality of learning. It continues to make and keep the risks too low. The second attitude not only makes the most sense but it also cuts down on the pollution problem. This is not meant to be flippant.

The basic question facing the arts at this point in history is a qualitative vs. a quantitative issue. The solution can only be found in the qualitative approach, whereby the notions of profit motive, vocational training, and therapy dilettantism are not the prime considerations. Many alternatives are possible. The closest type of ideal training is to be found in the professional art schools that are located in many larger cities in this country. These institutions usually have affiliated with a college or university for academic preparation in order to be certified to grant a baccalaureate degree. While this lends a certain amount of legitimacy to the program, it also tends to require the art school to acquiesce to the ground rules of the academic institution.

Perhaps an alternate type of artists' community center within close proximity to college and university resources and physical plants might be worth considering. This could be located in the major city of a particular state and would consolidate the art involvements of other colleges and universities within that state. Constant communication and activities could

be exchanged within these limited seventy-five or so centers, and numerous exchanges could take place among these faculties and students, particularly pertaining to their experimentations. (It would perhaps be necessary to have more than one center in the more populous states.) Duplication of approaches would be held to a minimum, and true pursuit and extension of *art* would take place.

These centers would serve to educate the most promising students and aspiring artists within any give geographical or population area. These institutions would not usurp or eliminate the need for college and university art departments or professional art schools but would allow for intensive pre- and post-professional work and study without the academic requirements of credit hours, clock hours, sections, grades, etc.

While this may suggest an elitist attitude, this would be offset by national, state, and regional competitions for admission, channeling of federal and state funding and grants, and, in reality, would actually be more egalitarian.

The specifics and logistics of these centers could be worked out. What is needed is the commitment to quality. This trend is somewhat in effect in numerous privately endowed and operated centers, colonies, and foundations. However, the funding of these on a private basis becomes increasingly difficult. The National Endowment for the Arts, as the main government funding agency for art in this country, would meet its desire for geographical distribution of funds and, at the same time, be promoting the very best talents.

The art establishment in this country must pay close attention to establishing a more efficient procedure for identifying, subsidizing, and nurturing the very best potential masters of art in this country. The sports establishment learned this years ago, and while art and sport are dissimilar in their ultimate goals they share a commonality of philosophy and spirit.

Many of the other disciplines, such as the sciences, architecture, painting, and industrial design, are, if not looking to the sculptor, assimilating the artist's form language as never before. The present state of dimensional explorations, however, has caused a slowdown in this assimilation. While the immediate reaction to conceptualism, process, information, body art, and other experimental forms is one of despair and futility, the essence of what is being said by the artist should be clear to the assimilators of this message. The experimental sculptor's message today is simply this: "You have put me on this treadmill of things that do not work, of services that are not forthcoming, of goods that cannot be acquired or delivered; you have enriched my life while at the same time you have debased it; the institutions have lost touch with me as an individual; the process has gone out of my life and has been replaced with instant gratification; your systems work magnificently but you misspell my name on the printout sheet. In short, when I talk, you do not want to listen. Well, you had better listen, because all your software and hardware, your computer technology, and all the rest of your finely-honed machine might someday lose the pin that holds it all together. The pin may be energy, or natural resources, or fundamental normal behavior, or a host of other factors, and when it's pulled other sensibilities will be necessary for survival."

Hopefully, the young understand this very well. Those who are seemingly in the best position to do something about it are slow in reading the handwriting on the wall, preferring instead to call it graffiti — an approach that does not make the problem go away. Knowledge of the relationships within and outside of visual form is a many-faceted jewel that must continually be nurtured for expansion of the artist's vocabulary and, ultimately, for progress in the reshaping of the individual's existence, society in general, and the world's environment. But progress in the visual arts is never even or steady. It is quite like advancing two steps and falling back one, advancing two, back one, and so on. The many artists in the world are constantly pushing and probing up the steps of new visual and dimensional frontiers. Many of their efforts fail, but a certain percentage succeed; they grope on, not in lockstep, logical fashion,

but with more advances than declines. Even the declines give meaning and importance to the advances. When you multiply this by thousands of individuals, stretching their minds and form to the limit, you begin to see what an enormous task it is and what exciting promise it holds.

When we add all of the means of mass communication and intermedia presently available plus means not yet discovered or understood in the current experimentation, the potentials are staggering. However, the artist builds on previous knowledge. The moon and outer space are inaccessible without the space vehicles necessary; spaceships are impossible without miniaturization and new materials, new fuels, new communication media, all the way back to the theory of relativity, and further back to basic mathematics, and even as far back as the very beginning of knowledge. So, too, the sculptor seeks to clarify the present and to search for the future, while relying on the knowledge and accomplishments of the past.

Much of contemporary sculpture seems to echo this thought of building on previous knowledge and form. If it is not an echo, at least its origins obviously occur in the immediate past. The antiart, antiobject experimentations of the present day have their roots in the Dada movement earlier in this century. The hard edge, minimal, kinetic sculpture of the present can be traced back to the Bauhaus experiments of the late 1920s and to futurism, constructivism, cubism, and further back to the *golden ratio* of ancient Greece. Many of the technological phenomena that are exploited today were also concerns of the artists in the Renaissance and even earlier in the civilization of Egypt. The concern with land projects relates to primary fascination with the universe and its phenomena.

One might inquire whether this is new or just old form in new attire. Although time may be the best judge, we can only assume that the quantity and quality of the present work, with its extension of the form language, concepts, and the availability and use of all materials, appear to be much more exploratory, exciting, and technically proficient. They seem, therefore, an advance of two steps. As in most endeavors, there are a tremendous number of practitioners who are not of the same quality as the innovators, and their work tends to be the most obvious decline of the one step. The true innovator also suffers from the backward step; however, one's forward progress surpasses the receded step, and so one advances.

Returning to the interdisciplinary concern for progress and direction, we find painters more concerned with actual dimension, environmental and dimensional concepts, and systems; architects with buildings as sculptural form and with incorporating mass and mixed media as homogenous parts of the structures; and designers reflecting many of the environmental qualities of contemporary sculpture. Sculptors, in turn, are adapting many of the tools of the sciences, engineering, and industry, the color and other concepts of the painters, the rigid edge, space relationships, and materials of the architects and engineers, and the environmental concerns of the naturalists. This mutual advancement of dimensional form and experiences can only continue to improve the future process of intermedia and indirectly have a great effect on contemporary society.

This then is the changing role of the sculptor: a keen awareness of the past with its abundant successes and failures, a strong sense of relating to peers in fields outside of one's own, and, last and most important, the ability to project new forms, ideas, objects, concepts, processes, images, and environments to be built upon in an advancing fashion by future generations of sculptors. This is the challenge for the contemporary sculptor, in a pivotal position with a new and expanded language of form: to keep pace with and contribute to the evolving new technology and society and what lies beyond.

These considerations, which are integral parts of matter, form, and content, are the sculptural idea. One cannot exist in isolation from the other. Greater emphasis was placed on form in these essays, but only because it is the most applicable. A thorough knowledge of matter, form, and content, although a desirable goal, is never attainable. A slight interdependent

understanding is more probable and workable. The artist has always felt the necessity to shape matter into a personal conception of reality and, through objects, ideas, and productivity, cause the individual spirit, forms, and attitudes to live on. This is what drives the sculptor and will continue a drive toward a blend of these factors in search of unique forms of expression that in themselves are real and ageless.

9

Materials and Their Characteristics

Although a theoretical base of information is a necessary element in the creation of sculpture, a more fundamental knowledge of various materials is indispensable. The very nature and purpose of this book is not to provide extensive instructions on *how to* procedures but rather to provide an overview of the most common approaches, mate-

rials, and techniques. Therefore, technical information is meant to serve only as a bridge between the theory of sculpture and the actual execution of a dimensional expression. For more specific details on any given materials, please consult the bibliography. Following is a summary of information on materials.

━━━━━ CLAY ━━━━━

GENERAL DESCRIPTION

Clay is a natural material that is made up primarily of decomposed rock. Residual clays are natural earth clays found in their original positions in relation to the parent material. Sedimentary clays are clays that have moved from their original locations and settled in lakes, river bottoms, and other low-lying areas. Clay has a plastic nature that can be readily molded and manipulated into various forms. Upon drying, it takes on a leather-hard surface and, if subjected to heat of 1100°F to 2600°F, it will vitrify. Clay is an extremely useful material for the sculptor not only for modeling and casting various forms of construction

but also as a general plastic material for the studio. Water-base and oil-base clays are the most commonly employed by the sculptor. Water-base clays come in powder or premixed form. The premixed type is mostly water by volume and, therefore, more expensive. The powder form is inexpensive, and the consistency is more controllable. Powdered clay is mixed by sifting the clay into a water solution and allowing it to become immersed. The excess water is removed and more dry powdered clay added for the right consistency. If the clay becomes too stiff to work, water can be added to soften it. If the clay becomes completely hard it can be

reprocessed by breaking up the clay into fine powder and small lumps and totally immersing it in water. This can be brought up to working consistency by adding dry clay and kneading the material in a process called wedging. This is accomplished by pushing the clay on a dry plaster or other absorbent surface. The oil-base clays come premixed and have the advantage of not shrinking or hardening. They are very expensive and have the disadvantage of not being able to be fired or hardened. Clay in its many forms (powder, lump, liquid, plastic, hardened, and fired) is indispensable to the sculptor. Further, it presents numerous possibilities as a material in itself. The most common applications, however, are the use of clay as a modeling material, as a casting substance, and as a means of creating constructed forms.

CATEGORIES

Modeling. Clay has been used for many centuries to model dimensional images. Its pliable nature and its hardening characteristic have allowed the sculptor to form not only functional utensils, but also representations of humans and their world. The selection of a clay for modeling should be based on three qualities: (1) plasticity, the ability to be shaped and modeled; (2) porosity; and (3) the capability to be fired to a hard and permanent state. The two types of clay employed for modeling are usually of the terra-cotta, earthenware variety or the fireclay and higher-fired stoneware. A simple inexpensive modeling clay is ordinary fireclay combined with ball clay for plasticity. If a textural quality is desired, grog, which is fireclay that has been fired and crushed to a fine grain, may be added. Old red or firebrick may be ground into fine particles and used for the same purpose. Sand may also be added for texture and porosity if the clay is not to be fired. If the sand has any lime-bearing particles and is mixed with the clay and fired, it might cause the piece to pit or even explode in the firing. Grog added to clay also increases its porosity.

The use of oil-base clay is commonly limited to those types of modeling where firing is not going to be done, and drying, shrinking, and hardening are factors to be avoided. The most common types on the market are plastilina, plasteline, and plastecine. They utilize different oil-bases such as wax, glycerine, plastic, or lanolin. They come in various colors from gray-green to red to white, black, blue, yellow, and brown. The gray-green is a good modeling color because of the light play on its surface.

Construction. Many types of clay can be utilized in the construction of sculpture, but the selection is dependent upon the stress that is to be placed on the material. If wheel-thrown forms are to be combined with each other or extraneous materials, a wheel-throwing clay must be used. This clay has a greater degree of plasticity and porosity that allows it to be formed in this manner and fired. If the construction is to be supported over an armature, the relative strength of the clay is not as crucial. If it is to be hand-built in a hollow fashion, its strength will have to be greater. The clay used for modeling can be employed for most construction techniques including slab construction, coil building, relief molding, and direct building.

Casting. Casting clays are of two varieties: regular clay that is used for modeling and construction and pressed into a mold and the fluid type referred to as slip clay for casting. It is usually comprised of various ball clays, water, soda ash, and sodium silicate (water glass).

GENERAL CHARACTERISTICS

Clay, through its various qualities of plasticity, porosity, and ability to vitrify, holds great potential for the sculptor. Its traditional usage allows for a wide range of form. The many states of the material (powder, lumps, plastic, fluid, solid) and its change into a vitrified mass make way for an endless latitude for experimentation. Its ability to take on natural and applied color further extends its scope.

STONE

GENERAL DESCRIPTION

Rock may be grouped into three types: igneous (granite), sedimentary (limestone, sandstone), and metamorphic (marble, slate, soapstone,

serpentine). Igneous rock is a solid and dense rock resulting from fire or volcanic action. Sedimentary rock is a somewhat softer material,

resulting from various deposits and the chemical and physical action of water and erosion. Metamorphic rocks are igneous or sedimentary rocks that have been formed by great heat, pressure, and chemical reaction.

CATEGORIES

Carving. The most common stones employed by the sculptor for carving are marble and the other metamorphic rocks. Limestone of the sedimentary class is relatively easy to carve, but the granites and basalt of the igneous class are extremely hard although they are the most permanent and take the highest polish. It is also possible to carve out of synthetic stone that is composed of various cements and plasters with aggregates of sand, marble chips, vermiculite, zonolite, etc. These synthetic mixtures have the advantage of relative hardness or softness controlled by the proportions and aggregates. In this regard, the following base materials may be used: plasters, keene cement, Portland white cement, Portland gray cement, hydrostone, hydrocal, and various combinations of all of them. Another advantage of employing such materials for carving is that the approximate form of the piece can be cast, leaving a minimum of roughing out to be done. Color, in the form of dye or pigment can also be added directly to the fluid mix and a variety of effects achieved. The most obvious disadvantage is that even when a solid block is cast the material is still a synthetic substance that is only a substitute for stone and lacks many of the inherent qualities of natural stone.

Construction. Recent sculptural involvements have employed stone in unconventional manners. If one approaches stone in a traditional, carved way the results will almost be predetermined. It is possible to extend form through the conventional method of carving, but the innovative approach to stone as a material will be limited. The form of stone may be powder, chips, stones, large rocks, and natural formations, up to and including actual sites in the environment. With the many adhesive materials, such as epoxy, it is now possible to attach stone together with glue and have it be extremely permanent. In addition, the approach to sculpture in recent years also makes possible a combination of stones with such disparate materials as string, wire, plastics, etc., or through mere placement within containers or the environment. Further possibilities are endless when one involves the material—stone—with conceptual approaches and attitudes.

GENERAL CHARACTERISTICS

Aside from all the above factual information, it is possible to make certain generalities about stone. Stone is usually considered hard and compact with varying degrees of color, texture, striations, graining, and workability for the sculptor. This workability includes carving, casting, constructing by building directly, and utilizing stone as a raw material in many forms for environmental and conceptual exploration.

―――――――――――― METAL ――――――――――――

GENERAL DESCRIPTION

The use of metal as a sculptural material has increased tremendously during the second half of this century. This is due primarily to the expansion and availability of the means to work this hard material. This popularity is also due to the desirable characteristics and physical properties of metal. These characteristics include:

Hardness
Structural strength—density
Malleability—ductility
Surface quality—luster
Change of state—solid to liquid to solid

Ability to combine with other metals—alloys
Permanence—resistance to corrosion

Commonly used metals include:

Aluminum
Copper
Gold
Iron
Lead
Magnesium
Nickel
Platinum

Silver
Steel
Tin
Zinc

Metal runs the full gamut of available form. It is available in powder, filings, ingot, sheet, wire, rod, tube, and discarded objects. Its adaptability is dependent on the ways it can be shaped by cutting, bending, forging, hammering, stamping, casting, exploding, placing, melting, and combinations of these methods. Metal may be joined by compressing, folding, welding, brazing, riveting, fusing, soldering, gluing, interlocking, inlaying, and securing with extraneous materials. Metal can be finished in a number of ways: grinding, polishing, staining, painting, metal spraying, electroplating, patining with chemicals, sand-blasting, coating with other materials, and combining any or all of these. The two most common approaches to the use of metal for sculpture are construction and casting.

CATEGORIES

Construction. Most metals lend themselves to various types of fabrication. Because the material is malleable it may be shaped in a number of ways. The most commonly employed metals for sculpture are copper, brass, aluminum, and steel. In sheet, rod, wire, and tube form, all of these are fabricated quite easily with the aid of power tools and equipment. Aluminum is increasingly employed for sculpture because of its light weight, its resistance to corrosion, its relatively low cost, and its availability. Though it is difficult to join by oxyacetylene welding, it can be accomplished with the aid of special fluxes and rods or the use of tungsten inert-gas welding (TIG) or metallic inert-gas welding (MIG) outfits. This will be discussed later in the technique section. Aluminum has certain surface qualities that are totally acceptable. Earlier, aluminum was regarded as an unaesthetic material just as certain plastics were rejected. Most of these attitudes toward certain materials are no longer with us. In fact, the reverse is true; all materials are fair game for the sculptor. While aluminum does not respond to chemical coloring mixtures, it can be colored through the addition of dyes in manufacture, by anodizing, painting, and some chemical action.

Brass is comprised of approximately 65 percent copper and 35 percent zinc. Its color is a golden yellow, and because of its copper content it takes chemical coloring fairly well. Various compositions of brass are available with different per-centages of copper, zinc, lead, and tin. Brass is resistant to corrosion but will oxidize and discolor. It is a metal that lends itself to construction through most fabricating techniques. Brass takes on an extremely high polish and gives off a high luster.

Copper is a common material employed by the sculptor in construction techniques. It is resistant to corrosion but will oxidize and discolor. Chemical coloring mixtures create a wide spectrum of color when applied to copper. Copper can be shaped by all conventional techniques of fabrication, and, because of its malleability, it can be hammered and shaped quite easily. It is quite soft but has a high physical strength. It is the base metal for bronze, brass, and nickel-silver alloys. It takes a high polish and possesses an intrinsic warmth of color.

Steel is perhaps the strongest metal used by the sculptor today. It is very hard and has a high tensile strength. In thin sheets, rods, tubes, and wire, it can be fabricated quite easily. It can be joined with a variety of techniques and responds well to welding and brazing. While steel will rust and corrode, stainless steel and the steels with a copper content (Cor-ten) will resist this corrosion or only rust to a predetermined degree. Steel will take a certain amount of chemical coloration, but this will eventually break down. It takes electroplating, metal spraying, and paint very well. It can be surface-coated with numerous other materials. Steel will take a moderate shine on bare metal but must be sealed with a protective coating; however, this also will break down.

Casting. The most commonly used metals for casting are aluminum, brass, bronze, lead, iron, and steel. Because of the high cost, silver, platinum, and gold are usually cast in very small sizes and the centrifugal-force method is employed. All of the individual characteristics of the metal described above also apply to the casting process. Some of the metals, because of various factors, lend themselves to the casting technique. Lead with its low melting point is readily cast but is quite heavy, does not take color, and has a rather dull intrinsic appearance. Aluminum also melts at a relatively low temperature and, while somewhat sluggish in pouring, gives moderately strong, inexpensive casts. Iron and steel have the main disadvantage of requiring high temperatures to melt and the resultant cast metal is very dense and heavy. The most commonly utilized metal for casting is bronze that includes varying percentages of copper, lead, tin, and zinc. A good casting bronze is called red brass, which is

85 percent copper, 5 percent zinc, 5 percent lead, and 5 percent tin. It is also referred to as 85-3-5. Phosphor bronze is another good casting metal, which is 88 percent copper, 11 percent tin, and 1 percent phosphorus. Many recipes exist for low-casting alloys which range in their melting points from approximately 140°F to 180°F. These tend to be very soft but serve a function as small, preliminary studies or models, where strength is not required. Metal casting, whether lost-wax method, sand casting, ceramic shell, full mold, or free-pouring method, has always been an important part of the sculptor's vocabulary. Its popularity fluctuates, but the process of taking a solid metal ingot, applying heat and changing its state to liquid, and then letting it cool and harden is an extension of the sculptor's form-and-material capabilities that will never be abandoned. To shape, form, and control liquid metal is a wondrous thing.

PLASTICS

GENERAL DESCRIPTION

Plastics are synthetic materials. They consist of various materials in combinations of carbon with oxygen, hydogen, nitrogen, and organic and inorganic elements. These materials are capable of changing their state from solid to liquid, and, through the application of heat and pressure, they can be formed into various shapes.

CATEGORIES

Thermoplastic. Thermoplastics become soft upon application of sufficient heat and harden when cooled. When reheated, they become soft and can be reformed. These plastics include the following:

ABS plastics
Acetal resin
Acrylic
Cellulosics
EVA plastics
Fluorocarbons
Ionomer
Nylon (polyamide)
Parylene
Phenoxy
Polycarbonate
Polyethylene
Polyphenylene oxide
Polypropylene
Polystyrene or styrene
Polysulfones
Propylene—ethylene polyallomer
Urethane
Vinyl

Thermosetting. Thermosetting plastics are set into permanent shape with the application of heat and pressure. Reheating does not soften them. Thermosetting plastics include the following:

Alkyds
Allylics
Amino plastics—melamine, urea
Casein
Epoxy
Phenolic
Polyesters
Silicone
Urethanes (foams and elastomers)

Polyimide. Polyimide is a non-melting plastic. It has the linear structure of thermoplastics but no measurable melting point.

GENERAL CHARACTERISTICS

Plastics have high tensile and impact strength, lightness, resistance to corrosion, low moisture absorption, resistance to salt water and many chemicals, transparency, range of color, opaqueness, and, through various combinations, give most any property desired.

PLASTICS INDUSTRY

Plastics Materials Manufacturers. Manufacturers formulate plastics from basic chemicals. These compounds are in the form of granules, powder, pellets, flake, liquid resins, and solutions. Some may form the resins into sheets, rods, tubes, and film.

Processors. Processors of plastics include molders, extruders, film and sheet processors, high-pressure laminators, reinforced plastics manufacturers, coaters.

Fabricators and Finishers. Using all types of machinery, fabricators and finishers complete the conversion of plastics into finished products.

Information courtesy of the Society of the Plastics Industry, Inc.

Plastic	Type	Properties	Forms and Methods of Forming	Typical Uses
ABS (acrylonitrile-butadiene-styrene)	Thermoplastic	High impact and mechanical strength. Heat resistant 140° to 250°. Resistant to acids, alkali, salts. Translucent to opaque.	Powder, granules, sheets. Injection molding, extrusion, calendering, vacuum forming.	Pipes, safety helmets, auto parts, telephones, tool handles, tote boxes.
Acetal resin	Thermoplastic	Extremely rigid. Resistant to most solvents. 180° to 250°, odorless, tasteless, nontoxic. High tensile strength. Translucent to opaque.	Powder. Molding, extrusion. High pressure and heat required.	Uses include gears, bearings, bushings, appliance parts.
Acrylic	Thermoplastic	Strong, rigid, will scratch. Can pipe light. 140° to 200°. Colorless, also full range of color. Translucent to opaque. Transparent is common form. Nontoxic. Not resistant to strong acids and alkalis.	Sheets, rods, tubes, powder. Fabrication, thermoforming, injection and compression molding, extrusion, casting.	Window glazing, facing panels, lighting fixtures, TV shields, skylights.
Alkyd	Thermosetting	Excellent dielectric strength, hard surface. Heat resistant 300° to 850°. Good resistance to moisture. Resistant to acids, ketone, alcohol, esters. Translucent to opaque.	Molding powder and liquid resin. Compression molding.	Auto parts, light switches, electric insulators.
Allylic	Thermosetting	Heat, moisture, chemical staining, weather resistant up to 350°. Odorless, tasteless, insoluble. Transparent to opaque. Not affected by acids or alkalis.	Monomer, prepolymers. Liquid and molding powders. Transfer, compression, injection molding, extrusion, laminating, coating, impregnating.	Electronic parts. Low- and high-pressure laminates.
Amino plastics (melamine and urea)	Thermosetting	Very hard, scratch resistant, chemical resistance good. Heat and weather resistant −70° to 200°. Strong toxicity in resin. Full color range.	Molding powders, granules, foam, solution as resins. Compression, transfer, plunger molding, lamination.	Tableware, buttons, table tops, appliance housings, electrical devices.
Casein	Thermosetting	Takes brilliant surface polish. Transparent to opaque. Strong, rigid. Good chemical resistance. Poor water and weathering resistance.	Sheets, rods, tubes, liquid, powder. Machining.	Buttons, buckles, knitting needles, toys, adhesives.
Cellulosics	Thermosetting	Cellulosics are among the toughest of plastics. Transparent to opaque. Withstand moderate heat. 155° to 220°. Does not weather well outdoors.	Pellets, sheets, rods, tubes, film, coating. Injection and compression molding, extrusion, laminating, machining, coating, drawing, blow molding, vacuum forming.	Recording tape, film, combs, steering wheels, pipe and tubing, appliance housings, pens.

Material	Type	Properties	Forms / Processing	Applications
Epoxy	Thermosetting	Good water, weather, chemical resistance. Extreme strength. −70° to 250°.	Molding compounds, resins, foamed blocks, liquid solutions, adhesives, coatings, sealants.	Protective coatings for pipes, cans, drums, gym floors. Employed in casting, laminating, coating, and adhesive bonding applications.
EVA (ethylene-vinyl acetate)	Thermoplastic	High impact strength, flexible, rubberlike excellent "snap-back." High resistance to cracking.	Injection molding, extrusion, blow molding.	Shower curtains, disposable gloves, syringe bulbs, inflatable toys, pool liners.
Fluorocarbons	Thermoplastic	Excellent chemical resistance. High thermal stability. Low friction and anti-stick properties. Extremely hard, strong.	Powders, granules, dispersions. Molding, extrusion, thermoforming or cold forming, machining, coating.	Gaskets, machine parts, coatings for frying pans, cooking utensils. Mold release.
Ionomer	Thermoplastic	Transparent and tough. Good chemical resistance. Clear but takes color well. Good adhesion.	Injection molding, blow molding, extrusion as shapes, film, coatings, insulation, thermoforming.	Skin packaging, toys, tool handles, bottles, vials, tubes, sheet.
Nylon (polyamide)	Thermoplastic	Resistant to extremes of temperatures. Strong, long wearing. Good chemical resistance. Transparent to opaque.	Powder, sheets, rods, tubes, filament. Injection, compression, and blow molding, extrusion.	Tumblers, brush bristles, fishing lines, fabrics, toys.
Parylene	Thermoplastic	High chemical resistance. High temperature resistance. Dimensional stability.	Film. Vacuum coating.	Insulation and protective coatings.
Phenolic	Thermosetting	Strong and hard. Heat and cold resistant. Chemical and water resistant. Color—black, brown.	Molding compound. Injection, compression, transfer, plunger molding, casting, laminating.	Distributor heads, knobs, dials, pulleys.
Phenoxy	Thermoplastic	Clear, transparent to opaque. Rigid, strong, hard, tough. High tensile strength. Good chemical resistance but will dissolve in solvents.	Pellets, resins. Blow molding, injection molding, extrusion. Adhesives, coatings.	Bottles, drug and food containers, packaging, appliance housings.
Polyallomer	Thermoplastic	High impact strength, greater melt strength, built-in hinge property. Good range of color.	Injection molding, extrusion, vacuum forming.	Pipe fittings, notebook binders, self-hinging containers.
Polycarbonate	Thermoplastic	Good heat and chemical resistance. Color, transparent to opaque. High impact strength. Rigid, dimensional stability.	Molding material. Film, extrusions, coatings, fibers, or elastomers.	Appliance parts, globes, and other lighting, lenses.
Polyester	Thermosetting	Strong and tough. Superior surface hardness. Good chemical and water resistance. Full range of color. Large areas can be covered and can be formed at room temperature with low or no pressure.	Liquids, dry powder, premix, molding compounds, cast rods, sheets, tubes. Reinforcing, molding, casting, impregnating, premixing.	Impregnated glass fibers, paper, synthetic fibers for auto and boat bodies, luggage, skylights, lenses.

Plastic	Type	Properties	Forms and Methods of Forming	Typical Uses
Polyethylene	Thermoplastic	Strong. Can be flexible or rigid. Hard surface, good heat and cold resistance. Good chemical, water, weather resistance. Transparent to opaque.	Pellets, powder, sheet, film, filament rod, tube, foam. Injection, compression, blow molding, extrusion, calendering, coating, casting, vacuum forming, heat sealing.	Flexible ice-cube trays, dishes, bottles, bags for food products, artificial flowers, greenhouses, toys.
Polyimide	Thermoplastic	Excellent heat, wear resistance. New class of nonmelting plastic. Linear structure of thermoplastic but no measurable melting point.	Supplied in form of finished precision parts. Wire enamel, laminates, adhesive, film. Machining, punching, direct forming.	Aerospace parts, valve seats, bearings, seals.
Polyphenylene oxide	Thermoplastic	High impact. Strength and rigidity. Good dimensional stability. Wide temperature range. $-275°$ to $375°F$. Opaque-beige.	Resin. All conventional methods, including extrusion and molding.	Battery cases, coil forms, medical-surgical instruments, valves, pumps, household appliances.
Polypropylene	Thermoplastic	Excellent flexibility. Good heat and chemical resistance. More dense and rigid than polyethylene.	Granules, foam. Injection molding, blow molding, extrusion, films may be heat sealed. Can be laminated to paper, cloth, aluminum.	Safety helmets, pipes, fittings, sterilizable bottles, battery boxes, flexible hinges, housewares, and appliance parts.
Polystyrene or styrene	Thermoplastic	Hard, rigid, good water and weather resistance. Good temperature resistance $140°$ to $225°F$. Most chemicals do not affect. Cleaning fluids, gasoline, and other solvents will harm the materials.	Molding powder, granules, sheets, rods, and other shapes, liquid, foam, adhesives, coatings. Injection, compression molding, extrusion, laminating, machining.	Kitchen items, food containers, toys, battery cases, wall tiles, instrument panels, coatings, adhesives.
Polysulfone	Thermoplastic	High tensile strength. Good chemical and extremes of temperature resistance. Color—transparent to opaque.	Resin may be used as adhesive. Extrusion, injection and blow molding, thermoforming. Machined. Join with solvent or heat sealing.	Appliance housings, hand power-tool housings, computer parts, switches, bonding, laminating.
Silicone	Thermosetting	Good chemical and water resistance. High heat resistance, $350°$ to $590°$. Good mold material.	Resins, fluids, silicone rubber coatings, greases. Compression and transfer molding, extrusion, coating, calendering, impregnating, laminating, foaming, casting.	Mold material, lubricants, release agents, coils, switch parts, insulation for motors.
Urethane	Thermoplastic and thermo-setting	Tough, shock resistant, tear resistant. Good adhesion. Good chemical resistance. Can be foamed in place.	Rigid or flexible foams, liquids, solids. Extrusion, molding, calendering, casting. Cured.	Rigid or flexible foams, adhesives, cushions, coatings, insulators.

Vinyl	Thermoplastic	Strong, abrasion resistant. Good chemical and water resistance. Good heat and cold resistance. Wide color range. Transparent to opaque. Excellent electrical qualities.	Flexible, elastomeric, rigid, cellular or foam. Molding powder, sheet, rod, tube, granules, emulsions, adhesives, lumps, film, resins, coatings, organosols, plastisols, compounds. Full range of working methods.	Raincoats, water toys, upholstery, garden hose, phonograph records, floor and wall coverings. Coated materials.

———— WOOD ————

GENERAL DESCRIPTION

Wood is a natural, fibrous, compact, strong, and readily available material. It varies in its degree of softness and hardness, and its weight is dependent on the specific species.

CATEGORIES

Carving. The most common woods utilized by the sculptor for carving include the fruit woods, apple, pear, cherry; the nut woods, walnut, hickory, oak; and hardwoods such as birch, maple, ebony, rosewood, lignum vitae, sandalwood, teak, and mahogany. Pine and fir are sometimes used for carving but have a tendency to cut and rip unevenly and because of sap deposits make poor carving woods. Many other domestic and imported woods are available for carving with various characteristics. These include ash, beech, bass, elm, satinwood, snakewood, vermilion, poplar, and olivewood.

Construction. The most common woods available for the sculptor are in the form of lumber and are derived mainly of pine and fir. Rough-cut lumber, secured from mills, is usually local wood such as oak, locust, poplar, pine, and fir. Lumber is wood that has been sawed and machined into boards or planks of varying thicknesses and widths. These are usually stand-ardized, e.g., $1'' \times 2''$, $1'' \times 4''$, $1'' \times 6''$, $1'' \times 10''$, $1'' \times 12''$, or $2'' \times 2''$, $2'' \times 3''$, $2'' \times 4''$, $2'' \times 6''$, $2'' \times 8''$, $2'' \times 10''$, $2'' \times 12''$, in lengths up to 16'. These are not the actual sizes of finished lumber, however, because the surfaces are planed (smoothed), so that a $2'' \times 4''$ may only measure $1\frac{3}{4}'' \times 3\frac{3}{4}''$. The shortage of wood and high labor costs are continually shrinking the standardized measurements. Wood by-products and processes also make available for construction such woodlike materials as plywood, masonite, particle board, and various wood panels that usually measure $4' \times 8'$, with thicknesses in multiples of $\frac{1}{8}''$.

GENERAL CHARACTERISTICS

The very nature of wood allows for a wide variety of color, grain, hardness, weight, and strength. A full range of sculptural forms is possible through carving to machine working. Finishes extend from natural coloration through the painted surface. Wood is easily worked with the proper hand tools and power equipment. Joining can be accomplished with a wide variety of adhesives, devices, and jointing.

———— MISCELLANEOUS INFORMATION ————

PLASTERS

It is better to control the setting of plaster through the temperature of the water and the amount of agitation rather than to depend on retarders or accelerators. More plaster can be added to thicken the mix, but water should never be added once the mixture has been agitated.

To harden the surface of plaster, brush with limewater.

To achieve a hard, dense plaster add 5 to 10 percent white Portland cement to a minimum of water.

Plaster Retarders

Cold water
Add alcohol or sugar to mix water
½ teaspoon of calcined lime to 1 quart water

Plaster Accelerators

Hot water
Maximum plaster to minimum water
1 teaspoon salt to 1 quart water

CEMENTS

Cements. A mixture of:

Cement	1 part
Sand	3 parts
Aggregate	3 parts

Masonry Cement. A mixture of:

Cement	1 part
Sand	3 parts
Lime	$\frac{1}{3}$ part

Prepared Cement Mixtures. Sakrete or Homecrete are good for direct building over a plaster base coat. Wet surface before applying.

INVESTMENTS

Facing

Plaster	2 parts
Silica flour	3 parts
Small quantity talc or grog	

Build ½'' thick. To this mixture add 50 percent luto (pulverized plaster molds) or ashes (60 mesh), complete mold.

Ceramic Shell

Slurry

1 pound liquid (colloidal silica)
2½ pounds powder (zircon)
5 drops (maximum) surfactant

Stucco

#1 grain—first coat
30/60 molochite—subsequent coats

Core Sand

Sharp sand	50 parts
Linseed oil (boiled)	1 part

Separators

Soapy water
Green soap
Liquid soaps
Oils—solvent mixes
Paste waxes
Water glass (sodium silicate)
Silicone sprays
Plastic release agents

WAXES

Modeling Wax

Mobil 2300
Microcrystalline wax
Soften with mineral oil or Vaseline, stiffen with paraffin

Pouring Wax

Microcrystalline wax	1 part
Rosin	3 parts
Beeswax	1 part
Paraffin	1 part
Rosin with 10% glycerine	1 part

WOOD FILLER

Wood flour	100 ounces
Powdered rosin	½ ounce
Mix together:	
Castor oil	½ ounce fluid
Alcohol	½ ounce fluid
Acetone	½ ounce fluid

Add to dry mix, blend, keep in sealed container. To color: use specific wood dust, walnut, cherry, etc., or add pigment for desired color.

LOW-MELTING ALLOYS

Comprised of varying proportions of cadmium, tin, lead, and bismuth. Usually:

Cadmium	12½%
Tin	12½%
Lead	25%
Bismuth	50%

Melting Points of Metals and Alloys (approximate)

Metal	°F
Aluminum	1220
Brass	1650
Naval brass	1625
Red brass	1830
Aluminum bronze	1940
Manganese bronze	1650
Nickel bronze	1965
Chromium	3275
Copper	1980
Gold	1945
Iron, cast	2150
Iron, ingot	2800
Lead	620
Monel	2425
Nickel	2645
Nickel silver	2000
Silver	1760
Stainless steel	2550
Tin	450
Zinc	785

Cleaning Solution for Aluminum. 10% sodium hydroxide with salt water solution. Boil, dip.

Coloring Solution for Aluminum

Gray—Dilute solution of hydrochloric acid. Dip, brush. Polish with drops of linseed oil on cloth.
Black—Boil 1 quart water, dissolve caustic soda (4 ounces), add salt (calcium chloride,

1 ounce). Immerse for at least 15 minutes. Clean-water rinse.

Blue—Do not boil; heat to approximately 150°F: ferric chloride (60 ounces per gallon) and potassium ferrocyanide (60 ounces per gallon).

Cleaning Solutions for Brass, Bronze, and Copper.

Always add acid to water slowly. Heat the work, brush or dip in cold solution. For large pieces, air cool and apply hot solution.

Bright Dip

Nitric acid	50%
Water	50%

Matt dip

Hydrochloric acid	1 part
Sulfuric acid	6 parts
Water	6 parts

Coloring Solutions for Brass and Bronze

Blue—Apply a very warm solution of:

Sodium thiosulphate	2 ounces
Lead acetate	1 ounce
Water	1 pint

Blue-Green—Heat to boiling and apply a solution of:

Sodium thiosulphate	¼ ounce
Ferric nitrate	2 ounces
Water	1 quart

Brown—Heat to boiling and apply to cold work a solution of:

Liver of sulfur	3 ounces
Water	1 gallon

Green—A solution of:

Ammonium chloride	16 ounces
Copper acetate	8 ounces
Water	1 quart

Blue-Black—Apply a cold solution of:

Ammonium sulfide	2 ounces
Water	1 quart

Black

Ferric nitrate	8 ounces
Water	1 gallon

Solution to Blacken Steel

Sodium thiosulphate	3 ounces
Water	1 gallon

Electroplating. Electroplating is a process that allows a thin coat of metal, such as brass, copper, silver, cadmium, chromium, or nickel, to be deposited on the surface of metals and other materials. This is accomplished by electric current passing through a metallic salt solution. A plating metal, as an anode, is suspended in the metallic salt solution, and, as the current passes through the solution, metal particles are dissolved from the anodes and deposited on the object (cathodes). Because of the deadly nature of the compounds, it is not recommended that this be undertaken by the student; the risk is not worth the proportionate cost. It is far wiser and safer to seek professional subcontracting.

Techniques and Processes

Each material used by the sculptor to execute an idea requires its own special techniques for handling. The following information on working with various substances is intended to provide some general knowledge on methods and procedures. For more detailed technical information, please consult the bibliography.

CLAY

METHODS OF WORKING

Modeling. Modeling in clay is done with various techniques, including direct building, forming over an armature, or building up solid and cutting apart, hollowing out, and replacing together. Modeling is primarily the manipulation of clay into a specific form and surface. No hard and fast rules apply to this technique, and it may be used by itself or with other methods.

Tools. To work effectively, it is important to have proper tools.

Assorted mallets

Plastic modeling tools—assorted flat shapes and sizes

Boxwood modeling tools—assorted flat shapes and sizes

Open, wire end, wood modeling tools

Spatulas and paddle

Calipers—aluminum-combination, outside-inside

Process. If the piece is to be unusually large or involves a great weight of clay, a supporting armature of pipe, wood, or hardware cloth (screening) should be devised. This support need only approximate the general line of the piece. Unlike direct building in plaster or cement, the armature is primarily a structural device in the center of the clay. It does not have to approximate the final form, but its main posts and appendages hold up the weight of the clay. Unlike plaster, clay does not set or harden quickly and therefore will not support its own weight. If twine, cloth, burlap, wire, or other materials are wrapped around this

169

main support, it will provide tooth to hold the slippery clay. Another device is to break two small pieces of wood, approximately $1'' \times 4'' \times 1/_8''$ thick, and tie them together with binding wire in a cross fashion. The wire should extend out from this "butterfly" and be secured to the main body of the armature. This can float and be placed within the clay for spot strength and as an aid in dispersing the weight of the clay.

With the armature constructed, begin by applying lumps of clay the size of golf balls and work them into and around the tooth of the armature. Continue to add lumps of the same size until the armature is covered and the form is starting to take shape. Do not try to blob too much clay on at one time. If this is done, it will tend to concentrate the weight, and the clay will not have all the overlapping and interlocking strength of the smaller units of clay. The size of the clay lumps should get progressively smaller as the form is shaped, pounded, pushed, squeezed, paddled, and modeled into shape. As the form becomes refined, so does the technique.

When the clay is not being worked for a period of time, it should be wrapped with a towel that has been moistened. If the clay tends to dry out while you are working on it, the surface may be sprayed with water to keep its workability. Be sure to wrap a sheet plastic, such as a polyethylene dry-cleaning bag or a trash bag, over the wet toweling if the work is left overnight or for long periods of time. The toweling should be wetted down when it drys out.

If the piece is to be kiln fired, it must be hollowed out. This is accomplished by cutting with a fine, thin wire with dowels wrapped at each end for gripping. The wire is drawn through the thickest and main axis of the form. This should only be done when the clay is approaching the leather-hard stage and has some body and strength. When the pieces are separated, the areas with the largest bulk are hollowed out. Wire tools are very useful for this process. The clay wall that remains should be as thin as possible and still remain structurally sound, somewhere around $1/_4''$ is ideal, depending on the configuration of the work. The pieces are then placed back together, and the resultant seam moistened with wet clay and kneaded and modeled back to its original form.

A wide range of surface qualities is possible with the various tools, hand and finger manipulations, and the impressing of other objects into the clay. This is an individual matter and most often a sculptor's style or manner comes through

in the finishing, or the form itself dictates the surface. The work is left uncovered, allowed to dry completely, and fired. Modeled forms that are to be cast are prepared for molding as described in the section under synthetic stone (plaster and cement).

Construction. Clay, a natural earth material, does not evoke a machine quality. However, there are various devices in working with clay for which a construction approach is suitable. One obvious method is to utilize wheel-thrown shapes, as mentioned previously. Others are the slab method, coil method, drape molds, and as a raw material in an environmental and conceptual context.

Tools. Same as those listed for modeling with the addition of rolling pin, knives, water pans, and sponges.

Processes. A full range of working techniques is possible within the construction methods of working with clay. The basic consideration of the clay construction method is the joining of the pieces. Joining is facilitated by taking a small amount of the clay being used and adding enough water to make a thinner mixture that is known as slurry. When two edges or surfaces are to be joined, the surfaces are incised or roughened by scratching with a wire tool, knife, or similar tool; this *tooth* is then covered with the slurry mix, and the clay of the edge and surrounding area is kneaded together. The surface may then require additional clay and surface reworking. This technique of joining can be applied to all of the methods of construction with clay.

The basic difference between the slab and coil methods is the way in which the clay is first shaped. In the slab method, the clay is wedged, patted out on a dry but not too absorbent surface (such as burlap, which gives texture), and rolled out like bakery dough to a uniform thickness. This thickness may be controlled by placing boards with a specific thickness (approximately $1/_4''$) on either side of the clay and rolling the pin down until it rides on these boards. When the slabs are rolled out, they may be cut in any shape desired and removed from the dry surface. They may then be used in endless ways to create hand-built objects by the joining technique.

The coil method, on the other hand, is formed by the action of rolling both palms of the hands over a quantity of clay. The resultant coil is then placed into a continuous cylinder of clay that defines the desired shape. The top surface of this clay shape is roughened, slurry added, another coil prepared in the same manner and placed directly on top of the first coil. This is then joined

in the same technique as above, and the process repeated until the desired height and form is achieved. The shape can be altered as subsequent coils are added. The outside surface can retain the coil appearance or be filled in with additional clay and texture or other surface qualities added. This method allows for a uniform wall thickness and permits the piece to be fired without the necessity of hollowing out the form.

The processes for using clay as a raw material in environmental or conceptual pieces are dependent on the context in which they are employed. Generally speaking, the form or state in which the material is explored will determine the technique. Powder, for example, can be made liquid, sloppy, lumpy, and so on. Liquid clay can be poured, dipped, thrown, brushed, etc. One should not discount the unique potential of clay as a raw material to move from a powder to a liquid, solid, or vitrified state.

Casting. In casting, clay objects are formed by pouring clay into a hollow mold and allowing it to remain long enough for a layer of clay to thicken on the mold wall.

Process. The two techniques used in casting with clay are pressing tempered clay of a modeling consistency into a preshaped form or mold, and the pouring of clay that is very fluid into a mold, then pouring out the excess, leaving a clay thickness around the wall of the mold. When this thickness is sufficiently hardened, the process is repeated until the desired wall thickness is achieved. In both of these techniques the mold material should be of an absorbent material such as plaster. If the mold is very dry, it can be dusted with fine powder to prevent sticking. If the mold is devoid of undercuts and is smaller at the bottom than at the top, the form can be cast in a one-piece mold. A cone shape, for example, may be cast in one piece. If the form is quite complex, the piece mold described in the section on synthetic stone (plaster and cement) will have to be employed. The clay for slip casting is best when it is purchased premixed. It is difficult to control the proper fluidity and viscosity of homemade mixtures.

Clay has many uses within the sculpture studio. Aside from the above uses, it can serve as a material for a preliminary study, as a sealant, a colorant, a thickening agent, and for many other uses which make it an indispensable aid.

STONE

METHOD OF WORKING

Carving. It is possible to acquire a wide variety of stone in every section of the country. The most useful resource guide for the sculptor is the Yellow Pages section of the telephone directory. If no companies sell stone in your area, sources such as monument dealers, building wreckers, or sculpture suppliers should be consulted. It is wise to begin by examining the stone from all angles and determining which way the stratification occurs. Flaws in the stone should be noted, and the design of the form should be related to the general shape and condition of the material.

Tools. Working in stone requires strong, well-made implements.

Carvers, hammer (2 to 4 pounds)
Bush hammer and pick
Large and small points
Pitching tool
Bush chisel
Toothed chisels (assorted widths)
Flat chisels (assorted widths)
Gouge chisel

Carbide-tipped drill bits
Power grinders
Air hammer and assorted stone chisels
Carborundum sharpening slips
Stone files, rifflers, and rasps
Wedges
Sledgehammer
Sandpapers (wet and dry), emery stone, sandstone, and pumice stone

Tools for working granite and other igneous rocks are thicker and heavier than those used for marble and limestone. Use the proper tool for the right stone. Tempering the points can best be accomplished by heating the last 2'' of the chisel to a cherry red and immediately dipping it into cold water up to the 1'' level, then sanding and polishing until the correct temper is achieved. Marble tools should take on a bluish color, and granite tools, a white to gold color. When the right color of temper and hardness is achieved, the tool is completely quenched in the cold water. This is at best a tricky process but proficiency will come with practice.

Process. Determine the overall nature of the stone and the relationship of the desired form within. Bed the stone on a flat surface that is very stable and strong. In the case of irregularly shaped stone, place sandbags underneath. Remove all of the excess stone by splitting as one would split a block of ice. Drill holes along the line to be broken, chisel between the holes to form a continuous line, then force wedges into the line and pound them in until the split occurs. Use the pitcher or large chisel to remove or spall larger chunks away from the main body of the stone.

Use a large, heavy point to begin roughing out the form. Move on to the lighter point, constantly refining the form as you go. Use the toothed chisels to continue refining the form. If the textural surface of the toothed chisel is undesirable, use a flat chisel. A bush hammer can be used at this time to give a mottled surface.

Finish with flat chisels, and, when working in soft stone, files, rasps, and rifflers may be employed to smooth the stone. Sandpapers are then used to smooth the surface for a high polish. Polishing is achieved by wetting down the stone, applying abrasive stones in reverse order of hardness, rubbing in and keeping it wet. Putty powder is applied, rubbed in, polished, and buffed with a soft cloth.

──────── SYNTHETIC STONE ────────

METHODS OF WORKING

Construction. The use of the word *construction* is somewhat of a misnomer. Actually, this section is devoted to the methods employed in creating sculptural forms through the use of synthetic stone materials. The various cements, plasters, and aggregates mentioned previously allow for a wide diversity of material appearance. There are three basic ways of working with synthetic stone: carving, direct building, and indirect casting. If one is interested in working with cements and plasters in one of these three ways, an understanding of the nature of these materials is necessary.

Cement. Cement ranges in color from white to gray. Through the use of dyes and pigments other colors and effects can be achieved. Cement comes in powder form and requires water and time in order to cure and reach its ultimate strength. Cement requires from 2 to 8 hours to set and between 10 and 25 days to fully cure. This time is dependent on atmospheric conditions and 70°F is ideal. During this curing period, the material should be covered with moist cloths to allow for gradual drying. Cement mixed with sand and a small quantity of lime is called mortar and makes an excellent binding material. Cement mixed with sand, stone, marble chips, and other aggregates is known as concrete. In preparing a cement mix, care must be taken that all dry ingredients are mixed first; then the water is added gradually and intermixed continuously. This will prevent a high water-saturation level and add to the final strength of the material. Additional dry mix or water may be added to bring the mix to the desired consistency. Follow instructions on the outside of the bag.

Plaster. Plaster also comes in a dry powder, and white molding or casting plaster are the best grades for sculptural purposes. Plaster, unlike cement, is added to water and takes approximately 15 minutes to set. Begin by taking a quantity of water in a flexible plastic or rubber bowl. Then, slowly sift the plaster through your fingers to disperse the mix over the surface of the water. As the plaster settles in the water mix, it will become saturated and eventually build up to the surface of the water. If not enough plaster is added in this manner, the resultant mix will be too thin and lack body. If too much plaster is added, the mix will be lumpy and will set very rapidly. It will also result in a very hard plaster. This, of course, can be used to advantage. When the correct proportion of plaster is immersed in the water, it should be allowed to saturate for a minute or so before agitating. Agitation should be thorough and the mix made consistent for working. Rapid and excessive agitation will increase the rapidity of setting. After the mix has been agitated, it should be allowed to stand for another minute or so before using. This allows for further dispersion and saturation of the plaster and water.

The consistency of the mix is dependent on the purpose for which it is to be utilized. If it is to be poured into a form or mold, it should be on the thin side; if it is to be used as a modeling material, it should be somewhat thicker. A good test for getting the desired consistency is to dip your clean hand into the mix to see how it clings to your fingers. If the mix has the proper proportions, it should be the consistency of a medium to heavy cream, and it should coat the hand evenly. It is best to begin with small quantities,

and, in the case of adding aggregates, it is sometimes easier to achieve dispersal if they are mixed in after the first agitation. Separation usually occurs when they are added first to the dry mix. Never add additional water to the mix. If it thickens and sets before you can use it, throw it away. Although it is not a good practice to add more plaster to a thin mix that has been agitated, this is not as crucial as adding wter. When using aggregates, dyes, pigments, or other additives, it is important to run tests to determine not only the qualities of the material but the setting time and the effect of the additives on the mix.

Note: It should be mentioned that there are other cements and plasters available. Some of these are patching cements, plastic-resinated cements, keene cement, hydrostone, and hydrocal. The principles of mixing these are basically the same. Instructions on the container should be consulted.

Carving. Carvings in cements and plasters have a great deal of advantage over stone. Because the material is at one stage in a fluid state, it may be poured into an approximation of the desired form. This eliminates a great amount of roughing out. Obviously, the material is intrinsically different from stone but does possess a stonelike quality and permanence. Because of their fluid nature, cement and plaster can be poured around objects that can be removed after setting has occurred, thereby leaving voids. These include balloons, styrofoam shapes, and any other material that can be collapsed or broken down and removed easily. It is also possible to create a stop-action quality with the material. For example, because the material moves from a liquid to solid state, it is possible to freeze the action of pouring, thereby achieving a variety of surfaces and textures.

Tools. Although stone-carving tools may be used for carving cements and plasters, it is wiser to use such tools as knives, discarded saw blades, spoons, and plaster-working tools. Upon hardening, the material can be worked with open-type rasps and other files and sandpapers.

Process. Mix the cement or plaster to the appropriate state. Pour into predetermined form or block. Ordinary cardboard boxes lined with plastic or coated with Vaseline, or plastic-coated cartons will serve as suitable containers. When the mix is in the form, shake the mix by tapping the side of the box. This forces the air bubbles out and will result in a more consistent density. When the mix is first set — 15 minutes for plaster, 2 hours for cement — remove the supporting form and start to carve directly into the material.

Structurally, the material is very weak at this point but strong enough to rough out the form. Allow to dry for a week or so before working on refinements of the form.

Direct Building. Through the technique of direct building, the form possibilities are greatly extended. This method involves the use of some supporting device which is commonly referred to as an armature. This can be a complex system of wood construction with wood lath approximating the final surface, or it can be constructed out of wire fencing, window screening, styrofoam blocks, pipe and wire construction, newspaper, and any other device that will hold the plaster or cement in place until it sets and a preliminary coat is established that covers the entire form. Subsequent coats are added until the desired form, thickness, and surface are achieved.

Tools. Plaster-working tools including modeling tools, spatulas, knives, discarded saw blades, open-type rasps, files, and sandpapers.

Process. Begin by deciding on the general configuration of the work. Proceed to construct an armature in materials that will allow for the necessary size, form, and weight of the finished piece. The armature should approximate the final form, but it should be slightly smaller by ½" to 1" all over the surface. The first coat of plaster should be a relatively thin mix that allows burlap or other reinforcing cloth to be dipped, permeated, and applied to the armature. It is best to work in small sizes for ease of handling, although it is possible to immerse and work with a large shape or an entire garment such as a shirt or pants. This impregnated material is then applied over the armature and serves as the bond between the support and subsequent coats.

It is not wise to work with a concrete-type mix in direct building. If cement is desired, a mortar mix or a patching cement or plastic-resinated cement mix should be used. Plaster should be employed in the first reinforcing coat regardless of the material used for subsequent coats. Between each layer that is built up, the surface should be left with a slight roughness or tooth and should be wet before the addition of plaster or cement. As the material is added, the form is refined further. Many surface qualities are possible in direct building with cement and plaster, from rough to smooth with all variations in between.

Casting. Casting is the process whereby a fluid mass is poured into a predetermined shape or mold until the mix hardens. When the fluid mix is set the mold material is removed to expose the finished casting. Synthetic stones that begin

in the form of a powder and are converted to liquid with the introduction of water and then harden make excellent materials for casting. These include cements and plasters with various aggregates, resinated cements, and various plastic materials. Though our concern here is with the casting of synthetic stone, the same techniques and principles apply to whatever material is being used as the casting liquid. In the case of plastics, a stronger separator must be employed. While the general term employed is casting, the central most important aspect is molding.

Molding. Although many forms of molding are available to the sculptor, the most common ones fall into four major categories: waste mold, piece mold, flexible mold, and relief mold. Molds are employed to make duplicate forms or to transfer a form from one material to another.

Waste-Mold Process. The waste-mold process is what the name implies—it is a one-time reproductive mold. The mold is lost. Plaster is usually the molding material. Begin by studying the form to be molded and try to determine the most logical division. Generally, if the high points of a form are examined, they will provide a key to the division seam, or shim line. If the material of the original is a soft, plastic substance such as clay, thin brass metal shims may be inserted into the clay along the dividing lines to a depth of $\frac{3}{8}''$ and protruding out to a height of approximately 1''. This serves to separate the form into pieces for molding.

If the original is of a hard material, thin strips of clay can be secured at right angles to the form along the division line. These clay shims should extend out approximately 1''. The surface of the hard original should be coated with a mild separator. It is not necessary to coat the original if the form is of clay or similar surface. If it is possible to remove all of the clay from a waste mold, divisions are not necessary and a one-piece mold can be employed.

The first coat of plaster is relatively thin and a colorant of pigment is added to discolor the material. This substance is then applied in a flicking motion, making sure that no air bubbles result on the surface. The shim edge must be kept scraped, and these edges are exposed after each successive coat. A heavy plaster mix is made ready and applied over the first warning coat. Subsequent coats are applied until the mold is built up to an approximate thickness of 1'' over the entire surface, with only the edges of the shims exposed. In the case of clay shims, one side is built up in the same fashion and allowed to harden. The clay

shim is then removed and the resultant separation coated with a separator of soap, oil, water glass, or similar solution. The same process of building a warning first coat and subsequent layers of plaster to a thickness of 1'' is continued on the rest of the form to be molded.

After the mold has set, wedges are placed along the shim line and the mold is forced open and taken off the original. The mold is washed and soaked in water to minimize the absorption of moisture by the mold, the separator is applied to the interior surface, the mold is placed back together and secured with wire, inner-tube bands, or burlap strips that have been dipped in plaster. The casting material is then poured in, the mold is tapped to drive off air and is set aside to harden. The materials used to secure the mold are removed, and the mold is chipped away down into the mold until the first warning coat is exposed. This colored layer serves notice that you are getting close to the immediate surface of the casting. In the removal of this mold, it is wise to cushion the shock of the hammering with chisels by placing sandbags underneath. Work from one end in a manner that which allows for the chips being removed to have somewhere to fly out. Do not go straight into the mold with hammer and chisels as you will send shock waves through the mold and casting that might damage the piece. Work in a semicircular method to clear and expose the casting gradually. Chase the shim-line feather by blending into the surrounding material.

Piece-Mold Process. The technique for making a piece mold is basically the same as for a waste mold, except that the pieces of the mold are designed and separated in such a manner that they are devoid of undercuts and crevices that lock the mold to the casting. The same principles of metal or clay shim used in the waste-mold process apply to the piece-mold technique. One exception is that the angle of the shim may have to be altered to allow the pieces to come apart and fit back together easily. In some cases, the sequence of fitting the pieces together is crucial to facilitate interlocking. It is often necessary to seal the shim line of the mold with moist clay to prevent leaking of the casting liquid. If the mold has a large enough opening on the bottom to allow your hand to pass through, it is possible to make a hollow cast by filling the mold approximately half full with the casting liquid in a heavy state and by rolling the mold around until the entire inside surface is coated. Before the material has set, burlap or other reinforcing cloth is pressed

into the material and allowed to set. The process is repeated until the desired thickness is obtained. If the opening in the mold is not large enough to get your hand in, or if you desire, the mold can be cast solid. In some instances, it is necessary to suspend a reinforcing metal rod within the mold before pouring the casting liquid.

Another variation of the piece mold is called a press mold. The individual pieces of the mold are used separately and material that is pressed into the pieces is somewhat more stable and heavy. Clay, putties, or dense plastic mixes are pressed to conform to the shape of each piece of the mold. The mold is then put together, and from the inside of the mold the remaining shim lines are pressed with the same substance.

Still another variation of the piece mold is simple draping over a form with a material such as impregnated burlap, cloth, or other pliable material. This is allowed to set and then removed and joined through various means.

Be sure to utilize a separator in all molding. Each form is individual, and it is impossible to cover every contingency. However, if care is taken to study the high lines and forms and regard it almost as an interlocking puzzle, most forms can be molded successfully. It is better to have more pieces, if in doubt, than to have fewer and have a casting locked in a mold. If this does occur, the mold will have to be sawed, cut, broken, or chiseled in some manner to release the casting.

Flexible-Mold Process. While there are various types of flexible molds possible in the casting of sculpture—gelatin or glue molds, polyvinyl chloride, vinyl compounds, synthetic rubbers—the most common is rubber latex. The process is quite lengthy and some shrinkage and warpage can occur, but the ease of handling and elasticity allow a reduction in pieces for moderate undercuts and crevices. The piece to be molded is treated with a separator of castor oil and alcohol. The same principles of piece molding are employed and the shims put in place. The latex can be brushed on in successive coats, making sure that the first coat is free of any air bubbles on the surface and that each coat is allowed to dry before the addition of the next coat. For large undercuts, the latex will have to be thickened with a filler such as Cab-O-Sil or sawdust. Subsequent layers are built up until the desired thickness is achieved. The latex should be allowed to follow the form and continue out to and encompass the shim and, in so doing, form a continuous flange of latex.

When the mold is approximately $1/16''$ to $1/8''$ thick and all undercuts are filled with molding compound or reinforcing fabric, a *mother* or back-up mold of plaster is formed over the latex. It is wise to coat the latex with a separator before applying the plaster for the mother mold. When the plaster of the back-up mold has set, it is cracked open; the flange is cut with a sharp knife or razor blade at the edge of the shim; and the mold is cleaned and replaced in the back-up mold. The separator is then applied, and the mold pieces are secured together, sealed with clay or plaster strips, and the casting liquid poured in, making sure air is driven off by tapping the side of the back-up mold. The mold is opened after the liquid sets, and it is wise to clean the mold after each use and rub some talc over the inside surface for storage.

Materials other than synthetic stone may be cast in a flexible mold. These include various plastics such as acrylic, polyester, epoxy, and other resins. Metallic auto-body putties may also be employed. Tests should be made to determine if the mold and the casting substance are compatible.

Relief-Mold Process. Relief molding is an easy method for reproducing a limited two-dimensional surface or shape that does not have any undercuts and is low relief and shallow dimension. The form may be a positive or negative type, around which is placed a retaining wall or box. The modeling material may be of clay or sharp sand. The molding plaster is simply poured within the retaining wall and allowed to harden. The mold is then removed and cleaned, a separator is applied to the mold surface, and the casting liquid is poured into the mold. If a raised thickness is desired, an additional retaining wall should be built up around the outside edge of the mold before pouring.

Finishing. The finishing of synthetic stone is a highly personalized attitude. It is possible to brush limewater over the surface and apply thin coats of boiled linseed oil. Sodium silicate is also used as a sealer. White beeswax that has been softened can be applied very thinly and buffed. Varnish, shellacs, and plastic sprays can all be used. The surface can be treated with weatherproofing material used for masonry. Paint, stain, and metallic-powder compounds may also be applied for color and surface effects. Some people feel that truth to materials is all-important; others, that any enhancement of the surface improves the overall quality of the piece. The choice must be an individual consideration.

━━━━━━━━━━━━━━━━━━━━ **METAL CONSTRUCTION** ━━━━━━━━━━━━━━━━━━━━

GENERAL DESCRIPTION

The techniques that may be utilized in the metal construction of sculpture are myriad. They include the following: bending, cutting, forging, hammering, stamping, melting, exploding, drilling, milling, turning, building through placement, and combinations of all of these. Metals may be joined by compression, folding, welding, brazing, riveting, screws, nuts and bolts, fusing, solder, epoxy glues, interlocking, inlay, and securing with extraneous materials, and combinations of all of these methods. Metal may be finished by grinding, sandblasting, polishing, staining, painting, metal spraying, electroplating, patination with chemicals, coating with other materials, and combinations of all of these. Space does not allow more than a cursory look at some of these many techniques, nor is it possible to cover every contingency. What follows is a brief description of a few of the processes. For more detailed information, the bibliography should be consulted.

Tools. The range of metal-working hand and power tools is enormous. Many of the power tools are extremely expensive and lie beyond the reach of the average sculptor. Many of the processes that they perform can be subcontracted or done by hand. It is wise when purchasing tools to buy the heavy-duty type rather than to save a few dollars. The nature of its sculptural use puts more strain on the equipment, and, unless it is of professional quality, it will not give the necessary service. Tools should be cleaned, oiled, sharpened, and serviced regularly. The tool is an extension of a person's power to shape and form material. The following is a general list of tools available.

Hand Tools. Hammers, files, pliers, wrenches, wire brushes, calipers, dividers, screw drivers, hacksaw, tin shears, chisels, centerpunch, clamps, circle cutters, countersinks, drill bits, riveting tool, levels, scribe, pipe cutters, pipe vise, combination set and squares, gauges, tape measure, steel rules, goggles, tap-and-die set, vise, anvil, sandpapers, steel wool, bending jig, gloves, soldering gun or iron, stakes, and forming tools.

Power Tools. Drill, drill press, disc sander and grinder, belt sanders, finishing sanders, circular saw, sabre saw with metal-cutting blades, bandsaw, metal shear (power and portable), metal lathe and accessories, power grinders and buffers, milling machine and accessories, bending brake, oxyacetylene welding outfit and accessories, electric arc welding outfit and accessories, tungsten inert-gas welding (TIG) outfit with accessories, or metallic inert-gas welding (MIG) outfit with accessories.

CONSTRUCTION PROCESSES

Cutting. Metal may be cut with a hacksaw, power hacksaw, power shear, portable shear, bandsaw, sabre saw, circular saw with metal blades, oxyacetylene and other welding equipment, tin snips, and wire cutters.

Oxyacetylene Cutting. The principle involved in the cutting of metal with an oxyacetylene process is the introduction of excessive amounts of oxygen to the metal which forms a molten puddle. This increases the oxidation and actually burns a hole through the metal. Once the molten stage has been reached and the excessive oxygen introduced, this can be pushed along any given line and direction, thereby cutting through the metal. This requires a special cutting-torch attachment that has an additional oxygen valve and an oxygen lever. It is so designed that when the extra oxygen is desired, the lever can be depressed and the oxygen released through the center hole in the cutting tip. Cutting requires that the pressure of the oxygen regulator be greatly increased. This is done in relation to the thickness of the metal to be cut. The metal to be cut should be elevated or suspended over the edge of a table in some manner so that the sparks and slag (excess burned metal) will have somewhere to fall away. One safety note—point the torch away from you and watch the direction in which the sparks fly. A back-up screen of treated canvas or a water or sand bed below the work are wise studio practices. Sparks and particles of molten metal will travel across a concrete floor rapidly. High-top shoes and welding goggles are also good safety practices when welding and cutting.

Drilling. Holes of various sizes and shapes can be achieved by using a portable power drill, drill press, and accessories such as drill bits, countersinks, hole saws, circle cutters, reamers, files and other shaping devices, punch press, notchers, and stampers.

Shaping and Bending. Bends can be placed in sheet metal by a bending brake, with a pipe-bending tool, by placing under extreme tension

Cutting Chart

Metal Thickness in Inches	Cutting Tip No.	Oxygen Pressure* (psi)	Acetylene Pressure* (psi)
1/4	0	30	5
3/8	1	30	5
1/2	1	40	5
3/4	2	40	6
1	2	50	6
2	4	50	7
4	5	60	8

*These pressures will vary between manufacturers and types of outfit. Consult and follow the instructions and procedure for the outfit being used.

or compression, by explosion, hammering-stakes, forms, bending jig, rotary machines, roll-forming machines, bending machines, and by using preformed shapes or discarded objects. Applying excessive heat to a piece of metal will cause it to weaken enough to bend by hand. Milling machines are capable of grinding down a metal surface and cutting various shapes into the metal. Metal lathes can turn down and shape metal on a cylindrical and symmetrical axis. Forging allows for shaping by subjecting the metal to heat just below the melting point and then hammering the metal to force it into the desired shape.

JOINING PROCESSES

General Discussion. Many techniques are employed for joining metals together. The process of adhesives is a relatively recent one with the development of extremely strong bonding agents such as epoxy glue. This is a two-part mixture that creates a catalytic action resulting in a glue that provides an extremely strong joint. These glue joints should not be exposed to high temperatures, which will cause the joints to weaken and give out. Glue, even of the epoxy variety, is a weak substitute for other methods of joining metals. These include the use of sheet-metal screws that have oversized threads which tend to lock the screws within the previously drilled holes.

Machine screws and bolts are also useful joining devices. These are placed through holes in the pieces of metal to be joined together and secured on the opposite end with washers and nuts. The size and type of these fasteners are determined by their diameter, their length, and the type of head. Specific information on screws is included in the section on wood construction. A variation on the machine screw or bolt is the joining of metals with the riveting technique. While there are commercial riveting tools on the market that work very well, ordinary rivets are relatively easy to use and are much cheaper.

A rivet is a thin shaft with a head that is inserted into corresponding holes in two or more pieces of metal. While the head is held firm, the back is pounded flat to cover the hole. This firms the rivets and sandwiches the pieces of metal together between the heads of the rivet. The obvious disadvantage is that access must be available to the back side of the rivet for flattening. While there are explosive rivets for this purpose, a pop riveting tool solves the problem quite easily. This tool feeds the rivet from one side and through reverse pulling action flattens the hidden end. It can be purchased in any hardware store and is an indispensable tool.

One other advantage of plain rivets, however, is that they can be used to join metal to other materials such as a piece of wood. This is done by drilling the corresponding holes in the materials to be joined, inserting a shaft of soft metal, such as aluminum or brass, and cutting the ends off so that a small amount can be hammered down to cover the holes. It is wise to drill the holes so that the shaft fits tightly, thus giving a stronger union.

Another method of joining metals is by crimping them together. This can be utilized on thin-gauge sheet metal with a crimping tool or by simply placing two edges of metal together, and bending and flattening them in a vise into an

interlocking position. It is also possible to join metals together by designing interlocking joints and angles that hold in place but do not bond the metals together. This is similar to wedging one piece of metal between two stationary objects. Though no bond exists, the metal is held in position through tension and compression. Still another method is to use wire or cable to suspend or secure pieces of metal together by means of a turnbuckle or cable clamps.

Metal also may be joined together by the use of extraneous materials such as twine, rope, plastics, cloth, sheeting, coatings, and many other materials. While they tend to be unconventional, these last few techniques extend the material and form usage of the sculptor. Perhaps the most common method of joining metals together is the fusing technique. Before we get into welding and brazing, it would be wise to discuss a more elementary method of this technique—soldering and spot welding.

Soldering is a process that joins two metals— usually of the same kind—together by heating the surfaces to be joined. When the surfaces are sufficiently heated, the area is touched with a low-melting metal such as lead, which melts and flows into the joint and fuses the metals to each other. Solder must be used with a flux to increase its ability to flow. This may take the form of a paste into which the solder is dipped, or it may be in the core of the solder itself. The most common of these types of solder is acid core or resin core. The acid type is best suited for metal. Other types of solder are silver solder and aluminum solder.

When soldering, the metal must be thin enough and the heat sources great enough to allow the metal to heat up and melt the solder. It is essential that all surfaces to be joined by soldering are thoroughly cleaned and free from oil or grease. Thin gauges of galvanized steel, copper, and brass are easily soldered. One difficulty is that if one joint is too close to one that has been previously soldered, the heat will travel through the metal and release other joints. The heat source for soldering may be a small air acetylene or propane unit, or it may be an electric soldering iron or gun.

Spot welding is a process that is used to bind two pieces of similar ferrous metals together by concentrating an electric charge between two shaft points that are activated when the jaw is clamped down onto the metals. The action is much like holding two pieces of paper between your thumb and index finger. The process is automatic when the switch is activated. The tongs come in various lengths and shapes to allow for getting into various interior spaces. Tips come in standard, flat, and offset shapes. There is a spot-welding gun on the market that eliminates the need for a backing plate. Two disadvantages of spot welding are that a certain amount of warpage takes place if too many welds are used and the surface is slightly marred by the spot. However, if controlled, both of these problems are minimal and the neat and strong bond outweighs these factors. A spot-welding machine, either portable or mounted, is a useful addition to any sheet-metal working. These two methods of joining—soldering and spot welding—are good introductions to the techniques of gas and electric welding that are employed for thicker and heavier metal joints.

Oxyacetylene Welding. Oxyacetylene welding is the joining of two metals together by applying excessive heat to the joint to bring these metals up to the melting point, and at the same time introducing a filler rod that also melts, fusing all three parts together.

There are three types of welds. A *fusion weld* uses the torch to heat the joint of the two metals up to the melting point. When this stage is reached, a small puddle of molten metal forms on each of the pieces of metal. The torch is then moved in a semicircular motion, and the puddle fuses together and is pushed along the seam or joint. With the second type of welding, two identical metals are joined with a filler rod of the same material. The process is the same as fusion welding except that when the puddle stage is reached, the filler rod is also melted and put into the puddle. The torch is worked in a semicircular motion around the rod, and the puddle is moved along the seam with this action. The third type of weld is called a *braze weld* or *brazing*.

Brazing is exactly like the previous technique except that the parent metals may be different types, such as brass and steel, and they are joined with a filler rod that is comprised of a nonferrous metal such as brass or bronze. Brazing can also be used to *float* a molten brass or bronze filler rod on a preheated metal surface and achieve a rough-surface brass- or bronze-plating effect. Filler rods come in many diameters and some are coated with a fluxing compound. Ferrous rods do not require flux. If nonferrous rods are used they must be fluxed by continuously dipping the hot rod into a flux powder and tapping to remove the excess. While the flux-coated rods are more expensive, they eliminate the need to dip rods in

flux powder, which is an advantage for a beginner in a technique that requires dexterity.

Equipment. For welding, the following equipment is necessary: one oxygen tank and one acetylene tank, high-pressure steel cylinders (rent or lease from welding supply); an oxygen regulator with two gauges—one showing the amount in tank and the other showing pressure (psi); an acetylene regulator with two gauges—one showing approximate amount in tank and the other showing pressure (psi); a torch that consists of a torch handle with two mixing valves for oxygen-acetylene and welding tips of different sizes.

A cutting torch attachment with an oxygen valve and a cutting oxygen valve lever and assorted cutting tips is an integral part of the torch set. A welding tip is a long, thin tube with a slight bend on the end and a single hole of varying size on the tip. A cutting tip is a short tube that is secured to the cutting attachment end and is distinguished by having four or more holes distributed around the flat end and one hole in the middle. These holes are also of varying size. Hoses are color coded: green for oxygen and red for acetylene. The couplings on either end of the hoses also have reverse threads so that they cannot be mixed. After the regulators have been attached to their respective tanks, one end of the hose is attached to the regulator, and the other end is attached to the torch handle, green to oxygen and red to acetylene.

Other equipment includes:

Igniter or spark lighter
Wrenches (combination for all fittings on outfit, supplied with welding outfit)
Goggles—welding, dark-colored optical
Gloves—wrist type, leather or asbestos
Tip cleaner tool
Welding pliers, clamps, and tongs
Wire brushes
Fluxes
Rods—assorted diameters

Note: Keep welding surface, gloves, cylinders, and all equipment free of oil and grease, which ignite violently in the presence of oxygen under pressure.

Process. To set up the equipment:
1. Secure the cylinders in an upright position chained to a cylinder truck or workbench.
2. *Crack* the cylinder valves to clean off dust, etc. Do not open near sparks, flames, or other sources of ignition.
3. Attach the regulators to the appropriate tanks.

4. Attach the hoses to the appropriate regulators, green to oxygen, red to acetylene.
5. Attach the other ends of the hoses to the torch-handle oxygen and acetylene inlets, green to oxygen, red to acetylene.
6. Tighten all fittings and test the outfit for leakage by using a grease-free soap solution brushed over and around the union. If the valves are open and the solution bubbles, leakage is present. Close cylinder valves and tighten all fittings. Repeat soap test.
7. Install welding tip to torch handle.
8. Open cylinder valves and set gauges for correct pressure.

To light the torch:
1. Put on welding goggles and gloves.
2. Open the torch oxygen valve not more than one quarter turn.
3. Open the torch acetylene valve one half to one full turn.
4. Light torch immediately with igniter. Do not use matches.
Note: If the flames burn away or blow out from the end of the nozzle, the gas pressure is probably too high. Readjust the regulators, reignite.
5. Adjust the valves until a neutral welding flame is achieved. If too much acetylene is introduced to the mixture, a carburizing flame will result. This is characterized by an inner cone that is intensely bright with a whitish color *feather* around it and an outer cone that is a pale blue color. The acetylene will have to be reduced or the oxygen increased according to the pressure desired. If excess oxygen is introduced, an oxidizing flame will be produced. The inner cone becomes shorter and the flame becomes noisier and hisses. This is corrected by reducing the oxygen or increasing the acetylene, depending on the pressure desired. The torch-handle oxygen and acetylene valves should be manipulated until a neutral flame is achieved. This flame does not have an acetylene feather, and the inner cone is somewhat longer and more clearly defined. This is the most commonly used flame in welding and serves as a reference point if any of the other flames are needed for specific tasks. An oxidizing flame is sometimes employed for concentrating heat, and an acetylene flame is used for avoiding scale buildup.

To shut off the torch:
1. To shut off the torch for a short time—30 minutes or less—close the oxygen and acetylene valves.

2. To shut off the torch for more than 30 minutes, close the oxygen and acetylene valves. Then:

Close both cylinder valves.

Reopen the torch valves to drain the hoses, regulators, and gauges.

Release the regulator pressure screws. The torch valves should be closed and all gauges registering zero.

Remove the acetylene wrench so that the welding outfit cannot be used by the inexperienced.

Fusion-Welding Process. Clean the metal around the weld zone with a wire brush or steel wool. Position the pieces, with a $\frac{1}{16}''$ space at

2. Heat the joint, then concentrate the heat at the starting point until the metal becomes molten and the puddle is formed.

3. Introduce your filler rod into the puddle, angle your tip at approximately 45° into the work and, with a semicircular motion around the rod, move the puddle along the joint. The flame of the tip should be approximately $\frac{1}{8}''$ to $\frac{1}{4}''$ away from the puddle. If you get too close the torch will clog and go out; if you are too far away from the work there will not be enough heat.

Braze-Welding Process. The process is the same as for the fusion weld except a nonferrous rod is used. Begin by cleaning the work to be joined. Position the work, clamp, and tack weld. Heat the work, use flux-coated rods or dip a heated rod into powdered flux. When the work is

Welding Chart*

Metal Thickness in Inches	Welding Tip No.	Oxygen Pressure (psi)	Acetylene Pressure (psi)
Less than $\frac{1}{32}$	0		
$\frac{1}{32}$ (22 gauge)	0		
$\frac{1}{16}$ (16 gauge)	1		
$\frac{3}{32}$ (13 gauge)	2	5	5
$\frac{1}{8}$ (11 gauge)	3		
$\frac{3}{16}$	4		
$\frac{1}{4}$	5		
$\frac{3}{8}$	7	7	7
$\frac{1}{2}$	7	7	7
$\frac{3}{4}$	9	9	9

*Each manufacturer has individual operating instructions and procedures. The above are generalized working operations, and each outfit should be operated according to the manufacturer's instructions. In purchasing a welding outfit, it is wise to check for the feel of the torch handle. Weight, balance, and ease of valve manipulation are crucial. After many hours of welding, these factors can be tiresome if the handle is too heavy or awkward in its balance. The chart above is a general guide for tip size and relative pressures of oxygen and acetylene. Each outfit may vary in its numbering system and its recommended pressures.

beginning of the weld and a $\frac{1}{8}''$ space at the end of the weld. Clamp if necessary.

1. Ignite torch and tack weld with a fusion weld, starting at the ends. Work from right to left if you are right handed, left to right if you are left handed.

cherry red in color and the melting point is reached, insert the rod into the puddle and progress along the joint. When the brass rod is inserted into the puddle, it tends to create a spitting action called *tinning*. This indicates that the metals and the rod are fusing together. On

thinner metals, brazing can be used like a solder, whereby the brass filler tends to run along the seam rather than form a bead.

Note: Oxyacetylene and braze-welding processes work on nonferrous materials such as brass, bronze, and copper, and on ferrous metals such as steel. Cast iron is difficult to weld and requires preheating, slow welding techniques, and special fluxes. Aluminum can be welded with oxyacetylene techniques but requires special aluminum rods and fluxes and is extremely difficult. It is best welded with a heli-arc outfit. Stainless steel in thin gauges may also be welded with oxyacetylene but it is very tricky and requires special rods, fluxes, and technique. Inert-gas-shielded arc welding is advised.

Electric Arc Welding. This is a technique in which an electric charge is passed through a special electrode (welding rod) that, when placed close to an oppositely charged piece of metal, creates an arc, or electric charge, that melts and fuses the metal and rod together. This technique is usually limited to steel that is at least $1/8''$ thick. It is instantaneous and provides an extremely

strong weld. There is an attachment called an arc torch that uses a specially designed handle with adjustable carbon rods. This creates a flame and allows for preheating, small brazing, and soldering jobs.

Tungsten Inert-Gas Welding (TIG). This process employs the striking of an arc in an inert-gas (usually argon) shielded area that fuses the metals and filler rod. It is ideal for aluminum and stainless steel.

Metallic Inert-Gas Welding (MIG). The MIG process employs the same inert-gas shield to protect the weld area. The main difference in this process is that a continuous wire electrode is fed through the torch at predetermined speeds. The TIG method relies on a handheld filler rod.

Note: TIG and MIG are relatively easy to learn if one is proficient in oxyacetylene welding. However, both machines are quite expensive and unless used extensively are not a wise investment for an individual. The electric arc welding machine can be purchased for approximately the same price as an oxyacetylene outfit.

─────────── **METAL CASTING** ───────────

GENERAL DESCRIPTION

The four most common techniques for casting in metal that are employed by the sculptor are the lost-wax method, the ceramic-shell method, sand casting (cope-and-drag), and sand casting (full-mold).

In the lost-wax method, the form is built up directly in wax or a wax pattern made from a mold and placed in an investment mixture (plaster, silica flour, luto) with vents, sprues, gates, and pouring cup also made of wax. The mold is allowed to set and is then placed in a burn-out furnace or kiln, and the wax is burned out and the mold heated. This may sometimes take two to three days. Molten metal, usually bronze, is then poured into the mold. This is allowed to cool; the investment is broken away; vents, sprues, gates, and pouring cup are cut away; the casting is cleaned, chased (surface detail), and finished with patina or other means.

The ceramic-shell method of metal casting begins with the same type of wax pattern, except that only an occasional sprue is necessary, no vents, and a pouring cup fashioned out of a

cone-shaped paper cup leading into the main gates that feed the metal to the piece. These gates are also constructed of wax. The pattern is then covered by brushing, spraying, or dipping a slurry mixture of a prepared chemical (collodial silica). This is immediately covered with a stucco grain (air-floated refractory grog) and allowed to dry. Subsequent coats are built up in this manner until a wall thickness of at least $1/4''$ is achieved. When the mold is dry it is placed in an oven or dewaxing furnace and the wax burned out. The temperature of the furnace should be approximately 1200°F, and the shell should be immersed quickly in the heat. This thermal shock *sets* the shell. The mold is left in the heat for approximately 15 minutes or until all signs of residue are burned out. The shell is packed in preheated sand, and the molten metal immediately is poured into the shell. Because the shell material is microscopically porous, the air and gas vent through the shell. This eliminates the need for vents and facilitates cleaning and a great deal of chasing.

Sand casting falls into two categories: cope-and-drag and full-mold process. Cope-and-drag molding, simply stated, consists of two frames of varying sizes and heights into which specially prepared molding sand is stamped around a pattern that occupies a central position. The molds are separated, the pattern removed, and the molds replaced together leaving a cavity in the middle into which the molten metal is poured. Venting takes place through the sand. For hollow pieces, cores made up of cured or self-setting sand are inserted into the mold prior to pouring. This is a very brief description of the process, and it will be explored in greater detail under the process section.

The full-mold sand casting process is much simpler in its technique. A pattern is made out of styrene foam or the more common styrofoam. This pattern is encased in a box or flask with molding sand packed compactly all around the styrofoam. A gate connects the pattern to the pouring cup. The gate is also constructed of styrofoam, and the pouring cup can be made with a cone pattern or styrofoam. The molten metal is poured directly into the styrofoam pattern and as the styrofoam vaporizes the metal fills in behind it. The sand will hold its shape long enough for this to occur. The result is a solid cast.

Foundry Equipment. A good choice for a furnace is the McEnglevan B-70 with blower and automatic cutoff system and 200 pounds-bronze capacity.

Other equipment includes:

Hoists, carts
Crucibles—graphite, silicon carbide, #10, #20, #30, #60, #80
Tongs for removing smaller crucibles from furnace, vertical lift
Shanks for pouring metal from crucible (one-person and two-person)
Pyrometer—handheld type
Flasks—assorted sizes
Sand-casting tools—trowels, runner tool, bench lifters, gatings tools, spoons, riddles, bench rammer, riser pins, parting powder
Ladles, skimmer
Asbestos safety gloves, aprons, suits, leggings
Burn-out furnace (may be constructed with firebrick and separate gas burners to size needed)
Dewaxing furnace (may be constructed of steel drum, lined with refractory material, and built with a separate gas burner; drum should have a large hole in the bottom to allow for wax runoff, and there should be a water bucket underneath)
Ceramic shell tools—shakers for stucco grain, slurry mixer, catch basins for slurry and stucco, steel rod and nichrome wire for suspending the shell in the dewaxing furnace
Sprue molds for casting wax into cylindrical shapes, made of plaster
Sheet molds for casting wax into sheet form, made of plaster
Modeling wax, casting wax
Molding sand
Investment materials
Styrofoam
Ingot metal

PROCESSES

Lost-Wax Investment Casting

1. The wax pattern may be built up directly in wax, modeled over a core armature, or cast in sheets for construction from a plaster piece mold. If the pattern is built up directly in wax, the thickness of the wax can easily be controlled. If wax is modeled directly over a core of refractory material, it should first be dipped in wax to assure a minimum wall thickness before modeling begins. If the wax pattern is cast from a plaster piece mold, it will be necessary to insert metal core pins through the wax so that when the core material is placed in the hollow wax pattern and the exterior covered with investment, the core will remain in place during the burning out of the wax.

2. To this wax pattern a series of wax sprues, called feeders or runners, must be added. Usually, they are distributed over the entire piece and also concentrated where a constricted form or bulk occurs. From these main feeder sprues, a single wax-pouring cup emanates. These should lead primarily from the pouring cup down to the lowest portions of the wax pattern, and from them secondary feeder sprues attach to the wax pattern. It is also necessary to have riser vents of wax to throw off the gases in the pouring. Like the sprues, these should be strategically placed to give the best distribution. When the pouring cup is placed in an upward position, the main sprues go downward with the secondary feeder sprues pointing upward and in toward the wax pattern. This helps to break the pressure and the force of the bronze and allows for the cavity to fill gradually from the bottom upward. The core must also have a vent. The length of the runner or feeder sprue is in direct proportion to **its**

diameter. The further the metal has to travel, the thicker the sprue. Each piece is so unique that only generalizations can be made. The sprue design should be constructed in such a manner that the removal, cleaning, and chasing are simplified.

3. A cylindrical container facilitates the making of an investment mold. Preferably, it should be of the type that is easily taken apart. This can be constructed of thin sheet metal that is shaped and secured into a cylinder. The bottom should be sealed with clay to a smooth, solid base. This cylinder should be lined with either a type of screening called hardware cloth or plaster lath material.

4. The pattern is cleaned with alcohol or acetone to remove any grease residue and is suspended within the screening, allowing from 2″ to 4″ for investment density all around.

5. Mix up enough of the facing investment to coat the entire surface approximately ½″ thick. Mix the filler investment and fill the cylinder in one pouring, up to the level of the edge of the pouring cup.

6. After the mixture has hardened, remove the supporting cylinder and let set for four to six hours.

7. The burn-out furnace can be built up directly around the mold. This may be done with firebrick and gas burners.

8. The heat should be kept at approximately 300°F for approximately six to eight hours until all the wax is burned off.

9. With the wax burned out, the furnace temperature is raised to approximately 1400°F. This is continued until the investment shows no color around the pouring cup and other openings, no flames or smoke are evident, and the mold appears to be red-heated throughout. This may take two to three days depending on size.

10. Shut off the furnace and allow to cool down at its own slow rate. Do not rush the process.

11. When it has cooled down sufficiently to handle, pack the mold into the sand pouring pit and pour the molten metal into the pouring cup without delay and with a steady stream.

12. The flask is allowed to cool for a few hours, and the investment chipped away.

13. The sprue system is cut away; the casting is cleaned, chased, and finished with patination chemicals or other methods.

Ceramic-Shell Casting

1. Create pattern in wax or other material that will burn out clean and easily.

2. Attach sprue riser from the heaviest part of the casting to a pouring cup made out of a paper cup.

3. Add other sprues if necessary. If the pattern has a section that is quite heavy, then thins down, and becomes heavy again, it is wise to construct a sprue between the heavier sections.

4. Dip or brush the pattern with alcohol or acetone to remove any grease residue.

5. Pour, dip, brush, or spray the slurry mix and cover the pattern. This first coat should not have any blemishes. If blemishes are found, wash with water and repeat process. Do not try to patch. Use catch basin.

6. Immediately apply a coat of stucco by sprinkling over pattern. Handle carefully at this stage. Use catch basins to recover excess stucco.

7. Put aside and let dry thoroughly. This may take an hour but can be speeded up by fans or blowers.

8. Apply subsequent coats, making sure that each coat is recorded in pencil on the inside of the pouring cup. Build up to at least five to six coats, approximately ¼″ wall thickness. The slurry mixture must be kept agitated at all times to insure dispersion. This can be done with a torque timer rig, by a power drill with a paint-mixing attachment, or by hand. Do not place the shell in sun to accelerate drying as the wax will expand and crack the shell.

9. When the pattern is completely dry and the proper wall thickness has been achieved, wrap nichrome wire around the shell in such a manner that it may be suspended in a dewaxing furnace. Make sure that the pouring cup points downward and that it hangs level.

10. Suspend in dewaxing furnace. The sudden thermal shock serves to set the shell. The wax may suddenly expand and crack the shell using this method, but if the gate, sprues, and pouring cup are large enough it will melt out. The shell can be preheated in an oven or with infrared lamps, or steam autoclave if this is a concern.

11. Allow the shell to remain in the furnace until all signs of residue are burned out. This may be checked by examining the pouring cup, which should be white and clear of any signs of carbon. This may take as long as 30 to 45 minutes but is usually completed within 5 to 10 minutes.

12. Immediately after removing from the dewaxing furnace, invert, pack in preheated sand, and pour molten metal into the shell. Be careful not to allow any sand to enter the shell.

13. Allow to cool. In cooling, the shell will often spall away from the cast. If not, it can be

picked off with hand tools, sandblasting, or hot salt baths.

Sand Casting (Cope-and-Drag)

1. Seal the pattern, if porous, with thinned shellac or other sealing material.
2. Determine the line on which the pattern is to be separated. This is one of the disadvantages of sand casting—there can be no undercuts or crevices that will lock the pattern in the sand mold.
3. The bottom half of the interlocking flask is called the drag; the upper half, the cope. The drag is filled with sand, packed with a ram, and leveled off to smooth.
4. An area slightly larger than the form to be cast is dug out of this sand and a quantity of sand is screened (riddled) over it, leaving a fine deposit. The pattern is then nestled into this area and depressed to the dividing line. Sand is packed around it up to the division.
5. All loose sand is removed and blown away, and a parting material dusted over the surface of the drag. It is best to buy commercial parting.
6. The cope is interlocked onto the drag.
7. A riser pin is inserted into the sand of the drag at the point where the metal is to be poured into the pattern cavity. The pin must rise above the edge of the cope.
8. Sand is riddled over the surface and then more is packed in the cope until it is completely filled. The pouring cup is cut in around the riser pin and the pin tapped and twisted out. Loose sand is removed.
9. The cope is removed from the drag and set aside.
10. The pattern is loosened by tapping it gently and is removed from the sand.
11. A runner is cut into the sand to the point of entry of the previously inserted riser pin. All loose sand is removed, and the mold is ready to have the cope placed back on top of the drag.
12. When this is accomplished, the molten metal may be poured into the mold. If casting in bronze, the sand around the pouring cup should be weighted with ingots or firebrick. This prevents the mold from heaving in reaction to the gases.
13. When the metal has cooled slightly and setting is assured, the flask may be shaken, the sand removed, and the casting exposed.

Note: Patterns of a more complex form may require the use of a core made of hardened sand or cast in sections and welded together.

Sand Casting (Full-Mold)*

1. Create a pattern utilizing styrofoam or polystyrene foam. The kind that employs pellets usually has the correct density.
2. Attach a riser of styrofoam and secure it to the thickest part of pattern with low ash glue (white glue), brass straight pins, or thin brass rods such as a brazing rod. This will be imbedded in the casting, so it should be of the same type as the parent metal or of a material that is not subject to rust and corrosion.
3. In a flask or wooden frame, pack a layer of sand into the bottom. Riddle a layer of sand onto this packing. Pack the bottom of the pattern as well as possible and nestle into the soft layer of sand and pack up to the bottom of the pattern as tightly as is accessible.
4. Pack sand around and into the rest of the pattern as tightly as possible and fill the rest of the flask with packed sand. While a riser pin may be used, a styrofoam gate riser tends to break the pressure of the molten bronze. It is wise when casting in bronze to use a styrofoam gate riser in the shape of an *L* and to make a side or bottom pour. This means that the riser to the pouring cup is attached to the side or bottom of the pattern. When casting in aluminum, the pressure and action of the molten metal is not as great, and a top pour and gate riser attached to the top of the pattern is satisfactory.
5. The pouring cup is shaped by hand or is a precast cone shape. Make sure that the styrofoam gate riser is clear of all molding sand where it enters the pouring cup.
6. The metal is poured into the pouring cup. This should be done slowly at first to allow the metal to react to the styrofoam. Occasionally, a large bubble forms in the pouring cup as a reaction of gases; this should be broken with a metal rod and the molten metal poured in a steady and continuous stream. It is wise to weight the top of the sand mold with ingots, firebrick, etc., when pouring in bronze. This will hold the sand firm against the pressure. It is also good practice to use a thin brazing rod and pierce the sand mold down close to the pattern to allow for venting. This can be done before pouring or after. When done after pouring, the risk of scarring the cast is greater. Most of the gases vent through the sand and, in the case of aluminum, this practice is not as crucial.

*Note: This is a patented process.

7. Allow to cool for at least 30 minutes before disturbing the sand mold. After sufficient cooling has taken place, remove from flask and clean.

MISCELLANEOUS INFORMATION

Sand Casting. There are various self-cure and self-setting sands on the market. These are silica sands with various resin binders. Because of their self-hardening qualities, they are very versatile for the sculptor and simplify the casting process. They also can serve as core material and can be readily shaped and carved. Another process of sand casting is the direct-carving method. By carving a negative form in a bed of sand, a relief pattern can be made. Molten metal can be poured directly into the cavity. This gives a solid and heavy cast but has an occasional application for the sculptor. This can be combined with the cope-and-drag method for safer foundry process. In this instance, the form is dug out of a sand-filled drag. The cope is filled with packed sand, a riser cut through to the gate and runner of the drag, and the metal poured.

In a unique technique of sand castings employed by Harry Bertoia, molten bronze was poured directly onto a bed of sand and worked with tools directly. Various extraneous objects such as rocks, sand, and water were thrown and placed into the molten metal, causing varied volcanic and surface effects. This technique can be seen in a relief at the Dulles International Airport in Washington, D.C. Obviously, it is a dangerous approach and should not be attempted by or recommended for beginners. In this same regard, molten metal has been experimented with by free-pouring it into many types of combustible and noncombustible materials. By the sculptor's creative nature, he or she is more likely to attempt this technique than the foundry worker. Safety and control must be built into any free-pouring experimentation.

PLASTICS

PROCESSES

Blow Molding. Blow molding, a method of forming used with thermoplastic materials, consists of stretching and then hardening against a mold. There are two methods: direct and indirect.

Direct: A quantity of molten thermoplastic material is formed into the approximate shape desired. This is inserted into a female mold, and air is blown into the plastic as into a balloon, forcing the plastic against the sides of the mold.

Indirect: A heated thermoplastic sheet is clamped between a die and cover. Air pressure forced between the plastic and the cover forces the material into contact with the die. Cool before removing.

Calendering. Calendering can be used to process thermoplastics into film and sheeting and to apply a plastic coating to supportive materials. The plastic film and sheeting is passed between a series of three or four large, heated, revolving rollers that squeeze and fuse the materials into a sheet or film.

Casting. Casting may be employed for both thermoplastic and thermosetting material in making special shapes, rigid sheets, film, sheeting, rods, and tubes. The difference between casting and molding is that no pressure is used in casting as it is in molding. In casting, the plastic material is heated to a fluid mass, poured into either open or closed molds, cured at varying temperatures, and removed from the molds.

Coating. Thermosetting and thermoplastic materials both may be used as a coating. The materials to be coated may be metal, wood, paper, fabric, leather, glass, concrete, ceramics, or other plastics. Methods of coating include knife or spread coating, spraying, roller coating, dipping, brushing.

Compression Molding. This is the most common method of forming thermosetting materials. It is generally not used for thermoplastics. Compression molding is simply the squeezing of a material into a desired shape by application of heat and pressure to the material in a mold. Plastic molding powder, mixed with fillers such as wood flour, cellulose, and asbestos to strengthen the form, is put directly into the open mold cavity. The mold is closed, pressing down on the plastic and causing it to flow throughout the mold. When the heated mold is closed, the thermosetting material undergoes a chemical change which permanently hardens it into the shape of the mold. Pressure, temperature, and the length of time that the mold is kept closed vary with the design of the object and the material being molded.

Extrusion. This method is employed to form thermoplastic materials into continuous sheeting, film, tubes, rods, profile shapes, and filaments, and to coat wire, cable, and cord. Dry plastic material is loaded into a hopper, fed into a long,

heated chamber by a continuously moving screw, and forced out through a small opening or specially shaped die. It is cooled by blowers or water.

Fabrication. Operations on sheet, rod, tube, sheeting, film, and special shapes are fabrications. The materials may be thermosetting or thermoplastic.

Machining. This process is used on rigid sheets, rods, tubes, and special shapes. Methods include grinding, sawing, reaming, milling, routing, drilling, tapping, or turning on a lathe. The material also may be processed by cutting, sewing, sealing of film, and sheeting—all the operations involved in fashioning plastic film and sheeting into things like inflatables, garment bags, raincoats, etc. The pattern is cut, sewn, or heat sealed.

Forming. Flexible thermoplastic sheets are cut into the approximate shape. This blank may be creased, beaded, folded, or deep drawn into male and female molds. In vacuum forming or molding, the heated sheet is clamped to the top of a female mold and either drawn down into the mold by vacuum or forced down by air pressure. In snapback forming, the heated sheet is drawn into a vacuum pot and a male mold lowered inside the bubble formed by the sheet. As the vacuum is released, the hot sheet snaps back against the male mold. Rigid sheets can be fabricated by welding them together with a torch that heats the welding gases electrically or with a second type of torch that uses an open flame of acetylene or propane that transfers its heat to a coil through which the welding gas passes.

Finishing. The finishing of plastics includes the different methods of adding surface effects to plastic. Film, sheeting, and coated materials are altered by being pressed against a heated roller or mold that is embossed with a pattern or other form. The plastics also may be printed on the surface with letter press, gravure, or silk screening.

Rigid plastics can be finished with metal plating. This can be accomplished by metal spraying, vacuum deposition, metal dusting, and painting. Other methods include stamping, offset, engraving, etching, or air blasting. Other surface qualities are achieved by incorporating them into the molds.

High-Pressure Laminating. Usually thermosetting plastics are employed in this process. High heat and pressure are required. In producing formed shapes, the reinforcing material is cut into pieces that conform to the contour of the object, fitted into the mold, and cured under heat and pressure.

Injection Molding. Injection is the principal method of forming thermoplastic materials. Plastic material is put into a hopper that feeds into a heating chamber. A plunger pushes the plastic through this chamber where the material is softened to a fluid state. At the end of this chamber there is a nozzle that rests firmly against an opening into a cool, closed mold. The fluid plastic is forced at high pressure through this nozzle into the cold mold. When the plastic cools to a solid state, the mold opens and the piece is ejected. Jet molding, offset molding, and screw-type machines are employed when using thermosetting materials.

Reinforcing. The reinforcing process usually employs thermosetting plastics, although some thermoplastics are used. Very low or no pressure is required. Plastic is used to bind together cloth, paper, or glass fibers. The reinforcing material may be in sheet or mat form of high strength and low weight. This is an easy, economical fabrication. A number of different techniques may be employed in reinforced plastics. In making formed shapes, impregnated reinforcing material is cut in accordance with the form into one piece or a number of pieces. The pattern or patterns are placed on a male mold in enough volume to give the final thickness and form. Molding is completed in heated, mated dies. A single mold may be used. The impregnated reinforcing material may be laid up on a male mold, inserted into a rubber bag from which all air is withdrawn so the bag presses around the layup, and cured in an oven. If a female mold is used, a diaphragm is placed over the end of the mold so that when air is withdrawn from within the mold, the diaphragm is drawn down inside the mold to press against the layup of resin-impregnated materials.

Rotational Molding. This technique is used to fabricate hollow, one-piece flexible parts from vinyl plastisol or polyethylene powder. Rotational molding consists of charging a measured amount of resin into a warm mold that is rotated around two axes in an oven. Centrifugal force distributes the plastic evenly throughout the mold, and the heat melts and fuses the charge to the shape of the cavity. Then it is cooled and removed.

Solvent Molding. Thermoplastic materials are used in this process of forming. Solvent molding is based on the fact that when a mold is immersed in a solution and withdrawn or when it is filled with a liquid plastic and then emptied, a layer of plastic film adheres to the sides of the mold.

Thermoforming. This process consists of heating a thermoplastic sheet to a formable

plastic state and then applying air or mechanical assists to shape it to the contours of a mold. Air pressure may range from almost 0 to 700 psi. Up to 14 psi, the pressure is obtained by evacuating the space between the sheet and the mold in order to utilize this atmospheric pressure. This range, known as vacuum forming, will give satisfactory reproduction of the mold in most instances. When higher pressures are required, they are obtained by sealing a chamber to the top sheet and building pressure within by compressed air. This system is known as pressure forming. Both methods are variations of the same basic technique. Variations of thermoforming include straight forming, drape forming, plug-and-ring forming, slip forming, snap-back forming, plug-assist forming, plug-assist-air-slip forming, and machine-die forming.

Transfer Molding. This process is generally used for thermosetting plastic. As in compression molding, the plastic is cured into an infusible state in a mold under heat and pressure. It differs from compression molding in that the plastic is heated to a point of plasticity before it reaches the mold and is forced into a closed mold by means of a hydraulically-operated plunger. Transfer molding was developed to facilitate the molding of intricate products with small deep holes or numerous metal inserts. The liquified plastic material in transfer molding flows around these metal parts without causing them to shift position.

Note: All of the above information on plastics was provided by the Society of the Plastics Industry, Inc., New York, New York. It should also be noted that, while most of this information has industrial application, it is generally of interest to the sculptor wanting to work in plastics. For more specific information on plastics, consult the bibliography.

━━ WOOD ━━

METHODS OF WORKING

Carving. Carving is a subtractive process in which gouges, chisels, rasps, and other files and hand tools are utilized to evolve a form. One should begin with well-seasoned wood for ease of carving. Green woods are not only hard on tools, but they tend to check (split) as they dry out. In preparing a log for carving, it is best to remove the bark and outer sap wood for air drying. Sealing the ends of the log with sealant paint or wax is an optional practice. The drying is slower and more even with less possibility of checking. Another method is to laminate seasoned planks or blocks of wood together with a resin glue and clamp until dry and set. This will minimize the possible checking but introduces lines of the glue joint to contend with in the sculptural form. If different kinds of wood are used, it also creates different colors and grains. These factors can be utilized to advantage but often distract from the form.

Tools. It is imperative that tools be kept sharpened while the work is in progress. A list of carving tools includes:

Mallets—lignum vitae 16 to 30 ounces
Gouges—assortment—¼″, ½″, ¾″, 1″
Chisels—assortment including flat, bent, spoon, V shape
Sharpening stones and slips—flat, shaped, tapered
Combination bench lag bolt-screw
Sandpapers

Ax, adz, hatchet
Power tools—chain saw, air hammer, power saw, drill, grinder, sander

Process. Begin by trying to envision the form you have in mind and its relationship and composition to the log. Rough out the log by removing as much unwanted wood as possible. At this stage, power equipment and tools such as the ax, adz, and hatchet are very useful. Secure the wood with a bench screw-bolt (screw into bottom of log, bolt through table surface), wood vise, clamps, bench stop, or log sawhorse. Continue to rough out the form with your larger chisels and gouges, or the air hammer with chisels. As you work, try to set up a pace or rhythm, striking the chisel at a moderate angle and allowing the wood you are removing to be free to fly out. Do not try to remove too much in one pass and keep one corner of the cutting edge of the chisel free. This will prevent the chisel from locking in the wood. If the chisel does lock in, do not lever the chisel but either dig out the surrounding wood with another chisel or hold the implanted chisel and knock the log away from it. It is a good practice to remove wood with the grain and gradually work down and into the form rather than to work across the grain and remove large chunks. Use counter strokes if trying to remove large chunks. First, go in one way at a 45° angle

and then the opposite way at a 45° angle. Your chisels must be very sharp to cut across the grain and avoid tearing the wood structure. Once the form has been roughed out, begin to refine the form by using progressively smaller chisels. If a rough-textured surface is desired, many of the large chisel and gouge marks may be left. If not, these can be worked over with smaller chisels, gouges, rasps, files, and sandpapers down to a smooth finish. This is an individual preference and should be relevant to the form.

Construction. The use of wood in a constructive manner is an additive process. Wood that has been machined into standardized forms of boards, planks, and sheet provides a full range of possibilities for the sculptor. Construction with wood allows it to be used for supportive means (armatures) or as forms in themselves. The range of working with machined lumber is too great and varied to go into here; however, there are two aspects that are central to wood construction: shaping and joining. Shaping is the basic alteration of the piece of wood, and joining is the means by which pieces are attached.

Tools. The following tools should meet every contingency in the alteration and shaping of wood.

Hand tools: hammer, mallet, saws (cross-cut, rip), plane, hand drill, brace and bits, rasps and files, chisels, screwdrivers, pliers, try square, tape measure, level, clamps, nail set

Portable tools: sanders, drill, circular saw, router, sabre saw

Power tools: tilting arbor saw or radial saw, jointer, planer, band saw, lathe, sander (belt and disc), drill press

Shaping Process. The uses of the hand tools mentioned should be self-evident. It is useful, however, to mention some of the shaping possibilities with the portable and power tools. A portable sander is an extremely efficient tool for smoothing a surface. The obvious advantage is that it can be taken to the work; whereas, the power belt and disc sander require that the work be taken to the machine. This also implies that the work will have to be limited in size. Other useful machines for smoothing a surface and reducing the thickness of a board are the jointer and planer. The sabre saw and band saw allow for irregular and interior cuts. The drill and drill press not only allow for penetration of wood, but with the many attachments available make a full range of shaping possibilities. The portable and

power saws make straight, diagonal, and miter-angle cuts, rip cuts, grooving, and routing a simple task. With attachments, it is also possible to dado (groove), tenon (projecting recessed end), and rout out forms.

Joining Process. The most common methods of joining wood are nailing, gluing, screwing, doweling, and various methods of interlocking. Nailed joints, while the most common, are not as strong as any of the others. There are two types of nails: a flat head or common, and a finishing nail with the absence of a pronounced head. The size of nails is determined by the term *penny*, which indicates diameter and length and usually is measured in multiples of two—two penny, four penny, six penny, etc. The symbol is "8d." When used in combination with glue, a nailed joint is somewhat stronger, although a joint that utilizes screws tends to pull the material together rather than just hold it in place.

Screws come in flat-head, oval-head, round-head, and binding-head form. Screw sizes are determined by length and shank dimension. It is useful to drill a pilot hole of a smaller diameter when screwing joints together to avoid splitting the wood. A combination of glue and screws is one of the strongest joints available.

The use of nuts and bolts is a variation on the screw with the exception that the shaft has a machined thread that penetrates the pieces to be joined and is secured with a nut on the other end. The most common forms of this type are the machine bolts, carriage bolts, stove bolts, machine screws, cap screws, and lag bolts. They come with various types of heads: hex, square, truss head, slotted round head, slotted flat head, and slotted oval head. Nuts come in square, hex, wing, and cap nut. In addition, there are *U* bolts, *eye* bolts, hook bolts, and turnbuckles, as well as continuous threaded rods. Bolt size is determined by the length and the diameter of the shaft. Washers are used in conjunction with nuts and bolts and are either plain or the various lock types. The use of a bolting system provides an extremely strong joint. If the head and nut are not recessed, however, it tends to give a bulky appearance.

Doweling is a joint process whereby a wooden shaft is coated with glue and forced into a slightly smaller corresponding hole. If the dowel is grooved or fluted, it will provide an even stronger joint. Interlocking joints that are commonly used in the joining of wood are the lap joint, box, miter, dovetail, mortise and tenon, splined joints, and combinations and variations of these. When used with glue,

nails, screws, or dowels, they provide the most structurally sound joints. It should be mentioned that any or all of the above methods of joining depend greatly on the particular needs of the form and the intent of the sculptor. In some cases, a well-crafted approach may be desired; in others, a more roughhewn appearance may be the goal. Other unconventional means of joining are possible and may have relevance for the contemporary sculptor. Such things as wire, string, tape, various forms of plastic sheeting, nylon cord, and many other materials can be applied to secure or join wood together. In this open-minded approach, one should be cognizant of the fact that wood takes on many forms that can be utilized by the sculptor. Sawdust, wood chips, wood pulp, wood fiber paper, and compressed-wood fiber board are but a few of the many available wood products that deserve consideration.

MISCELLANEOUS MATERIAL AND TECHNIQUE INFORMATION

GENERAL COMMENT

Many materials and techniques beyond conventional means have relevance for the contemporary sculptor. With the expansion of the sculptural idea into broad areas of reality, all materials and techniques are fair game for the sculptor. Listed below are but a few of these possibilities.

Electrical — Electronic Manipulation. Electric circuitry, computer technology, sound, light, equipment, media-control systems, laser-holograms, videotape, neon, fluorescent light.

Chemical — Action, Reaction, Interaction. Chemokinesis, chemoresistance, chemosynthesis, chemotropism, state change, raw and refined materials, nondegradable, biodegradable.

Mechanization. Mechanical systems, manual machines, working, nonworking, horizontal drive, vertical drive, power conversion, kinetics, combustion, steam, pumps, found and discarded objects.

Natural Forces and Phenomena. Wind, water, earth, fire, space. Site and environment manipulation, placement, state change. Physical laws of weight, balance, gravity, tension, compression, etc.

Human — Action, Reaction, Interaction. Concepts: form, thought, actual, implied; environmental, situational context; information-communication; isolation, alteration, extension of process; compartmentalization-dehumanization; human physical, social, and organizational systems.

Appendix A

Resource Information

OUTLINE OF CRITICAL THINKING

1. Definition
2. Interaction: historical, societal, economic, aesthetic factors
3. Associations, relationships, conceptualization
4. Shifting rules, knowledge, applications
5. Informational input and feedback
6. Control, selection, action, projection
7. Dispersal and assimilation
8. Redefinition and extension

REFERENCES

Howwink, R. *The Odd Book of Data*. New York: Elsevier, 1965.

Koberg, Don, and Bagnall, Jim. *The Universal Traveler*. Los Altos, California: William Kaufmann, 1976.

Perrin, Alwyn T., ed. *The Explorer's Ltd. Source Book*. New York: Harper and Row, 1973.

Wiener, Philip P., ed. *Dictionary of the History of Ideas: Studies of Selected Pivotal Ideas*. New York: Scribner, 1973.

POTENTIAL CONSIDERATIONS AND EXPLORATIONS

Acoustics, sound
After image
Analogue computer
Anodization
Aqueous, water
Atmosphere, air
Atomizer
Cable TV
Cathode-ray tube
Chemical conversion
Chroma key
Circuits, closed
Compiler
Computer
Converter
Cooling and heating
Corrosion
Cybernetics
Data (banks and systems)
Decoder

Design systems
Diffraction
Digital circuits
Digital computer
Dispersion
Distillation
Domes
Dyes
Electric, electronic mixing
Electric microfilm recorder
Electromagnets
Encoders
Enlarging
Environments
Extensions
Fabrication
Facsimile
Feedback
Fibers, fabrics
Fillers
Finishing
Fire, heat, energy
Fluorescence
Form
Fortran
Fountains, water technology
Freeze
Gases
Generation
Glaze
Gravity
Grids
Hardness
Hardware
Heat
Hologram
Hose(s)
Hydraulics
Hydrometry
Hypercube
Images
Inertia
Information-theory-systems
Infrared
Input/output
Insulate
Integration systems
Jacks
Joints
Junctions
Kinetic
Lamination

Land, earth
Laser
Light
Lubrication
Magnetic tape
Mathematics
Matrix
Mechanization
Melting
Method, system
Microwave
Moire
Monitor
Moog synthesizer
Multiplex
Mylar
Natural phenomena
Nomenclature
Optics
Organizations
Oscillator
Paint, pigment
Panels, solar
Perception
Permanence
Phosphor
Photo cell
Photo emulsions
Photo sensitive
Preamplifier
Printout
Process
Program
Projection
Pump
Quality, quantity
Radiation
Radiograph
Rain
Random access
Reaction, action
Reflection
Refraction
Regeneration
Relief
Resources
Retard, accelerate
Scale
Sealers
Selection, rejection
Separation
Silicon chips

Software
Solar
Spatial relationships
Symbols
Synergy
Synthetic
Tactile
Telecopier
Telex
Temperature
Tensegrity
Tension, compression
Thermo
Thixotropy
Tint, shade
Tonal systems
Topology
Toxicity
Transistors
Translucent
Transparent
Universality
Utilization
Vacuum
Vapor
Ventilation
Verifax copier
Videotape
Visualization
Wave lengths
X ray

REFERENCES

Bibliographic Guide to Technology, Boston, Massachusetts: G. K. Hall, 1977.

Collocott, T. C., ed. *Dictionary of Science and Technology.* New York: Barnes Noble, 1972.

Davis, Douglas. *Art and the Future,* New York: Praeger, 1973.

Ertel, James, ed. *Yearbook of Science and the Future.* Chicago, Illinois: Encyclopedia Britannica, published annually.

Hoye, Robert E., and Wang, Anastasia C., eds. *Index to Computer Based Learning.* Englewood Cliffs, New Jersey: Educational Technology, 1973.

Lapedes, Daniel L., ed. *McGraw-Hill Encyclopedia of Science and Technology.* New York: McGraw-Hill, 1971 plus yearbooks.

———, ed. *Dictionary of Scientific and Technical Terms.* New York: McGraw-Hill, 1976.

Laughlin, William, *Laughlin's Fact Finder.* West Nyack, New York: Parker, 1969.

Leerburger, Benedict A., Jr., ed. *Cowles Encyclopedia of Science, Industry, and Technology.* New York: Cowles Education, 1967.

Rossini, Frederick. *Fundamental Measures and Constants for Science and Technology.* Cleveland, Ohio: C. R. C. Press, 1974.

—— CHEMICAL AND PHYSICAL CONSIDERATIONS ——

CHEMISTRY

Nature of elements—combinations that form compounds

Physical properties—color, odor, taste, density (weight)

Chemical properties—reaction of one substance with another
A. Classifications—kinds of chemical substances
 1. Elements—hydrogen, carbon, atoms, particles, protons, neutrons
 2. Compounds—combinations of elements, molecules, radicals
 3. Solutions—combinations of one or more substances
 4. Suspensions—uniform distribution without dissolving
 5. Mixtures—nonuniform distribution of substances
B. Formation of compounds
 1. Atomic structure
 2. Valence—electrons in atom's outer shell
 3. Chemical bonds—forces that hold atoms together
 Ionic bonds, covalent bonds
 4. Structural formulas
C. Chemical groups
 1. Elements—metals, nonmetals
 2. Inorganic compounds
 3. Organic compounds
D. Chemical reactions
 1. Chemical weights
 2. Chemical equations

Chemical Considerations

Absorption
Calcination
Catalysis
Combustion
Condensation
Corrosion
Crystallization
Decomposition
Diffusion
Distillation
Electrolysis
Evaporation
Flotation
Fluoridation
Homogenization
Hydrogenation
Hydrolysis
Ionization
Neutralization
Oxidation
Pasteurization
Polymerization
Reduction
Spontaneous combustion
Sublimation
Transmutation of elements

PHYSICS

A. Mechanics
B. Heat
C. Light
D. Electricity and magnetism
E. Sound
F. Atomic and nuclear physics
G. Solid state physics

Physical Considerations

Mechanics

Acceleration
Adhesion
Aerodynamics
Ballistics
Bernoulli's principle
Capillarity
Cohesion
Condensation
Dyne
Efficiency
Falling bodies

Force
Friction
Gas
Gravity (center)
Horsepower
Hydraulics
Inertia
Lever
Liquid
Momentum
Motion
Osmosis
Pendulum
Power
Pressure
Pulley
Screw
Siphon
Surface tension
Torque
Vacuum
Velocity
Viscosity
Wedge
Work

Heat

Absolute zero
Boiling point
BTU
Calorie
Centigrade scale
Combustion
Distillation
Dust explosion
Entropy
Evaporation
Expansion
Fire
Freezing
Heat
Insulation
Melting point
Pyrometry
Radiometer
Regelation
Specific heat
Spontaneous combustion
Steam
Sublimation
Temperature
Thermal barrier

Thermocouple
Thermodynamics
Thermograph
Thermometer
Thermostat

Light

Artificial
Brightness
Chemical effects
Diffraction
Dispersion
Electromagnetic waves
Interference
Natural
Photoconductive
Photoelectric
Photosynthesis
Polarization

Reflection, refraction, absorption
Scattering
Speed
Visible spectrum

Sound

Acoustics
Decibel
Echo
Harmonics
Loudness (intensity)
Noise
Phon
Pitch
Sound
Tone
Tuning fork
Ultrasonic wave
Vibration

CHECKLIST OF SAFETY WORK PROCEDURES

PERSONAL SAFETY

1. Always wear protective shields for eyes, face, and other exposed areas of the body when using machinery. This includes respirators if noxious fumes are present, ear protectors if exposed to excessive noise, gloves, protective hats, and shoes.
2. Secure loose clothing and hair. Do not go barefooted in studio.
3. Practice hygienic procedures by washing hands, face, and other exposed areas during and after studio work. Separate and wash work clothes individually.
4. Do not eat or smoke in the studio, especially if toxic substances, such as solvents, chemicals, and resins, are in use.
5. Have emergency first-aid materials readily accessible. Try to anticipate and have contingency plans for various emergencies. Keep telephone numbers handy for doctor, fire, and emergency.

STUDIO SAFETY

1. Ventilation is the single most critical factor. If windows and doors will not draw off noxious fumes, install necessary exhaust system.
2. Store flammable and combustible materials including used rags in appropriate containers, such as metal cabinets.

3. Use vacuum cleaners to draw out dirt and dust so that dust is not generated in the studio.
4. Keep a fire extinguisher handy. A dry-chemical type is recommended.
5. Be alert to the intermixing of esoteric substances, chemicals, and fumes.
6. Do not use questionable materials in living quarters. Maintain a separate work area where specific safety precautions have been established.

REFERENCES

Encyclopedia of Occupational Health and Safety. 2 vols. New York: McGraw-Hill, 1971.

McCann, Michael. *Health Hazards Manual for Artists.* New York: Foundation for the Community of Artists, 1975.

———. *Artist Beware.* New York: Watson-Guptill, 1979.

Safe Practices in the Arts and Crafts: A Studio Guide. New York: College Art Association, 16 East Fifty-second Street, 10022, 1979.

Sax, Irving N. *Dangerous Properties of Industrial Materials.* New York: Van Nostrand, Reinhold, 1975.

Siedlicki, Jerome. *The Silent Enemy.* Washington, D.C.: Artists Equity, 2813 Albemarle Street N.W., 20008, 1975.

Stellman, Jeanne, and Daum, Susan. *Work Is Dangerous to Your Health.* New York: Vintage, 1973.

CHECKLIST OF GRANTS-IN-AID ASSISTANCE

1. As a student am I eligible for a Basic Educational Opportunity Grant, scholarship, assistantship, state, regional, or federal aid? Would a loan program suffice?
2. Is there specific aid for which I qualify because of race, national origin, etc.?
3. What organizations subsidize artists' work, proposals, studio and living expenses?
4. Which local, regional, and national government agencies, corporations, foundations, and businesses patronize the arts and artists?
5. Specifically, is the emphasis and trend towards sculpture in public places?
6. Does my work lend itself to architectural scale, space, and format? Should it? Is this a concession?
7. Are these large monumental geometric configurations tomorrow's oddities? White elephants?
8. What other types of aid exist for sculptors who are not interested in graduate work, architectural commissions, or conventional forms? Does this apply to me?
9. Are there colonies or alternate places or means whereby I can accomplish my goals? Organizations, individuals?
10. The concept of barter or exchange of goods and services is a form of aid that is indispensable. Have I explored this possibility?
11. What strings, if any are attached to the aid? Are they clearly spelled out in detail? See number 12.
12. Is there a reciprocal agreement expected in exchange for the aid? Length, type, and finances of the arrangement?
13. What then are my specific needs? Informational? Financial? Material? Studio? Equipment? Living?

REFERENCES

Angel, Juvenal L. *How and Where to Get Scholarships and Loans.* 2d ed. New York: Regents Publishing, 1968.

Business Committee for the Arts. New York: 1700 Broadway, 10019.

Educational Financial Aids. Washington, D.C.: American Association of University Women, 1976.

Feingold, Norman S. *Scholarships, Fellowships and Loans.* Arlington, Massachusetts: Bellman Publishing, 1972.

Foundation Center. *List of Organizations Filing as Private Foundations.* New York: Columbia University, 1973.

Foundation Center. *About Foundations: How to Find the Facts You Need to Get a Grant.* 2d ed. New York: 888 Seventh Avenue 10019, 1979.

Harl, Lewis D., ed. *Financial Aids for Graduate Students.* Revised annually. Cincinnati: College Opportunities, 1971.

Keeslar, Oreon. *Financial Aids for Higher Education.* Dubuque, Iowa: William C. Brown, 1975.

Lewis, Marinanne O., ed. *Foundation Directory: Index and Supplements.* New York: Foundation Center, 1975.

Millsaps, Daniel, ed. *Grants and Aids to Individuals in the Arts.* 3d ed. Washington, D.C.: Washington International Arts Letter, 1977.

———, ed. *The National Directory of Arts Support by Private Foundations.* Vol. 3. Washington, D.C.: Washington International Arts Letter, 1977.

———, ed. *National Directory of Arts Support by Business Corporations.* Washington, D.C.: Washington International Arts Letter, 1979.

National Endowment for the Arts. *Guide to Programs.* Washington, D.C., published annually.

Private Foundations and Business Corporations Active in the Arts. Washington, D.C.: Washington International Arts Letter, 1976.

Searles, Aysel, Jr., and Scott, Anne. *Guide to Financial Aids for Students in Arts and Sciences for Graduate and Professional Study.* New York: Arco, 1974.

Turner, Roland, ed. *Grants Register.* New York: St. Martin's Press, 1975 and 1977.

Washington International Arts Letter. Financial information for the arts. Box 9005, Washington, D.C. 20003.

Wilson, William K. and Betty L., eds. *Research Grants.* Scottsdale, Arizona: Oryx Press, 1975.

CHECKLIST OF GRADUATE WORK CONSIDERATIONS:
ALTERNATIVE EDUCATION OPPORTUNITIES

1. What is my purpose in going to graduate school? To acquire greater skills? To have time and facilities to work? To study with name artists? To mature? To make contacts? To get credentials for a teaching job?
2. Am I disciplined enough to work independently? Must I be motivated by the competition of other artists, students, or art community?
3. Is the relative cost worth the acquired benefits and vice versa.
4. Would I perform better in an independent program? An apprenticeship? Industrially related job, e.g., welder, foundryman, or plastic technician?
5. Is it more advantageous to maintain a job and approach graduate work and advanced training gradually?
6. Do the environment and resources of a city vs. a rural location make a difference?
7. Have I investigated alternate forms of advanced study?
8. What does a consensus of my art teachers, contacts, and artist friends advise?
9. What do I see as the role of art in the world? In my society? My place in it? In relation to my abilities, desires, needs, and objectives?
10. Will I be fulfilling these goals or just filling roles?

ALTERNATIVE EDUCATION OPPORTUNITIES

Alternative University Program. Association of Artist-run Galleries, New York City. Phone: 212-636-8374. Experience-courses apprenticeships.

Cosanti Foundation, Arcosanti, Arizona. Architectural and sculptural apprenticeships and workshops.

Eastman House, Rochester, New York. Photographic stipends.

Fine Arts Work Center, Provincetown, Massachusetts. Independent, nonacademic structure, visiting artists, seminars.

Haystack Mountain School of Crafts, Deer Isle, Maine. Crafts, sculpture, and graphics (summers only).

Independent art schools and colleges in most major cities.

International Sculpture Conference, National Sculpture Center, University of Kansas, Lawrence, Kansas 66045. Workshops, panels (biennial).

Johnson Atelier, Technical Institute of Sculpture, Princeton, New Jersey. Apprentice program (foundry).

Kitchen Center for Video and Music, 59 Wooster Street, New York City.

Live Injection Point (LIP). Franklin Street Arts Center, 112 Franklin, New York City. Television (video production).

Modern Art Foundry, box 1978-18-70, Forty-first Street, Long Island City, New York. Award program, two apprenticeships.

New Haven Center for Independent Study (CIS). 3193 Yale Station, New Haven, Connecticut 06520.

New York School of Holography, New York City. Laser and holography.

112 Workshop, 112 Greene Street, New York City. Arts administration, catalog publication project, studio assistance.

Skowhegan School of Painting and Sculpture, Skowhegan, Maine (summers only).

Study Abroad Programs: most major university fine arts departments have foreign affiliations.

Visiting Artists Collaborative (VAC), 167 Crosby Street, New York City. Touring informational group.

White Mountain Center for the Arts, Jefferson, New Hampshire. Sculpture workshop (summers only).

Whitney Museum of American Art Independent Study Program, 945 Madison Avenue, New York 10021. Graduate and advanced undergraduate students (painting and sculpture).

REFERENCES

Barron's Profiles of American Colleges. Woodbury, New York: Barron's, 1976.

Career Resources List for Visual Artists. Kansas City, Missouri: UICA, 4340 Oak Street 64111, 1976.

Cohen, Marjorie. *Whole World Handbook: Guide to Work, Study, Travel Abroad.* New York: Arthur Frommer, 1974.

College Blue Books. 15th ed. New York: Macmillan, 1975.

Graduate Programs and Admissions Manual. New York: Graduate Records Examination Board, 1972.

Hegener, Karen C., ed. *Peterson's Guides to Graduate Study.* Princeton, New Jersey: Peterson's, 1980.

Keyes, H. M. R., and Aitken, D. J., eds. *International Handbook of Universities.* 7th ed. Washington, D.C.: American Council on Education, 1975.

Livesey, Herbert, and Robbins, Gene. *Guide to American Graduate Schools.* New York: Viking, 1967.

MFA Programs in the Visual Arts. New York: College Art Association of America, 1976.

Study Abroad. Paris: UNESCO, 1972.

Study in Europe. New York: Institute of International Education, 1976.

Watts, Susan, ed. *College Handbook.* New York: College Entrance Exams, 1977.

Zils, Micael, ed. *World Guide to Universities.* 4 vols. New York: R. R. Bowker, 1971.

CHECKLIST OF SURVIVAL CONSIDERATIONS: RESUMES, JOB HUNTING, RELATED WORK

1. Is it possible for me to support myself on the income from the sale of my art production? Improbable!
2. If not, is it best to try to secure a job in an art-related field? Or is it less taxing on one's aesthetic sensibilities to do something totally unrelated?
3. Individual choice and opportunity. Perhaps it is wise to develop skills or credentials to earn a living and produce art without monetary concern. Naive? "What are you?" "I sell shoes uptown." "I didn't ask you what you do but what you are." "Oh, I'm a sculptor."
4. Are my goals clearly defined for the next five years?
5. What is the best course of action to achieve these objectives?

REFERENCES

Artists-in-Schools Program, National Endowment and State Arts Councils.

Dickhut, Harold, and Davis, Marvel J. *Professional Resume/Job Search Guide.* Chicago: Management Counselors, 1975.

Farmer, Helen, and Backer, T. *New Career Options for Women.* New York: Human Services Press, 1972.

Gaine, John F., ed. *American Architects Directory.* 3d ed. New York: R. R. Bowker, 1970.

Goldman, Bernard. *Reading and Writing in the Arts: A Handbook.* Detroit: Wayne State University Press, 1972.

Harris, Cyril M., ed. *Dictionary of Architecture and Construction.* New York: McGraw-Hill, 1975.

Lyons, Delphine. *Whole World Catalog.* New York: Quadrangle and New York Times, 1973.

McKay, Ernest A. *Macmillan Job Guide to American Corporations.* New York: Macmillan, 1967.

McKee, Bill. *New Careers for Teachers.* Chicago: H. Regnery, 1972.

Renetzky, Alvin, ed. *Directory of Internships, Work Experience Programs and OJT Opportunities.* Thousand Oaks, California: Ready Reference Press, 1976.

Sheehy, E., ed. *Guide to Reference Books.* Chicago: American Library Association, 1976.

Spilman, George. *What Every Veteran Should Know.* Monthly supplements. East Moline, Illinois: Veterans Information Service, 1976.

U.S. Department of Labor. *Dictionary of Occupational Titles.* Washington, D.C.: Government Printing Office, 1965.

Wallechinsky, David, and Wallace, Irving. *The People's Almanac.* Garden City, New York: Doubleday, 1975.

CHECKLIST OF EXHIBITION PRACTICES

1. Show work to dealers.
2. Make appointments or pound pavements but don't be obnoxious. Be flexible and confident.
3. Have good-quality photos or slides and viewer.
4. Select galleries based on their affinity to your work.
5. Have a body of *consistent* work available at studio for viewing.
6. Deal with reputable, established galleries.
7. Avoid "vanity" galleries.
8. You may have to wait a long time before an offer occurs. Select alternate exhibition opportunities carefully. Avoid amateur associations and exhibitions with entry fees that are excessive.
9. If a dealer is interested, do not leave your work without an understanding of agreement and a receipt.
10. Fully discuss and put into writing the terms of commitment, frequency of exhibitions, responsibilities, expenses, commissions, term.
11. Cover restrictions: exclusivity, exhibiting, selling.
12. Promotion: reviews, photographs.
13. Reproduction rights.
14. Contracts: dealer representation.
15. Payments: consignments, advances.

CHECKLIST OF BUSINESS CONSIDERATIONS

1. Professionalism
2. Accounting: materials, inventory, records, expenses.
3. Sales: invoices, taxes, receipts.
4. Verification of costs.
5. Separate personal and business checking accounts.
6. Business cards, telephone.
7. State tax and other licensing: local, state, statutes, codes.
8. Employee records (if applicable).
9. Capital: investments, acquisitions, expenditures.
10. Copyrights, patents.
11. Taxes: local, state, federal, (see tax section).
12. Gallery practices: sales, agreements, contracts (see law and gallery sections).
13. Insurance, retirement, estate planning.

REFERENCES

American Artist Business Letter, Cincinnati, Ohio: 2160 Patterson Street, 45214.

American Crafts Council. *Contemporary Crafts Marketplace.* New York: R. R. Bowker, 1977-78.

Chamberlain, Betty. *The Artist's Guide to His Market.* New York: Watson-Guptill, 1976.

Cummings, Paul, ed. *Fine Arts Market Place.* New York: R. R. Bowker, 1977-78.

Polking, Kirk, and Prince, Liz, eds. *Artist's Market 76.* Cincinnati, Ohio: Writers Digest, 1976.

Porter, Sylvia. *Money Book.* New York: Doubleday, 1975.

Small Business Administration. *Handbook of Small Business Finance.* Washington, D.C.: Government Printing Office, SBA 1.12:15.

Small Business Administration. *Starting and Managing a Small Business of Your Own.* Washington, D.C.: Government Printing Office, SBA 1.15:1.

CHECKLIST OF LAW CONSIDERATIONS

1. Does my studio conform to all local and state codes and regulations?

2. Do I have the necessary state tax-collection license, if required?

3. Am I aware of the copyright laws and the changes of 1977? Protection, publication, registration, transfer?
4. Gallery arrangements: agreements, records, payments, insurance, advances, liabilities (see section on galleries).
5. Publication and reproduction rights.
6. Sales and commissions.
7. Tax problems: responsibilities, income, Social Security, estate.
8. Contracts: forms, continuation, transfer.
9. Royalties: California statute.
10. First amendment safeguards: censorship, limits of artistic freedom, artistic integrity.

ASSISTANCE

Associated Councils of the Arts, 1564 Broadway, New York 10036.

Volunteer Lawyers for the Arts, 36 West Forty-fourth Street, New York 10036.

REFERENCES

Associated Council of the Arts. *The Visual Artist and the Law.* New York: Praeger, 1974.

Crawford, Tad. *Legal Guide for the Visual Artist.* New York: Hawthorn, 1977.

Feldman, Weil. *Art Works: Law, Policy, Practice.* New York: Practicing Law Institute, 1974.

Hodes, Scott. *The Law of Art and Antiques.* New York: Oleana Publishing, 1966.

————. *What Every Artist and Collector Should Know About the Law.* New York: Dutton, 1974.

Merryman, John, and Elsen, Albert. *Law, Ethics and the Visual Arts.* New York: Matthew Bender, 1978.

———— CHECKLIST OF TAX CONSIDERATIONS ————

1. City, state, and federal tax requirements.
2. Provisions that reduce taxes: expenses, materials, studio, travel, transportation, depreciation, investment credit, methods, loss, special deductions.
3. Withholding, unemployment taxes.
4. Estimated tax: preparing tax form, income averaging.
5. Maintenance of inventory and other records.
6. Social Security, retirement plans, estate taxes.
7. Educational and research expenses.

8. Tax on grants and fellowships.
9. Recent tax rulings.

REFERENCES

Connaughton, Howard. *Craftsmen in Business.* New York: American Crafts Council, 1975.

Federal Tax Guide. Issued annually. Englewood Cliffs, New Jersey: Prentice-Hall, 1977.

Lidstone, Herrick K., ed. *Tax Guide for Artists and Art Organizations.* Lexington, Massachusetts: Lexington Books, 1979.

———— CHECKLIST OF LOCAL, REGIONAL, AND NATIONAL RESOURCES ————

Academic contacts

Artist's Equity Association Inc., 2813 Albermarle Street N.W., Washington, D.C. 20008.

Art Workers News, published by the Foundation for the Community of Artists, New York City.

Art Yellow Pages. Associated Council of the Arts, 570 Seventh Avenue, New York 10018.

Directory of Artists Association in the U.S.A. Boston Visual Artists Union, 14 Reservoir Road, Wayland, Massachusetts 01778.

Industrial contacts—sculpture and industrial suppliers.

Local, regional, and national professional art organizations.

Manufacturer's Directory, Thomas Register of American Manufacturers, MacRae's Blue Book.

National Art Workers Community, 220 Fifth Avenue, New York City 10001.

National Sculpture Center, University of Kansas, Lawrence, Kansas 66045. Newsletter provides research exchange on the arts.

Newsletter and Art Journal. College Art Association of America, 16 East Fifty-second Street, New York 10022.

Sculptor's News Exchange, 743 Alexander Road, Princeton, New Jersey 08540.

Southern Association of Sculptors, University of Alabama, Huntsville, Alabama 35805. Various publications, biennial conferences, workshops, demonstrations, panels.

Survey of Arts Administration Training. American Council for the Arts, 570 Seventh Avenue, New York 10018.

Technical Assistance for Art Facilities: A Sourcebook. National Endowment for the Arts, 850 Third Avenue, New York 10022.

Telephone Yellow Pages.

REFERENCES

Murphy, Harry J., ed. *Where's What: Sources of Information for Federal Investigators.* New York: Quadrangle and New York Times, 1975.

Official Museum Directory. Skokie, Illinois: National Register Publishing, 1980.

Sullivan, Linda, ed. *Encyclopedia of Governmental Advisory Organizations,* 2d ed. Detroit: Gale Research, 1975.

Velluci, Mathew, ed. *National Directory of State Agencies.* Washington, D.C.: Information Resources Press, 1974-75.

Appendix B

Abrasives, Glues, Metric Conversions

_____ **ABRASIVES** _____

Sandpaper

Grit	"0" Series	Emery	Flint	Uses
600			Super fine	Wet or dry. High smooth finish
500				
400	10/0			
360				
320	9/0			
280	8/0		Very fine	Wet sanding. Lacquer-finish sanding
240	7/0			
220	6/0			
180	5/0	3/0	Fine	Final sanding—raw material
150	4/0	2/0		
120	3/0	1/0	Medium	General sanding
100	2/0	½		
80	1/0	1		
60	½	½	Coarse	Rough sanding
50	1	2		
40	1½	2½		
36	2	3	Very coarse	Rough machine sanding
30	2½			
24	3			
20	3½			
16	4			
12	4/2			

Types of Sandpaper

Aluminum oxide: metal and wood—all uses
Silicon carbide: glass—wet sanding
Garnet: wood
Flint: gummed materials
Emery cloth: metal—general and polishing
Crocus cloth (very fine): metal—mirror finish

Paper Weight

A—light
D—heavy (machine use)

Cloth Weight

J—light
X—heavy

Steel Wool

Fine
Medium
Coarse
Superfine: 0—00—000

GLUES

Type	Wood	Metal	Leather	Vinyl	Water Resistance	Uses
White glues	G	U	F	U	U	Inexpensive, convenient. Rapid dry. Clamp while curing, minimum 3 hours. Works best on porous materials. Light to heavy duty.
Aliphatic glues	G	U	U	U	U	Wood—heavy duty. Clamp, rapid dry. Indoor use.
Wood glues						
Plastic resin	G	U	U	U	U	Wood—heavy duty. Clamp.
Resorcinol	G	U	G	U	G	Two-part mix. Clamp. Outdoor. High temp.
Hide glue	G	U	F	U	U	No mix—slow set. Long clamping.
Epoxy glues	G	G	U	U	G	Rigid materials—heavy duty. Indoor, outdoor. Two-part mix. Slower sets—harder, stronger. High strength.
Urethane glues	G	F	G	G	G	All-purpose. Outdoor, indoor. Heavy duty. Longer cure, no mix, not as strong as epoxies.
Instant glues	F	F	U	U	F	Nonporous. Indoor. Hazardous, skin to skin, strong fumes. Use with extreme caution. No mix. Set in minutes. Short shelf life.
Silicone glues	F	F	U	U	G	Glass, china. Sealer, caulk. Long cure. Flexible.
General purpose glues	F	F	G	G	G	All-around glue, light duty. Fast dry, no clamp. Clear, opaque types.
Hot glue	G	U	G	G	G	Quick-setting, all-purpose glue. Ability to direct in fine line with gun.

G = good
F = fair
U = unsatisfactory

Common Brand Names of Glues

White

Elmer's Glueall
Devcon Gripwood
Duratite—Dap White Glue
H. B. Fuller White Glue

Aliphatic

Titebond—Franklin
Elmer's Professional Wood Glue
Wilhold Aliphatic Resin Glue

Wood Glues

Elmer's Plastic Resin
Weldwood Plastic Resin
Wilhold Plastic Resin
Elmer's Waterproof Glue
Franklin Hide Glue

Epoxies

Devcon R35
Devcon 2 Ton

Epoxy Bond
P.C.-7
Ross Epoxy
Scotch Epoxy
Weldwood 258
Dap Duratite Epoxy

Urethane

Dow Urethane Bond

Instant

Krazy Glue
Eastman 910
Wilhold Flash Glue
Super Glue
3-Duro
Zip-Grip
10-Devcon

Hot Glues

U.S.M.

Silicone

G.E.
Dow
H. B. Fuller
Permatex

General Purpose

Devcon—Plastic Mender
Duco Cement
Elmer's Household
Goodyear Pliobond
Miracle Sheer All Purpose
Duro Household

--- **FORMULAS FOR AREA AND VOLUME** ---

Square
Area = S^2

Rectangle or Parallelogram
Area = bh

Right Triangle
$C^2 = a^2 + b^2$

Triangle
Area = ⅓bh

Circle
Ratio of circumference
to diameter = π = 3.1416
Area = πr^2
Circumference = $2\pi r$

Sphere
Volume = $\frac{4}{3}\pi r^3$
Surface area = $4\pi r^2$

Cone
Volume = $\frac{1}{3}\pi r^2 h$

Pyramid
Volume = ⅓abh

Rectangular Solid
Volume = abh
Surface area = 2ab + 2bh + 2ah

Cylinder
Volume = $\pi r^2 h$

To establish a right angle on ground:
divide string into 12 equal parts, lay out with
sides 3, 4, and 5 parts.

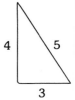

───────────────────── **METRIC CONVERSIONS** ─────────────────────

TAP AND DRILL SIZES

Decimal Equivalents

Inches Fractions	Decimals	Millimeters	Centimeters	Tap Size	Drill Size
$1/16$.0625	1.5875	.16	64NC	53
				72NF	53
$1/8$.1250	3.1750	.32	48NS	31
$3/16$.1875	4.7624	.48	24NC	16
				28NF	14
				32NEF	13
$1/4$.2500	6.3499	.64	20NC	$13/64$
				24NS	$7/32$
				28NF	$7/32$
				32NEF	$7/32$
$5/16$.3125	7.9374	.79	18NC	$17/64$
				24NF	$9/32$
				32NEF	$9/32$
$3/8$.3750	9.5249	.95	16NC	$5/16$
				24NF	$21/64$
$7/16$.4375	11.1124	1.11	14NC	$3/8$
				20NF	$25/64$
$1/2$.5000	12.6999	1.27	13NC	$27/64$
				20NF	$29/64$
				24NS	$29/64$
$9/16$.5625	14.2874	1.44	12NC	$31/64$
				18NF	$33/64$
$5/8$.6250	15.8749	1.59	11NC	$17/32$
				18NF	$37/64$
$11/16$.6875	17.4624	1.76		
$3/4$.7500	19.0498	1.91	10NC	$21/32$
				16NF	$11/16$
$13/16$.8125	20.6374	2.07		
$7/8$.8750	22.2248	2.22	9NC	$49/64$
				14NF	$13/16$
$15/16$.9375	23.8124	2.40		
1	1.0000	25.3998	2.54	8NC	$7/8$
				12NF	$15/16$
				14NS	$15/16$

NC—national coarse　　　NS—national special
NF—national fine　　　　NEF—national extra fine

LENGTH

English Units

12 inches = 1 foot
3 feet = 1 yard
5280 feet = 1 mile

Metric Units

1 millimeter = 0.001 meter
1 centimeter = 0.01 meter
1 kilometer = 1000 meters

English to Metric

1 inch = 2.54 centimeters
1 inch = 25.4 millimeters
1 foot = 30.48 centimeters
1 foot = 304.8 millimeters
1.09 yards = 1 meter
0.62 miles = 1 kilometer

To Convert	Into	Multiply By
inches	centimeters	2.54
feet	centimeters	30.48
yards	meters	0.91
miles	kilometers	1.61
millimeters	inches	0.04
centimeters	inches	0.39
meters	feet	3.28
meters	yards	1.09
kilometers	miles	0.62

Fractions

$\frac{1}{16}$ inch = 0.16 centimeter
$\frac{1}{8}$ inch = 0.32 centimeter
$\frac{1}{4}$ inch = 0.64 centimeter
$\frac{3}{8}$ inch = 0.95 centimeter
$\frac{1}{2}$ inch = 1.27 centimeters
$\frac{5}{8}$ inch = 1.59 centimeters
$\frac{3}{4}$ inch = 1.91 centimeters
$\frac{7}{8}$ inch = 2.22 centimeters
1 inch = 2.54 centimeters

AREA

English Units

1 square foot = 144 square inches
1 square yard = 9 square feet
1 acre = 43,560 square feet
1 acre = 4,840 square yards
1 square mile = 640 acres

Metric Units

1 square meter = 10,000 square centimeters
1 square kilometer = 1,000,000 square meters
1 are = 100 square meters
1 hectare = 10,000 square meters
1 hectare = 100 ares
1 square kilometer = 10 hectares
1 square kilometer = 10,000 ares

English to Metric

1 square inch = 6.45 square centimeters
1 square foot = 929.0 square centimeters
1 square yard = 0.83 square meter
1 acre = 0.004 square kilometer
2.47 acres = 1 hectare
1 square mile = 2.59 square kilometers

To Convert	Into	Multiply By
square inches	square centimeters	6.45
square feet	square meters	0.09
square yards	square meters	0.84
square miles	square kilometers	2.59
acres	ares	40.47
acres	hectares	0.40
square centimeters	square inches	0.16
square meters	square yards	1.20
square kilometers	square miles	0.386
ares	acres	0.0247
hectares	acres	2.47

VOLUME

English Units

1 pint = 16 ounces
1 quart = 32 ounces
1 quart = 4 cups
1 gallon = 4 quarts
1 tablespoon = 3 teaspoons
1 cup = 16 tablespoons
1 cubic foot = 1,728 cubic inches
1 cubic yard = 27 cubic feet

Metric Units

1 liter = 1000 milliliters
1 liter = 1000 cubic centimeters
1000 liters = 1 cubic meter

English to Metric

1 cubic inch = 16.39 milliliters
1 fluid ounce = 29.57 milliliters
1 gallon = 3.78 liters
1.06 quarts = 1 liter
2.11 pints = 1 liter
0.26 gallon = 1 liter
35.31 cubic feet = 1 cubic meter
1.31 cubic yards = 1 cubic meter

To Convert	Into	Multiply By
teaspoons	milliliters	4.9
tablespoons	milliliters	14.8
fluid ounces	milliliters	29.57
cups	liters	0.24
pints	liters	0.47
quarts	liters	0.95
gallons	liters	3.78
cubic inches	cubic centimeters (or milliliters)	16.39
cubic feet	cubic meters	0.03
cubic yards	cubic meters	0.76
milliliters	teaspoons	0.2
milliliters	tablespoons	0.7
milliliters	fluid ounces	0.03
milliliters	cups	0.004
liters	cups	4.23
liters	pints	2.11
liters	quarts	1.06
liters	gallons	0.26
cubic centimeters or milliliters	cubic inches	0.061
cubic meters	cubic feet	35.32
cubic meters	cubic yards	1.31

WEIGHT

English Units
16 ounces = 1 pound
2000 pounds = 1 ton (short)

Metric Units
1000 milligrams = 1 gram
1000 grams = 1 kilogram
1000 kilograms = 1 metric tonne

English to Metric
1 grain = 0.0648 gram
1 ounce = 28.35 gram
1 pound = 453.6 gram
1 pound = 0.4536 kilogram
1 short ton = 0.9072 metric ton

To Convert	Into	Multiply By
ounces	grams	28.35
pounds	kilograms	0.45
short tons	tonnes	0.91
grams	ounces	0.035
kilograms	pounds	2.20
tonnes	short tons	1.10

TEMPERATURE

Fahrenheit = °F
Celsius = °C (metric)

To Convert	Into	Multiply By
Fahrenheit	Celsius	5/9 (after subtracting 32)
Celsius	Fahrenheit	9/5 (then add 32)

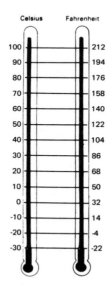

Bibliography

Suggested Further Reading

Ashton, Dore. *Modern American Sculpture.* New York: Abrams, 1969.

Associated Council on the Arts. *The Visual Artist and the Law.* New York: Praeger, 1974.

Baldwin, John. *Continuing Sculpture Techniques: Direct Metal and Fiberglass.* New York: Reinhold, 1967.

Battcock, Gregory. *Minimal Art: A Critical Anthology.* New York: Dutton, 1968.

———, ed. *Idea Art: A Critique.* New York: Dutton, 1970.

———, ed. *New Art: A Critical Anthology.* New York: Dutton, 1970.

——— . *Why Art.* New York: Dutton, 1976.

Batten, Mark. *Stone Sculpture by Direct Carving.* New York: Studio Publications, 1957.

Bazin, Germain. *History of World Sculpture.* Greenwich, Connecticut: New York Graphic Society, 1968.

Bell, D. A. *Intelligent Machines: An Introduction to Cybernetics.* New York: Blaisdell Publishing, 1962.

Benthall, Jonathan. *Science and Technology in Art Today.* New York: Praeger, 1972.

Bowness, Alan. *Modern Sculpture.* New York: Dutton, 1967.

Bragg, William. *Concerning the Nature of Things.* New York: Dover, 1954.

Brett, Guy. *Kinetic Art: The Language of Movement.* New York: Van Nostrand, Reinhold, 1968.

Burnham, Jack. *Beyond Modern Sculpture.* New York: George Braziller, 1968.

——— . *Structure of Art.* New York: George Braziller, 1971.

Calas, Nicolas and Elena. *Icons and Images.* New York: Dutton, 1971.

Clarke, Geoffrey, and Cornock, Stroud. *A Sculptor's Manual.* New York: Reinhold, 1968.

Coleman, Ronald. *Sculpture: A Basic Handbook for Students.* Dubuque, Iowa: William C. Brown, 1968.

Compton, Michael. *Pop Art.* New York: Hamlyn, 1970.

Coutts-Smith, Kenneth. *Dada.* London: Studio Publications, 1970.

Crawford, Tad. *Legal Guide for the Visual Artist.* New York: Hawthorn, 1977.

Crosby, Harry H., and Bond, George R. *McLuhan Explosion: A Casebook on Marshall McLuhan and Understanding Media.* New York: Van Nostrand, Reinhold, 1968.

Davis, Douglas. *Art and the Future.* New York: Praeger, 1973.

Dawson, Robert. *Practical Sculpture.* New York: Viking Press, 1970.

Eco, Umberto, and Zorzoli, G.B. *The Picture History of Inventions.* New York: Macmillan, 1963.

Edie, James E. *The Primacy of Perception.* Evanston, Illinois: Northwestern University Press, 1964.

Experiments in Art and Technology Inc. *EAT News.* New York, published sporadically.

Finch, Christopher. *Pop Art: The Object and the Image.* New York: Dutton, 1968.

Geldzahler, Henry. *New York Painting and Sculpture, 1940-1970.* New York: Dutton, 1969.

Ghiselin, Brewster. *The Creative Process.* Berkeley, California: University of California Press, 1952.

Gibson, James J. *The Perception of the Visual World.* Boston: Houghton Mifflin, 1950.

Giedion-Welcker, Carola. *Contemporary Sculpture: An Evolution in Volume and Space.* New York: Wittenborn, 1955.

Goldwater, Robert. *What Is Modern Sculpture?* Greenwich, Connecticut: New York Graphic Society, 1969.

Greenberg, Clement. *Avant-garde Attitudes.* New York: Wittenborn, 1969.

Gross, Chaim. *Techniques of Wood Sculpture.* New York: Arco, 1966.

Guggenheim, Solomon R., Museum (sponsor). *On the Future of Art: Essays.* New York: Viking Press, 1973.

Hale, Nathan Cabot. *Welded Sculpture.* New York: Watson-Guptill, 1968.

Hall, Edward T. *The Hidden Dimension.* New York: Anchor, 1969.

Herbert, Robert, ed. *Modern Artists on Art.* Englewood Cliffs, New Jersey: Prentice-Hall, 1964.

Herzka, Dorothy. *Pop Art.* New York: Wittenborn, 1965.

Hodes, Scott. *What Every Artist and Collector Should Know About the Law.* New York: Dutton, 1974.

Holton, Gerald, ed. *Science and Culture: A Study of Cohesive and Disjunctive Forces.* Boston: Houghton Mifflin, 1965.

Irving, Donald J. *Sculpture: Material and Process.* New York: Van Nostrand, Reinhold, 1970.

Ivins, William. *Art and Geometry: A Study in Space Intuitions.* New York: Dover, 1972.

Johnson, Ellen H. *Modern Art and the Object.* New York: Harper and Row, 1977.

Kepes, Gyorgy, ed. *The Language of Vision.* Chicago: Paul Theobald, 1951.

————, ed. *Vision and Value Series.* New York: George Braziller, 1965.

Korner, Stephan. *Conceptual Thinking.* New York: Dover, 1959.

Kubler, George. *The Shape of Time: Remarks on the History of Things.* New Haven, Connecticut: Yale University Press, 1962.

Kuh, Katherine. *Break-up: The Core of Modern Art.* Greenwich, Connecticut: New York Graphic Society, 1965.

Kulterman, Udo. *The New Sculpture: Environments and Assemblages.* New York: Praeger, 1968.

Lancome, Fred. *Sculptor Speaks to the Onlooker.* Boston: Branden, 1966.

Lanteri, Edward. *Modelling and Sculpture.* 3 vols. New York: Dover, 1965.

Lewis, Arthur O., Jr., ed. *Of Men and Machines.* New York: Dutton, 1963.

Lippard, Lucy R. *Pop Art.* New York: Praeger, 1966.

———. *Five Hundred Fifty Seven, Eight Seven.* New York: Wittenborn, 1970.

———. *Changing: Essays in Art Criticism.* New York: Dutton, 1971.

———. *Six Years: The Dematerialization of the Art Object from 1966-1972.* New York: Praeger, 1973.

———. *From the Center: Feminist Essays on Woman's Art.* New York: Dutton, 1976.

Lynch, John. *Metal Sculpture.* New York: Studio Publications, 1957.

McCann, Michael. *Health Hazards Manual for Artists.* New York: Foundation for the Community of Artists, 1975.

McDarrah, Fred. *Artist's World in Pictures.* New York: Dutton, 1967.

Malevich, Kasimir. *The Non-objective World* (1927). Translated by Howard Dearstyne. Chicago: Paul Theobald, 1959.

Mayer, Ralph. *The Artist's Handbook of Materials and Techniques.* New York: Viking, 1957.

Meilach, Dona Z. *Contemporary Art with Wood.* New York: Crown, 1968.

———. *Creative Carving.* Chicago: Reilly and Lee, 1969.

———, and Seider, Donald. *Direct Metal Sculpture.* New York: Crown, 1969.

Meyer, Fred. *Sculpture in Ceramics.* New York: Watson-Guptill, 1971.

Meyer, Ursula. *Conceptual Art.* New York: Dutton, 1972.

Mills, John W. *The Technique of Sculpture.* New York: Van Nostrand, Reinhold, 1965.

———. *The Technique of Casting for Sculpture.* New York: Van Nostrand, Reinhold, 1967.

———. *Sculpture in Concrete.* New York: Praeger, 1968.

———, and Gillespie, Michael. *Studio Bronze Casting: Lost Wax Method.* New York: Praeger, 1970.

Moholy-Nagy, Laszlo. *The New Vision and Abstract of an Artist.* New York: Wittenborn, 1946.

———. *Vision in Motion.* Chicago: Paul Theobald, 1947.

Morris, J.D. *Creative Metal Sculpture.* St Paul, Minnesota: Bruce Publishing, 1971.

Muller, Gregoire. *New Avant-garde: Issues for the Art of the Seventies.* New York: Praeger, 1972

Myers, Bernard. *Sculpture: Form and Method.* New York: Van Nostrand, Reinhold, 1965.

Nelson, Glenn C. *Ceramics: A Potter's Handbook.* New York: Holt, Rinehart and Winston, 1970.

Newman, Thelma R. *Plastics as an Art Form.* Philadelphia: Chilton, 1970.

———. *Plastics as Design Form.* Philadelphia: Chilton, 1972.

———. *Plastics as Sculpture.* Radnor, Pennsylvania: Chilton, 1974.

Norman, Edward P. *Sculpture in Wood.* New York: Transatlantic, 1966.

Ortega y Gasset, Jose. *Dehumanization of Art and Other Essays on Art, Culture, and Literature.* Princeton, New Jersey: Princeton University Press, 1968.

Panofsky, Erwin. *Meaning in the Visual Arts.* Garden City, New York: Doubleday, 1955.

Panting, John. *Sculpture in Fiberglass.* New York: Watson-Guptill, 1972.

Percy, H. M. *New Methods in Sculpture.* New York: Transatlantic, 1966.

Petersen, Karen, and Wilson, J. J. *Women Artists.* New York: Harper and Row, 1976.

Piene, Otto. *More Sky.* Cambridge: Massachusetts Institute of Technology Press, 1972.

Read, Herbert. *The Art of Sculpture.* New York: Pantheon Books, 1956.

——. *A Concise History of Modern Sculpture.* New York: Praeger, 1964.

Rich, Jack C. *The Materials and Methods of Sculpture.* New York: Oxford, 1961.

——. *Sculpture in Wood.* New York: Oxford University Press, 1970.

Richardson, Anthony, and Stangos, Nikos, eds. *Concepts of Modern Art.* New York: Harper and Row, 1972.

Rickey, George. *Constructivism: Origins and Evolution.* New York: George Braziller, 1967.

Rood, John. *Sculpture in Wood.* Minneapolis: University of Minnesota Press, 1950.

——. *Sculpture with a Torch.* Minneapolis: University of Minnesota Press, 1963.

Rosenberg, Harold. *The Tradition of the New.* New York: McGraw-Hill, 1965.

——. *The Anxious Object.* New York: Mentor, 1966.

Roukes, Nicholas. *Sculpture in Plastics.* New York: Watson-Guptill, 1968.

Russell, Bertrand. *The Analysis of Matter* (1927). New York: Dover, 1954.

Russell, John, and Gablick, Suzi. *Pop Art Redefined.* New York: Praeger, 1969.

Schneider, Ira, and Kordt, Beryl. *Video Art.* New York: Harcourt, Brace, Jovanovich, 1976.

Schwartz, Paul. *Hand and Eye of the Sculptor.* New York: Praeger, 1969.

Selz, Jean. *Modern Sculpture: Origins and Evolution.* New York: George Braziller, 1963.

Selz, Peter. *The New Images of Man.* New York: The Museum of Modern Art and Doubleday, 1959.

Seuphor, Michel. *The Sculpture of This Century.* New York: George Braziller, 1960.

Siegel, Curt. *Structure and Form in Modern Architecture.* New York: Van Nostrand, Reinhold, 1962.

Sinnott, Edmund, W. *The Problem of Organic Form.* New Haven, Connecticut: Yale University Press, 1963.

Sondheim, Alan, ed. *Individuals, Post Movement Art in America.* New York: Dutton, 1976.

Sopcak, James E. *Handbook of Lost Wax or Investment Casting.* Mentone, California: Gembooks, 1969.

Sternberg, N., ed. *Kitsch.* New York: St. Martin's Press, 1972.

Struppeck, Jules. *Creation of Sculpture.* New York: Holt, Rinehart and Winston, 1952.

Thompson, D'Arcy Wentworth. *On Growth and Form.* 2 vols. London: Cambridge University Press, 1952.

Tomkins, Calvin. *The Scene: Reports on Post Modern Art.* New York: Viking, 1976.

Trier, Eduard. *Form and Space: Sculpture of the Twentieth Century.* New York: Praeger, 1968.

Tuchman, Maurice, ed. *American Sculpture of the Sixties, An Exhibition and Book Catalog.* Los Angeles: Los Angeles County Museum of Art, 1967.

Vasari, Giorgio. *Vasari on Technique.* New York: Dover, 1962.

Venturi, Lionello. *History of Art Criticism.* New York: Dutton, 1964.

Verhelst, Wilbert. *Sculpture: Tools, Materials and Techniques.* Englewood Cliffs, New Jersey: Prentice-Hall, 1973.

The Way Things Work, an Illustrated Encyclopedia of Technology. 2 vols. New York: Simon and Schuster, 1967.

Weyl, Hermann. *Symmetry.* Princeton, New Jersey: Princeton University Press, 1952.

Whyte, Lancelot Law. *Accent on Form.* New York: Harper and Row, 1954.

Wiener, Norbert. *Cybernetics.* Cambridge: Massachusetts Institute of Technology Press, 1961.

Wilcox, Donald. *Wood Design.* New York: Watson-Guptill, 1968

Wilenski, R. H. *The Meaning of Modern Sculpture* (1932). Boston: Beacon Press, 1965.

Wolstenholme, Gordon. *Man and His Future.* Boston: Little, Brown, 1963

Young, Louise B. *The Mystery of Matter.* New York: Oxford University Press, 1965.

Yovits, Marshall C., and Cameron, Scott, eds. *Self-organizing Systems.* New York: Pergamon Press, 1960.

Zaidenburg, Arthur. *Sculpting in Steel and Other Metals.* New York: Chilton, 1974.

Index

Abrasives, 204
Adhesives, 204-205
Alternative education, 152-153, 197-198
Area, formulas for, 206
Artpark, Lewiston, N.Y., 9

Bauhaus, 154
Business considerations, 199

Calder, Alexander, 35, 113
California royalty law, 5
Carving. *See* Cements; Plasters; Synthetic stone; Wood
Casting. *See* Cements; Clay; Metal casting; Plasters; Plastics; Synthetic stone
Cements, 166-167, 172; carving, 173; casting, 173-174; direct building, 173; finishing, 175; molding, 174-175
Center for Advanced Visual Studies, MIT, 109
Center for Welded Sculpture, 110
Chemical and physical considerations, 189, 193-95. *See also* Chemical and synthetic materials
Chemical and synthetic materials, 129-136; change of matter, 131
Classicism, 15-16
Clay, 157-158, 169-171; casting, 158, 171; construction, 158, 170-171; modeling, 158, 170-171
Collaboration, 33, 34-35, 46
Color, 81-83
Constructivism, 16-17, 154
Content, 12, 22, 25, 101-106; definition, 101; and form, 35, 99, 101-102, 103-106; and matter, 101-102, 103-106; meaning, 102-103; response to, 102; and style-manner, 102; will of sculptor, 102

Context, 12, 21, 30, 43, 55, 73, 85
Craftsmanship, 94, 150
Critical thinking, 191
Cubism, 17, 154

Dada, 154
Dehumanization/mechanization, 23-25
Dimension and scale, 7
Drawing, 96

Education, 151-153, 197-198
Electronic equipment, 122, 124
Electronic manipulation, 121-124, 189
Environmental commentary, 21-23
Environmental sculpture, 7-8, 21-23, 137-148
Exhibition practices, checklist, 199
Experiments in Art and Technology (EAT), 108-109, 123, 136
Expo '70, 123
Expressionism, 19-20

Fibonacci numbers, 35
Fleischner, Richard, "Sod Maze," 40
Form, 33-46, 65-99; color, 81-83; and content, 35, 99, 101-102, 103-106; definition, 65-66; individuality, 44-46, 96-99; line, 77-79; mass, 66-69; and matter, 62-63, 103-106; order, 83-84; plane, 73-74; space, 85-92; and technique, 93-96; texture, 79-81; time, 92-93; universality, 33-46; volume, 69-71
Formulas for area and volume, 206
Fuller, Buckminster, 35
Funding, 6, 8-9, 153, 196
Futurism, 154

Geodesic dome, 35
Gesture, figurative, 14
Glues, 204-205
Graduate work, 197-198
Grants-in-aid assistance, 196
Gravity, 43, 131
Golden ratio, 35, 154
Golden section, 35
Group N, 113
Group T, 113
Group Zero, 113
Guggenheim, Solomon, Museum, 35

Happenings, 21
Hard edge, 154
Heat, 194-195
Human form, 11; conceptual, 12; representational, 11
Humanity and technology, 136-140
Humanization/process, 26-27

"Information" exhibition, Museum of Modern Art, New York, 34
Institute for Art and Urban Resources, New York, 8
Institute of Contemporary Art, London, 123
International style, 7
Investments, 167

Kinetic sculpture, 113, 154
Kitchen Center for Video and Music, New York, 108-109, 122, 136
Krebs, Rockne, 36

Laser, 36, 123
Law considerations, 199-200
Light, 126, 195
Line, 77-78
LIP Franklin Street Arts Center, New York, 109-110
Lye, Len, 36

McLuhan, Marshall, 112
"Making it," 5-6
Marketplace, 4-6, 8-9, 151
Masonry cement, 166
Mass, 66-69
Materials. See Cements; Clay; Investments; Metal; Miscellaneous materials and techniques; Plasters; Plastics; Stone; Synthetic stone; Waxes; Wood; Wood filler
Matter, 47-63, 97; and content, 101-102, 103-106; definition, 47; exploitation, 62; and form, 62-63, 103-106; manipulation, 58-61; selection, 49-56. See also Materials
Mechanics, 194
Mechanization, systems, and process, 124-129, 189
Metal, 159-161, 167-168, 176-185; cleaning solutions, 167, 168; coloring solutions, 167-168; electroplating, 168; low-melting alloys, 167; melting points, 167. See also Metal casting; Metal construction
Metal casting, 160-161, 181-185; foundry equipment, 182; processes: ceramic shell, 181, 183-184; cope and drag, 182, 184; free pour, 185; full mold, 182, 184; lost wax, 181, 182-183; sand casting, 182, 184-185; self-set, 185
Metal construction, 160, 176-181; bolting, 177; brazing, 180-181; crimping, 177-178; cutting, 176; drilling, 176; electric arc welding, 181; fusion welding, 180; joining, 177-181; metallic inert-gas welding, 181; oxyacetylene cutting, 176, 177; oxyacetylene welding, 178-181; riveting, 177; shaping and bending, 176-177; soldering, 178; spot welding, 178; tools, 176; tungsten inert-gas welding, 181
Metric conversions, 207-210
Miniaturization, 122
Minimal sculpture, 154
Miscellaneous materials and techniques, 166-168, 189
Mobius strip, 42
Molding. See Cements; Plasters; Plastics; Synthetic stone
Monumentality, 7, 13, 43
Museum of the Media, New York, 110, 136
Museum of Modern Art, New York, 34
Museum of Modern Art, Paris, 8

Nassau Museum of Fine Arts, Roslyn, N.Y., 9
National Endowment for the Arts, 5, 8, 9, 153
National Sculpture Conference, 110
Natural force, systems, and phenomena, 113-121
Neon light, 124

Optics, 113, photography, 122

Plane, 73-74
Plasters, 166, 172-173; carving, 173; casting, 173-174; direct building, 173; finishing, 175; molding, 174-175
Plastics, 131-132, 161-165, 185-187; categories, 161; processes and forming, 185-187; properties, 161-165; types, 162-165
Prepared cement mixtures, 167

Resin, synthetic, 132
Resources, checklist, 200-201
Rickey, George, 36

Safety work procedures, 195-196
Scale and dimension, 7
Sculptor, 2-3, 44-46, 96-99, 102, 149-150; changing role of, 149-155; education of, 151-153; interdisciplinary concern of, 153, 154; and marketplace, 4-6, 8-9, 151; professional role of, 151; style-manner of, 97-99
Sculptor's News Exchange, 110
Sculpture in the Environment (SITE), Inc., 8, 136, 137
Situational reality, 28-31
Skill, craftsmanship, and art, 150
Smithson, Robert, "The Spiral Jetty," 35
Smithsonian Institute, 123
Society of the Plastics Industry, Inc., 187
Sound, 113-118, 195
Southern Association of Sculptors, 110
Space, 85-92
Status quo, rejection of, 7
Stone, 158-159, 171-172; carving, 159, 171-172; construction, 159; tools, 171
Stonehenge, 42
Style-manner, 97-99, 102
Subject matter, 35, 103
Super realism, 25-26
Surrealism, 18
Survival considerations, checklist, 198

Synthetic stone, 172-175; carving, 173; casting, 173-174; direct building, 173; finishing, 175; molding, 174-175

Tax considerations, checklist, 200
Technique, 58, 93-96; craftsmanship, 94, 150; possibilities for exploration, 94
Technology, 107-148; chemical and synthetic materials, 129-136; electronic manipulation, 121-124; and environmental sculpture, 136-140; mechanization, 124-129; natural force, systems, and phenomena, 113-121; resources, 108-112; responses to, 107-108, 111-112, 140
TelePromPter/Manhattan cable, 110
Television, 109, 121
Texture, 79-81

Three-dimensional design, 83, 85
Time, 92-93
Transition from romantic to modern period, 13-15
Tsai, 35
Tuttle, Richard, 77

Volume, as element of form, 69-71; formulas for, 206

Waxes, modeling, 167; pouring, 167
Welding, 178-181
Wood, 166, 187-189; carving, 166, 187-188; construction, 166, 188-189; joining, 188-189; lumber, 166; shaping, 188; tools, 188
Wood filler, 167
Wright, Frank Lloyd, 35

Class Nolan. AFAR Jle